# JOHN BELL,

## Patron
## of British
## Theatrical Portraiture

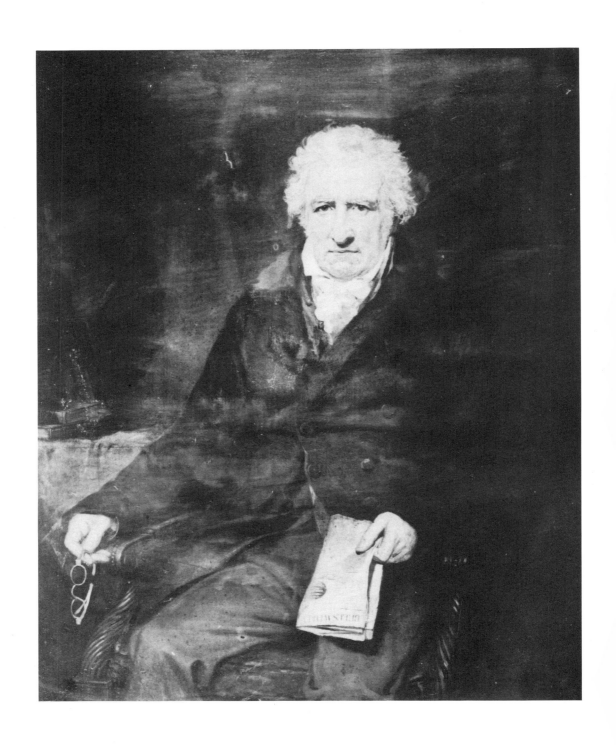

JOHN BELL.
BY G. CLINT, A.R.A.

# JOHN BELL,

## Patron of British Theatrical Portraiture

A Catalog of the Theatrical Portraits

in His Editions of

*Bell's Shakespeare*

and

*Bell's British Theatre*

Kalman A. Burnim and Philip H. Highfill Jr.

SOUTHERN ILLINOIS UNIVERSITY PRESS  *Carbondale and Edwardsville*

Copyright © 1998 by the Board of Trustees,
Southern Illinois University

Printed in the United States of America

01  00  99  98  4  3  2  1

*Frontispiece:* John Bell, by G. Clint. Courtesy of the
British Museum.

Library of Congress Cataloging-in-Publication Data
Burnim, Kalman A.
    John Bell, patron of British theatrical portraiture : a
    catalog of the theatrical portraits in his editions of
    Bell's Shakespeare and Bell's British theatre /
    Kalman A. Burnim and Philip H. Highfill Jr.
        p.   cm.
    Includes bibliographical references.
    1. Actors—Great Britain—Portraits—Catalogs.
    I. Highfill, Philip H.   II. Title.
    PN2597.B75   1998
    016.792′028′092241—dc21                          97-4085
        ISBN 0-8093-2123-8 (cloth : alk. paper)        CIP

The paper used in this publication meets the minimum
requirements of American National Standard for
Information Sciences—Permanence of Paper for
Printed Library Materials, ANSI Z39.48-1984. ⊗

# CONTENTS

# PREFACE

The hundreds of engraved portraits of performers in action that were commissioned by John Bell to supply frontispieces to the plays in his editions have been, for the most part, ignored by art historians. They (and the play texts that they embellish) await the closer attention of theatrical and cultural historians.

Our present purposes are to make these pictures readily available for study and to describe briefly the editions in which they appeared. We also include in the catalog engraved portraits that were published by Bell but were not in any of his editions of *Shakespeare* or *British Theatre*, and we offer information about original portraits that were not engraved but were once owned by Bell. We believe that this presentation of portraits of actors, in such numbers and of such interest, is unique. The majority of the portraits are by James Roberts or Samuel De Wilde, who were the leading painters of actors and actresses between 1770 and 1820. But many others were drawn or painted by the rising young artists Johann Heinrich Ramberg and Edward Francis Burney. Also included are a few pictures by Richard Cosway, William Hamilton, Gilbert Stuart, and other estimable portraitists. The engraved versions are by James Thornthwaite, William Leney, Philippe Audinet, and other prominent engravers.

Included in the individual entries of the catalog are details of publication, a description, locations of the originals when known, provenance and related pictures, and some commentary. When possible, each entry is illustrated with a reproduction of the engraving and/or original picture; their dimensions are always given in centimeters. In the details of publication, CMBT stands for *Cawthorn's Minor British Theatre*, 1805, and the Bell editions are identified as follows: BBT (*Bell's British Theatre* and

the year of edition), BET (*Bell's English Theatre*, 1792), and BS (*Bell's Shakespeare* and the year of edition).

It has seemed proper to offer a sketch of the career of the enterprising, engagingly pugnacious John Bell. Some sixty-eight years ago, in 1930, the typographical historian Stanley Morison contributed a study of Bell as typefounder and newspaper publisher. But Morison gave scant attention to the play editions on which Bell had lavished so much care. Despite its narrative disorganization, Morison's biography supplies many details of Bell's tangled business affairs. We have drawn gratefully on that account, supplementing it with contemporary news notices and other sources.

The sophisticated computerized bibliographical analyses by William J. Cameron in the *Western Hemisphere Short-Title* series have greatly assisted our descriptions of the various drama editions. Cameron did not, however, deal with paper, bindings, or portraits of actors.

We are pleased to acknowledge our enormous debt to Jennie Walton, who has provided most of the photographs of the engravings from her own collection. Others to whom we are grateful for allowing us to have photographs of pictures in their collections include Dr. Jeanne Newlin, of the Harvard Theatre Collection, Jack Reading, Peter Siddons, the British Museum, the Folger Shakespeare Library, the Garrick Club, the Manchester City Art Galleries, and the Royal National Theatre. A number of reproduced engravings are from the collection of Kalman A. Burnim.

We also thank Molly Highfill, who has read our text with care and offered fruitful suggestions, and Jean Miller, of the Folger Shakespeare Library, for assistance in identifying painters and engravers.

# PART 1

*John Bell and the Portraits*

# 1 JOHN BELL AND HIS EDITIONS OF PLAYS

JOHN BELL, publisher, journalist, bookseller, binder, and typographer, was born in 1745, for he was eighty-six when he died in 1831. His place of birth and parentage are unknown. On 29 October 1769, he married a Miss Doree, of Ongar in Essex.[1] The London *Times* for 3 March 1789 reported the death on 1 March at Whittle in Essex of "Miss Bell, only child of Mr. Bell of the British Library Strand." The *Gentleman's Magazine* that month added that she was nineteen years old. But a son, John Browne Bell (1779–1858), became a publisher and was disinherited because of his radical politics. He married Mary Ann Millard in 1805.[2]

That John Bell's origins were middle class is suggested by the fact that his niece married Francis Ludlow Holt, K. C. (1780–1844), a government official and eminent legal author.[3] We know also that John Bell had a nephew Edward Bell (fl. 1794–1847) who was a prominent London engraver. Another nephew, James Bell, and a great-nephew, John Chapman Bell, were residents of Trowse, near Norfolk, when our subject made his will in 1820.[4] There seem to be no other recoverable facts about the family of John Bell, that "mischievous spirit—the very Puck of booksellers."[5]

Bell was selling books in his shop at No 132, the Strand, "at the corner of Exeter 'change," as early as 1768, when he was twenty-three. He would remain for the following forty years at the same address, near Dr Samuel Johnson's favorite haunt, the Cheshire Cheese, and not far westward from the Chapter and other coffeehouses in Paternoster Row, where publishers gathered to arrange their "congers."[6] Bell's premises were also near enough to Drury Lane and Covent Garden theatres that the young publisher would very soon become familiar with the performers and managers. Nearby, too, were the law courts of Chancery and the King's Bench, with which Bell in time would become painfully acquainted. He would, in fact, remain in the same general neighborhood for more than fifty years, a familiar character in the purlieus of booksellers and publishers in Westminster and the City until toward the end of the Regency.

In 1769, Bell acquired from a Mrs Bathoe the proprietorship of "The British Library in the Strand," a banner under which both Bell's famous circulating library and his brisk book-publishing business would march until he was forced to relinquish the Library in 1796. Stanley Morison found a receipt dated 13 September 1769 "for Four Pounds in full for one half of my 16th share of Francis's Horace bought at Miller's sale," a document that represents the earliest known activity by Bell as a book publisher.[7]

In 1770, Bell and an older printer and publisher, Christopher Etherington of York, brought out in weekly numbers *The Dramatic Censor*, an influential critical work by Francis Gentleman, the raffish actor, playwright, poet, and teacher of oratory. The essays were collected in two volumes in 1771. Bell and Etherington joined in the publication of six other titles by Gentleman between 1770 and 1774.[8]

The close and frequent association with

Gentleman led to a decision by Bell and Etherington to publish the first "acting" text of Shakespeare's plays, to be edited by Gentleman from the promptbooks of the patent theatres, Drury Lane and Covent Garden. The edition alarmed important members of the London publishing establishment (the current conger), who believed that their exclusive rights to the Bard had been invaded.

The *Shakespeare* emerged in several editions and states, beginning in 1773; and from 1775 to 1778, it appeared in separate numbers, each play with a full-length portrait of a performer apparently in action. The success of the "acting" *Shakespeare* encouraged Bell in 1776 to begin the serial publication of *Bell's British Theatre*, which eventually numbered one hundred forty plays, though many accumulated after Bell lost control of the series.

In 1772, Bell had joined a syndicate of eleven prominent Londoners, among whom were the Pall Mall auctioneer James Christie, the Reverend John Trusler, and the Reverend Henry Bate, the "fighting parson," to publish the *Morning Post; and Daily Advertising Pamphlet*. The first number was on 2 November 1772. Trusler and Bate were the editors, but Bell's was also a dominant voice.[9] In a maneuver at which he certainly connived, the newsprint was folded twice to reduce it to half-normal, or "pamphlet" size. The stamp tax was thus to be evaded, or so its publishers imagined. But the authorities quickly disagreed, and the paper was expanded to proper newspaper dimensions, becoming the *Morning Post, or Cheap Daily Advertiser*.[10]

That enterprise proceeded without further incident until the dismissal of the newspaper's printers, Corral, Bigg, and Cox, who retaliated by bringing out a counterfeit *Morning Post*, typographically indistinguishable from the original. The Lord Chamberlain handed down a decree obliging the faux publication to change *its* title to *New Morning Post*.

That affair included a hot battle of billingsgate in which the Reverend Gentlemen Trusler and Bate were characterized by the rival journalists as "two parsonical banditti" who operated "with all the chicane of sacerdotal hypocrisy," while John Bell was said to be "a piratical intruder upon the profession of a bookseller." Bell replied in kind, for he enjoyed debate, and his keen instinct for publicity assured him that such exchanges did his book publishing no harm at all.[11]

In fact, Bell deliberately exacerbated the quarrel by sending his employees parading in the street, masked and uniformed. Horace Walpole (whose short series called *Miscellaneous Antiquities* Bell had issued in 1773) wrote to Lady Ossary on 13 November 1775: "Yesterday just after I arrived, I heard drums and trumpets in Piccadilly; I looked out the window and saw a procession with streamers flying."

The "corps" marched "well-dressed, like hussars, in yellow with blue waistcoats and breeches, and high caps. . . . In short this was a procession set forth by M. Bates [*sic*] . . . author of the old *Morning Post* and meant as an appeal to the town against the new one." The old *Post* exulted in rhyme: "Nor was [Bate] yet deficient in his plan / A troop was raised at one pound per man / The hired troop was staunch—that I can tell, / For they were all bookbinders to John Bell."[12] Bell remained a proprietor of the *Morning Post* for fourteen years.

His delight in battle, and simultaneous involvement in several large projects, led Bell also in 1776 to throw down another gauntlet before the principal London conger of the moment by beginning the publication of the serial *Poets of Great Britain Complete from Chaucer to Churchill*, printed for Bell by the Martins at their Apollo Press in Edinburgh.

The publisher Edward Dilly, in a letter to James Boswell, sneered that "the little trifling edition" of Bell's *Poets* had type so small that many persons could not read it." Nevertheless, "about forty of the most respectable booksellers of London," alarmed at "an invasion of what we call our Literary Property," quickly met and agreed to produce their own collection, "with a concise account of each authour, by Dr. Samuel Johnson."[13] Despite Dilly's scorn, and organized detraction by the opposing publishers, Bell's attractive little 18mo edition, cheap and conve-

nient to the hand, sold well and achieved 109 volumes by 1783. And, of course, the irritant that Bell supplied was the indirect cause of Johnson's writing the *Lives of the Poets*.

In 1779, the energetic Bell joined John Wheble in publishing another newspaper, the *English Chronicle*, edited by Henry Bate and William Radliffe. Bell continued to expand offerings at his lending library, and in 1780, he signaled his growing interest in foreign books (and foreign subscribers) by advertising a "*Collection de petit[e] formats*" to be had "*chez John Bell Impremeur-Libraire, à la Librairie Britannique dans le Strand*." Also that year, he published the fourth volume of Horace Walpole's *Anecdotes of Painting*. (There was disagreement over the terms; Walpole later accused "the rascal" Bell of cheating him of £500 on the contract, "and now [he] sets me at defiance because he found I would not arrest him.")[14]

Bell's elaborately produced "literary" *Shakespeare* (as distinguished from the early "acting" edition) began to unfold periodically in 1785. But that year was also enlivened by a newspaper squabble involving Bell, his errant partner Trusler, and the publisher John Walter. Bell had eagerly agreed to handle the publication of Alexander Bicknell's memoir of a popular actress, *An Apology for the Life of George Ann Bellamy*, in six volumes. The work was to be published under Trusler's auspices by Walter's "Logographic Press." But Walter's process proved slow, and his printing was flawed. Bell, fearing that his reputation (and the sales of his new *Shakespeare*) would be damaged by shoddy work, printed his own independent edition. Bell lost an expensive suit brought by Walter in the King's Bench.[15]

In 1786, Bell sold his shares in the *Morning Post*, thus, as he said, "reserving myself a perfect freedom and irreproachable liberty to act as I please with respect to any new undertaking whatever."

Foremost among his new undertakings was the establishment of Bell's British Letter Foundry. Stanley Morison believed that the fonts that Bell designed wrought a profound and permanent change in English printing, though the only innovation we remember today is the substitution of the round *s* for the form so easily mistaken for *f*. Bell promoted his foundry with characteristic zeal and hyperbole. His advertisements for a projected edition of Arthur Murphy's comedy *The Way to Keep Him* are typical. Because of the new type, "J. Bell flatters himself that he will be able to render this THE MOST PERFECT and in every respect the MOST BEAUTIFUL BOOK, that ever was printed in any country." He boasted that even "The ink will be prepared by himself." But on 5 December 1789, in an announcement emphasizing his dedication to the improvement of printing ("the happiest invention that ever employed the faculties of man"), Bell relinquished the firm to his "late partner," Simon Stephenson.[16]

On 1 June 1788, he had introduced the *World, or Fashionable Gazette*, a newspaper "Printed under the Direction of J. Bell at the British Library in the Strand." He had secured a one-third interest, but the largest bloc of shares was owned by his financial backer, the rich and elegant Captain Edward Topham (1751–1820). Boulevardier, guardsman, and playwright, Topham was a friend of the Prince of Wales, of R. B. Sheridan, and of the radicals Horne Tooke and John Wilkes. Topham's mistress (and mother of four of his children), the actress Mary ("Becky") Wells, took a hand in the editing of the paper, as did the rich and convivial playwright Miles Peter Andrews and the clergyman Charles Este. The paper, established principally to advance the stage career of Becky Wells, also facilitated the mawkish verse of the Florentine English "Della Cruscan" school of poetry. But the *World* was also popular among "The Fancy," London's sporting crowd, and its circulation was greatly assisted by the news of the prize ring, especially the colorful reciprocal challenges of Mendoza and Humphries.[17]

Bell had now acquired the patent of "Bookseller to the Prince of Wales," to whom he dedicated his "literary" *Shakespeare*, when finished and collected, in 1788. The dedication to the Prince was a social event noticed approvingly by the rival *Times* for 28 June 1788: "Yester-

day Mr. *Bell*, of the British Library, had the honour of being introduced to his ROYAL HIGHNESS the PRINCE of WALES by Mr. Sheridan; and at the same time presenting his Dedication Copy of *SHAKESPEARE's WORKS*, elegantly bound in Thirty-eight Volumes, which was commended and admired as the most elegant Work that this Country has produced."

Bell and Topham tippled together with the Prince at parties at Bell's house. But they disagreed about their newspaper's direction, and there were irritable words over expense accounts and other matters, including a code devised (probably by Bell) to transmit war correspondence secure from journalistic rivals. Bell had branched out from publishing to reporting and had followed the British army to France. The *Times* on 15 October 1788 archly gossiped:

> We hear that a very alarming misunderstanding has taken place between the *Captain* [Topham] and the great *Bell* of the Strand, in consequence of the large charge brought in by the latter for private correspondence from the camp of St. *Omer*'s. It seems *Bell* was sent express to the camp to communicate intelligence for the Captain's paper; and as it was to be of the most superior and secret nature, the communications were to be sent in *hieroglyphics*.—The Parson [Este] who was said to be well versed in these characters, acted as secretary—but a mistake happening, in placing one for another, the whole as it came before the public, turned out a falsity, and accounts for the lies which appeared in the *superior* print, under the head of "Camp Intelligence."

Topham forced Bell from the *World* partnership on 9 May 1789.

On 11 May, several journals announced that Bell would head a new paper, the *Oracle, or Bell's New World*. It appeared on 1 June 1789, handsomely set in type from the British Letter Foundry, with six columns devoted to Bell's "Statement of Previous Facts," an attack on Topham.[18] Bell's presses were still busy turning out books, and the center of all his activity, the

British Library, continued healthy. The *Times* and other papers, on 15 January 1789, had given notice to the public that Bell had completed an "extensive catalog" with an up-to-date appendix. A subscription to the Library's "vast and expensive Collection," which had "cost many Thousand Pounds," was now a guinea a year.

The series, called *Bell's Classical Arrangement of Fugitive Poetry*, was instituted early in 1789. Bell promised twenty volumes, one to arrive the first day of each month. To his advertisement of the second volume, in the *Times* of 28 March, he was able to append a letter from William Woodfall, editor of the *Morning Chronicle*, who wrote of volume 1, "the printing . . . is a singular example of neatness and accuracy, in an age more remarkable for slovenly Composition and Press-Work, perhaps, than any that has preceded it." Also in 1789, the public was invited to acquire *Bell's New Pantheon, or, Historical Dictionary of the Gods, DemiGods, Heroes, and Fabulous Personages of Antiquity*. There would be fifty numbers at a shilling each, the first one to be introduced "with a fine Figure of Apollo Belvidere." In May 1790, the *English Review* praised its "uncommonly elegant" typography and "beautiful engravings," and Bell of course cited the praise. But his motive to such publications was much more than his conspicuous vanity and obvious desire for profit. Bell had an educational purpose. As he saw it, "The Advantages of large and valuable Works being published periodically, at short intervals, consist principally in the inducement to young Minds, and to Persons not accustomed to sedentary Studies, to read such Works . . . regularly in the process of Publication."[19]

The year 1790 saw Bell's entry into the magazine field, with one of the most popular of his publications, *La Belle Assemblée, or Bell's Court and Fashionable Magazine addressed particularly to the Ladies*. Elevated in tone, it was a colorful miscellany of poetry and politics, admonitions to genteel behavior, celebrity anecdotes, needlework patterns, and reports on fashions in dress.[20] Bell would be its proprietor until 1820.

By 1790, Bell's reputation as a publisher intent on popular publications of superior intellectual and aesthetic quality was firmly established. When he proposed to resuscitate his massive *British Theatre* in a fresh format, with portraits of performers painted by Samuel De Wilde, the *Times* of 13 December 1790 contributed a magnanimous editorial commendation headed "The Competition of Bell, Boydell, and Macklin":

> The pretentions to public patronage which Mr. BELL holds out in his new publication of the *British Theatre*, are reputable to the fine arts and the *Belles Lettres*, and there is no doubt that the NOBILITY will sanction his spirited enterprise by honouring him immediately with permission to grace with their names his present voluminous list of Subscribers.—
>
> To enterprises like the above is Britain indebted for the extension of her literary fame: no small portion of the British Classics, promoted by the accurate and elegant manner in which they have been produced:—indeed we date the revival of, if not the original taste for, fine Painting and elegant Book Establishments in England, to the enthusiasm and perseverance of Mr. BELL in that line of business—for the productions of the Press may be said to have been in a barbarous state of [*sic*] this country, until he awakened public curiosity, and invited emulation by his beautiful editions of the Poets of Great Britain and of our immortal dramatic Bard. From the avidity with which those elegant publications were received, may be attributed the present spirited plans of BOYDELL and MACKLIN. But we perceive with pleasure that the competition is not in these rival instances the consequences of envy, but the fair and laudable efforts of honest ambition, and judicious speculation:—The undertakings of these respectable and emulative Proprietors are perfectly distinct—let them therefore go hand in hand to the Temple of Fame.[21]

But Bell's financial affairs—always precarious because of his venturesome spirit and exuberant social life—became more complicated in 1791, when he began to publish the new series of *Bell's British Theatre*, the enterprise so highly commended by the *Times*. A "Society of Private Gentlemen" assisted him to finance it, laying out "nearly twenty thousand Pounds," he said. That outlay would haunt Bell.

Early in 1792, he was involved in a lawsuit brought in the Court of Chancery by Lord Lonsdale, who was indignant over some unflattering expressions in a poem by the popular satirist "Peter Pindar" (Dr. John Wolcot) printed by T. Evans and published by John Bell. Both Evans and Bell were discharged by the Court when affidavits of their innocence of intent were introduced and Wolcot handsomely assumed all responsibility. But the affair was expensive for Bell.[22]

Something more serious was brewing, however, for in 1792 Bell was also charged by the Crown with "libelling" the Foot Guards, in an article in the *Oracle* of 5 January 1792, by censuring their control of a crowd that had gathered to see the king and queen enter a theatre. Bell was indicted on 7 January. After a lengthy trial, he was found guilty on 9 July 1792, but he failed to appear when summoned for judgment on 5 February 1793. He apologized to the Court on 5 March, but the size of the sum that was nevertheless levied probably helped to precipitate his bankruptcy.[23]

On 27 March 1793, in the first of several efforts to stave off ruin, Bell sold off at Christie's in Pall Mall most of the original paintings and drawings that he had commissioned for various drama editions until 1790. (He was able to withhold some painted by De Wilde for the new edition of *Bell's British Theatre*.)[24] In May 1793, he was declared bankrupt. On 8 August, "By Order of the Assignees" (i.e., his creditors, probably including some of the "Society of Private Gentlemen" who had backed his 1791 edition of plays), Bell's entire stock in quires and the "Copperplates belonging to each Article" were knocked down in an auction before "a Select Company of Booksellers" at the Horn Tavern, Doctors Commons. Somehow, under the complicated and permeable laws governing

bankruptcy at that time, he was able to seques-
ter the plates published from 1791 to 1793 in the
new edition of *Bell's British Theatre*. Evidently
the purchaser of the largest portion of the un-
protected remainder of Bell's stock was the
publisher James Barker, who presently would
begin publishing both the "acting" *Shakespeare*
of 1773–75 ("under assignment") and sixty se-
lected plays from *Bell's British Theatre*.[25]

The disposition of the *Oracle* after the 1793
bankruptcy is also puzzling. For a period of
time, the paper was published as "Printed for
James Bell, Jun," probably John Bell's nephew,
"and sold at the Oracle office, British Library
in the Strand." Was some share still owned by
John Bell, and was James Bell only the shadow
publisher? As reported in the *Oracle* of 11 June
1794 (in a dispatch claiming to have been writ-
ten at "two o'clock this morning") the elder Bell
was still launching (or inspiring) attacks on
Topham and his *World*. At Ranelagh on the
previous evening a

> gay and grand scene of jollity and mirth had
> been prepared by the Managers with great
> attention and liberality. The lamps, innumer-
> able, were disposed luminously, with great
> taste and elegance. A Box with appropriate
> decorations, was prepared for the accommo-
> dations of their Royal Highnesses the Prince
> of Wales, Duke of York, and Duke of
> Clarence, with their Party. [There were] gro-
> tesques masques. . . . The most distinguish-
> able character in the room was the Oracle
> [John Bell himself?] mounted on a Magic
> Car from which he distributed Pasquinades,
> and uttered poignant reflections upon the
> variegated groupe around: He was attended
> by a band of News-carriers, who circulated
> *Bell's New World* [the *Oracle's* subtitle] with
> great success, and distributed the following
> verses,

which were several satirical quatrains urging
the public to desert the old *World* for the new.

Whatever his new relationship to the man-
agement of the paper may have been, Bell con-
tinued to work for it. In May 1794, he took an-
other extensive tour in Flanders as the *Oracle's*
war correspondent, following the army com-

manded by the Duke of York. Bell marched
with the troops from Courtrai to Tournai.
While he was absent on his "perilous excur-
sion," he was characterized as a Francophile
radical by the editors at the *Times* and other
rival papers. In the *Oracle* for 24 June, he indig-
nantly defended his patriotism, denying any
"Jacobinical heresies" and challenging his tra-
ducers to find "any *seditious* tenets" or "gallic
blasphemy" anywhere in his career.

In his financial extremity, Bell had perhaps
taken the publisher George Cawthorn into
partnership. Certainly Bell had drifted into
debt to Cawthorn. After a suit in Chancery and
long arbitration conducted by two other, sup-
posedly neutral, publishers, Cawthorn was in
effect awarded all future profits of *Bell's British
Theatre*, on 31 December 1796. He also acquired
the right to inscribe "The British Library" on
his other title pages.[26]

Bell had moved in 1795 to No 90, the Strand.
Neither his verve nor his ingenuity seems to
have been diminished by his latest misfortunes.
Even in the midst of them, he had somewhere
found the resources to start yet another news-
paper. On 1 May 1796, the first number of *Bell's
Weekly Messenger* came to London's Sunday
breakfast tables. One of his acquaintances tes-
tified that "when Bell set up . . . his *Weekly
Messenger* (which had a woodcut at the top of
it, of a newsman blowing his horn), he went to
a masquerade in the newsman's character." The
paper set circulation records, and Bell appar-
ently managed to hold on to a piece of it despite
a new financial cataclysm.[27] On 11 September
1796, the *Messenger* carried a pathetic appeal to
his fellow Freemasons for help. On 4 January
1797, the *Times* reported that John Bell was
again a bankrupt.

Information about Bell's activities after 1797
is sparse. From 1805 to 1813, his concerns were
occupying two locations—in Herbert's Pas-
sage, Beaufort Buildings, and in Southampton
Street, Strand. From 1813 through 1819, he was
in Clare Court, Drury Lane.[28] In 1814, he pub-
lished his last major series of books, *Bell's Con-
stitutional Classics*, beginning with Blackstone's
*Commentaries* in four volumes, "Printed at the

revived Apollo Press" (but now in London, not with the Martins at the old address in Edinburgh).

In 1820, John Bell sold *La Belle Assemblée* and retired from all business. From time to time over his more than fifty years of professional activity, he had plied each of the associated book and newspaper trades—as printer, publisher, bookseller, typefounder, bookbinder, and journalist—usually practicing several of them simultaneously. He had soared to success, exciting bitter jealousy among his competitors (the publisher Andrew Miller wrote to his associate Thomas Cadell, "It is as bad as robbery for Bell to supply the market with every book").[29] But Bell had also suffered ruinous reverses, often in bruising battles with adversaries who employed tactics less scrupulous than his own sometimes dubious maneuvers.

The few hints we have of Bell in his workplace suggest an employer whimsical but humane and indulgent. He gave encouragement to the famous typographer William Bulmer when Bulmer came as a youth from Newcastle.[30] When journeymen binders struck Bell's and other shops, he seems to have taken their part, and he even furnished bail for William Hall, one of the strikers charged with conspiracy.[31]

At the time he signed his will in 1820, Bell was a sharer in the *Weekly Messenger*, along with two partners, Francis Ludlow Holt, his niece's husband, and Francis Henchman "of Lamb's Conduit Street."

John Bell died at his house in Fulham on 26 February 1831, aged eighty-six. The provisions of his will indicate that before his death his fortunes had once again strongly rebounded, probably due to the very popular *Weekly Messenger*. His estate was left to his niece Jane Ludlow in trust for his great-nephew John Bell of Trowse, near Norwich, "son of my nephew James Bell of Trowse." Total worth was not specified, but personal and real properties included "my pictures, statues, sculptures, medals, drawings and prints," as well as "all my carriages and horses and the harness and equipment belonging to the same."[32]

The obituary in his *Weekly Messenger* was formally adulatory, though syntactically somewhat disordered: "Perhaps few men were so much lamented by his friends and acquaintances, as all his domestic qualities were such as to endear him to them. He was kind-hearted to an excess, which prudence could scarcely justify, generous beyond the bounds of caution and so exempt from selfishness as to find more pleasure in planning for others than for himself."[33]

The typographical anecdotist C. H. Timperley praised Bell's "masculine understanding, which a long course of observation, and a particular quickness and facility in observing, had very highly cultivated—so as to have given him a judgment as just and exact as his powers of conception were vigorous and acute. He had an instinctive perception of what was beautiful in every combination of the arts."[34]

A more piquant character has been preserved for us by that peerless observer of human nature, Leigh Hunt:

> The first time I saw him he was standing in a chemist's shop, waiting until the road was clear [of bailiffs] for him to issue forth. He had a toothache, for which he held a handkerchief over his mouth; and, while he kept a sharp look-out with his bright eye, was alternately groaning in a most gentlemanly manner over his gums, and addressing some polite words to the shopman. I had not then been introduced to him, and did not know his person; so that the effect of his voice on me was unequivocal. I liked him for it and wished the bailiff at the devil.

It was, Hunt remembered, in Bell's "house in the Strand I used to hear of politics and dramatic criticism, and of persons who wrote them." Hunt saw in Bell more than a bohemian bookseller and journalist or "speculator in elegant typography."

> Bell was upon the whole a remarkable person. He was a plain man, with a red face, and a nose exaggerated by intemperance; and yet there was something not unpleasing in his countenance, especially when he spoke. He had sparkling black eyes, a good-natured smile, gentlemanly manners, and

one of the most agreeable voices I ever heard. He had no acquirements, perhaps not even grammar; but his taste in putting forth a publication, and getting the best artists to adorn it, was new in those times, and may be admired in any; and the same taste was observable in his house. He knew nothing of poetry. He thought the *Della Cruscans* fine people; because they were known in the [fashionable] circles; and for Milton's *Paradise Lost* he had the same epithet as for [the actress] Mrs Crouch's face,[35] or the phaeton of Major Topham: he thought it "pretty." Yet a certain liberal instinct, and turn for large dealing, made him include Chaucer and Spenser in his edition; he got Stothard to adorn the one, and Mortimer the other. . . .

Unfortunately for Mr. Bell, he had as great a taste for neat wines and ankles as for pretty books; and, to crown his misfortunes, the Prince of Wales, to whom he was bookseller, once did him the honour to partake of an entertainment, or refreshment . . . at his house.[36] He afterwards became bankrupt. He was one of those men whose temperament and turn for enjoyment throw a sort of grace over whatsoever they do, standing them in stead of everything but prudence. . . . He had become so used to lawyers and bailiffs, that the more his concerns flourished the more his debts flourished with him.[37]

## Bell's Editions of Dramatic Works

From 1773 until the end of the eighteenth century, the editions of British plays published by John Bell, separately and in collections, were the most numerous, popular, carefully produced, and prominently advertised publications of that genre. They presented the most striking innovations in design, print, and illustration, and hence were widely copied or plagiarized. When remainders and rights became available through sale, they were eagerly bought and continued in circulation. They were:

1. *Bell's Edition of Shakespeare's Plays as they are now performed at the Theatres Royal in London* (9 vols.), 1773, 1774, 1775–78

2. *Bell's British Theatre* (21 vols.), 1776–78, 1780–81; (90 vols.), 1793; (140 vols.), 1790–97

3. *Supplement to Bell's British Theatre* (4 vols.), 1782–84

4. *Bell's Shakespeare: Dramatic Writings of Will. Shakespere, printed complete from the best editions of Sam. Johnson and Geo. Steevens* (20 vols.), 1785–88

5. *Bell's English Theatre* (14 vols.), 1792

These editions are briefly described in the following pages.

### Bell's "Acting" *Shakespeare*

Francis Gentleman the actor and critic perhaps deserves the credit for suggesting to John Bell an edition of the plays of Shakespeare that were in the current repertory, to be taken directly from the promptbooks of the London patent theatres. Certainly it was Gentleman who secured from the managers, David Garrick at Drury Lane and George Colman at Covent Garden, permission to employ their prompt copies. It is also likely that Gentleman negotiated the crucial cooperation of his acquaintances the respective prompters, William Hopkins and Joseph Younger.[38]

Securing the texts, particularly those from Drury Lane, was a surprising coup for the slippery Gentleman. Deep in Garrick's debt in 1770, Gentleman had dedicated to him the first volume of the collected *Dramatic Censor*, published in 1771. But, also in 1771, thinly disguised as "Sir Nicholas Nipclose," Gentleman had attacked the manager in *The Theatres: A Poetical Dissection*, earning Garrick's contemptuous characterization of him as "a dirty, dedicating knave."[39]

Gentleman had somehow regained favor by 1773. Perhaps he wooed the susceptible Garrick by holding out the flattering prospect of another dedication, this time to a collection of plays by Garrick's idol. Gentleman (or Bell) may also have convinced Garrick and Colman that commercial advantage would accrue if cheap and attractive acting texts were put into the hands of playgoers, with a patent theatre featured on every title page. Or maybe John Bell

simply paid the managers for the privilege of printing the prompt copies. However they were obtained, we believe they represent, as they purport to do, the texts of Shakespeare that audiences saw and heard during the decade of the seventies, and probably much longer.

The enterprise has always been known as "Bell's Shakespeare," but the publisher was aided in his self-promotion by Gentleman's furtive preference for anonymity. Signing himself only as "the Authors [*sic*] of the Dramatic Censor," Gentleman, like all the editors of Shakespeare, leaned on his predecessors for commentary. But his original pronouncements hold perhaps greater interest for today's students of cultural currents in the later eighteenth century. His comments are a quizzical mixture of practical theatre judgment, affected prudery and piety, and the increasingly fashionable "sensibility," all of which had been plainly adumbrated in Gentleman's anonymous *Dramatic Censor*. But in the *Shakespeare* they are given application to specific textual loci by footnotes.

The purposes of the "editors" were outlined in the "Advertisement" prefatory to the first volume: even the Bard's idolaters agree that he has some "scenes and passages highly derogatory to his incomparable general merit; [that] he is sometimes obscure, and, sometimes, to gratify a vitiated age, indelicate." Critical correction is therefore required; and "is not the corrective hand frequently . . . the kindest?" Gentleman concludes that

> as the THEATRES, especially of late, have been generally right in their omissions . . . we have printed our *text* after their regulations; and from this part of our design, an evident use will arise; that those who took books to the theatre will not be so puzzled themselves to accompany the speaker; nor so apt to condemn performers for being imperfect, when they pass over what is designedly omitted.

David Garrick himself has "suggested" to the "editors" a "delicate fear" that the "prunings, transpositions, or other alterations, which in his province as manager he had often found

necessary to make . . . might be construed into a critical presumption of offering to the literati, a reformed and more correct edition of our author's works."

But Gentleman insists that "to expect anything more of this work, than *as a companion to the theatre*, is to mistake the purpose of the editors," who have only "pointed out the leading beauties as they occur" and "furnished an explanation of theatrical terms." With the "glaring indecencies being removed, and intricate passages explained . . . what we call the essence of Shakespeare" will be more "instructive and intelligible."

Gentleman's commentary and the printed texts themselves provide fascinating (and neglected) insights on the moral and ethical restrictions imposed on performance. But textual criticism and cultural commentary are not our present purposes. The primary focus in this catalog is on the engraved portraits of performers in costume and action, which John Bell introduced in the course of the development of the "acting" edition, and which he retained as the prime visual attraction in most of his subsequent popular collections of drama.

The other physical features of the "acting" *Shakespeare*—paper, type, ornamentation, binding—which together form the matrix for the pictures, prefigure similar features in Bell's later publications. They earned him praise for aesthetic judgment. So the morphology of the early *Shakespeare*, long puzzling to bibliographers, deserves some attention.

The work was published by subscription, as was usual when sizable undertakings were proposed. In his publisher's "Advertisement" dated 7 December 1773, John Bell thanked some eight hundred ninety "Encouragers of Dawning Merit" for subscribing for more than sixteen hundred sets of the first five volumes (those containing the twenty-four plays in the active repertory). On the list was the expected collection of academics, intellectual aristocrats, and miscellaneous Shakespeare lovers plus a number of provincial booksellers. The frugal Garrick, even though he was dedicatee-apparent, subscribed for only one set. Prompter

Younger also took only one, prompter Hopkins four. The prompt texts, of course, were no novelty for actors, but some—out of friendship or curiosity—subscribed: Thomas Hull, John Palmer, Tom Weston, Francis Waldron, Henry Woodward, the Dubellamys.

One name on the subscription list is especially provocative—that of George Steevens, coeditor with Samuel Johnson of the prestigious scholarly edition of Shakespeare that had been published by Bathurst on 22 October 1773, only a few months before the appearance of Bell's "acting" edition. Steevens subscribed for a "royal" set. But after perusal, he decided that it was, in the words of his friend Isaac Reed, "the worst edition that ever appeared of any English author."[40] James Boaden declared that Steevens expressed that spleenful view to Reed because of the feared effect of Bell's "acting" edition on the sales of the scholarly one.[41] Steevens was also speaking the sentiments of his publisher Bathurst and of his close associates in the publishers' cabal, the conger, who asserted an "honorary" copyright to all of Shakespeare's works.

Bell would have been pleased to see his edition on sale before that of Steevens and also before the start of the 1773–74 theatrical season on 18 September. But it was not until 30 December 1773 that he could announce in the *Daily Advertiser*: "*This Day is published*, Dedicated to David Garrick, Esq. *Bell's* Edition of *Shakespeare*'s Acting Plays, with 24 Engravings." Each play was

> ornamented with a beautiful Frontispiece, and regulated by Permission of the Managers, agreeable to the present Mode of Performance at the Theatres Royal in London, by Mr. Hopkins Prompter, at Drury-Lane; and Mr. Younger, Prompter at Covent-Garden; with Notes critical and illustrative, respecting the Text, and the Requisites necessary to do each material Character Justice on the Stage. By the Authors of the Dramatic Censor. The Introduction contains an Essay on Oratory, which may serve as Improving Lessons to Professors of the Pulpit and the Bar, as well as the Stage. Printed for John

Bell, near Exeter Change, in the Strand; and C. Etherington, at York.

In his publisher's preface to volume 1 (dated 7 December 1773) Bell anticipated a three-volume "continuance" containing the plays *not* in the current repertory. The "Engravings" for them, he claimed, "are nearly finished . . . which, with the Letterpress, will be published next Spring [1774], in three volumes, Price Nine Shillings sewed; those, therefore, who wish to complete their Setts, will be pleased to forward their Address." But like the first five volumes, the "continuance" would hang fire for a time.

Title pages for the twenty-four plays in the first five volumes are all dated 1773. But after printing the preface dated 7 December 1773, Bell evidently concluded that he would not be able to bind many sets before the end of the year. So he ordered his engraver Whitchurch to alter the title page plate of each *volume* from "MDCCLXXIII" to the unusual (except in clockfaces) "MDCCLXXIIII," though it slightly marred the symmetry of the design.

As for volumes 6 to 8 (the "continuance"), finding that they could not appear in the spring of 1774, Bell set in type a new advertisement predicting their publication on 1 September. It was inserted, date unchanged, in at least some copies of volume 4 of the "second edition" of volumes 1–5—which was not published until 12 November 1774. In fact, the "continuance" would not finally be ready for sale until 20 January 1775.

A survey of advertisements in Christopher Etherington's *York Chronicle* is instructive. Bell's eager partner signaled to the York public on 9 April 1773 that five volumes were "in the press," and on 24 September, he assured readers that they would be published by the first of October. But on 15 October, Etherington stated that the plate for the portrait of Garrick in volume 1 was holding up publication. On 17 December 1773, he announced that the first five volumes were now published. That does not, of course, square with Bell's announcement of 31 December as a publication date. The discrepancy may be accountable to the time it

would have taken to ship the books from York, where they were printed, to London.

Etherington told his readers on 4 November 1774 that the four-volume continuation would be out by 21 November and that a *new* edition of volumes 1–5 was ready for delivery; and on 2 December, he declared that both would be at booksellers in "a few days." On 10 February 1775, he announced that they were "complete and published."[42] Clearly, then, by 10 February 1775, there were two editions of the first four volumes and one edition of the three-volume continuation of plays, plus a ninth volume, the *Poems*, which also contained a short "Life" of Shakespeare and a long "Essay on Oratory," both by Gentleman.

In the resettings constituting the second edition of volumes 1–5, Gentleman made changes in spellings (e.g., "blemish'd" to "blemished"), and there were a few moderations in the rigor of the criticism. In *Macbeth*, for example: "as the witches, though admirably written, are an insult to common sense; the ghosts, though well introduced, still more so," became "The witches, however trespassing upon the bounds of probability, are finely written and the ghosts admirably introduced." But there are no substantive changes either in Shakespeare's text as altered by the promptbooks or in the general tenor of Gentleman's criticism.

The twenty-four engravings that Bell had promised on 30 December 1773 were scenes, one from each play, but there were no portraits of actors. But by early 1774 at the latest, Bell must have been commissioning portraits that would grace the third edition. On 6 October 1775, he announced that "Shakespeare's Works in Sixpenny Numbers" would begin to appear weekly on 7 October, with *Hamlet* as the first. Its frontispiece, the beautiful and notorious Jane Lessingham as Ophelia, began a parade of thirty-six attractive engravings of prominent players, dressed in the extravagant costumes of the era. (There were thirty-six because neither *Pericles* nor *The Two Noble Kinsmen* had yet been admitted to the canon.)

Each of the three Caslon-set, half-sheet duodecimo editions of the "acting" *Shakespeare*

was available in both small "demy" and "large royal" size paper. Though later in his career Bell would print his fine editions on "wove" paper, the early *Shakespeare* was on "laid" paper, most of it of foreign origin.[43] Sheets of the "fine demy" paper are watermarked with a fleur-de-lis five centimeters high, countermarked "I V." Almost all of the many "small" examples that we have seen appear to have this paper throughout, for though there are often pages and even volumes seemingly without the mark, comparison shows them to be of the same stock as marked sheets.[44]

In Bell's "Advertisement" before volume 1 of the two collected editions, he assured prospective customers that "throughout every Department of this Work, the Publisher has been particularly desirous of producing Perfection; should any Blemishes appear, he hopes they will not be attributed to his Want of Attention, having procured the best Materials, and spared no Expence in the Execution." But typographical blemishes, especially in the first edition, are fairly numerous, the reason perhaps being Bell's haste in the autumn of 1773.

Bell's brief but influential experiment as an innovative typefounder was a dozen years in the future, and the letterpress of the early *Shakespeare* exhibits none of his innovations, not even the round *s*. Bell always preferred an open page, and the eight volumes in the first and second editions lack ornamentation in the text. But they are embellished with elegant calligraphy in the engraved title pages, with portraits of Shakespeare and Garrick, and with thirty-six copperplate scenes. The third edition "separates" have (so far as we have seen) only the performers' portraits. One more engraved title page and two more scenes were supplied in volume 9, the *Poems*. The plates are discussed below.

## Barker's Continuation of *Bell's Shakespeare*

We do not know how often Bell himself reprinted the "acting" *Shakespeare* after the ap-

pearance of the last separates of the third edition, which are dated 1778. At the bankruptcy sale of Bell's literary properties on 8 August 1793, the publisher James Barker acquired nearly 50,000 copies of the British plays in Bell's inventory, including the 1773–78 *Shakespeare* separates, ranging from 1,741 copies of *Othello* and 1,120 of *Titus Andronicus* down to 13 each of *King Lear, Romeo and Juliet,* and *Cymbeline,* with their associated copperplates. Gentleman's Introduction and ten titles were missing from the catalog list, but those plays could have been among "416 Tragedies and Comedies, 12mo." not itemized. And perhaps Barker already had numbers of most titles, for he had had nearly twenty years to accumulate them.

In 1794, Barker brought out a complete collected "edition" of Shakespeare's plays and poems, made up of Bell's remainders—with title pages unchanged—and of Barker's reprints, employing Gentleman's text and notes. For those plays that he reprinted, Barker supplied title pages with new dates and the assertion that they were "By assignment, for J. Barker." The cursive "JB" device familiar for so many years as John Bell's was impudently purloined. Barker also supplied Bell's portraits, but with one poignant substitution—of John Kemble as Macbeth for David Garrick in that character.

Barker (later J. Barker and Son) also reprinted and sold (or vended Bell's remainders of) the plays as separates. There was also at least one more Bell/Barker collected edition, the volumes undated but, from various indications, issued between 1797 and 1801.[45]

The Bell "acting" edition of Shakespeare would finally die only after its dismemberment. Both the scenes and the portraits of actors were repeatedly advertised by Bell and his successors to be sold separately and also sewn in "setts." The rascally Wally Chamberlain Oulton put his name to a *Life* of Shakespeare, most of it stolen from Gentleman, accompanying Bell's text of the *Poems* published by Chappell in London in 1804. And the "First American Edition" of *The Poems of Shakespeare. To which is added an Account of his Life* (Boston, 1807) has Gentleman's biography and footnotes.

### Bell's British Theatre

By publishing their early *Shakespeare,* Bell and Etherington had rudely challenged the "honorary" copyright assumed by the powerful consortium of booksellers who styled themselves "the capital Booksellers of London." In the *St James's Chronicle* for 2–4 May 1776, Bell gave these worthies further grave offense by announcing an intention to bring forth *Bell's British Theatre,* a "Grand Work," with "magnificent Embellishments," one number of which would appear "every Saturday till the whole is completed, at 6d. each." The play texts were said to be taken from the promptbooks of the patent houses through the cooperation of prompters and managers.

During the 1760s, Thomas Lowndes (one of the members of the booksellers' conger of the 1770s) had issued a series of forty plays called *The British Theatre,* and he was affronted by Bell's appropriation of the title. So, joined by twenty-six fellow publishers, including Dodsley, Rivington, Dilly, and Caslon, Lowndes struck back at Bell by announcing a fresh reprint series called *The New English Theatre* (in sixty numbers).

Both Bell and his competitors were encouraged to proceed by the public's warm reception of Bell's early *Shakespeare,* especially the third edition, with its actor portraits. The competing advertisements that now blossomed heavily emphasized plates depicting actors.

The first series of *Bell's British Theatre* began to issue on 4 May 1776 with Aaron Hill's popular adaptation of Voltaire's *Zara* and terminated in 1778 with William Whitehead's *The Roman Father.* Bell had advertised that, besides a small demy plain-paper version at 6d., "a few copies will be printed on large Royal paper; and will contain Proof Impressions of the Prints, at 1s. each number."

The one hundred separate numbers were collected by Bell in twenty volumes in 1778. In

1780, the collection was reissued, with new volume title pages. In 1781, Bell provided volume 21: eight comedies, farces, and operettas, with ten new plates of performers. (For some reason, in 1780, he also issued a selection of seventy-five of the plays from the 1778 group, all reset, in fifteen volumes.) From 1782 to 1784, he published a *Supplement to Bell's British Theatre*, in four volumes of comedies and farces, but with no portraits.

*Bell's British Theatre*, set in small-pica old face imitated from Caslon, had been printed on Etherington's *York Chronicle* presses in 1776 and early 1777, and the title pages had read: "Bell's edition . . . London: for John Bell, and C. Etherington, at York." (The portraits were probably also managed there; Etherington proudly advertised: "Copper-plates wrought off neat as in London.") But in January 1777, Etherington was declared bankrupt, and after January, the title pages announced this to be "Bell's edition . . . London: For John Bell," and the impressions were from the printshop of Bell's *Morning Post*. For a brief period in 1779, they were "By the Etheringtons, for John Bell," but they reverted to Bell as sole publisher and probable printer in 1781. The series was called in 1782 "Bell's characteristical edition . . . Edinburg [*sic*]" and was printed at the Apollo Press "By the Martins, for Bell, London."

By 1790, Bell had vanquished the conger by repeatedly asserting his right of equal access not only to Shakespeare but to all British poetry. He had won wide popular approval for his cheap books and a *succès d'estime* for his finer ones. He was even given credit in the *Times* article of 13 December 1790 (which we have quoted above) for elevating British taste and for spreading the fame of the British arts abroad. The occasion for that praise was his proposal for a spectacular revival of the *British Theatre* which he declared would now "challenge the admiration of the World."

The totally new edition would offer one hundred ten of "the most esteemed English Tragedies, Comedies, and Operas," beginning on 29 January 1791. Each weekly number would be adorned by a portrait of a principal performer painted by Samuel De Wilde, the engravings executed by Bartolozzi, Thornthwaite, and other prominent limners. Purchasers could choose from three kinds of impressions:

> The FIRST SORT will be printed on Vellum Paper, small size, price One Shilling and Sixpence, with Vignette and Characteristic Prints. The SECOND, an ordinary sort, is printed on coarse Paper, price Sixpence each, with *inferior* Impressions of the *Character Print* only. But, at the request of many *Amateurs* of fine *Works*, another sort is printed on ROYAL PAPER, with *extensive Margins*, and will contain PROOF IMPRESSIONS OF BOTH THE PRINTS, and sold at *Five Shillings* each play. The Work will cost the Proprietors nearly Twenty Thousand Pounds. It is conducted by Mr. BELL for a Society of private Gentlemen, who will enable him to execute it with the utmost Spirit and Punctuality.

Bell added an assertion that may only reflect his unquenchable optimism: "Most of the London Wholesale Booksellers have laudably and liberally vanquished all interested prejudices, and propose to give this Work a free Circulation, as a means of convincing the World, that the Productions of the BRITISH PRESS are not at present to be excelled by the Artists of any Country upon earth." The plays duly appeared in both octavo and duodecimo impressions, and each was issued in a numbered paper wrapper.[46]

From 1791 through 1793, the title pages without exception stated that the series was published "For the proprietors under the direction of John Bell." Who those proprietors ("the Society of private Gentlemen") were is not now known. How far Bell's own resources were encumbered is a question. In 1793, the year of his first bankruptcy, the beleaguered Bell bound up and sold the first ninety numbers of the new De Wilde-illustrated edition without general volume title pages. One Nathaniel Scarlett, acting for the "Proprietors," was advertising those volumes in November 1794 at reduced prices. After

that, the details of publication and ownership of *Bell's British Theatre* are not completely decipherable.

What seems clear, however, is that Bell fought strenuously to keep control of the publication of separate plays. He resumed the new series in December 1794 with No. 91, but he gradually lost control to his debtor George Cawthorn. For a short period, both Bell and Cawthorn claimed and advertised the series, sometimes in the same journal. In 1795, the title pages of separates began to assert that they were "For and under the direction of, George Cawthorn." After the Chancery suit of 1795 (alluded to in our sketch of Bell above) and the arbitration of 1796, apparently Cawthorn owned all rights to the work. In 1797, he issued the completed series, one hundred forty plays in twenty-eight volumes, without general title pages.

Bell and Cawthorn, however, were not the only contenders for that valuable property. We have seen how James Barker had acquired and reissued the "acting" *Shakespeare* after the 1793 sale. He had also bought remainders of the 1776–82 editions of *Bell's British Theatre*. At some time after 1795, Barker tinkered together an aggregation of sixty plays in twelve duodecimo volumes, with the general title "*Barker's (late Bell's) British Theatre* London: (by assignment) for J. Barker [n.d.]." About this aggregation it is not possible to generalize usefully, for apparently only one set survives, at Wayne State University. That set is made up of Bell's texts of various dates from 1776 to 1795 (including five for which Barker is exclusive publisher; four of those were said to be "By assignment"). There are also three plays from other publishers, including one of 1787, issued by a conger composed of Barker and four others.[47]

### Bell's English Theatre

*Bell's English Theatre* (14 vols. [London, 1792]) is an amalgam of remainders from several editions of the early *Shakespeare* and from *Bell's*

*British Theatre*, employing the relevant engraved portraits of actors.

The series seems to represent an attempt by Bell to extract one final bit of profit from the two titles before his financial debacle of 1793.

### Bell's "Literary" *Shakespeare*

John Bell's first presentation of Shakespeare's works (1773–78) had been a considerable success within the limits of its primary intention, which had been to reflect the actual current practice of the stage. But Bell's career-long compulsion to associate his name with projects of high cultural value made it inevitable that he would at some time also produce a "literary" edition of the national poet. The time seemed ripe in 1785.

Samuel Johnson had dawdled—notoriously—for two decades over his own scholarly edition after proposing it in 1745. It finally appeared in October 1765. On 1 February 1766, George Steevens published his prospectus for a Johnson-Steevens text, with a new scholarly apparatus. That edition was issued by Bathurst in ten volumes on 22 October 1773, just in time, as we have seen, to meet uncomfortable competition from Bell's "acting" edition of 30 December 1773, which invited the angry condemnation of Steevens.

There was a second Johnson-Steevens edition in 1778 and a third, "augmented by the Editor of Dodsley's Collection of Old plays [Isaac Reed]," in 1785. Samuel Johnson had died in 1784, and Steevens and Reed had no monopoly on the text and apparently no control over notes and commentary.

In 1785, Bell began to issue separate plays, seriatim, collecting them in twenty quarto volumes in 1788 as *Dramatick Writings of Will. Shakespere, printed complete from the best editions of Sam. Johnson and Geo. Steevens*. The patronage of the Prince of Wales (and Bell's assiduous advertisement of that privilege) obtained for the collected edition a cachet that attracted more than eighteen hundred subscribers, including the royal family (except the sovereign),

the queen of France and monsieur the king's brother, and a collection of seventy nobles, ambassadors, and right honorables. Mrs Siddons subscribed, as did twenty-five other performers, and, among many notables, Bell's old friend and foe Edward Topham, Isaac Reed, and George Steevens (for him, two copies, as in 1774).

In Bell's "Advertisement of the Present Publisher," he defended at some length, by reference to seventeenth-century documentary precedents, his deviation "from the usual mode of printing the Author's name . . . by omission of the letter A in the last syllable." Bell also proudly called attention to his banishment from the text of the long form of the letter *s*, as "being liable to error from the occasional imperfection of the letter 'f' " and from the accidental substitution of *s* for *f*.

Exhaustive *Prolegomena to the Dramatic Writings* occupy the first two of Bell's twenty volumes and consist of the 1623 preface of Heming and Condell, those of Pope, Theobald, Hanmer, and Warton, and a variety of other features, including the Will, Commendatory Verses, and an attempt to ascertain the order of the plays.

What principally distinguishes Bell's scholarly edition from his "acting" one and, indeed, from all others up to that date is the elaboration of its presentation. There are portraits of Shakespeare, the Prince of Wales, Sir Thomas Hanmer, Bishop Warton, Samuel Johnson, Edward Malone, Nicholas Rowe, and David Garrick, and engravings of places and artifacts associated with Shakespeare.

In his "Advertisement," Bell boasted that "in point of *exterior*, it is believed that [the edition] hath as yet no rival, either in ornaments, printing or paper." The volumes were finely printed on smooth "wove" paper, gilt-edged, and handsomely bound in calf, probably in Bell's own bindery.

But what most concerns this catalog is the fact that Bell continued and expanded the sorts of embellishments he had introduced with the "acting" *Shakespeare*. In the early collected edi-

tions of *Bell's British Theatre*, he had abandoned the "vignette" scenes of the early *Shakespeare*, settling for rotating personifications of Comedy and Tragedy at the appropriate divisions. But with the 1788 *Shakespeare*, there were both vignette scenes and what he now called "Character Prints," the *ad vivum* portraits of prominent performers in action.

The edition was a critical and social triumph for Bell. But its production put another strain on his resources, for it was accomplished over some of the busiest years of his involvement with other major publications. And apparently Bell could exercise no permanent control over his apparatus and embellishments. The text was free to any taker, not the property of any conger or individual; Bell had established that in 1773. The scavenger George Cawthorn boldly took Bell's whole edition of the 1785–88 *Shakespeare* for Cawthorn's *Minor British Theatre* in 1806.

## Notes

1. *London Chronicle*, 19–21 October 1769.

2. She assisted John Bell in fashion publications in the 1790s. *A Catalogue of Books, Newspapers &c. Printed by John Bell* (London: 1931), p. 5.

3. *The Dictionary of National Biography*, ed. Leslie Stephen and Sidney Lee (Oxford: Oxford University Press, 1917), 9:1096 (hereafter *DNB*).

4. Stanley Morison, *John Bell, 1745–1832* (Cambridge: Cambridge University Press, 1930), p. 86.

5. Charles Knight, *The Shadows of the Old Booksellers* (London: Bell & Daldy, 1865), p. 276.

6. A "conger" consisted of several booksellers or publishers combining forces for the publication of a specific title, but it was also used as a term for more enduring syndication. The word is perhaps related to "congress" and "congeries." One popular etymology would have it refer to the voraciousness of the conger eel.

7. Morison, p. 1. He bound Daniel Werner apprentice at £100 on 1 January 1770 and Edward Stone at the same amount on 10 April 1775. See Ian Maxted, *The British Book Trades 1710–1777* (Exeter: by the author, 1983), p. 9.

8. Christopher Etherington was a bookseller at the Sign of the Pope's Head in Coney Street in York

by 1758. He was afterward at the Pavement. Bankrupt in 1777, his association with Bell then ended, but it was resumed briefly (with his son) in 1779. See William and E. Margaret Sessions, *Printing in York from the 1490s* (York: William Sessions, 1976), pp. 43–45; and John Feather, *The Provincial Book Trade in Eighteenth-Century England* (Cambridge: Cambridge University Press, 1985), pp. 45–46. For Gentleman, see *A Biographical Dictionary of Actors, Actresses, Musicians, Dancers, Managers and Other Stage Personnel in London, 1660–1880* (Carbondale: Southern Illinois University Press, 1973–93), 6:138–53 (hereafter *BDA*).

9. John Trusler was the son of the proprietor of Marylebone Gardens, brother-in-law of the musician Stephen Storace the elder, and uncle of the celebrated singer Anna Storace. Trusler, a graduate of Emmanuel College, Cambridge, translated, with the elder Storace, *La serva padrone*, the first burletta performed at Marylebone Gardens. He was later ordained as an Anglican priest. See *BDA*, 15:50–51. Bate (later Sir Henry Bate Dudley), a quarrelsome man but talented editor, was involved in several duels and bouts of fisticuffs. A friend of David Garrick's, he married a sister of the actress Mrs Elizabeth Hartley; see *DNB*, 6:102–4. James Christie resigned his naval commission to establish the famous auction house. He was a Garrick intimate and close to Reynolds and Gainsborough; see *DNB*, 4:283.

10. Cheap: a double meaning is intended—both "bargain" and "trade," as in Eastcheap and Cheapside.

11. Morison, pp. 2–5.

12. *Horace Walpole's Correspondence with the Countess of Upper Ossary*, ed. W. S. Lewis and A. Dayle Wallace (New Haven: Yale University Press, 1965), 1:331–32.

13. *Boswell's Life of Johnson*, ed. George Birkbeck Hill, rev. and enl. by L. F. Powell (Oxford: Oxford University Press, 1934–50), 3:110–11. For a discussion of the genesis of Bell's *Poets*, see Thomas F. Bonnell, "John Bell's *Poets of Great Britain*; The Little Trifling Edition Revisited," *Modern Philology* 85 (1987): 128–52.

14. Walpole, 2:35.

15. Morison, pp. 13–15, provides an interesting account of that dispute. For Bellamy, see *BDA*, 2:6–20.

16. Morison reproduced specimens of Bell's type, examples of his title pages, reduced facsimiles of newspaper pages, and some photographs of Bell's bindings.

17. Morison, pp. 8–12 and passim. For Topham,

see *DNB*, 19:980–82; for Tooke, *DNB*, 19:967–74; for Mary Wells, *BDA*, 15:344–56; for Wilkes, *DNB*, 21:242–50.

18. Morison, pp. 26–43 and passim.

19. *Oracle*, 3 January 1791, quoted by Ian Mayes, in "John Bell, *The British Theatre*, and Samuel De Wilde," *Apollo* 113 (1981): 100.

20. Morison, pp. 61–75.

21. "The first bookseller to combine a publishing venture with an Exhibition of Gallery Painting was Thomas Macklin (d. 1800), who opened his Poet's Gallery in Pall Mall in 1787/8. Boydell's Gallery followed in 1789" (Joseph Burke, *English Art, 1714–1800* [Oxford: Clarendon, 1976], p. 253). For Boydell, see Sven H. A. Brüntjen, *John Boydell, 1719–1804* (New York: Garland, 1985).

22. *Times* (London), 11 February 1792.

23. *Times* (London), 6 February 1793, 8 March 1793.

24. *Catalogue Raisonée. A Catalogue of the Curious and Inestimable Collection of Original Drawings, which have distinguished Bell's Various Editions of the British Classics. . . . Which will be sold by Auction By Mr. Christie, at his Great Room, Pall Mall, on Wednesday March the 27th, 1793 at Twelve o'Clock. . . . Catalogues may be had (at One Shilling each) as above; and at Mr. Bell's British Library, Strand.* An annotated copy of this catalog is at Christie's, King Street, London.

25. See William Cameron's introduction to *Western Hemisphere Short-Title Catalog*, no. 17 (London, Ontario: University of Western Ontario, 1984) (hereafter *WHSTC*). James Barker was a printer and bookseller in Russell Court, Drury Lane from 1779 to 1796, at No 19, Great Russell Street, Covent Garden, from 1800 to 1818. He ran the *Dramatic Repository*. See Maxted, p. 17.

26. "George Cawthorn, bookseller, printer, publisher, stationer and circulating library, 132 Strand 1790–1805. Partner with John Bell 1795. Set up on own at same address 1795. . . . Proprietor of British Library 1799–1802. . . . Bankrupt 17 November 1801" (Maxted, p. 42).

27. Morison, pp. 47–48, 81–82.

28. Maxted, p. 17.

29. Quoted by H. R. Plomer, G. H. Bushnell, and E. R. McC Dix, *A Dictionary of Printers and Booksellers . . . in England, Scotland, and Ireland from 1726 to 1775* (Oxford: Oxford University Press, 1932), p. 22.

30. For Bulmer, see *DNB*, 3:258–59.

31. The strikers had sought to have their daily hours reduced from fourteen to thirteen. See Ellic

Howe, *The London Bookbinder, 1780–1806* (London: Dropmore, 1950), p. 6.

32. We rely on Morison (pp. 84–85) for the few details from the will. It seems to have disappeared from the Principal Probate Register since Morison saw it in 1930. Our attempts to find it in other registers have failed.

33. Quoted by Morison, p. 87.

34. *Encyclopedia of Literary and Typographical Anecdote* (London: H. Johnson, 1842), p. 916.

35. Mrs Edward Rawlings Crouch, Anna Maria, née Phillips (1763–1805), actress and singer. See *BDA*, 4:80–88.

36. Leigh Hunt, like his close friend Shelley and some other romantic writers, had come to detest the prince regent. An attack on the prince in Hunt's *Examiner* in 1812 cost Leigh and his brother John two years' imprisonment.

37. *The Autobiography of Leigh Hunt*, rev. ed., with an introduction by Edward Blunden (Oxford: Oxford University Press, 1928), pp. 187–89.

38. For Hopkins and Younger, see *BDA*, 7:407 and 16:364–68.

39. See *BDA*, 6: 149. Bell was probably out of favor with Garrick, for he had published both the *Dramatic Censor* and *The Theatres*.

40. *Biographia Dramatica*, ed. Isaac Reed (London: Rivington, Payne, et al., 1782), 1:188, perpetuated in the 1812 edition by Stephen Jones, 1:273.

41. James Boaden, ed., *The Private Correspondence of David Garrick* (London: H. Colburn & R. Bentley, 1831), 1: 103 n.

42. Cameron, *WHSTC*, no. 15 (1983), p. 2.

43. "Wove" papers are poured into molds covered by wire closely woven like cloth and show no marks of laid lines or chain lines. See Richard H. Hills, *Papermaking in Great Britain, 1488–1988* (London: Athlone, 1988), pp. 30–40.

44. Some examples we have seen, however, begin and end with the superior paper but are pieced out in some middle volumes with stock of inferior quality. That may have been deliberate adulteration, a strategy to cut costs. But the cheaper (probably domestic) paper may occur only because foreign stock was temporarily inaccessible. The "superfine Royal Paper, large enough to admit of marginal notes," which in his advertisements is given emphasis second only to the engravings, justifies Bell's pride. The page measures 20.63 cm × 12.7 cm. The watermark is Strasbourg arms, so-called: a shield with a bend dexter, surmounted by a fleur-de-lis 11.43 cm high, with "L V G" beneath the device, and countermarked "I V." There is a variant, occurring infrequently and on paper of the same quality, in which the fleur is within a shield surmounted by a crown.

All of the foreign paper probably came from Holland. The "I V" is the mark of Jean Villedary the younger (fl. 1758–1812), who sent paper to the British market from some Guelderland mill. "L V G" stood for one of a succession of Gerrevinks, who were factors at the Phoenix mills at Alkmaar and Egmond aan Zee. See Edward Heawood, *Watermarks, Mainly of the Seventeenth and Eighteenth Centuries* (Hilversum: n.p., 1950), 1:65, 76.

45. Cameron, *WHSTC Bibliography*, no. 13 (1983).

46. Cameron, *WHSTC Bibliography*, no. 5 (1982), p. 2.

47. Cameron, *WHSTC Bibliography*, no. 17 (1984), passim.

# 2 THE PORTRAITS

ENGRAVING was a depressed profession in England in the early eighteenth century. Hogarth, in a pamphlet of 1730, deplored the plight of the engraver, who had no way to distribute his prints except to entrust them to a printseller. The seller often took an unfair percentage of the profit, kept the plates, and made copies that he palmed off as originals. Such acts of piracy led Hogarth and others to lobby for the Act of 1735, which extended copyright on an engraving for fourteen years.[1]

Toward the middle of the century, John Boydell, attracted by the increased demand for fine prints (principally those engraved in France after the landscapes of Salvator Rosa and Claude Lorraine), established a shop specializing in foreign prints. French engravers of distinction were drawn to the higher wages that Boydell and his competitors began to pay, and the lot of skilled Britons also improved.[2]

By the 1760s, line and stipple engraving supplanted the more expensive mezzotints, and the price for all prints declined.[3] Annual exhibitions began at the Society of Arts, the Free Society of Artists, and the Royal Academy. Prints were displayed also in the shops of growing numbers of purveyors. Painters both prominent and obscure were discovering that displaying engravings of their works was profitable and gratifying.[4]

Among the kinds of prints sold by Boydell, and presently by John Bell and others, landscapes and portraits were the most popular. Portraits of the nobility and wealthy gentry brought the largest fees, and they could also be engraved with the most profit. But after mid-

century, the public's growing interest in the private activities of actors created an entire new class of potential subjects for engravings.

A symbiosis between graphic artist and actor began to be acknowledged by both. Artists could attract favorable attention to their work and thus to their subjects, and actors were not averse to publicity. The alert Garrick was the first performer to exploit the relationship by commissioning the portraitist Benjamin Wilson to paint him in theatrical costume. Johan Zoffany sprang into prominence by depicting Garrick in action in what purported to be (but were not) theatrical sets. The most celebrated portraitists, even the august president of the Royal Academy, Sir Joshua Reynolds, condescended to paint such conversation pieces, as well as actors in pastoral landscapes and actresses as mythological figures.[5]

John Bell's entry into drama publication with the early "acting" *Shakespeare* provided him an opportunity to express his deep interest in the graphic arts and, more important, to turn a profit from the new craze for print collecting. For all Bell's interest in aesthetics and in the theatre, his principal purpose in commissioning pictures was to sell books. He believed that attractive portraits of actors would boost sales of plays.

In his drama publications between 1775 and 1795, Bell sponsored the largest accumulation of engraved full-length portraits of performers, in costume and purportedly in action, in theatrical history. (He also printed with his plays more than one hundred other portraits, symbolic and mythological frontispieces, imaginative scenes,

and other embellishments created by more than one hundred painters, engravers, and calligraphers.)

Bell's first contacts with designers of theatrical pictures were, in fact, for "illustrative" scenes, not portraits. The frontispieces for plays in the first two editions of the "acting" *Shakespeare* (1773 and 1774) were groups of figures in pastoral or architectural settings. (Scenes of this sort would also be published in the collected version of Bell's 1785–88 *Shakespeare* edition and also in some editions of his *British Theatre*. All are discussed in appendix 1, where examples are reproduced.)

Beginning with the third edition, Bell began to furnish a portrait of a prominent actor or actress with each of the thirty-six plays as it was issued. Twenty-one were drawn by James Roberts, nine or ten by Thomas Parkinson, four by Robert Dighton, and one probably by John Keyes Sherwin (after Benjamin Vandergucht). Charles Grignion was the principal engraver, contributing sixteen plates.[6]

Those likenesses of costumed actors in poses of significant action were said to be drawn "from the life." No background was sketched in; each subject was set in a visual void. Costumes were carefully detailed, and a relevant line of dialogue was engraved in cursive script beneath each figure. The style of presentation was strongly influenced by the series of exquisite little portraits of actors that had been drawn by De Faesch, engraved by Grignion, and published by Smith and Sayer (1769–73). But Bell's were larger, rectangles measuring from about 13 cm × 9 cm to about 15 cm × 10 cm.

Bell's subscribers to the *Shakespeare* found the simple, unpretentious style attractive, and James Roberts continued to follow it closely when he was also employed for the next drama series, *Bell's British Theatre*, which in 1776 began to overlap in publication the third edition of the "acting" *Shakespeare*. Roberts designed the plates for all one hundred portraits in the twenty-one volumes of the *British Theatre* that appeared through 1781. J. Thornthwaite was

the most frequent engraver, with sixty-four plates. Roberts himself engraved at least a dozen.[7]

Bell had long deliberated a "literary" edition of Shakespeare, and in 1783, he set about recruiting artists, with the hope that they could produce his finest aesthetic achievement. His first recruit for the portraits was the twenty-year-old Johan Heinrich Ramberg, a student at the schools of the Royal Academy, where he won a medal in 1784 for his drawing "from the life." Ramberg had come from Hanover under the admiring patronage of George III, but Bell's patronage would be more valuable to him. He was later to achieve distinction both in England and in Hanover as a portrait painter, landscapist, and theatrical scene designer.

Ramberg furnished twenty-one of the portraits for the "literary" *Shakespeare*, which began serial publication in 1785 and was collected in twenty volumes in 1788. Edward F. Burney provided a dozen portraits, and Mather Brown four (two of them after Gilbert Stuart).[8] The journeyman James Thornthwaite engraved at least twenty, with the rest distributed among eight other hands.[9] Bell was staking considerable amounts of money and prestige on the principal designers, all of whom were under twenty-five years of age. With Ramberg, of course, he was also currying favor with royalty.

Some of the changes in intellectual and social outlook and artistic fashion that were taking place during the years between the beginning and the end of the two Shakespeare ventures are reflected in the different treatment of the later portraits. Softening influences of "sensibility" and other aspects of romanticism that were beginning to appear in literature are discernible in some of these pictures. Continental ideas were brought to their creation by the Hanoverian Ramberg, as they were to the accompanying illustrative scenes by Garrick's brilliant Alsatian scenographer Philippe Jacques De Loutherbourg, the Rome-trained William Hamilton, and engravers such as Jean Marie Delattre, a Parisian, and the Florentine Francesco Bartolozzi.

The performers' poses in the earlier "acting" *Shakespeare* were usually standing, full profile, in a small pool of shadow thrown down as if from the old-fashioned hoop stage candles. Those compositions have an engagingly naive starkness. The new portraits project more movement, but attention is sometimes drawn from the figure to the setting of a martial camp (No. 34), gloomy seascape (No. 19), or formal interior (No. 57). A few suggest a stage set (No. 49).

As with the "acting" *Shakespeare*, but with much more elaboration, scenes suggested by the text and populated by imaginary figures paralleled the actors' portraits. (See appendix 1.) De Loutherbourg, not concerned in painting the portraits, was a leading contributor to the scenes.

In 1789, invigorated by critical and royal approval of his sumptuous scholarly edition of Shakespeare, and with the financial backing of his "Society of Gentlemen," Bell laid plans for a lengthy continuation of *Bell's British Theatre*. It began to appear in periodical numbers in 1791. His hold on it would weaken after his 1793 bankruptcy, and he would lose control entirely in 1795, but by then he had probably entered into all of his contracts for painting and engraving.

Again, in the selection of principal designer for the portraits of performers, Bell gambled on a relatively obscure painter, Samuel De Wilde. De Wilde had exhibited a few pictures at the Free Society of Artists and the Royal Academy, but he had shown little talent for portraiture. Nevertheless, Bell puffed him in his *Oracle* as the superior of Zoffany and settled him in a studio in the premises of the British Library.[10]

De Wilde painted at least one hundred of the one hundred thirty-eight portraits for the new edition of *Bell's British Theatre*. Only one, however, bears a publication date after July 1795, about the time Bell was losing the project. James Roberts, working now in mode and spirit far different from the 1775–80 portraits, contributed twenty-three, and John Graham twelve. The prolific Thornthwaite again led the engravers, with thirty-seven plates. Philippe

Audinet, one of John Hall's old apprentices, engraved thirty-four. William Leney, who worked for Boydell (and wound up in America as a bank-note engraver), furnished twenty-six. William Charles Wilson, another sometime Boydell employee, engraved eight, and William Bromley, the engraver of Corbauld's drawings of the Elgin Marbles, turned out four. The rest of the enormous job was distributed among thirteen other hands, one or two apiece.[11]

For the portraits accompanying this edition, Bell used the same overall dimensions—about 11.5 cm × 8 cm—nearly the same as the 1775–78 *Shakespeare* and the first editions of the *British Theatre*. De Wilde and his assistants adopted both the oval-within-rectangle format of the 1785–88 *Shakespeare* and the lush landscapes and opulent interiors. De Wilde was not only the leading contributor but also the finest artist, especially in the delineation of personality in the faces of his sitters. (The oval-in-rectangle "vignettes" by Stothard, Fuseli, Corbauld, and Graham, which accompany the plays, engraved by Wilson, Heath, Legat, and Audinet, were in the same romantic vein as those in the "acting" *Shakespeare*.)

We list in the catalog three hundred fifty-two portraits, most of them assembled from Bell's drama editions. Numbers 1 through 78, from Bell's *Shakespeare* editions, are of performers shown in Shakespearean roles, alphabetically arranged by performer and without regard to edition. Most of those portraits numbered 79 through 352 are from the successive editions of *Bell's British Theatre*, one of which is of an actor in a Shakespearean role: Thomas Cooper as Pericles (No. 135). Falling outside either category are twenty-seven pictures that we have included because they were produced under Bell's sponsorship.[12]

No complete rationale for Bell's choices of actors, roles, or scenes to be depicted can now be offered. We can connect no picture unquestionably to specific performances or runs of performances. Nearly one-third of these purported portraits present actors in roles that they did not play.[13] Sometimes, indeed, the play be-

ing illustrated, like *Pericles*, had not even been performed in London during the career of the actor pictured.

Bell published a wide spectrum of distinguished plays from the sixteenth century onward, some of them long absent from the repertory. He also included some popular but insubstantial trifles. Some three hundred twenty-five plays had, finally, to be furnished with portraits of performers.

In the companies of London's two winter patent theatres in 1775–76, there were one hundred twenty-eight dramatic actors and actresses (as distinguished from dancers, singers, and other musicians).[14]

In 1795–96, there were one hundred seventy-two. The yearly average for those twenty seasons during which Bell was commissioning pictures was about one hundred fifty. Of course, young performers constantly appeared, and old ones departed. But most of the cadre of successful players enjoyed surprisingly long careers. Some were in London during most of those twenty years, a few during all of them. The pool of people of sufficient popularity or notoriety to yield portraits that were likely to boost sales was not large.

The first requisite for portraiture being popularity, the relative dearth of suitable candidates was rectified principally by repetition. Garrick's portraits appeared with ten plays in the Bell series; one of them was published sixteen years after his death. (Another was issued separately.) The superb tragedienne Mary Ann Yates was pictured twelve times (once with Garrick—there are a few foldouts showing two subjects), and the wildly popular comedienne Frances Abington nine times. The greatest actress of the century, Sarah Siddons, adorned twelve texts; her scarcely less eminent brother John Philip Kemble was shown seven times. Elizabeth Pope and Ann Barry each appeared nine times; William Smith seven times; Joseph George Holman eight; and John Henderson and John Quick six.

A few other stars and habitual headliners of longtime popularity achieved multiple showings: Charles Macklin six; Thomas Hull, Robert Bensley, and Thomas King five; and John "Plausible Jack" Palmer four. Of course, some actors had been associated so firmly and for so long with certain roles that a few choices were almost inevitable—Garrick as Macbeth, for instance, Susanna Cibber as Monimia, Charles Macklin as Shylock, and (after Garrick's death), John Philip Kemble as Hamlet and Richard III.

Celebrated beauties claimed attention, even though some of them lacked talent. The gorgeous Elizabeth Hartley was shown eleven times, despite her awkwardness and dissonant voice. "Breeches" appearances were useful, especially as Sir Harry Wildair in *The Constant Couple*. Susan Greville's Sir Harry on the stage was "very bad," according to the prompter Hopkins, but her figure was splendid. Charlotte Goodall also qualified with a "person" that, a fellow performer testified, was "remarkably well proportioned."

Margaret Martyr, a star for twenty-five years, was, strangely, chosen for only two pictures, but one of them showed her in a breeches role that she had not played. The death of Maria Macklin was attributed to her fondness for such parts: "She went often into breeches, and, by buckling her garter too tightly, a large swelling took place in her knee, which, from motives of delicacy, she would not suffer to be examined, till it had increased to an alarming size." She endured an "operation with great firmness," but she never regained health. She is remembered in a favorite breeches part.

Scandal lent some assistance in filling up the picture frames. Greenroom gossip and newspaper squibs ignited by the vivid lives and loves of Margaret Cuyler, Sophia Baddeley, Ann Catley, and Gertrude Mahon ("The Bird of Paradise") made their portraits as valuable for Bell's purposes as if they had been stellar actresses. Momentary interest in prominent amateur actors was responsible for portraits of the Earl of Barrymore as Scrub in *The Beaux' Stratagem* and of Harry Angelo, the fashionable fencing master, in the "skirts" role of Mrs Cole in Foote's *The Minor*.

The reasoning behind one of Bell's most interesting artistic/commercial decisions about the portraits may be imagined. On 16 September 1777, he "published" portraits of both David Garrick (No. 159) and John Henderson (No. 187) in the role of Bayes in *The Rehearsal*. Both portraits were drawn by Roberts and engraved by Pollard. Henderson's accompanied the play in *Bell's British Theatre*. Garrick's was vended separately, from Bell's shop. Why? We think Garrick's picture had already been drawn in this, one of his best comic roles, when Henderson played the part at the Haymarket for the first time on 25 August. Henderson was being actively advertised for his Drury Lane debut (as Hamlet) on 30 September. The young man from Bath was a novelty ripe for exploitation. Garrick was two years past retirement but could still sell pictures, so his plate was not wasted.

But other puzzles remain to be solved. Why, for instance, was the middling actor James Middleton awarded three portraits when he had acted in none of the roles shown? Why was John Palmer represented as Warwick in *3 Henry VI* twice, when he never acted the part? Why were characters leapfrogged from one play to another? Elizabeth Pope was shown as Cleopatra in *Antony and Cleopatra*, though she had played the sultry queen only in *All for Love*. Mary Ann Wrighten was presented as Katherine in *The Taming of the Shrew*, when she had only acted Catherine in Garrick's farce *Catherine and Petruchio*.

Whatever the reasons for the choices, the primacy of the actor in Bell's calculated plan for stimulating the sale of these editions is obvious—the actor, not the play or the role, or even the actor in the role, usually.

How did these pictures originate? How accurate are they in conveying the action? How faithfully do they portray their subjects? It seems plain that even when actors were portrayed in roles we know were in their recent repertoires, the artists were seldom if ever drawing "from the life" as we usually understand the phrase. Seldom could they have managed more than a hasty sketch during a performance. And it is not probable that busy actors went often in costume to pose for artists in their studios.

But assuring fidelity to faces and figures should not have been difficult. Featured players were well known to London's graphic artists, professionally and often socially. Countenances evidently matched the originals closely enough to satisfy both the subjects and Bell's London subscribers. As for the rest—costumes and the action shown or implied—it seems that they were in most instances "compiled" by the artist from his store of artistic training and theatrical observation. As we shall see, he shared certain basic assumptions with both actor and audience. Tradition, familiarity with acting practices, and dogma laid down in contemporary educational theory and theoretical criticism guided the painter's hand. He knew almost instinctively how to depict the gesture or stance suggested by the line from the play text that would be engraved beneath the portrait. Within pretty narrow limits, the "rules" dictated that the same gesture would be made in similar dramatic circumstances or in illustrating the same dramatic "points."

It is important to remember that the *vocal* share in the stage success of any action depicted would have been very large. And we should also understand that, within the constriction of the actors' "rules" for movement, as much subtle variation was possible as within the "rules" for the heroic couplet, the fugue, the ballet, or any other narrowly circumscribed artistic expression of this formal century. But conveying dramatic nuance is usually the function of voice and motion. The painter of static portraits can ordinarily hope to catch only the frozen climax of an action.

## Notes

1. The act was 8 George II, cap 13, *An Act for the Encouragement of the Arts of Designing Engraving, and Etching historical and other Prints, by vesting the Properties thereof in the Inventors and Engravers* . . . . Cited by Sven Brüntjen, *John Boydell, 1719–1804* (New York and London: Garland, 1985), p. 49. There were two

more acts, tightening the rights of engravers as the print trade increased.

2. Brüntjen, p. 28.

3. Engraving: "Lines or flicks are incised into a copper . . . plate by the use of a burin or 'graver.'" For stippling, a roulette, containing spikes, is used. Mezzotinting involves brushing or scraping the plate to produce light and shade. See Richard Godfrey, *Printmaking in Britain* (New York: New York University Press, 1968), pp. 237–39.

4. J. A. Rouquet, in *Present State of the Arts in England* (1755), remarked that "the name of the painter appears under the picture, and he sees it with pleasure when he looks in the shop window of the print seller. It is a public acknowledgment of his existence which perhaps might be obscure otherwise." Quoted by Brüntjen, p. 33.

5. See Shearer West, *The Image of the Actor* (London: Pinter, 1991), p. 28. West traces the relationship of painters to actors throughout the century.

6. And probably he contributed a number of the fifteen plates with no engraver's name inscribed. Grignion would be principal engraver for *Bell's Poets* beginning in 1776.

7. Twelve plates carried no engraver's name; six others were by J. Page; five by Robert Pollard; three by Thomas Cook; three by Burnet (or D.) Reading; one each by Anthony Walker, J. G. Walker, and William Walker; and one by J. Collyer. Brief biographical notices for these and other artists concerned in Bell's plays are in appendix 4.

8. John Sanders, Gilbert Stuart, and William Hamilton each contributed one. The first of Ramberg's was "published" over a year, and the second six months, before the publication of the plays for which they were intended. This was a precaution against the rampant piracy.

9. Charles Sherwin five; Charles Grignion four; and one or two each for Bartolozzi, Cook, Delattre, Hall, Newnham, and Sharp.

10. Ian Mayes, "John Bell, *The British Theatre*, and Samuel De Wilde," *Apollo* 113 (1981): 99–103, gives an analysis of the nurturing relationship between Bell and De Wilde.

11. J. Chapman, John Corner, James Fittler, Robert Cromek, Richard Godfrey, [Jean?] Matthieu, John Neagle, J. Pegg, Burnet Reading, William Skelton, J. Thomson, Thomas Trotter, and one of the Walkers.

12. Nos. 21, 90, 97, 124, 127, 134, 147, 148, 265, 275, 310, and 343 were drawn but never published; 26, 32, 38, 62, 71, 93, 104, 136, 159, 202, 271, 281, 307, and 316 were issued separately; and 237 appeared as the frontispiece to Macklin's *Works*.

13. Virtually all performances in the patent houses of London in this period are reported in Charles Beecher Hogan, ed., *The London Stage, 1660–1800*, 3 vols. (Carbondale: Southern Illinois University Press, 1970). In a number of instances, last-minute substitutions in casts went unreported in the bills. But the substitute players were almost always seasoned in the roles.

14. Only four portraits of performers who were primarily dancers are in the catalog: Giovanna Bacelli, Adelaide Simonet, and Vestris the Elder and the Younger.

# 3 THE ACTION IN THE PORTRAITS

OCCASIONALLY in theatrical history, the sudden appearance of a performer who combines extraordinary charisma with an impressive gamut of fresh interpretation seems to justify the critical declaration that a revolution in performance has occurred.

The playwright Richard Cumberland, gazing back over fifty years, remembered young David Garrick playing Lothario in a production of *The Fair Penitent* in which the veteran James Quin was Horatio:

> [W]ith very little variation of cadence, and in a deep full tone, accompanied by a sawing kind of action, which had more of the senate than of the stage in it, [Quin] rolled out his heroics with an air of dignified indifference, that seemed to disdain plaudits. . . . [W]hen after long and eager expectation I first beheld little Garrick, then young and light and alive in every muscle and in every feature, come bounding on the stage . . . heavens, what a transition! it seemed as if a whole century had been stept over in the transition of a single scene; old things were done away, and a new order at once brought forward, bright and luminous, and clearly destined to dispel the barbarisms and bigotry of a tasteless age.[1]

Cumberland's recollection is often quoted to introduce discussions of the revolution in acting style that Garrick was said by his contemporaries to have led in the 1740s. There is no doubt that Garrick, perhaps the greatest of all English actors, had a profound influence on acting style.[2] But various memoirs—of Charles Macklin, John Philip Kemble, Edmund Kean—also asserted the lasting influence of those actors, although not so emphatically. Cumberland certainly knew that some "barbarisms," like exaggerated movement, "rant," and "toning" (or "cadence"),[3] persisted among some players throughout the careers of all of the above. Changes in acting practices, styles, and techniques have always been partial and incremental. Few innovations in the eighteenth century were instantly and universally adopted.

The numerous commentaries on eighteenth-century English acting since Alan Downer's pioneer study more than fifty years ago have agreed generally with his description of the successive "schools" of acting and the differences in individual styles.[4] Some more recent essays have offered valuable suggestions as to the nature of the profession; others have provided insights into the mannerisms of individual players, drawn from contemporary comment.[5] Still others have explored acting theory all the way back to Quintilian's *Institutio Oratoria* and have related performance to other arts and to philosophical currents and psychological fashions.[6] Readers interested in eighteenth-century performance, in schools and styles and attempts to capture idiosyncrasies and what we have called the "nuances" of performance, have a wide choice of stimulating critical opinions to explore. But the Bell portraits have relatively little to do with nuance, and even less with originality.

The "rant" and "cadence" practiced by Quin's generation, and also by some members of the generations of Garrick and Kemble, were encouraged by the fustian that eighteenth-century playwrights deliberately wove into their tragedies. Stentorian declamation was also

sometimes made necessary by audience turbu-
lence and, toward the end of the century, by the
increasing size of the playhouses.[7]

But Bell's portraits tell us nothing about
how the actors sounded. Can we conclude any
more about their movements and gestures? In
rare cases, perhaps, we are actually being shown
the performer in an attitude sketched at (or re-
membered from) a specific performance. But
almost always the artist is "directing" an action,
whether or not the actor being portrayed has
ever played the role. The artist has usually (but
not always) supplied the gesture or attitude that
was declared by the "rules" to be appropriate for
the demonstration of the line(s) of dialogue en-
graved on the plate. The gesture would prob-
ably have been the same had the subject been
any other actor, especially if it came at the cli-
max of a "point."

"Points" were important passages of dia-
logue toward which the performer would build
rhetorically. The appropriate (usually obliga-
tory) stance and gesture would be held for the
appreciative applause of the audience, much in
the manner of the frozen moment after an aria
in an opera performance. W. B. Worthen ob-
serves that "as a device emphasizing technique
rather than meaning, pointing naturally pro-
vided the opportunity to compare the talents of
various actors in the same parts. More impor-
tant, pointing tended to fix the dramatic role
in the performance tradition. Woe to the ac-
tor who, under the misguided influence of an
original conception of his character, scanted
the public's keen anticipation of Hamlet's or
Jaffeir's or Sir John Brute's familiar points."[8]

Some basic rules for performance, estab-
lished by ancient authority, were ratified in the
eighteenth century by critics, artists, philoso-
phers, and performers all over Europe. Though
there was some local variation, teachers of
dancing, declamation, acting, sculpture, and
painting agreed generally on rules for posture
and gesture. Students of each art were enjoined
to study the others. Actors, particularly, were
advised to give close attention to Greek and
Roman sculpture and Renaissance painting.

Many of the Bell portraits provide graphic

illustration of the fundamentals of eighteenth-
century tragedy performance that are recited in
a recent study by Dene Barnett.[9] Conversely,
many of the generalizations and descriptive de-
tails offered by Barnett constitute a resource
for interpretation of the Bell portraits. We are
indebted to Barnett's generalizations and con-
clusions in the following survey of dramatic
"action" as reflected in the portraits. (In our dis-
cussion, we cue engravings to principles or ges-
tures by citing their catalog numbers.)

As all critics and theorists of the century
agreed, the noble characters and the idealized
themes of tragedy demand Grace, Beauty, Dig-
nity, and Decorum—inviolable requirements
for all principal tragic characters whether in tri-
umph or defeat, wooing or dying. Gestures and
postures, while prescriptive, are expected to be
slightly varied from use to use.

The *face* is the map of the emotions and
reflects them with theatrical emphasis. Samuel
De Wilde's mastery of expression was particu-
larly vivid: see 142, 143, 269. Also see James
Roberts's 145. *Head* and *eyes* are turned gravely
upward when reverent statements are uttered,
or when a deity, the heavens, the moon, or stars
are mentioned (11, 60, 100, 119, 264, 297).

*Feet* are the basis for bodily action. For "pic-
torial elegance" they should be set in dance po-
sitions, "with toes turned well out, and the
weight resting on one foot," the "engaged" foot
(22, 110, 141, 234). The "free" leg should bend
gracefully. Weight should seldom be sustained
on both feet equally. (The posture of the Apollo
Belvedere is often cited and sometimes imi-
tated: 218.) The fencer's stance or half-crouch
sometimes modifies those prescriptions (29, 68,
158). Energetic advance, frightened retreat, or
intense passion widens the distance between
the feet.

*Hands*—pointing, circumscribing, direct-
ing—are managed with grace (329) but with
crisp decision (326). In repose, they should
remain naturally curved (281) but in anger
clenched (261), in agitation expressively spread
(95, 302). If the *left* hand is advanced, the *right*
foot should also be advanced, in contrast (300).

*Arms* and *hands* should never be raised above

the shoulders, except in epic action (8, 10). This exception seems also to extend to villainous action (see the two Iagos, 13 and 32). Arms should be held six inches from the torso in ordinary declamation, and the *right* hand should not extend in gesture farther toward the *left* side than the heart (37, 38, 98, 99; again villainy seems privileged, as in 32).

The *right* hand should go to the breast when the actor is referring to himself (99, 218, 266). The *right* hand extended toward others shows friendship or benevolent and peaceful intent (5, 204) or supplication (35). The *right* hand leads the *left* in illustration or narration (197, 215). It should lead in calls to action and in brave declarations (326).

Eighteenth-century actors, commentators, and theorists gave particular attention to the management of the *left* hand because of the many centuries of religious, artistic, folkloric, and heraldic association of that sinister member with evil, dire prediction, and misfortune. The *left* hand pointing or gesturing denotes scorn (43) or indignation, distaste, defiance, or anger toward the person or object indicated (4, 6, 38, 75, 164, 277). The *left* hand should otherwise not act alone but adapt itself to the *right*.

The gestures that expressed the primary emotions (the "Universal Passions") were easily interpreted by playgoers, who reacted to them predictably. Condemnation by both critics and audiences was the penalty for inartistic manipulation of the expected movement or radical deviation from it. But good actors were not automata, and eighteenth-century audiences were receptive to the nuanced action that distinguished performers each from each, and the gradations of motive, and hence motion, between closely related emotions.

*Fear* and *surprise* are nearly related and call for subtle discrimination by the interpreter. *Fear* often arrives with *surprise*, which startles, opens wide the eyes and mouth, lifts the eyebrows, and thrusts the hands forward or aside (133, 141). Thomas Wilkes, in *A General View of the Stage* (1759) adds a refinement: "But when . . . surprise reaches the superlative, which I take to be astonishment, the whole body is ac-

tuated; it is thrown back, with one leg set before the other, both hands elevated, the eyes larger than usual, the brows drawn up, and the mouth not quite shut."[10] That, of course, describes Garrick's celebrated "start" of Hamlet meeting the Ghost.[11] It is, unfortunately, not one of the poses struck by Garrick in the Bell pictures. But a similar—though less fearful—"start" is given by J. G. Holman as young Douglas (193). Holman never played the part, but De Wilde, the plate's designer, was confident that the depicted attitude was required by the line to be quoted under the picture: "Say, who was my Father!"

*Anger* starts forward, face stern, fists clenched, weight on the forward foot, the free foot withdrawn (109, 306, 334). Anger may lead to *hatred* and is also related to *malevolence* and *malice.*

*Contempt* (218) is evidently an intensification of *aversion.* Contemporary critics do not seem to mention *hauteur*, which often involves prideful *contempt.* But hauteur is an important component of tragic action. The required physical attitude seems prescribed—for the superiority of Publius (314), the confidence of Phocyas (312), the triumph of the Bastard Faulconbridge (34) or of Warwick (52), the assumed brutality of Petruchio (74), or the pitiable hubris of Malvolio (78). Hauteur involves a resolute facial expression and the left arm akimbo, left hand on hip.

There are of course instances in the portraits where these and other general "rules" are transgressed. After all, as we have posited, the artists, though much influenced by the rules, were not bound by them.

Most of those rules and nearly all of the background theory of performance in the eighteenth century concern Tragedy. But several requirements—Beauty, Grace, and even a certain amount of Dignity and Decorum—were imposed, though less rigorously, on the principal characters of the comedy of manners and sentimental comedy.

In comedy with a satirical content, the rules of tragedy had relevance also, for comic appearance and action depended for effect on their violation or debasement. The graceful manners

and dress of beaux (110, 152, 310) were counterpointed in the exaggerated "graces" of fops (115, 145). A ridiculous, crotchety old gentleman is often yesterday's beau, outmoded. Consider one "dis-graceful" device by which farcical and satirical intent is communicated—what might be called the "comical straddle"—in impudent young or, especially, irascible aged characters: wide-apart feet, bent knees, sour countenance, dégagé air. The prime tragedy requirement of grace is employed by turning it on its head (85, 88, 92, 233, 256, 267, 287, 299, 352).

For farceurs and low comedians, there were few traditions to follow, beyond the comic devices depending on props. More often than in tragedy, success in comedy depended on physiognomy or physique. There was also more room for individuality, for originality of mannerism. Comedians sometimes had what would be called today a "shtick," some trick well known to the audiences; there does not, however, seem to have been any tradition resembling the *lazzi* performed by the *Zanni* of the commedia dell'arte, at least in Britain.[12] Some of the piquancy of comic performance is captured in several of the pictures—if performance is what we are witnessing (2, 7, 22, 80, 229). Successful comedic acting was intensely personal, many actors specializing in one or several-type characters: hearty John Bull, country gentlemen, old maids, pert servants, or comedy Irishmen. Others, of wider talents, could play not only genteel or low comedy but tragedy too. But high or low, comic or tragic, one was likely to identify them by their dialects or accents, and of course by their dress.

## Notes

1. Richard Cumberland, *Memoirs of Richard Cumberland* (London: n.p., 1808), 1:80.
2. See Kalman A. Burnim, *David Garrick, Director* (University of Pittsburgh Press, 1961); also George Winchester Stone Jr. and George M. Kahrl, *David Garrick: A Critical Biography* (Carbondale: Southern Illinois University Press, 1979, esp. pt. 6, "The Actor"; and Leigh Woods, *Garrick Claims the Stage* (Westport: Greenwood, 1984).
3. Rant was the practice of delivering lines in an extravagant or overwrought manner; tone or cadence was measured, rhetorical affectation.
4. "Nature to Advantage Dressed, Eighteenth-Century Acting," *PMLA* 55 (1943): 1002–37.
5. See Bertram Joseph, *The Tragic Actor* (London: Kegan, Paul, 1959); William Appleton, *Charles Macklin: An Actor's Life* (Cambridge, MA: Harvard University Press, 1960); the relevant chapters on acting in Charles Beecher Hogan, ed., *The London Stage, 1660–1800*, 3 vols. (Carbondale: Southern Illinois University Press, 1970); and the commentaries in the entries of the *BDA*.
6. See esp. Joseph Roach, *The Player's Passion: Studies in the Science of Acting* (Newark: University of Delaware Press, 1985); William B. Worthen, *The Idea of the Actor Drama and the Ethics of Performance* (Princeton University Press, 1984); and Joseph Donohue, *Dramatic Character in the English Romantic Age* (Princeton University Press, 1970).
7. The problem of size is discussed by Edward A. Langhans, "The Theatres," in *The London Theatre World, 1660–1800*, ed. Robert D. Hume (Carbondale: Southern Illinois University Press, 1980), pp. 35–65; Harry W. Pedicord, *The Theatrical Public in the Time of Garrick* (New York: King's Crown, 1954); and Leo Hughes, *The Drama's Patrons* (Austin: University of Texas Press, 1971).
8. Worthen, p. 72.
9. Dene Barnett, *Art of Gesture: The Practice and Principles of Eighteenth-Century Acting* (Heidelberg: Carl Winter Universitätsverlag, 1986). Strangely, Barnett cites hundreds of English and Continental sources but not the Bell publications.
10. Quoted by Barnett, p. 47.
11. See Burnim, pp. 159–60.
12. Pantomime was a different matter, with a long Continental history by the beginning of the eighteenth century. The Bell pictures were not concerned with pantomime.

# 4 THE COSTUMES IN THE PORTRAITS

THEATRICAL historians tend to focus on the performer's likeness and the suggestion of action in the Bell portraits. For Bell's subscribers, most of them theatregoers and connoisseurs of current fashion, costumes probably competed very closely for attention with faces, figures, and gestures. But costumes also have interest and instruction for the attentive historian.

Dressing the actors was a challenge and a considerable expense for theatre management in the eighteenth century. Costumes could not be lightly discarded,[1] yet the wardrobe had constantly to be supplemented or altered because of the subtle pressures of fashion and the increasing critical demands for less anachronism and more realism.

David Garrick, by far the most influential theatrical personality in the century, retired from the management of Drury Lane Theatre in 1776, shortly after John Bell's long succession of portraits began. Yet Garrick's influence was present in the Bell costumes. Garrick had given actors' dress his close attention from the beginning of his twenty-nine-year reign at Drury Lane and had brought the wardrobe there from shabbiness to splendor. In that matter, as in others, he had been followed by the competition at Covent Garden.

By 1775, there was more critical condemnation of extravagance and historical inappropriateness than of meanness in the Drury Lane costumes. Mrs Yates, appearing on 13 October 1775 in *Jane Shore*, "disguised the former part of her character in a kind of dress calculated only for an Italian Princess."[2] Talented and hardworking mantua-makers[3] and wardrobe keepers provided fine tailoring to managerial order, but they had no control over the bizarre uses to which their handiwork was sometimes put by actors.

In the heyday of type-characterization, with comic actors often confining themselves to one or two related "lines," audiences could recognize, by dress alone, many occupations, religious persuasions, national types, and class differences (examples are cited by their catalog numbers): tradesmen (143), sailors of low rank (92) or high rank (256), Quakers (155), braggart soldiers (233), servants (7), country men (112), country maids of varying degrees of simplicity (91, 230, 246), villains (often Spanish; see 116 for an actual cloak-and-dagger Spaniard), fops (115, 145), rakes (154), or beaux (110, 152, 310), and so on. Such types could often be dressed from the wardrobe or from the clothing allowance sometimes granted players. Star comediennes occasionally demanded more expensive attention.

Costumes for leading tragedy roles were especially costly. They were also vital to performance, particularly in the presentation of "heroic" tragedy. Even before the opening lines were spoken, the first intimation that horrid deeds and noble sacrifice would be the order of the evening was the distinctive raiment of the principal players. Brightly colored, bejeweled, and high-plumed, their finery was the sign of exalted rank and heralded intense emotion and violent action.

"Roman" dress was stylized early in the eighteenth century: male patrician civilians wore togas, and military heroes were outfitted in torso-molded, leather breastplates, metal-

studded short skirts, greaves, and plumed helmets (160, 314). The conventional "Roman" costumes, in various permutations, usually served also for Greek characters (221, 235, 312); see No. 133 for the most elaborate example of this Graeco-Roman fantasy. Even Trojans were Romanized (14). Those clichés persisted throughout the period covered by the Bell portraits, though the interest among writers of tragedy shifted (with politics) from republican to imperial Rome and from armor to togas (60, 218).[4]

Male leads and supporting players in almost any tragedy set in Turkey, North Africa, or the Near East—whether sultan, shah, or pasha—wore "Persian-style" attire: turbans with plumes and crescent medallions, brocaded robes generously trimmed with ermine, fur-topped soft boots, and scimitars with falcon-head hilts (101, 105, 107, 224). Sometimes "Greek" characters resembled more the "Persian" than the "Roman" (309). "Chinese" and other Oriental stage clothing was vaguely similar to "Persian" but with voluminous pantaloons gathered at the ankles (109).[5]

Tragic heroines inhabiting any of those countries, whether of ancient or recent times, were apt to wear (until late in the century) some version of the gowns that their European, modern sisters wore (199, 209). The only variations for the exotic royal heroines were ermine-trimmed capes and a profusion of ostrich feathers bursting from the centers of the small coronets surmounting the high-piled coiffures (95, 100, 102). In the 1780s, English offstage fashion began to favor a narrower profile, and the stage followed suit. The elaborately decorated gowns, stretched over hoops or panniers, which leading ladies of rank had worn in drama set in any period or country, were seen less frequently. They were abandoned altogether when the "classical revival" began to assert its preference for less decoration and higher waistlines (114, 119, 168, 324). These changes are observable in the Bell engravings over the span of their publication, 1775–95. (Contrast 80 and 199 to 138 and 214.)

Some prominent characters in Shakespeare's English history plays very early assumed their standard visual identity. The accoutrements of sixteenth-century kings, which were approximately accurate for Henry VIII (courtesy of Holbein's portrait), were made to serve also for the somewhat earlier Richard III. They changed but little throughout the eighteenth century: plumed hat; ermine-lined cloak; sleeves puffed, pleated, and slashed; neck ruff; the Order of the Garter (5, 18, 42); or body armor and robe (66, 106).

Falstaff appeared always in his signature bonnet and ruff, doublet, trunk hose, and boots, with sword and targe (31, 61, 189). Some actors were content with modern dress. Garrick appeared in *Macbeth* attired like a Georgian military officer (29; and that dress is confirmed by other portraits). Frequently, even important secondary characters dressed in modern breeches, smallclothes, jackets, and tricorn hats (22).

From the 1760s on, well into the 1790s, male stage dress, especially for principals in plays set in foreign lands in the previous century, was often heavily influenced by the figures in paintings by Van Dyck. Doublets and breeches were liberally covered with slashes, and collars were of pointed lace (53, 96, 205). Ladies' dresses also felt that influence (96, 250).[6]

The latter part of the eighteenth century was less contemptuous than the baroque period had been toward all those "barbarous" times between the fall of Rome and the reign of Elizabeth I. After midcentury, theatrical medievalism increased along with literary interest in ruins and balladry. But costumers were still uncertain about "Gothick" dress. So minor actors felt free to grab any garb the wardrobe afforded when they acted in a medieval setting.

Managers made few attempts to depict the "national" dress of the various ethnic groups in the British Isles until fairly late in the century. Tradition assigns to Charles Macklin the credit of first bringing "the old Caledonian habit" onto the stage, in his production of *Macbeth* at Covent Garden in 1773. However, no representations of him in the part survive except for several unreliable caricatures. Two of the Bell portraits are of actors in the title character of

Home's *Douglas* (1756), a presentation of medieval Scotland. Anthony Webster was pictured in the part by James Roberts in 1776, wearing a kiltlike garment (330). Webster had played the role that year, and his costume may be authentic. Samuel De Wilde painted a portrait of J. G. Holman as Douglas in tartan trews, with a claymore at his side and wearing a Scotch bonnet. But the engraving of that picture was dated 7 April 1791, and Holman did not play Douglas until 20 December 1792. Thus here, as is so often the case, the painter seems to be the *costumier manqué*, presenting the character as *he* would have dressed it (193).

The artist John Graham's 1796 evocation of Thomas Caulfield as the rugged Arviragus in Mason's tragedy *Caractacus* is a half-naked, barefoot figure in a bearskin (129). But the piece had not been played for nearly two decades, and Caulfield did not revive it. In 1778, James Roberts depicted Maria Hunter (208) in the title role of Boadicea in Glover's tragedy. The heroic early British queen of Roberts's conception wears an elaborate hooped gown and boasts a full-coiffed eighteenth-century "head" topped by a wide circlet of steel from which springs a forest of feathers. Her ears are adorned with drops. She holds a spear, though she is obviously too cluttered for combat. But the century moved on, and ideas of historical realism took hold. In 1791, Samuel De Wilde showed Jane Powell as Boadicea in a dark Roman-style gown, her torso encircled by a steel corselet. She, too, holds a spear, and she wears a spiked crown. These are more reasonable details, for Boadicea lived and fiercely died under Roman rule (283). *But* neither Maria Hunter nor Jane Powell ever played the part.

Some costumes are unquestionably authentic, though. Charles Macklin carefully researched and dressed his revolutionary Shylock, and he and others left descriptions of the long black gown, baggy trousers, and red skullcap. The knife and scales, emphasized in Shakespeare's text, completed the sinister ensemble in the Macklin portraits drawn by Parkinson in 1776 (48) and by Ramberg in 1785 (49). The artists would scarcely have dared alter the essentials, so long familiar to London theatre patrons.

Other costumes find weaker but still persuasive corroboration. One of Tom King's great characters was the Fool Touchstone in *As You Like It*. Hazlitt remembered King's portrayal, "with wit sprouting from his head like a pair of ass's ears," and that is indeed the crowning touch of King's parti-colored attire in the plate designed by Parkinson (44).

Several other pictures perhaps fetch their lineage from the stage, but at several removes. Such a one is Mather Brown's noble figure of J. G. Holman as the Bastard Faulconbridge in *King John* (34). Instructed by the text ("Austria's head lie there" [III.2]), Holman's rapier points to the severed head on the ground. Richard Coeur-de-Lion's lion skin is draped incongruously over the shoulder of Holman's modified eighteenth-century military uniform. However, Holman never played the part. The inscription on the plate reads "M Brown del from a Portrait by M^r Steward [Gilbert Stuart]." The painting was entered in the *Mathews Catalogue* at the Garrick Club but is not now to be found. How much of Brown's detail was in Stuart's portrait? And was any of it suggested by the dress of some player of the role?

Ann Storace did not act Euphrosyne in *Comus*, though De Wilde's portrait of her (315), engraved by Thornthwaite in 1791, illustrates the text of Bell's late edition of the play. But it is possible that she had at least posed in the costume. De Wilde has equipped the figure appropriately to star in this dramatic mixture of myth and Milton. She is classically gowned, with vine leaves in her hair, and she holds a glass of wine. Miss Storace, similarly clothed, but hoisting the wineglass in a different pose (316), was engraved by Thornthwaite in 1791 from a picture by Corbauld. Where did these details come from? Tradition perhaps? But Ann Catley, who had been shown by Roberts (126) in the same role in 1777 (she *had* played it), did not hold a cup, though the vine leaves, both in her hair and appliquéd on her flowing sacque gown, are prominent.

Questions about significant detail frequently fret our curiosity when we examine these pictures. A final example: in 1775, Maria Macklin is shown as Helena in *All's Well That Ends Well*

(50). In act III, scene 5, Helena informs a questioner that she is on a pilgrimage "To Saint Jacques le Grande" (lines 33–35). At the end of the play (V.3.30), she steps into our Bell picture in a gown that is decorated on its periphery with scallop shells. Scallop shells are the emblematic badges of those who have *completed* the journey to the shrine of St James of Compostela. Who thought to add this deft touch? Miss Macklin, who indeed played the role? James Roberts, who drew the picture? Or were the shells traditional and obligatory? Would they have been on the gown in act III?[7]

Although agreement in mode and manner among the principal designers of these pictures ensured generic resemblances in technique for each series, artistic individuality was of course irrepressible. Even to the casual observer certain repetitions in detail are obvious: in the mid-seventies, Roberts added to all his dresses—whether sacques, pelisses, open gowns, or polonaises—trains far longer than anything authorized by current fashion. In the nineties, Ramberg surrounded all of his ladies with long, swirling, diaphanous scarves.

A great many nagging questions regarding painters, actors, and wardrobes are raised by costume details such as these. But the changing pageant of theatrical dress staged for us by the twenty-year run of the Bell portraits invites more studious examination than we have space for here.

# Notes

1. The only surviving complete inventory of costume and stage properties in the eighteenth century lists more than one thousand items. Made more than thirty years before the first Bell portraits, it nevertheless illustrates wardrobe management. See Philip H. Highfill Jr., "Rich's 1744 Inventory of Covent Garden Properties," *Restoration and Eighteenth-Century Theatre Research* (November 1966), 5:7–26; and (May 1967), 6:27–35.

2. Clipping dated 13 October 1775, Folger Library, quoted by Kalman A. Burnim, *David Garrick, Director* (University of Pittsburgh Press), pp. 75–76. Diana De Marly, *Costume on Stage* (London: Batsford, 1982), chap. 3, provides a short overview of

stage dress in eighteenth-century England. For our period esp., see Charles Beecher Hogan, *The London Stage, 1660–1800*, pt. 5, pp. lxvii–lxxii.

3. Early examples of loose gowns called mantuas were made from Italian silk from Mantua (Nora Waugh, *The Cut of Women's Clothes, 1600–1930* [New York: Methuen, 1968], p. 101). Costumers were called mantua-makers. Most are historically anonymous. During much of our period, Mary Rein (fl. 1780–1815) served the function at Drury Lane Theatre where, by the 1790s, she was reckoned important enough to be credited in the bills. See *BDA*, 12:310–12.

4. Some of the entries in Rich's inventory pique our interest: Along with assorted classical curiosities like "Pluto and Jupiter's coronets" and "6 sattin Satyrs jackets," were "53 Roman shapes and guards trim'd copper," "8 Roman foils," "14 bases for Citizens in Julius Caesar," and "18 gilt old leather armours diff[t] sorts." A dozen years into his management at Drury Lane some of Garrick's inventory was still in poor condition. On 3 August 1758, he answered a request of his friend William Young for the loan of some costumes for Young's private theatricals:

> Our Roman Shapes at Drury Lane are so very bad, that we are now making New Ones for y[e] Revival of Anthony & Cleopatra, & our false trimming will not be put upon 'Em till a little time before they are Wanted, as it is apt to tarnish with lying by. I cannot therefore Accommodate You wth Dresses & indeed if we had any . . . how could we let You have 'Em in y[e] Month of Sep[br]?—for We Open y[e] 15th & make Use of those kind of Dresses in Every Roman & Greek Play.

*The Letters of David Garrick*, ed. David M. Little, George M. Kahrl, and Phoebe de K. Wilson (Cambridge, MA: Harvard University Press, 1963), letter 208.

5. Highfill "Inventory" passim. There are notations such as "9 turbants," "a cherry Persian petticoat," "a blue mantua sultan's dress," and "Grimaldi & his sons Chinese dress of cherry col[d] [colored] and green silk."

6. De Marly, chap. 3 passim.

7. When Mather Brown portrayed Ann Warren as Helena in 1786 (she had not acted the role), he gave her a broad hat with a scallop shell on the brim, another shell at her breast, a third on her gown, a crucifix, and a palmer's staff. She appears thus attired at IV.4.10–11: "You must know / I am supposed dead." Was Brown following a tradition or emulating Roberts?

# PART 2

*The Catalog of Portraits*

Numbers 1 through 78, from Bell's *Shakespeare* editions, are performers shown in Shakespearean roles, alphabetically arranged by performer and without regard to edition.

Numbers 79 throught 352 are from the successive editions of *Bell's British Theatre*, similarly arranged. (But one is of an actor in a Shakespearean role: No. 135, Thomas Cooper as Pericles). Also included here are twenty-seven pictures, falling outside either category, that were otherwise produced under Bell's sponsorship.

When a description of the original portrait is known, it is described before the engraving, and is sometimes reproduced. Given the vagaries of eighteenth-century adapters and editors of Shakespeare's plays, the act and scene divisions indicated are not always those to be found in modern scholarly editions.

For further information about the sitters, the reader is referred to Philip H. Highfill Jr., Kalman A. Burnim, and Edward A. Langhans, *A Biographical Dictionary of Actors, Actresses, Musicians, Dancers, Managers, and Other Stage Personnel in London, 1660–1800*, 16 vols. (Carbondale: Southern Illinois University Press, 1973–93), hereafter cited as *BDA*.

# 1

## Frances Abington  1737–1815
### as Beatrice in *Much Ado about Nothing*

ARTIST: James Roberts

ENGRAVER: Anonymous

DATE PUBLISHED: 19 January 1776

BELL EDITION: BS75–78; BET92.IV

Drawing, full-length, standing, holding a mask in her right hand and a closed fan in

her left hand; wearing a decorated dress with a wide panniered skirt and a hat with feathers. Line engraving 14 × 5, with the quotation (V.4): "Bene. ———, which is Beatrice? / Beat. I answer to that name, what is your will?"

LOCATION OF ORIGINAL: Unknown.

PROVENANCE: Bell sale, Christie's, 27 March 1793 (lot 79); bought, with another drawing of

Mrs Abington as Beatrice by Ramberg, for £1 1s. by Mitchell.

RELATED: See No. 2.

Mrs Abington acted Beatrice for the first time on 6 November 1775, at Drury Lane Theatre, when Garrick played Benedict. The prompter Hopkins wrote in his diary that night, "Mrs Abington Beatrice, first time—very Great Applause." The *Gazetteer and New Daily Advertiser* reported that Beatrice "very happily has got into the hands of Mrs Abington."

# 2

## Frances Abington  1737–1815
### as Beatrice in *Much Ado about Nothing*

ARTIST: J. H. Ramberg

ENGRAVER: C. Sherwin

DATE PUBLISHED: 17 February 1785

BELL EDITION: BS85–88.IV

Colored drawing (9.8 × 6.7), full-length, standing to front in a wood, her left hand

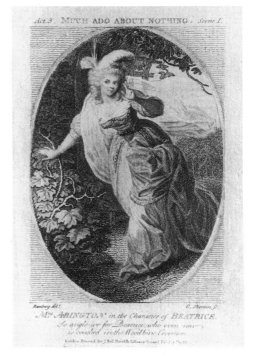

raised and her right arm extended at her side; wearing a dress with a voluminous skirt and train and a hat with plumes. Line and stipple engraving 9.8 × 6.4, for Bell's British Library, with Ursula's line (III.1): "So angle we for Beatrice; who even now is couched in the Woodbine Coverture."

LOCATION OF ORIGINAL: British Museum (Burney I, No. 3).

PROVENANCE: Bell sale, Christie's, 27 March 1793 (lot 79); bought, with another drawing in lot by James Roberts of Mrs Abington as Beatrice, for £1 1s. by Mitchell.

RELATED: A line engraving (9.2 × 6.4) by W. Leney, after Ramberg, was printed for Cawthorn, 1806. See also No. 1.

When Mrs Abington returned to the stage after a seven-year absence to act Beatrice at Covent Garden Theatre on 6 October 1797, she was sixty years old and had grown heavy. But James Boaden remembered that "she still gave to Beatrice what no other actress in my time has ever conceived; and her old admirers were still willing to fancy her as un-impaired as the character herself." The critic in the *Monthly Visitor* (October 1797), however, found that although her earlier performances of Beatrice had been "captivating" and her deportment was still "easy and graceful," she was "too big and heavy to give any effect to the more gay and sprightly scenes."

# 3

Frances Abington   1737–1815
as Rosalind in *As You Like It*

ARTIST: E. F. Burney

ENGRAVER: J. Thornthwaite

DATE PUBLISHED: 9 November 1785

BELL EDITION: BS85–88.VII

Full-length, standing in a forest, looking to right, with a staff in her right hand; wearing

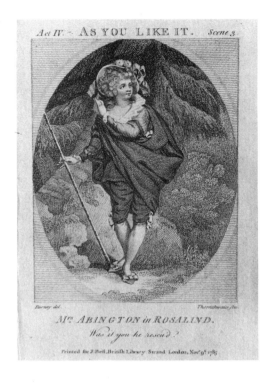

*Act IV. — AS YOU LIKE IT.     Scene 3*

*Burney del.                    Thornthwaite sc.*

*M^{rs} ABINGTON in ROSALIND.*
*Was it you he rescu'd ?*

*Printed for J. Bell, British Library, Strand, London, Nov^r 9^th 1785*

breeches, a large cloak, and a hat with feathers. Line engraving 8.9 × 6.6, for Bell's British Library, with the quotation (IV.3): "Was it you he rescu'd?"

LOCATION OF ORIGINAL: Unknown.

PROVENANCE: Unknown.

RELATED: A copy of the engraving was published by Cawthorn, 1806.

Mrs Abington seems not to have acted Rosalind in London.

# 4

Francis Aickin   d. 1805
as Bolingbroke in *Richard II*

ARTIST: R. Dighton

ENGRAVER: C. Grignion

DATE PUBLISHED: 26 February 1776

BELL EDITION: BS75–78; BET92.VIII

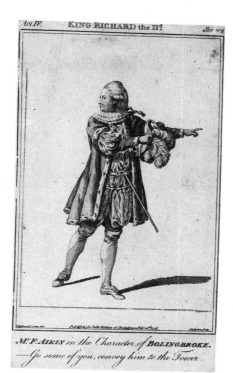

M.<sup>r</sup> F. AIKIN *in the Character of* BOLINGBROKE.
— *Go some of you, convey him to the Tower.*

# 5

James Aickin   ca. 1735–1803
as King Henry in *2 Henry VI*

ARTIST: R. Dighton

ENGRAVER: W. Walker

DATE PUBLISHED: 29 February 1776

BELL EDITION: BS75–78; BET92.VIII

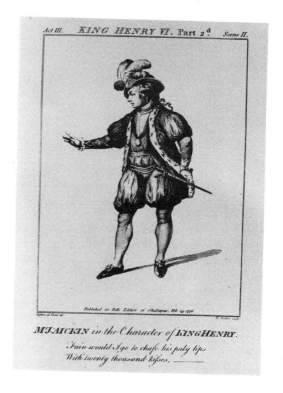

M.<sup>r</sup> AICKIN *in the Character of* KING HENRY.
*Fain would I go to chafe his paly lips*
*With twenty thousand kisses, ———*

Drawing in india ink tinted with watercolors (10.5 × 7.9), full-length to front, profile left, arms extended to right, holding a feathered hat in his right hand, a sword thrust under his belt; wearing hose, breeches, an ermine-trimmed coat, a ruff at his neck, and a short wig. Line engraving 13.7 × 9.2, with the quotation (IV.1): "—Go some of you, convey him to the Tower."

LOCATION OF ORIGINAL: British Museum (Burney I, No. 61).

PROVENANCE: Bell sale, Christie's, 27 March 1793 (lot 42).

RELATED: None.

Francis Aickin did not act Bolingbroke in *Richard II* in London; the play was not performed during his long career there from 1765 to 1792. However, he did play the title role in both parts of *Henry IV*. A portrait in watercolor by William Loftis of Aickin as Henry IV is in the Folger Shakespeare Library.

Drawing, full-length, standing, profile to left, with his right hand extended, and a rapier at his left side; wearing hose, pantaloons, ermine-trimmed coat, and a hat with plumes. Line engraving 12.7 × 8.9, with the quotation (III.2): "Fain would I go to chafe his paly lips / With twenty thousand kisses, ———."

LOCATION OF ORIGINAL: Unknown.

PROVENANCE: Bell sale, Christie's, 27 March 1793 (lot 43).

RELATED: None.

This play was not performed in London during James Aickin's career at Drury Lane Theatre between 1767 and 1800. But Aickin did play Henry VI in Colley Cibber's version of *Richard III*.

# 6

### Robert Baddeley   1733–1794

as Peter in *2 Henry VI*

ARTIST: M. Brown

ENGRAVER: J. Thornthwaite

DATE PUBLISHED: 28 April 1786

BELL EDITION: BS85–88.XIV

A drawing in india ink (8.9 × 6.7), full-length, standing slightly to right, holding mug in his left hand; wearing breeches, waistcoat, and a shirt with a ruff at collar and short sleeves. Drum and stick on floor right. Line engraving 7.09 × 6.7, for Bell's British Library, with Peter's line (II.3): "I have taken my last draught in this world."

LOCATION OF ORIGINAL: British Museum (Burney I, No. 102).

PROVENANCE: Bell sale, Christie's, 27 March 1793 (lot 96).

RELATED: None.

*2 Henry VI* was not performed in London during Baddeley's career.

# 7

### Robert Baddeley   1733–1794

as Trinculo in *The Tempest*

ARTIST: T. Parkinson

ENGRAVER: Anonymous

DATE PUBLISHED: 20 January 1776

BELL EDITION: BS75–78

Colored drawing (11.4 × 8.3), full-length, standing half left, wringing out the tail of his coat, rolled up in both hands; natural shoulder-length hair. Line engraving 14.3 × 8.9.

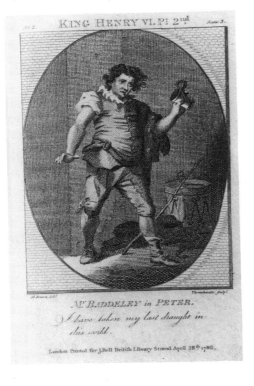

KING HENRY VI. P! 2.ᵈ

M.ʳ BADDELEY in PETER.
*I have taken my last draught in this world.*

London Printed for J. Bell British Library Strand April 28ᵗʰ 1786.

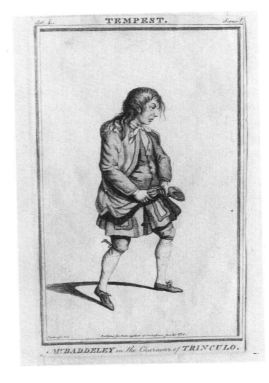

TEMPEST.

M.ʳ BADDELEY in the Character of TRINCULO.

LOCATION OF ORIGINAL: British Museum (Burney I, No. 105).

PROVENANCE: Bell sale, Christie's, 27 March 1793 (lot 36).

RELATED: None.

A drawing in india ink (8.3 × 6.4) by an unknown artist of Baddeley as Trinculo is also in the British Museum (Burney I, No. 107); that portrait was engraved by an anonymous engraver and published by Wenman as a plate to an edition of the play, 1778. Baddeley first acted Trinculo at Drury Lane Theatre on 22 April 1768.

# 8

## Sophia Baddeley   1745?–1786
as Joan la Pucelle in *1 Henry VI*

ARTIST: J. Roberts

ENGRAVER: Anonymous

DATE PUBLISHED: 16 February 1776

BELL EDITION: BS75–78; BET92.XIII

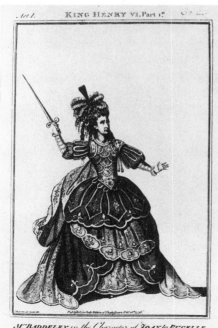

Full-length, standing, brandishing a sword in her upraised right hand; wearing a richly brocaded dress with panniered skirt and a headpiece with plume. Line engraving 14.9 × 9.8, with the quotation (I.2): "I am prepar'd, here is my keen edged Sword."

LOCATION OF ORIGINAL: Unknown.

PROVENANCE: Unknown.

RELATED: None.

*1 Henry VI* was not performed in London during the period of Mrs Baddeley's career.

# 9

## Mrs Barnes   [fl. 1782–1808?]
as Anne Bullen in *Henry VIII*

ARTIST: E. F. Burney

ENGRAVER: J. Thornthwaite

DATE PUBLISHED: 24 June 1786

BELL EDITION: BS85–88.XV

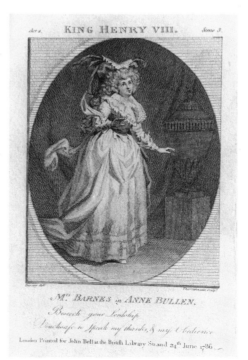

Drawing, full-length, standing in a room, her left hand extended, with curly hair; wearing long dress with ruffled collar, feathers in hat; an urn and drapery behind. Line engraving 8.9 × 7, for Bell's British Library, with Anne's line (II.3): "Beseech your Lordship / Vouchsafe to Speak my thanks, & my Obedience."

LOCATION OF ORIGINAL: Unknown.

PROVENANCE: Bell sale, Christie's, 27 March 1793 (lot 99); bought with other drawings in lot for £1 by Gretton.

RELATED: None.

Mrs Barnes did not act Anne Bullen during her several seasons on the London stage prior to Burney's portrait of her. She made her debut at Covent Garden Theatre as Alicia in *Jane Shore* on 21 January 1782, and after several more performances, she left London for the provinces. She returned to act only one more time in London, as the Old Nun in *'Tis Well It's No Worse* at the Haymarket Theatre on 25 April 1785.

# 10

## Ann Barry  1734–1801
as Constance in *King John*

ARTIST: J. Roberts

ENGRAVER: Anonymous

DATE PUBLISHED: 26 December 1775

BELL EDITION: BS75–78; BET92.XII

Full-length, standing, profile right, her right arm raised at her head, clutching headdress, her left arm extended to her left; wearing a pearl necklace and a decorated panniered dress with train. Line engraving 15.6 × 10.2, with the quotation (III.4): "I will not keep this form upon my head, / when there is such disorder in my wit."

LOCATION OF ORIGINAL: Unknown.

PROVENANCE: Bell sale, Christie's, 27 March 1793 (lot 36).

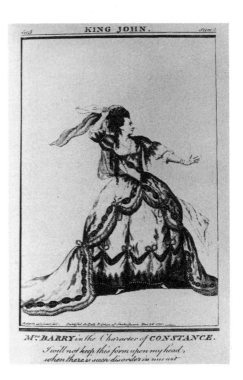

RELATED: None.

Mrs Barry first acted Constance at Drury Lane Theatre on 2 February 1774, and the prompter Hopkins wrote in his diary that she "was not so well in Constance as expected." But it eventually became one of her powerful roles. According to James Boaden, when Mrs Barry made her "terrific exit" at the end of the third act, lamenting the loss of her son, she frequently "paralysed a crowded theatre—actually depriving the audience of the power of applauding."

# 11

## Spranger Barry  1717?–1777
as Timon in *Timon of Athens*

ARTIST: J. Roberts

ENGRAVER: W. Walker

DATE PUBLISHED: 1 February 1776

BELL EDITION: BS75–78

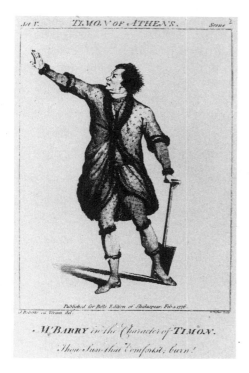

Full-length, standing to left, right arm raised, holding a spade in his left hand; wearing a spotted fur-trimmed coat and breeches. Line engraving 12.7 × 8.9, with the quotation (V.1): "Thou Sun that Comfort'st, burn!"

LOCATION OF ORIGINAL: Unknown.

PROVENANCE: Unknown.

RELATED: None.

Barry first acted Timon (in Richard Cumberland's alteration) in London on 4 December 1771, at Drury Lane Theatre. Mrs Barry played Evanthe in that performance. One of the leading actors of his day, Barry was especially effective in scenes of love and tenderness and in what one commentator called "the blended passages of rage and affection."

# 12

Jane Barsanti   d. 1795
as Helena in *A Midsummer Night's Dream*

ARTIST: J. Roberts

ENGRAVER: C. Grignion

DATE PUBLISHED: 1 March 1776

BELL EDITION: BS75–78; BET 92.XIII

Colored drawing (13 × 8.1), full-length, standing, profile to right, her right hand extended, plumes in her hair; wearing an eighteenth-century dress with decorated panniered skirt and overskirt and long train. Line engraving 13.7 × 9.5, with the line (III.2): "And will you rent our ancient love asunder? / to join with Men in scorning your poor Friend?"

LOCATION OF ORIGINAL: British Museum (Burney I, No. 190).

PROVENANCE: Unknown.

RELATED: None.

Jane Barsanti did not act Helena in London.

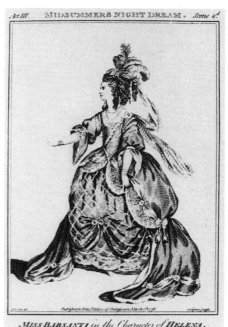

# 13

Robert Bensley   1742–1817
as Iago in *Othello*

ARTIST: J. Roberts

ENGRAVER: C. Grignion

DATE PUBLISHED: 15 November 1775

BELL EDITION: BS75–78

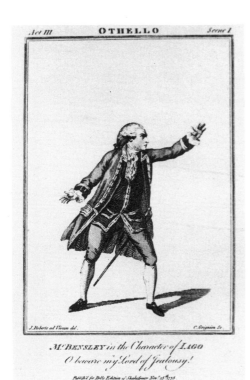

Full-length, standing, looking upward to right, arms extended in gesture; wearing a contemporary coat, waistcoat, and breeches, with tiewig, and a sword at his left side. Line engraving 13.3 × 8.9, with the quotation (III.1): "O beware my Lord of Jealousy!"

LOCATION OF ORIGINAL: Unknown.

PROVENANCE: Unknown.

RELATED: None.

Bensley acted Iago for his first time in London on 28 January 1771, at Covent Garden Theatre. During his thirty-one years on the London stage, Bensley acted more than fifty roles. He was not a distinguished actor, but according to Willam Hawkins in *Miscellanies in Prose and Verse* (1775), though he added little to the science of acting, "the cast of parts he is in receipt with, somewhat entitles him to a place among the principal performers."

# 14

William Brereton   1751–1787
as Troilus in *Troilus and Cressida*

ARTIST: Dighton

ENGRAVER: Anonymous (Dighton?)

DATE PUBLISHED: 1 February 1776

BELL EDITION: BS75–78; BET92.XII

Drawing, india ink, tinted with watercolor (12.9 × 9.2), full-lenth, standing, his right arm

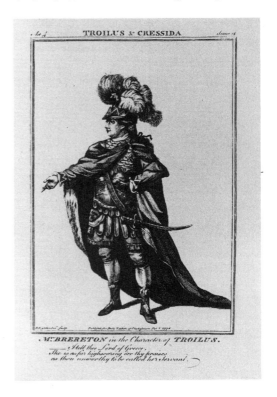

extended, his left hand on hip; wearing a helmet with large feathers, breast armor, and a long cloak. Line engraving 14.6 × 9.5, with the quotation (IV.4): "—I tell thee Lord of Greece, / She is as far high-soaring o'er thy praises / as thou unworthy to be called her Servant."

LOCATION OF ORIGINAL: British Museum (Burney II, No. 45).

PROVENANCE: Bell sale, Christie's 27 March 1793 (lot 41).

RELATED: None.

Brereton did not act Troilus in London. The play was not performed there during the last half of the eighteenth century.

# 15

## Anne Brunton　1769–1808
as Cordelia in *King Lear*

ARTIST: E. F. Burney

ENGRAVER: J. Thornthwaite

DATE PUBLISHED: 29 September 1785

BELL EDITION: BS85–88.XVII

Full-length, standing outdoors before tent, looking upward, arms extended in gesture; wearing a long dress with sash at waist and a feathered headpiece. Line engraving 9.2 × 6.7, with Cordelia's line (IV.4): "O dear Father / it is thy business that I go about."

LOCATION OF ORIGINAL: Unknown.

PROVENANCE: Unknown.

RELATED: A copy (line 8.9 × 7) was engraved by E. Scriven and published as a plate to Cawthorn's *Minor British Theatre* (1806).

Miss Brunton first acted Cordelia at Covent Garden Theatre on 6 March 1786. She was also pictured in this role in an engraving by T. Cook, published by W. Bent, 1785.

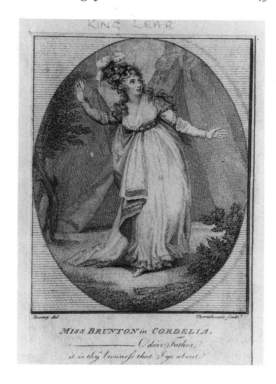

MISS BRUNTON in CORDELIA.
——— O dear Father,
it is thy business that I go about.

# 16

## Mary Bulkley　1748–1792
as Mrs Ford in *The Merry Wives of Windsor*

ARTIST: J. Roberts

ENGRAVER: Anonymous

DATE PUBLISHED: 1 February 1776

BELL EDITION: BS75–78

Full-length, standing, profile left, arms crossed in front at waist; wearing a dress with an apron and a hat with a small plume. Line engraving 14.6 × 9.5, with the quotation (III.3): "I your Lady Sir John? alas I would be a pitiful Lady."

LOCATION OF ORIGINAL: Unknown.

PROVENANCE: Unknown.

RELATED: None.

Mary Bulkley did not act this role in London. She did act Mrs Page in this play on

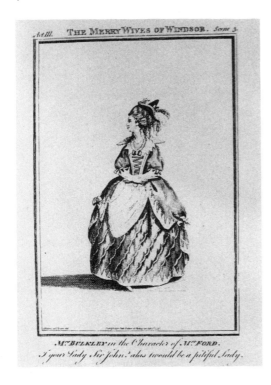

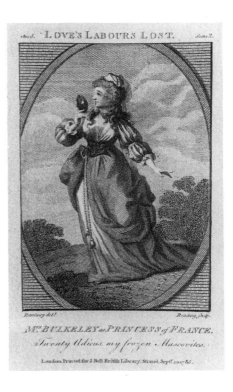

22 December 1789 at Covent Garden Theatre.

# 17

Mary Bulkley   1748–1792
as Princess of France in *Love's Labour's Lost*

ARTIST: J. H. Ramberg

ENGRAVER: J. Thornthwaite

DATE PUBLISHED: 20 September 1785

BELL EDITION: BS85–88.VI

Drawing (11.7 × 7.6) india ink, with wash and pen slightly tinted, full-length, standing in a wooded landscape, holding mask in upraised hand, her left hand extended down to side; wearing a long dress with cord belt. Line engraving 9.5 × 6.4, for Bell's British Library, with the Princess's line (V.2): "Twenty Adieus my frozen Muscovites."

LOCATION OF ORIGINAL: British Museum (Burney II, No. 67).

PROVENANCE: Bell sale, Christie's, 27 March 1793 (lot 87).

RELATED: The same picture in an engraving (line 8.1 × 6.4) by B. Reading, after Ramberg, was also published on the same date for Bell's British Library.

This play was not performed in London during Mary Bulkley's career.

# 18

Matthew Clarke   d. 1786
as Henry VIII in *Henry VIII*

ARTIST: J. Roberts

ENGRAVER: C. Grignion

DATE PUBLISHED: 1 January 1776

BELL EDITION: BS75–78

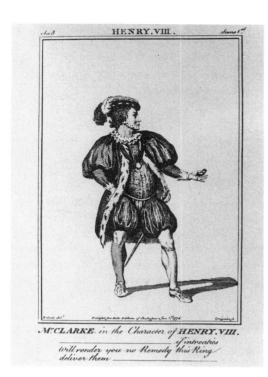

Full-length, standing, right hand on hip, holding a ring in his extended left hand; wearing hose, pantaloons, an ermine-trimmed coat, and a flat hat with feathers. Line engraving 13.7 × 9.5, with the quotation (III. 1): "—if intreaties / will render you no Remedy this Ring / deliver them—."

LOCATION OF ORIGINAL: Unknown.

PROVENANCE: Unknown.

RELATED: None.

Clarke first acted Henry VIII in London on 6 November 1772, at Covent Garden Theatre. An anonymous engraving of him in this role was published by J. Wenman, 1778. Clarke was a mainstay at Covent Garden for more than thirty years, acting an extensive line of secondary characters. A Bristol critic wrote, "He was very respectable both in appearance and performance, seldom out of his latitude; and if he never mounted to a great height, he never sank below a proper level."

# 19

## Anna Maria Crouch 1763–1805
### as Miranda in *The Tempest*

ARTIST: J. H. Ramberg

ENGRAVER: C. Sherwin and C. Grignion

DATE PUBLISHED: 21 January 1785

BELL EDITION: BS85–88.III

Drawing, sepia and indigo wash and pen (12 × 5.4), full-length, standing on rocks by the sea, her left arm stretched out, her right hand at her right side holding the end of a long veil; wearing a long dress with a sash at waist. Line engraving 9.5 × 6.4, called "Miss Phillips," for Bell's British Library, with Miranda's line: "O! the cry did knock against my very heart. Poor souls! they perish'd." The engraving states the scene as I.1, but it is I.2 in Shakespeare's version.

LOCATION OF ORIGINAL: British Museum (Burney III, No. 25).

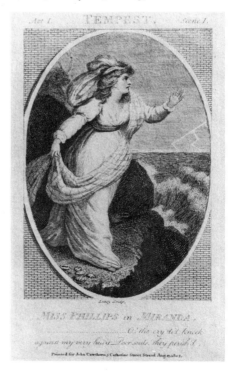

PROVENANCE: Bell sale, Christie's, 27 March 1793 (lot 76); bought, with other drawings in lot, for £2 by Gretton.

RELATED: A copy engraved by Leney was published for Cawthorn, 25 August 1805.

When Miss Phillips, Anna Maria acted Miranda for the first time at Drury Lane Theatre on 13 November 1781. A picture by Thomas Stothard of a scene from *The Tempest*, with Mrs Crouch as Miranda and Robert Palmer as Prospero, sold at Sotheby's on 20 July 1983 (lot 43) for £495.

# 20

## Margaret Cuyler   1758–1814
### as Cressida in *Troilus and Cressida*

ARTIST: E. F. Burney

ENGRAVER: J. Thornthwaite

DATE PUBLISHED: 18 October 1785

BELL EDITION: BS85–88.XIX

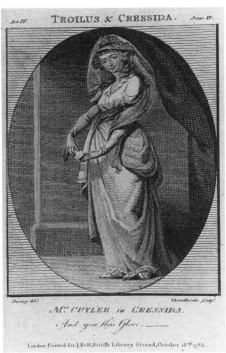

Drawing, full-length, standing, holding a glove in both hands extended down in front of her; wearing a long dress and a hat with a veil. Line engraving 9.2 × 9.5, for Bell's British Library, with Cressida's line (IV.4): "And you this Glove—."

LOCATION OF ORIGINAL: Unknown.

PROVENANCE: Bell sale, Christie's, 27 March 1793 (lot 89).

RELATED: None.

Margaret Cuyler did not act Cressida on the London stage; that play was not performed in London during the last half of the eighteenth century. Between 1777 and 1809, Margaret Cuyler appeared regularly in London, mainly at Drury Lane Theatre. Her line was elegant young ladies in farces and light comedies.

# 21

## James William Dodd   1740?–1796
### as Sir Andrew Aguecheek in *Twelfth Night*

ARTIST: J. H. Ramberg

ENGRAVER: Not Engraved

DATE PUBLISHED: Not Published

Description unknown.

LOCATION OF ORIGINAL: Unknown.

PROVENANCE: Bell sale, Christie's, 27 March 1793 (lot 86), bought for 12s. by Smith.

RELATED: None.

This portrait seems not to have been engraved for publication and is known only by its listing in the Bell sale catalog. In the same lot in the Christie sale was a portrait of Elizabeth Farren as Olivia. Dodd is shown as Sir Andrew Aguecheek in a painting by Francis Wheatley of a scene from *Twelfth Night*, with Elizabeth Younge (Mrs Pope) as Viola, James Love as Toby Belch, and Francis Waldron as Fabian. That painting is in the

Manchester City Art Galleries; an engraving by J. R. Smith was published in 1774.

Dodd first acted this role at Drury Lane Theatre on 10 December 1771, and, as one of his best parts, he played it very often during his career. "What an Aguecheek the stage lost in him!" wrote Charles Lamb after Dodd died:

> In expressing slowness of apprehension this actor surpassed all others. You could see the first dawn of an idea stealing slowly over his countenance, climbing up by little and little with a painful process, till it cleared up at last to the fulness of a twilight conception, its highest meridian. He seemed to keep back his intellect as some have power to retard their pulsation.

# 22

## James William Dodd   1740?–1796
as Mercutio in *Romeo and Juliet*

ARTIST: T. Parkinson

ENGRAVER: C. Grignion

DATE PUBLISHED: 24 November 1775

BELL EDITION: BS75–78

Full-length, standing, arms extended to left; wearing tricorn, contemporary breeches, waistcoat, and coat, with a sword at left side. Line engraving 13.7 × 8.6, with the quotation: "See where he steals—."

LOCATION OF ORIGINAL: Unknown.

PROVENANCE: Unknown.

RELATED: None.

Dodd acted Mercutio for the first time at Drury Lane Theatre on 18 May 1767. This dashing and attractive character was not in Dodd's main line. But he was still playing that part at the end of his career, at the age of about fifty-six. The *Monthly Mirror* for May 1796 reported of his performance on the twentieth of that month: "Poor Dodd tottered through 'the young Mercutio' as well as his

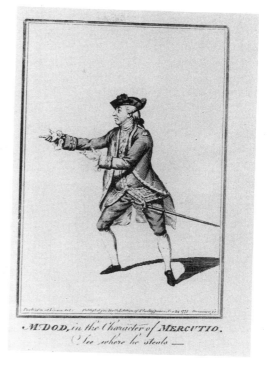

*Mr. DOD, in the Character of MERCUTIO.*
(*See where he steals* —

age and corpulency would permit him." Dodd died several months later, on 17 December 1796.

# 23

## John Dunstall   1717–1778
as Syracusan Dromio in *The Comedy of Errors*

ARTIST: T. Parkinson

ENGRAVER: C. Grignion

DATE PUBLISHED: 19 February 1776

BELL EDITION: BS75–78; BET92.IV

Drawing in india ink and watercolor tint (11.4 × 8.3), full-length, standing to front, holding a rope in his extended right hand; wearing breeches, coat buttoned up front, with some gaudy decoration, and a helmet-shaped hat. Line engraving 14.3 × 9.8.

LOCATION OF ORIGINAL: British Museum (Burney III, No. 135).

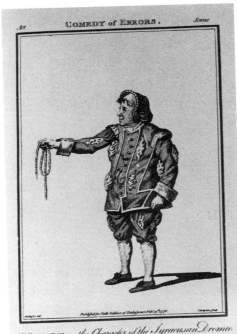

hot enough to purchase your Spice." The engraving states the scene is IV.3 (Colman's adaptation), but the line in Shakespeare's version is in IV.2.

LOCATION OF ORIGINAL: Unknown.

PROVENANCE: Unknown.

RELATED: A copy was engraved by Woodman and published by Cawthorn, 19 July 1806.

Edwin first acted the role of Autolicus on 18 July 1777 at the Haymarket Theatre, in a performance of George Colman's adaptation of *The Winter's Tale*, called *The Sheep-Shearing*. For a number of seasons between 1776 and 1790, Edwin was a leading comedian on the London stage. Colman called him "the best burletta singer that the theatre had ever seen," and in his *Retrospections* John Bernard acclaimed him "the most original actor . . . in the old world or the new."

PROVENANCE: Unknown.

RELATED: None.

Dunstall first acted in *The Comedy of Errors*, in Hull's adaptation called *The Twins*, on 24 April 1762 at Covent Garden Theatre.

# 24

## John Edwin the Elder   1749–1790
as Autolicus in *The Winter's Tale*

ARTIST: J. H. Ramberg

ENGRAVER: C. Grignion

DATE PUBLISHED: 8 January 1785

BELL EDITION: BS85–88.IX

Full-length, standing in a wooded landscape with a picket fence behind, holding up a purse in left hand, right hand on hip; wearing rustic clothing. Line engraving 9.5 × 6.4, for Bell's British Library, with Autolicus's line: "Prosper you, Sweet Sir!—your Purse is not

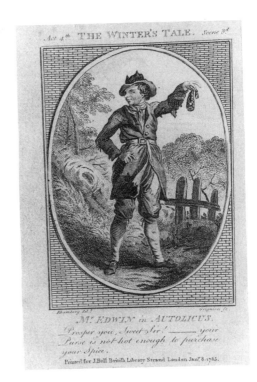

# 25

SITTER: Elizabeth Farren 1762–1829
as Hermia in *A Midsummer Night's Dream*

ARTIST: J. H. Ramberg

ENGRAVER: S. Newnham

DATE PUBLISHED: 5 August 1785

BELL EDITION: BS85–88.VI

Full-length, seated on a mound in the forest, starting from sleep; wearing a long dress with a sash at the waist and a long train of fabric hanging down from the back of her head. Line engraving 9.2 × 6.7, for Bell's British Library, with the quotation (II.3): "Help me Lysander. Help me! do thy best, / To pluck this crawling Serpent from my Breast."

LOCATION OF ORIGINAL: Unknown.

PROVENANCE: Unknown.

OTHER VERSIONS: The same picture was engraved by W. Leney and published by Cawthorn, 1805.

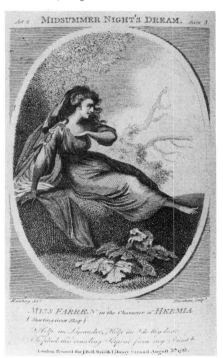

Elizabeth Farren did not act this role in London. Shakespeare's play was not performed there during her career, and she did not appear in Colman's adaptation, *The Fairy Tale*.

# 26

Elizabeth Farren 1762–1829
as Olivia in *Twelfth Night*

ARTIST: J. H. Ramberg

ENGRAVER: C. Grignion and F. Bartolozzi

DATE PUBLISHED: 20 August 1785

BELL EDITION: Issued Separately

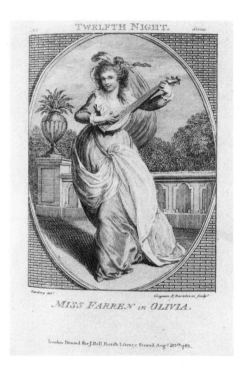

Full-length, standing to front on a terrace with balustrade and trees behind, playing lute; wearing a long flowing dress and a small hat with feathers. Line engraving 8.9 × 6.7, "Printed for J. Bell. British Library. Strand Aug. 20th 1785."

LOCATION OF ORIGINAL: Unknown.

PROVENANCE: Bell sale, Christie's, 27 March 1793 (lot 86).

RELATED: A copy was engraved (line 8.9 × 6.7) by Scriven.

Also see No. 27.

# 27

## Elizabeth Farren   1762–1829
as Olivia in *Twelfth Night*

ARTIST: E. F. Burney

ENGRAVER: J. Thornthwaite

DATE PUBLISHED: 10 September 1785

BELL EDITION: BS85–88.IX

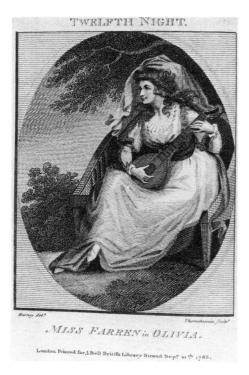

India ink and wash drawing (8.9 × 7); full-length, seated in a wood, playing a lute; wearing a lace veil over her head and a long dress with voluminous skirt. Line engraving 9.2 × 7, "Printed for J. Bell British Library Sep$^r$ 10$^{th}$ 1785."

LOCATION OF ORIGINAL: British Museum (Burney III, No. 213).

PROVENANCE: Bell sale, Christie's, 27 March 1793 (lot 86).

RELATED: See No. 26.

In the engraved version, Elizabeth Farren wears a different dress and hairstyle. She first acted this role on 20 May 1780 at Drury Lane Theatre. Elizabeth Farren became a favorite in the roles of popular heroines. Hazlitt wrote that she possessed "fine-lady airs and grace, with that elegant turn of her head and motion of her fan and tripping of her tongue."

# 28

## Mary Farren (Mrs William Farren) 1748–1820
as the Queen in *Richard III*

ARTIST: E. F. Burney

ENGRAVER: J. Thornthwaite

DATE PUBLISHED: 7 July 1786

BELL EDITION: BS85–88.XI

Drawing, full-length, standing, right hand extended, handkerchief in left hand, wearing a dress with a large skirt and white bodice, with a veil on top of her head; a woodland scene behind. Line engraving 8.1 × 7.

LOCATION OF ORIGINAL: Unknown.

PROVENANCE: Bell sale, Christie's, 27 March 1793 (lot 100); bought for £1 by Gretton.

RELATED: None.

The sitter has usually been identified as Elizabeth Farren (as in the *BDA*), but her name does not appear in the bills for acting this role. The bills do show that *Mrs* Farren, another actress, of Drury Lane Theatre, went over to Covent Garden Theatre on 7 December 1778 to act this role. And the engraving caption specifies "Mrs Farren." More-

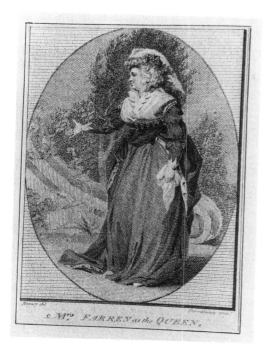

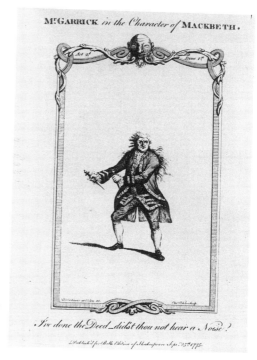

over, the face and figure do not resemble the lovely Elizabeth Farren in the least.

# 29

## David Garrick 1717–1779
as Macbeth in *Macbeth*

ARTIST: T. Parkinson

ENGRAVER: C. White

DATE PUBLISHED: 25 September 1775

BELL EDITION: BS75–78

Full-length, standing to left, face to front, daggers in both hands extended to his right, legs spread; wearing breeches, long waistcoat, long coat, and short wig. Line engraving 14.9 × 8.6, with the quotation (II.1): "I've done the Deed—did'st thou not hear a Noise?"

LOCATION OF ORIGINAL: Unknown.

PROVENANCE: In the sale of Bell's collection of drawings at Christie's on 27 March 1793 were three drawings of scenes from

*Macbeth* (lot 32), credited to Edwards. One of them was said to be of Garrick as Macbeth.

RELATED: A copy by an anonymous engraver was published on 18 January 1776. Possibly Edwards's drawing was the original (after Parkinson) that was used for this second engraving.

For other pictures of Garrick as Macbeth, see the *BDA*. Garrick first acted Macbeth (in his restoration, in the main, of Shakespeare's text) on 7 January 1744, at Drury Lane Theatre. It remained one of his greatest portrayals.

# 30

## Elizabeth Hartley 1750?–1824
as Hermione in *The Winter's Tale*

ARTIST: J. Roberts

ENGRAVER: C. Grignion

DATE PUBLISHED: 10 October 1775

BELL EDITION: BS75–78

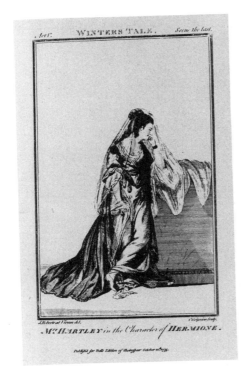

Full-length, standing, right profile, her left elbow resting on a pedestal at right, her hand supporting her chin; wearing a long dress with a cloak and a transparent shawl trailing from the back of her head. Line engraving 12.7 × 7.9. "Published for the Bell Edition of Shakespeare October 10ᵗʰ 1775."

LOCATION OF ORIGINAL: Unknown.

PROVENANCE: Unknown.

RELATED: None.

Mrs Hartley acted Hermione only once, at Covent Garden Theatre on 12 March 1774. William Hawkins in *Miscellanies in Prose and Verse* (1775) described her as "the finest figure on the London stage." During the 1770s, the press was full of tributes to her stunning beauty. In October 1777, a critic in the *London Magazine* proclaimed that "this lady's figure seems to have been moulded by the hand of Harmony itself. . . . In a word, taking her altogether, she gives the idea of a Greek beauty." A portrait of her as Hermione (204.2 × 130.8)

by Angelica Kauffmann is in the Garrick Club (Ash291, CKA438); it was bought by Mathews in the Harris sale (lot 49) at Robins on 12 July 1819. Another portrait of her in this character by an anonymous engraver (13.3 × 8.3) was published by Fielding & Walker, 1780.

# 31

## John Henderson   1747–1785
as Falstaff in *The Merry Wives of Windsor*

ARTIST: J. H. Ramberg

ENGRAVER: C. Grignion

DATE PUBLISHED: 12 January 1784

BELL EDITION: BS85–88.IV

Colored drawing (9.2 × 6.4); full-length, standing to front, holding paper in right hand, left hand on heart, with a cane hanging from left wrist; wearing a tunic over his

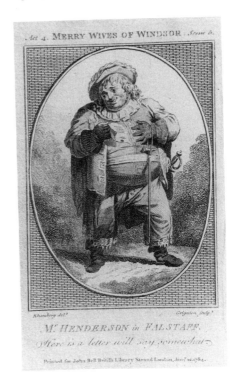

padded stomach, a short jacket, trousers with fringes at bottom, a ruff, gauntlets, and a floppy hat, with a sword at left side. Line engraving 9.8 × 6.7, for Bell's British Library, with quotation (IV.5): "Here is a letter will say somewhat" (Mistress Quickly's line).

LOCATION OF ORIGINAL: British Museum (Burney IV, No. 200).

PROVENANCE: Bell sale, Christie's, 27 March 1793 (lot 88).

RELATED: None, but see No. 189.

For other portraits of Henderson as Falstaff, see the *BDA*. Henderson acted Falstaff in *The Merry Wives of Windsor* for the first time on 11 September 1775 at Bath. He acted that character in *1 Henry IV* for the first time in London on 24 July 1777 and in *The Merry Wives of Windsor* on 3 September 1777, both at the Haymarket Theatre. Henderson's portrayal of Falstaff was described by James Boaden:

> Henderson stands before me with the muster of his recruits legible in his eye, and I hear the fat and chuffy tones by which he added humour to the ludicrous terms of the poet's description. . . . The bursts of laughter he excited by this, which he did not hurry, but seemed mentally to enjoy, as the images rose in succession, were beyond measure delightful. He made his audience for the time as intelligent as himself.

# 32

## John Henderson   1747–1785
as Iago in *Othello*

ARTIST: J. H. Ramberg

ENGRAVER: J. Thornthwaite

DATE PUBLISHED: 24 November 1785

BELL EDITION: BS85–88.XIX

Full-length, standing, right arm across chest, right forefinger pointing over left shoulder; wearing long coat, breeches, and cloak; the walls at the corner of a room are behind.

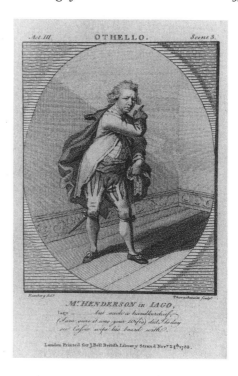

Line engraving 9.2 × 7, for Bell's British Library, with Iago's lines (III.3): "—but such a handkerchief, / (I am sure it was your wife's) did I today / see Cassio wipe his beard with." A copy (8.9 × 7), engraved by Scriven, was also published on 28 February 1786.

LOCATION OF ORIGINAL: Unknown.

PROVENANCE: Unknown.

RELATED: See No. 33.

Henderson first acted Iago in London on 10 November 1780, at Covent Garden Theatre. "In the prominent display of Iago's jealousy," wrote one critic, "Henderson's claim to praise is quite unrivalled."

# 33

## John Henderson   1747–1785
as Iago in *Othello*

ARTIST: Gilbert Stuart

ENGRAVER: F. Bartolozzi

DATE PUBLISHED: 1786

BELL EDITION: Published Separately

Canvas, half-length, 51.4 × 41.9, turned right, facing front; wearing cloak, unfinished. Engraving 11.45 × 9.52.

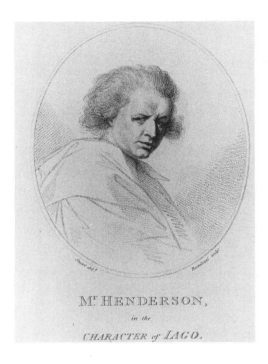

Mr HENDERSON,

*in the*

CHARACTER *of* IAGO.

LOCATION OF ORIGINAL: Theatre Museum, London.

PROVENANCE: Probably the Theatre Museum picture is the portrait by Stuart of Henderson as Iago that was originally in the *Mathews Catalogue* (No. 144) but did not find its way to the Garrick Club. It had come to the Victoria and Albert Museum from the Dyce Bequest in 1869. Earlier it was sold by John Ireland at King's 6 March 1810 and bought by Field. An engraving of the Stuart was done by Bartolozzi and published by Bell in 1786, but not as part of *Bell's Shakespeare*; another state was published by Baldwyn; a third state is in the Harvard Theatre Collec-

tion, without line of publication; and another engraving, by W. Read, after Stuart, was published as a plate to *Dramatic Table Talk*.

RELATED: None.

For other portraits of Henderson as Iago, see the *BDA*.

# 34

## Joseph George Holman   1764–1817
as Faulconbridge in *King John*

ARTIST: M. Brown (after G. Stuart)

ENGRAVER: J. Thornthwaite

DATE PUBLISHED: 4 June 1786

BELL EDITION: BS85–88.X

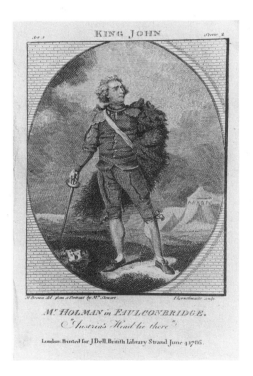

KING JOHN

Mr HOLMAN in FAULCONBRIDGE.
"Austria's Head lie there"

London. Printed for J Bell. British Library Strand June 4 1786.

Full-length, standing, looking to right, drawn sword in right hand, Austria's decapitated head at his feet; wearing breeches, a short

jacket, and a lion skin; encampment in background. Line engraving 9.2 × 7, for Bell's British Library, with Faulconbridge's line (III.2): "Austria's Head lie there."

LOCATION OF ORIGINAL: Unknown.

PROVENANCE: Bell sale, Christie's, 27 March 1793 (lot 98), bought for £1 by Gretton; Bell sale, 23 May 1805 (lot 258). The original portrait by Gilbert Stuart was included in the *Mathews Catalogue* (No. 145) but is not located at the Garrick Club.

RELATED: A copy (8.9 × 7) engraved by R. Woodman was published by Cawthorn, 1806.

The Thornthwaite engraving states after M. Brown, "from a Portrait by Mr. Stewart [Gilbert Stuart]." Holman seems not to have acted this role in London.

# 35

## Elizabeth Hopkins (Mrs William Hopkins) 1731–1801

as Volumnia in *Coriolanus*

ARTIST: J. Roberts

ENGRAVER: C. Grignion

DATE PUBLISHED: 12 February 1776

BELL EDITION: BS75–78

Drawing, full-length, kneeling on her left knee to her right, her right arm extended; wearing a plumed headpiece and a long loose-fitting dress with a long train down the back. Line engraving 13.7 × 9.5, with the quotation (V.6): "—he turns away! / Down Ladies, let us shame him with our Knees."

LOCATION OF ORIGINAL: Unknown.

PROVENANCE: Bell sale, Christie's, 27 March 1793 (lot 39); bought, with other drawings in lot, for £1 1s. by North.

RELATED: A pencil drawing by Roberts in the Harvard Theatre Collection, which

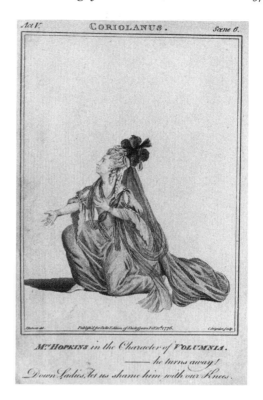

Mrs HOPKINS in the Character of VOLUMNIA.
—— he turns away!
Down Ladies, let us shame him with our Knees.

shows only Mrs Hopkins's head, seems to be a study for the portrait.

Mrs Hopkins seems not to have acted Volumnia in London.

# 36

## Priscilla Hopkins (Later Mrs John Philip Kemble) 1758–1854

as Lavinia in *Titus Andronicus*

ARTIST: J. Roberts

ENGRAVER: Anonymous

DATE PUBLISHED: 6 March 1776

BELL EDITION: BS75–78; BET92.IX

Full-length, standing to front, turned right, holding a bow in her left hand; wearing eighteenth-century dress, with feathers in hair.

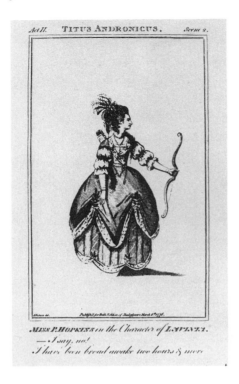

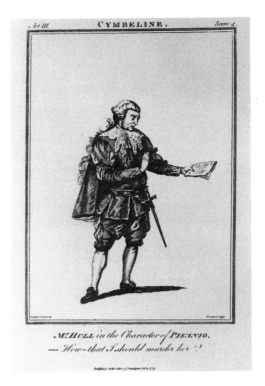

Line engraving 14 × 8.3, with the quotation (II.2): "—I say no! / I have been broad awake two hours & more."

LOCATION OF ORIGINAL: Unknown.

PROVENANCE: Unknown.

RELATED: None.

Priscilla Hopkins did not act Lavinia in London.

# 37

Thomas Hull   1728–1808
as Pisanio in *Cymbeline*

ARTIST: T. Parkinson

ENGRAVER: C. Grignion

DATE PUBLISHED: 11 October 1775

BELL EDITION: BS75–78

India ink and watercolor tint drawing (10.2 × 7); full-length, holding a letter in left hand;

wearing hose, breeches, long waistcoat, and short cloak, with a sword hanging from a belt at his waist. Line engraving 13.3 × 9.8, with the quotation (III.4): "—How—that I should murder her?"

LOCATION OF ORIGINAL: British Museum (Burney V, No. 8).

PROVENANCE: Unknown.

RELATED: None.

Hull first acted Pisanio at Covent Garden Theatre on 28 December 1767.

# 38

Maria Hunter   [fl. 1774–1779]
as Lady Anne in *Richard III*

ARTIST: J. H. Ramberg

ENGRAVER: Anonymous

DATE PUBLISHED: 31 December 1785

BELL EDITION: Issued Separately

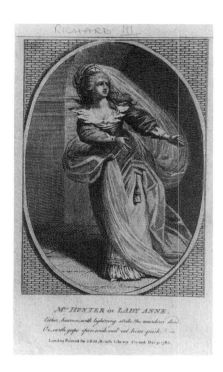

The engraving with the British Library copy of BS85–88.XIV is of J. P. Kemble as Richard III.

# 39

## Elizabeth Inchbald   1753–1821
as Lady Abbess in *The Comedy of Errors*

ARTIST: J. H. Ramberg

ENGRAVER: C. Sherwin

DATE PUBLISHED: 25 April 1785

BELL EDITION: BS85–88.V

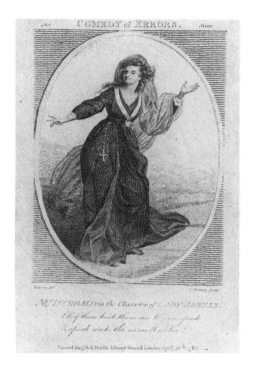

Watercolor drawing (25.4 × 17.1), full-length, standing in front of an arch, body twisted to right, left arm extended right; wearing a long dress with train and a headpiece with a long scarf down back. Line engraving 9.5 × 6.4, "J. Bell, British Library, Strand Dec 31 1785," with the line quotation (I.2): "Either heaven with lightning strike the murderer dead. / Or earth gape open wide, and eat him quick."

LOCATION OF ORIGINAL: Harvard Theatre Collection.

PROVENANCE: Bell sale, Christie's, 27 March 1797 (lot 97); bought, with other drawings, for £1 by Gretton. With Thomas Agnew in 1976.

RELATED: None.

Maria Hunter made her debut at Covent Garden Theatre on 21 October 1774 as Mrs Oakly in *The Jealous Wife*. She first acted the Queen in *Richard III* on 1 January 1776, but she seems not to have played Lady Anne in London.

Drawing, full-length, standing, face slightly left, right arm extended right, left hand raised left; wearing a long dress with train, a veil hanging from the back of head, and a crucifix on chain hanging from waist. Line engraving 8.9 × 6.4, for Bell's British Library, with the Abbess's line (V.1): "O, if thou be'st the same Aegeon, speak, / speak unto the same Amelia!"

LOCATION OF ORIGINAL: Unknown.

PROVENANCE: Bell sale, Christie's, 27 March 1793 (lot 91).

RELATED: A copy, after Ramberg, engraved by E. Scriven, was printed for Cawthorn, 1806.

An engraving by Wooding of Mrs Inchbald as the Lady Abbess was published as a plate to *New Lady's Magazine* (1786). Elizabeth Inchbald first acted the Lady Abbess on 18 January 1781 at Covent Garden Theatre. She had made her debut there on 3 October 1780, as Bellario in *Philaster*. After 1788–89, she left the stage and turned to writing novels, plays, and critical essays. A woman of exceptional beauty but handicapped in speech, Mrs Inchbald "carried herself further as an actress than she herself expected" (*BDA*).

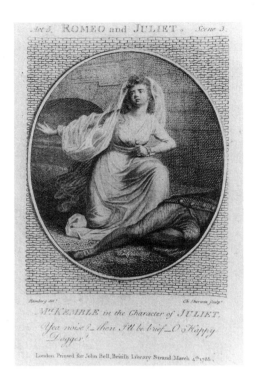

# 40

## Elizabeth Kemble (Mrs Stephen Kemble)   1762?–1841
as Juliet in *Romeo and Juliet*

ARTIST: J. H. Ramberg

ENGRAVER: C. Sherwin

DATE PUBLISHED: 4 March 1785

BELL EDITION: BS85–88.XX

Drawing, full-length, kneeling beside the prostrate Romeo, and thrusting a dagger into her breast; a scarf extends from her head to her right hand, which is thrust out to her right. Line engraving 8.6 × 6.4, for Bell's British Library, with the Juliet's line (V.3): "Yea noise?—then I'll be brief—O Happy Dagger!"

LOCATION OF ORIGINAL: Unknown.

PROVENANCE: Bell sale, Christie's, 27 March 1793 (lot 81); bought, with other drawings in lot, for £1 1s. by North.

RELATED: None.

When Elizabeth Kemble first acted Juliet at Covent Garden Theatre on 22 September 1783 and then again on 27 October, she was still Miss Satchell. She married Stephen Kemble on 20 November 1783. When she acted Juliet again on 19 January 1784, her name appeared in the bills as Mrs Kemble. Though her early performances in London did not impress the critics, eventually she was praised for such things as the "elegance of her figure and the genuine simplicity of her demeanour." She became warmly regarded at Edinburgh, where she acted some one hundred fifty roles between 1792 and 1800 and co-managed with her husband.

# 41

## John Philip Kemble   1757–1823
as Hamlet in *Hamlet*

ARTIST: J. H. Ramberg

ENGRAVER: T. Cook

DATE PUBLISHED: 20 March 1785

BELL EDITION: BS85–88.XVIII

Full-length, standing in a room, with a sword in his right hand; dressed in Hamlet black;

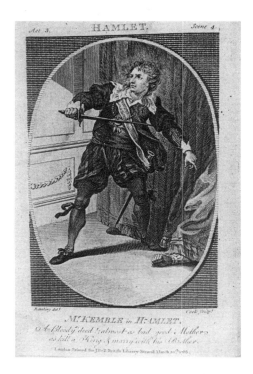

the hand of dead Polonius is seen under the curtain at right. Line engraving 9.5 × 6.4, for Bell's British Library, with the quotation (III.4): "A Bloody deed! almost as bad good Mother as kill a King & marry with his Brother."

LOCATION OF ORIGINAL: Unknown.

PROVENANCE: Unknown.

RELATED: None.

This portrait was inadvertently omitted from the iconography of J. P. Kemble in the *BDA*. For other portraits of him as Hamlet, see that iconography.

Kemble made his London debut as Hamlet on 30 September 1783 at Drury Lane Theatre. It was a "great" event, as one critic put it, and

the actor Thomas Davies claimed he had never seen an audience more moved. Though William Hazlitt wrote that Kemble played Hamlet "like a man in armour," he was describing Kemble toward the end of his career. His earlier performances of the character were powerful and marked by intensity and outbursts of passion.

# 42

### John Philip Kemble  1757–1823
as Richard III in *Richard III*

ARTIST: M. Brown (after G. Stuart)

ENGRAVER: J. Thornthwaite

DATE PUBLISHED: 10 May 1786

BELL EDITION: BS85–88.XIV

Drawing, full-length, standing to left before a castle, a finger on his right hand pointing up, plumed hat on ground; wearing breeches and a long cape and a sword at his left side. Line engraving 8.9 × 6.7, with Richard's line

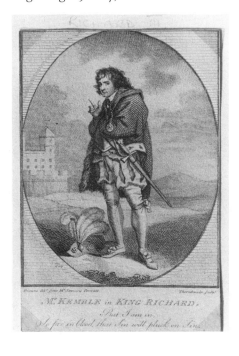

(IV.2): "But I am in / So far in blood, that Sin will pluck on Sin." The engraving states "Browne del . . . from Mr Stewart's [*sic*] Portrait."

LOCATION OF ORIGINAL: Unknown, but see below.

PROVENANCE: Bell sale, Christie's, 27 March 1793 (lot 97); bought, with other drawings in lot, for £1 by Gretton.

RELATED: See below.

Some confusion has existed about Gilbert Stuart's portrait of Kemble as Richard III. Such a portrait was mentioned in the *Morning Chronicle* in the spring of 1786. Stuart, however, seems to have done two portraits of Kemble as Richard III: the one Brown copied in preparation for the engraving in *Bell's Shakespeare* in 1786 and the one engraved at later dates by Keating (mezzotint 27.9 × 21.6), 1 January 1788, for Boydell; by Houston (10.5 × 8.9), 1796; by Meyer (14.3 × 9.5), published as a plate to *The Cabinet*, 1808; and by J. Rogers (called "Hamlet" and as by Harlowe), published as a plate to Oxberry's *Dramatic Biography* (1825).

The latter portrait, described by Lawrence Park in *Gilbert Stuart* (1926), is half-length (73.7 × 61) and shows Kemble turned to the right and wearing a red cloak with star; the present whereabouts of this second portrait is unknown. (According to Kerslake's catalog of Georgian portraits in the National Portrait Gallery, this portrait was a "romanticized" development of the Stuart portrait of Kemble in private character now in the NPG [No. 49].) In 1868, the second Richard III portrait was owned by Sir Henry Halford, when it was in the Third Exhibition of National Portraits at the South Kensington Museum. It was formerly in the Cottesloe Collection when it was in the exhibition Midland Houses at Birmingham in 1938 (No 100). It, or another version, was sold at Sotheby's on 3 October 1973 (lot 83). A copy (53.3 × 40.6) was painted by Thomas Sully in 1867 and was owned by A. T. Bay, of New York, in 1921; the art information service files in the National Gallery, Washington, have no record of this portrait's location.

Nothing further, however, is known about the provenance or present location of the portrait copied by Brown for Bell. The engraving by Thornthwaite for *Bell's Shakespeare*, after the drawing by Brown, uses Stuart's portrait of the head. In the Garrick Club (Ash380, CKA496) is a pen-and-ink drawing (21.6 × 18.1) by Harding, after Stuart, of Kemble as Richard III. The Harding drawing is probably a copy of the mezzotint by G. Keating, published by Boydell, 1 January 1788.

Kemble appeared as Richard III in London for the first time on 6 November 1783 at Drury Lane Theatre. He had acted the role in the provinces before engaging with Wilkinson on the Yorkshire circuit in 1778. He also had acted the role at the Smock Alley Theatre in Dublin on 26 April 1782.

# 43

## John Philip Kemble   1757–1823
as Timon in *Timon of Athens*

ARTIST: J. H. Ramberg

ENGRAVER: W. Sharp

DATE PUBLISHED: 21 September 1785

BELL EDITION: BS85–88.XVII

Colored drawing (12.7 × 8.6), full-length to front, seated on a rock, dropping coins from his extended left hand, with chin resting on his right arm, his right foot on an overturned jar; coins scattered on the ground; wearing a rustic tunic, with bare arms and legs. Line engraving 9.5 × 7, for Bell's British Library.

LOCATION OF ORIGINAL: British Museum (Burney V, No. 142).

PROVENANCE: Bell sale, Christie's, 27 March 1793 (lot 88).

RELATED: None.

Kemble did not act Timon in London. The only performance of the play during Kemble's career was in Shadwell's adaptation at Covent

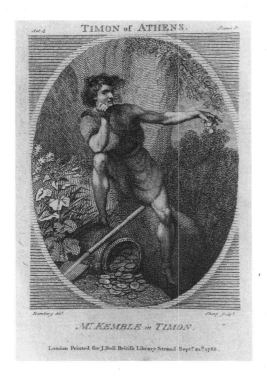

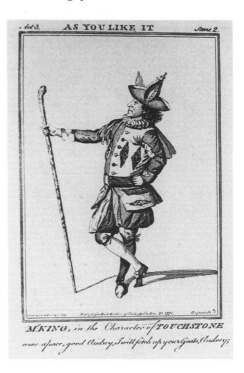

Garden Theatre on 13 May 1786, with Holman as Timon.

# 44

## Thomas King   1730–1895
as Touchstone in *As You Like It*

ARTIST: T. Parkinson

ENGRAVER: C. Grignion

DATE PUBLISHED: 20 December 1775

BELL EDITION: BS75–78

Full-length, standing, legs crossed, staff in right hand; wearing motley. Line engraving 13.7 × 9.5, with the quotation (III.2): "come apace, good Audrey, I will fetch up your Goats, Audrey."

LOCATION OF ORIGINAL: Unknown.

PROVENANCE: Unknown.

RELATED: None.

King acted Touchstone for the first time in London on 22 October 1767. Hazlitt described King as a performer "whose acting left a taste on the palate, sharp and sweet like a quince," and his Touchstone as a clown "with wit sprouting from his head like a pair of ass's ears, and folly perched on his cap like the horned owl."

Other portraits of King as Touchstone include a painting (91 × 55.5) by Zoffany in the Garrick Club (Ash401, CKA384); an india ink drawing by an unknown artist, in the British Museum, published by Wenman in an anonymous engraving with an edition of the play, 1777; and an anonymous engraving published as a plate to *Hibernian Magazine* (1789).

# 45

## Jane Lessingham   1739?–1783
as Ophelia in *Hamlet*

ARTIST: J. Roberts

ENGRAVER: C. Grignion

DATE PUBLISHED: 1 October 1775

BELL EDITION: BS75–78

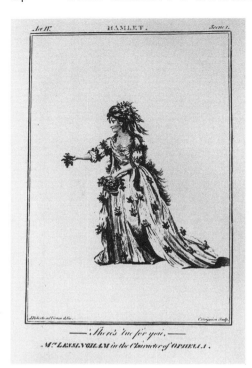

Watercolor drawing (8.9 × 7.6), full-length, standing to left, holding a basket in her left hand, her right hand outstretched scattering flowers; wearing long dress decorated with flowers. Line engraving 14 × 9.5, with the quotation: "—There's rue for you—." The engraving places the moment in II.1, but it occurs in Shakespeare's version in IV.4.

LOCATION OF ORIGINAL: British Museum (Burney V, No. 248).

PROVENANCE: Bell sale, Christie's, 27 March 1793 (lot 25).

RELATED: An engraved copy in reverse is in the Harvard Theatre Collection.

Jane Lessingham acted Ophelia for the first time at Covent Garden Theatre on 21 April 1772, for her benefit. In an epistle called *The Ring* (1768), written in Jane Lessingham's defense by Thomas Harris (her manager and lover), she was described as "fine-figured, with glossy brown hair, fair skin, laughing eyes," and was judged as an actress equal or superior to Ann Barry, Isabella Mattocks, and Mary Ann Yates.

# 46

William Thomas Lewis   ca. 1746–1811
as the Prince of Wales in *1 Henry IV*

ARTIST: T. Parkinson

ENGRAVER: Anonymous

DATE PUBLISHED: 14 October 1775

BELL EDITION: BS75–78

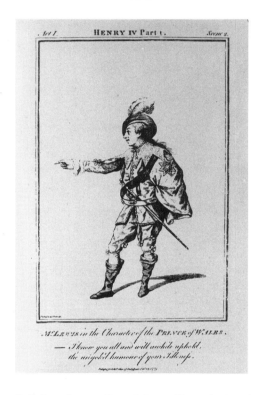

Full-length, standing, left profile, right hand extended and pointing to left; wearing boots, breeches, a wide Vandyke collar, baldric and cloak, with a sash across his chest and sword in belt. Line engraving 14.3 × 8.6, with the quotation (I.2): "—I know you all and will awhile uphold, / the unyok'd humour of your Idleness."

LOCATION OF ORIGINAL: Unknown.

PROVENANCE: Unknown.

RELATED: None.

See also No. 47.

## 47

### William Thomas Lewis ca. 1746–1811
as the Prince of Wales in *1 Henry IV*

ARTIST: E. F. Burney

ENGRAVER: J. Thornthwaite

DATE PUBLISHED: 18 January 1786

BELL EDITION: BS85–88.XI

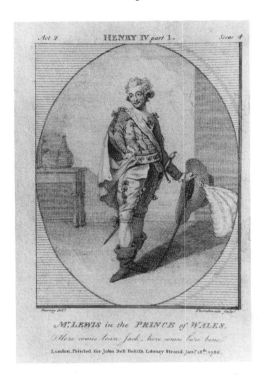

Drawing, full-length, standing in a room, face to front, holding a plumed hat in left hand, his right hand on his hip; wearing a modified Vandyke costume with a short cloak. Line engraving 8.9 × 6.7, for Bell's British Library, with the quotation (II.4): "Here comes lean Jack, here comes bare bone."

LOCATION OF ORIGINAL: Unknown.

PROVENANCE: Bell sale, Christie's, 27 March 1793 (lot 93, attributed to Ramberg), bought with other drawings in lot by Gretton for £1.

RELATED: A larger copy (15.9 × 9.2) of Thornthwaite's engraving, by an unknown en-

graver, was published as a plate to *Hiberian Magazine* (August 1790).

A watercolor drawing by William Loftis of Lewis as the Prince of Wales is in the Folger Library. For a portrait of Lewis as the Prince of Wales by Parkinson, see this catalog, No. 46. Lewis played this role for the first time in London on 15 March 1774, at Covent Garden Theatre.

## 48

### Charles Macklin 1699–1797
as Shylock in *The Merchant of Venice*

ARTIST: T. Parkinson

ENGRAVER: C. Grignion

DATE PUBLISHED: 20 November 1775

BELL EDITION: BS75–78

India ink drawing (10.8 × 7.6), full-length, standing, holding knife in his right hand and scales in his left; wearing dark pantaloons

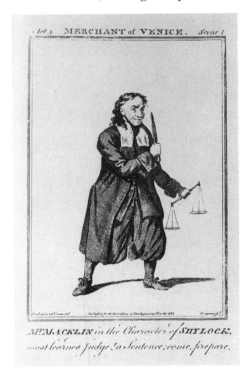

and a long dark coat. Line engraving 10.8 ×
8.9, with the quotation (IV.1): "most learned
Judge! a Sentence; come, prepare."

LOCATION OF ORIGINAL: British Mu-
seum (Burney VI, No. 41).

PROVENANCE: Bell sale, Christie's, 27 March
1793 (lot 34).

RELATED: A sketch by Parkinson, in the
same lot at Christie's, is also in the British
Museum.

See also No. 49. For other portraits of
Macklin as Shylock, see the *BDA*. Macklin's
"revolutionary" performance of Shylock at
Drury Lane Theatre on 14 February 1741 was
one of most significant events in the eigh-
teenth-century English theatre. His "natural"
and menacing portrayal, a departure from the
usual comic interpretation, drew crowds from
all over town for more than twenty perfor-
mances, and for decades no other performer
would essay the role, so firmly was it attached
to Macklin's reputation. The whole town
knew, it seems, the couplet, attributed to
Pope: "This is the Jew / That Shakespeare
drew."

# 49

## Charles Macklin   1699–1797
as Shylock in *The Merchant of Venice*

ARTIST: J. H. Ramberg

ENGRAVER: T. Cook

DATE PUBLISHED: 20 March 1785

BELL EDITION: BS85–88.VII

India ink, wash-and-pen drawing (9.2 × 6.4),
full-length, standing, holding knife and
scales; wearing long coat and skullcap. Line
engraving 9.5 × 6.4, for Bell's British Library,
with Shylock's line (IV.1): "O Most learned
Judge!—a Sentence, come, prepare."

LOCATION OF ORIGINAL: British Mu-
seum (Burney VI, No. 39).

PROVENANCE: Bell sale, Christie's, 27 March

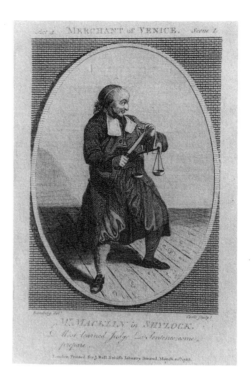

1793 (lot 82); bought with other drawings in
lot for £1 2s. by Mitchell.

RELATED: An engraving from the same plate
was published by Cawthorn, January 1806.

See also No. 48. For other portraits of
Macklin as Shylock, see the *BDA*. The Ger-
man traveler Georg C. Lichtenberg described
Macklin's first entrance:

Imagine a rather stout man with a coarse yel-
low face and a nose generously fashioned, in all
three dimensions, and a long double chin, and
a mouth so carved by nature that the knife ap-
pears to have slit him right up to the ears, on
one side at least. . . . He wears a long black
gown, long wide trousers, and a red tricorne. . . .
The first words he utters, when he comes to
the stage, are slowly and impressively spoken:
"Three thousand ducats." The double "th" and
the two sibilants, especially the second after the
"t," which Macklin lisps as lickerishly as if he
were savoring the ducats and all they would
buy, make so deep an impression in the man's
favour that nothing can destroy it. Three such
words uttered thus at the outset give the key-
note of the whole character.

# 50

## Maria Macklin　ca. 1733–1781
as Helena in *All's Well That Ends Well*

ARTIST: J. Roberts

ENGRAVER: Grignion

DATE PUBLISHED: 1 December 1775

BELL EDITION: BS75–78

Full-length, standing to her right, right arm extended to her right; wearing long dress with puffed sleeves, hair set in long curls. Line engraving 14 × 9.2, with the quotation (III): "—'tis but the shadow of a Wife you see."

LOCATION OF ORIGINAL: Unknown.

PROVENANCE: Unknown.

RELATED: None.

Maria Macklin first acted Helena in a revival of Shakespeare's play at Drury Lane Theatre on 24 February 1756. According to the prompter, Cross (from a notation in his diary), the "Play went off Dull."

# 51

## Isabella Mattocks　1746–1826
as Princess Catherine in *Henry V*

ARTIST: J. Roberts

ENGRAVER: C. Grignion

DATE PUBLISHED: 1 December 1775

BELL EDITION: BS75–78

Colored drawing (14.3 × 9.5), full-length, standing, head profile to right, her right arm outstretched to right. her left across her chest; wearing a dress with a panniered skirt and a long train. Line engraving 14.3 × 9.5, with the quotation (V): "de tongues of de mans is full of Deceit" (Alice's line).

LOCATION OF ORIGINAL: British Museum (Burney VI, No. 109).

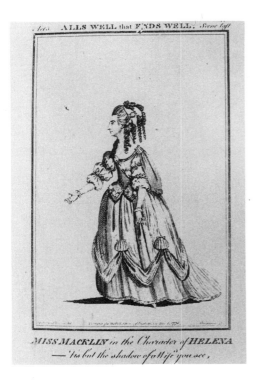

MISS MACKLIN in the Character of HELENA
— 'tis but the shadow of a Wife you see,

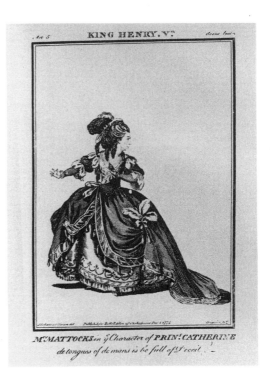

Mᴿˢ MATTOCKS in ỹ Character of PRINˢˢ CATHERINE
de tongues of de mans is be full of Deceit —

PROVENANCE: Bell sale, Christie's, 27 March 1793 (lot 38); bought with other drawings in lot for £1 11s. by Gretton.

RELATED: None.

When still Miss Hallam, Isabella acted Princess Catherine for the first time in London on 16 October 1762, at Covent Garden Theatre.

# 52

## John Palmer   1744–1798
as the Earl of Warwick in *3 Henry VI*

ARTIST: T. Parkinson

ENGRAVER: C. Grignion

DATE PUBLISHED: 4 January 1776

BELL EDITION: BS75–78; BET 92.VIII

Full-length, standing, sword in outstretched right hand; wearing breeches, a short jacket, a cloak over his left shoulder, and a hat with plume. Line engraving 12.7 × 7.6, with the quota-

tion (II.6): "—off with the Traitor's Head / and rear it in the place your Fathers Stands—."

LOCATION OF ORIGINAL: Unknown.

PROVENANCE: Unknown.

RELATED: None.

Palmer did not act the Earl of Warwick; *3 Henry VI* was not performed in London during his career. See also No. 53.

# 53

## John Palmer   1744–1798
as the Earl of Warwick in *3 Henry VI*

ARTIST: J. Sanders

ENGRAVER: J. Thornthwaite

DATE PUBLISHED: 9 May 1786

BELL EDITION: BS85–88.XIV

Full-length, to right, facing left, standing out-doors before a tent. A sword in his right hand, crown in left; wearing "Elizabethan"

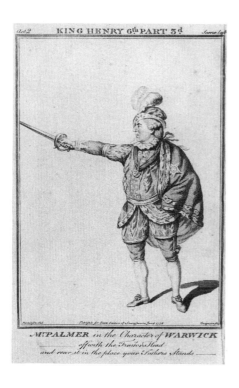

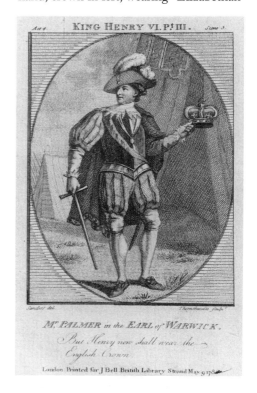

costume and a plumed hat on his head. Line engraving 9.2 × 6.7, for Bell's British Library, with Warwick's line (IV.3): "But Henry now shall wear the English Crown."

LOCATION OF ORIGINAL: Unknown.

PROVENANCE: Unknown.

RELATED: None.

John Palmer did not act the Earl of Warwick; *3 Henry VI* was not performed in London during his career. See also No. 52.

# 54

## William Parsons   1736–1795
as Justice Shallow in *2 Henry IV*

ARTIST: J. H. Ramberg

ENGRAVER: C. Grignion

DATE PUBLISHED: 12 December 1785

BELL EDITION: BBT85–88.XII

Drawing, full-length, standing in a street, with view of Westminster Abbey in back-

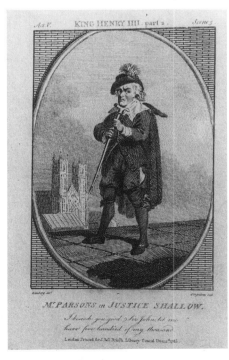

ground; holding a cane and wearing breeches, coat, cape, and a hat with feather. Line engraving 9.2 × 6.5, with Shallow's line (V.3): "I beseech ye good Sir John, let me have five hundred of my thousand."

LOCATION OF ORIGINAL: Unknown.

PROVENANCE: Bell sale, Christie's, 27 March 1793 (lot 93); bought, with other drawings in lot, for £1 by Gretton.

RELATED: None.

Parsons appeared as Justice Shallow for the first time in London on 19 January 1770, at Drury Lane Theatre. He also played this character in William Kenrick's *Falstaff's Wedding*, a sequel to *2 Henry IV*, on 12 April 1766.

**Miss Phillips.** See Anna Maria Crouch, No. 19.

# 55

## Alexander Pope   1762–1835
as Posthumus in *Cymbeline*

ARTIST: M. Brown (after G. Stuart)

ENGRAVER: J. Thornthwaite

DATE PUBLISHED: 28 February 1786

BELL EDITION: BS85–88.XX

Full-length, standing in landscape with tree stump at his left, holding a cloth in his right hand; wearing breeches, a long coat with a belt at waist, and tiewig. Line engraving 8.9 × 7, for Bell's British Library, with the Posthumus's line (V.1): "Yea, bloody cloth I'll keep thee."

LOCATION OF ORIGINAL: The location of Mather Brown's drawing is unknown, but see below for the painting by Stuart at the Garrick Club.

PROVENANCE: Unknown.

RELATED: A portrait by "Thomas Stewart" [*recte* Gilbert Stuart] of Pope as Posthumus was in the sale of Bell paintings at Leigh & Sotheby's on 25 May 1805 (lot 258). It was

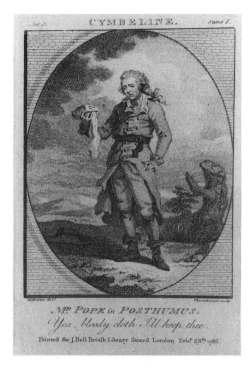

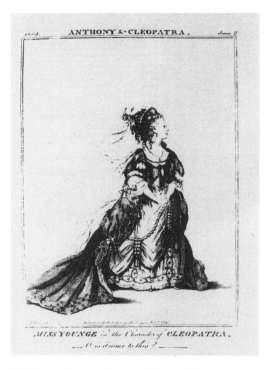

bought by Charles Mathews (No. 135) and is now in the Garrick Club (Ash681, CKA296). Formerly, it had been cataloged as an unknown sitter by an unknown artist, but Geoffrey Ashton has identified it as Stuart's portrait of Pope as Posthumus. The drawing of the portrait for the Bell edition was by Brown. Another impression of the engraving was published by Cawthorn, 1805.

Pope's name does not appear in the bills for Posthumus; his usual role in *Cymbeline* was Iachimo, in which he appeared for the first time in London on 27 April 1787, at Covent Garden Theatre.

# 56

Elizabeth Pope   ca. 1740–1797
as Cleopatra in *Antony and Cleopatra*

ARTIST: J. Roberts

ENGRAVER: Anonymous

DATE PUBLISHED: 3 February 1776

BELL EDITION: BS75–78; BET92.IX

Full-length, standing, profile to right; wearing a decorated dress with a long and heavy cloak. Line engraving 15.7 × 8.3, with the quotation (III.2): "O, is it come to this?"

LOCATION OF ORIGINAL: Unknown.

PROVENANCE: Unknown.

RELATED: None.

Also see Burney's portrait of her as Cleopatra, No. 57. Mrs Pope (at the time, Miss Younge) did not appear as Cleopatra in Shakespeare's play; it was not performed in London during her career there. She did act Cleopatra in Dryden's *All for Love* at Drury Lane Theatre, for the first time, on 17 December 1772.

# 57

Elizabeth Pope   ca. 1740–1797
as Cleopatra in *Antony and Cleopatra*

ARTIST: E. F. Burney

ENGRAVER: J. Thornthwaite

DATE PUBLISHED: 22 August 1786

BELL EDITION: BS85–88.XVI

Watercolor, full-length, seated on a couch, looking to right, her left elbow leaning on

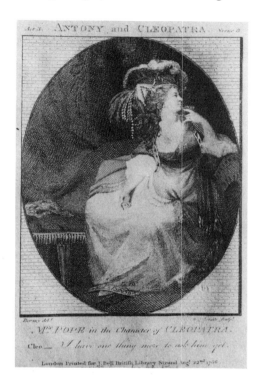

the arm of the couch and her left forefinger at her chin; wearing a full-skirted dress and a headdress with plumes and pearls. Line engraving 8.9 × 7, for *Bell's British Theatre*, with Cleopatra's line (III.3): "I have one thing more to ask him yet."

LOCATION OF ORIGINAL: Unknown.

PROVENANCE: Bell sale, Christie's, 27 March 1793 (lot 104).

RELATED: None.

See No. 56, Roberts's portrait of her as Cleopatra.

The only revival of *Antony and Cleopatra* in the eighteenth century occurred at Drury Lane Theatre in January 1759, when Cleopatra was acted by Mary Ann Yates. Mrs Pope (when Miss Younge) played Cleopatra

in Dryden's *All for Love* for the first time on 17 December 1772, and the role remained in her repertoire. It is likely that because she was known as Cleopatra in the Dryden play, she was used by Bell to illustrate Shakespeare's play.

# 58

## John Quick   1748–1831
as Launce in *The Two Gentlemen of Verona*

ARTIST: J. H. Ramberg

ENGRAVER: C. Grignion

DATE PUBLISHED: 12 January 1785

BELL EDITION: BS85–88.III; CMBT 1805

Drawing, full-length, standing outdoors holding a dog on leash; wearing breeches, waistcoat, a short jacket, and a floppy hat. Line en-

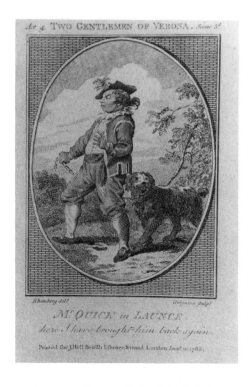

graving 9.5 × 6.7, for *Bell's British Library*, with the line (IV.3): "here I have brought him back again."

LOCATION OF ORIGINAL: Unknown.

PROVENANCE: Bell sale, Christie's, 27 March 1793 (lot 102); bought with other drawings in the lot for 15s. by Gretton.

RELATED: A similar picture, a vignette by an unknown engraver, was published by Cawthorn, Catherine Street, Strand, 1806.

Quick acted this role in London for the first time on 13 April 1784, at Covent Garden Theatre, for his benefit. At the conclusion of the play he gave "a new *Occasional Address . . .* riding on an Elephant."

# 59

## Samuel Reddish   1735–1785
as Edgar in *King Lear*

ARTIST: T. Parkinson

ENGRAVER: C. Grignion

DATE PUBLISHED: 25 October 1775

BELL EDITION: BS75–78

India ink and watercolor tint drawing (12.7 × 8.6), full-length, standing to right, brandishing a staff in raised hands to his right; wearing breeches, waistcoat, long cloak, and hat, with hair disheveled. Line engraving 13.7 × 9.5, with the quotation: "There could I have him now, & there, & there again, and there" (given on the engraving as in III.3, but correctly III.4).

LOCATION OF ORIGINAL: British Museum (Burney VII, No. 172).

PROVENANCE: Bell sale, Christie's, 27 March 1793 (lot 33); bought (with other drawings in lot) for £1 1s. by Mitchell.

RELATED: None.

After passing about eight years on provincial stages, Reddish made his debut at Drury Lane Theatre on 18 September 1767 as Lord Townley in *The Provok'd Husband*. About a month after his London debut, he acted Edgar, on 21 October 1767. An actor of a number of leading and supporting roles dur-

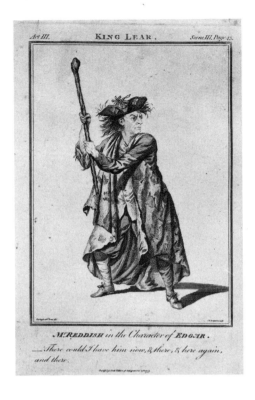

Act III.     KING LEAR.     Scene III. Page 45.

M.ʳ REDDISH *in the Character of* EDGAR.
. . . *There could I have him now, & there, & here again, and there.*

ing his career at Drury Lane, Reddish was at his best playing young beaux and noblemen in sentimental plays. Plagued by bouts of madness during his career, he died in the York Asylum in December 1785.

# 60

## Thomas Sheridan   1719–1788
as Brutus in *Julius Caesar*

ARTIST: J. Roberts

ENGRAVER: White

DATE PUBLISHED: 9 January 1776

BELL EDITION: BS75–78; BET92.XII

Full-length, standing, looking upward, right hand in front of body; wearing cuirass and armored short skirt, covered by a long dark cloak. Line engraving 14 × 8.9, with the quotation (II.1): "It must be by his Death."

LOCATION OF ORIGINAL: Unknown.

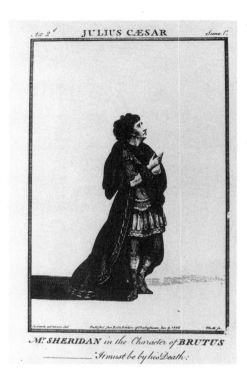

MR SHERIDAN in the Character of BRUTUS
"It must be by his Death."

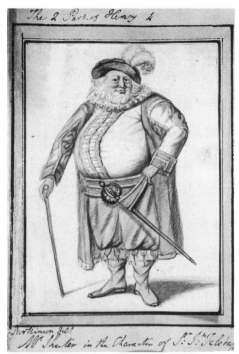

MR Shuter in the Character of Sr Jn Falstaffe

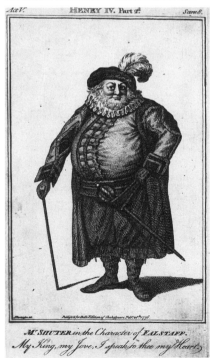

MR SHUTER in the Character of FALSTAFF.
My King, my Jove, I speak to thee my Heart.

PROVENANCE: Unknown.

RELATED: None.

Thomas Sheridan, the father of the playwright Richard B. Sheridan, was a leading actor and manager in Dublin in the middle of the eighteenth century. He enjoyed some success in London, but his manner, somewhat oratorical and intellectual, remained out of tune with the more "natural" style introduced by Garrick. Brutus was one of Sheridan's most successful roles. He first acted Brutus at the Smock Alley Theatre, Dublin, on 17 March 1743. He appeared in the role for the first time in London at Covent Garden Theatre on 18 April 1744.

# 61

## Edward Shuter   1728?–1776
as Falstaff in *2 Henry IV*

ARTIST: T. Parkinson

ENGRAVER: Anonymous

DATE PUBLISHED: 28 February 1776

BELL EDITION: BS75–78

Drawing in india ink and watercolor tint (12.7 × 8.6), full-length, standing slightly to left, looking front, with padded stomach, a sword hanging from belt at center of his waist, his right hand on a stick; wearing a riding cloak, boots, a ruff at neck, and a hat with plume. Line engraving 15 × 9.2, with the quotation: "My King, my Jove, I speak to thee my Heart" (given on the engraving as V.8, but V.5 in Shakespeare's text).

LOCATION OF ORIGINAL: British Museum (Burney VIII, No. 112).

PROVENANCE: Bell sale, Christie's, 27 March 1793 (lot 37).

RELATED: None.

Shuter first acted this role in London on 11 December 1761, at Covent Garden Theatre. He had made his first appearance as Falstaff in part 1 on 10 April 1755. In *A General View of the Stage* (1759), Thomas Wilkes claimed that although Shuter was a "young Falstaff," he played it "better than any man now on the Stage." Francis Gentlemen described Shuter as an actor "whom nature conceived and brought forth in a fit of laughter."

# 62

## Sarah Siddons    1755–1831
as Desdemona in *Othello*

ARTIST: J. H. Ramberg

ENGRAVER: C. Sherwin

DATE PUBLISHED: 25 November 1785

BELL EDITION: Issued Separately

India ink, wash-and-pen drawing (12.7 × 8.3); full-length, seated on bed, right arm raised; wearing a nightgown and nightcap; a large blanket over her legs. Line engraving 9.5 × 6.7, "Printed for J. Bell. British Library."

LOCATION OF ORIGINAL: British Museum (Burney VIII, No. 167).

PROVENANCE: Unknown.

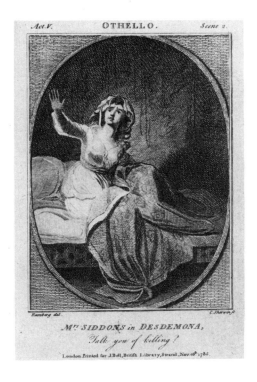

*Act. V.*    OTHELLO.    *Scene 2.*

Mᴿˢ SIDDONS in DESDEMONA,
*Talk you of killing?*
London Printed for J. Bell, British Library, Strand, Nov. ʳᵈ 1785

RELATED: None.

Mrs Siddons acted Desdemona for the first time on 29 January 1777 at Manchester with her brother John Philip Kemble as Othello. She appeared in the role in London for the first time on 8 March 1785, again with her brother, at Drury Lane Theatre. The engraving was not published with BS88; the picture for *Othello* in those volumes is Henderson as Iago.

# 63

## Sarah Siddons    1755–1831
as Isabella in *Measure for Measure*

ARTIST: J. H. Ramberg

ENGRAVER: J. Hall

DATE PUBLISHED: 10 March 1785

BELL EDITION: BS85–88.V

Gray ink, wash, and watercolor drawing, oval in rectangle (8.9 × 6), inscribed "H.

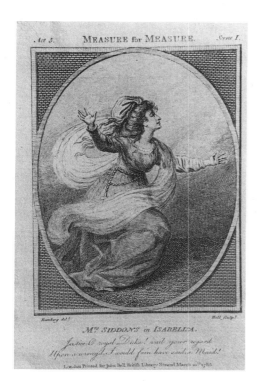

# 64

## Sarah Siddons 1755–1831
as Lady Macbeth in *Macbeth*

ARTIST: J. H. Ramberg

ENGRAVER: J. M. Delattre

DATE PUBLISHED: 26 August 1784

BELL EDITION: BS85–88.X

Drawing, full-length, walking in sleep away from her bed, her hands extended to right, a candle in her right hand; wearing a long nightdress. Line engraving 8.9 × 6.4, for Bell's British Library, with the quotation (V): "yet here's a Spot."

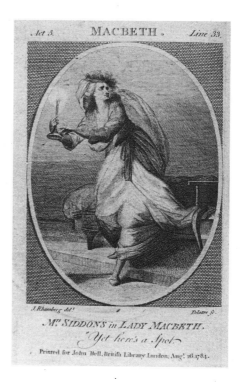

Ramberg/del. 1785." Full-length, to right, arms extended, beseeching; wearing a voluminous habit and a long scarf that hangs from the back of her head around her left arm and body, a crucifix and beads at her waist. Line engraving 8.9 × 7, for Bell's British Library, with Isabella's line (V.1): "Justice, O royal Duke! visit your regard / Upon a wrong'd, I would fain have said, a Maid!"

LOCATION OF ORIGINAL: Folger Shakespeare Library.

PROVENANCE: Bell sale, Christie's, 27 March 1793 (lot 77); bought for £1 by Gretton.

RELATED: An engraving (8.9 × 7) by E. Scriven, after Ramberg, was published by Cawthorn as a plate to an edition of the play, 1808.

Mrs Siddons first acted this role at Bath on 11 December 1779. It was the first Shakespearean role she acted in London, on 3 November 1783, at Drury Lane Theatre.

LOCATION OF ORIGINAL: Unknown.

PROVENANCE: Two drawings by Ramberg of Mrs Siddons as Lady Macbeth were in the Bell sale, Christie's, 27 March 1793 (lot 78); bought for £1 1s. by Cash (or for cash?).

RELATED: Another impression was published by Cawthorn, 1806.

For many other pictures of Mrs Siddons as Lady Macbeth, see the *BDA*. She first acted Lady Macbeth in London on 2 February 1785, at Drury Lane Theatre (she had played the role for the first time at Bath on 27 September 1779), and was acclaimed for her astounding portrayal of what became her greatest role. *The Public Advertiser* of 24 February 1785 called her sleepwalking scene "the greatest act that has in our memory adorned the stage."

# 65

Sarah Siddons   *1755–1831*
as Princess Katherine in *Henry V*

ARTIST: E. F. Burney

ENGRAVER: J. Thornthwaite

DATE PUBLISHED: 6 December 1785

BELL EDITION: BS85–88.XII

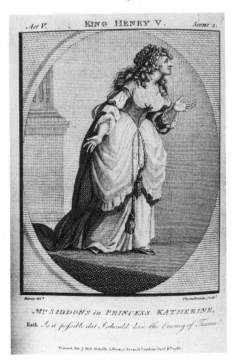

Full-length, standing, profile left, her left hand raised and her right hand at her side; wearing a long dress with a sash hanging from her waist, long hair with curls, and a strand of pearls. Line engraving 9.2 × 7, for Bell's British Library, with the quotation (V.2): "Is it possible dat I should love the Enemy of France?"

LOCATION OF ORIGINAL: Unknown.

PROVENANCE: Unknown.

RELATED: In 1806, Cawthorn advertised the publication of an engraving of Mrs Siddons in this role for his new edition of *Bell's Shakespeare*, but the engraving does not seem to have appeared, and there is no record of it in Mrs Siddons's iconography in the *BDA*.

Mrs Siddons did not act this role in London. The usual player of Princess Katherine in J. P. Kemble's adaptation of *Henry V* was Clementina Collins.

# 66

William Smith   *1730–1819*
as Richard III in *Richard III*

ARTIST: J. Roberts

ENGRAVER: Anonymous

DATE PUBLISHED: 1 November 1775

BELL EDITION: BS75–78

Full-length, standing to left, a sword in his outstretched right hand, his left arm upraised; wearing "Elizabethan" costume with ermine-trimmed cloak. Line engraving 14 × 10.2, with the quotation (V): "—of one or both of us The time is come."

LOCATION OF ORIGINAL: Unknown.

PROVENANCE: Unknown.

RELATED: None.

Smith acted Richard III for the first time in London on 30 March 1761, at Covent Garden Theatre, for his benefit. He also acted this

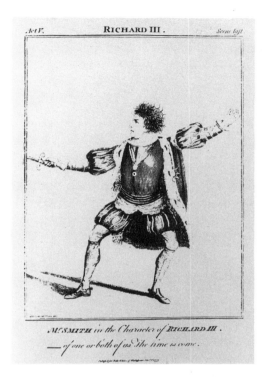

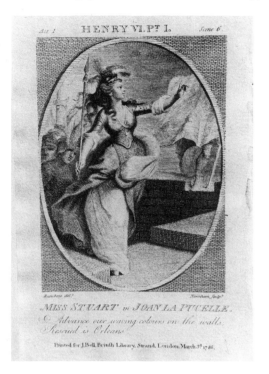

role on the occasion of his debut at Drury Lane Theatre on 22 September 1774. In his *Miscellanies* (1775), William Hawkins stated that Richard was one of the roles Smith acted with "great fervour and manly spirit."

# 67

## Ann Stuart  d. 1809
as Joan la Pucelle in *1 Henry VI*

ARTIST: J. H. Ramberg

ENGRAVER: S. Newnham

DATE PUBLISHED: 3 March 1786

BELL EDITION: BS85–88.XIII

Full-length, standing outdoors, spear in right hand, left hand extended; wearing a long dress with underskirt; a wall and some soldiers behind her. Line engraving 9.5 × 6.7, for Bell's British Library, with Joan's line (I.6): "Advance our waving colours on the walls; / Rescued is Orleans."

LOCATION OF ORIGINAL: Unknown.

PROVENANCE: Unknown.

RELATED: None.

Ann Stuart never played this role in London; the play was not produced there during the last half of the eighteenth century. She played a number of supporting roles at Covent Garden Theatre during the 1780s and 1790s.

# 68

## Joseph Vernon  ca. 1731–1782
as Thurio in *The Two Gentlemen of Verona*

ARTIST: J. Roberts

ENGRAVER: Anonymous

DATE PUBLISHED: 7 March 1776

BELL EDITION: BS75–78; BET92.VIII

Colored drawing on vellum (11.1 × 8.3), full-length, standing, head to left, playing a lute; wearing breeches, a long waistcoat, Vandyke

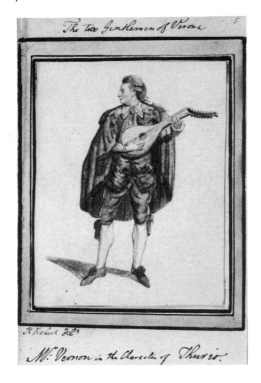

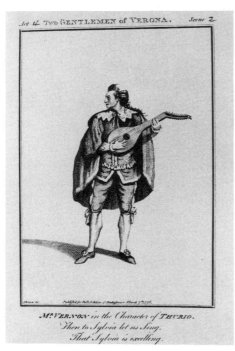

collar, a cloak, and rosettes on pumps. Line engraving 14.6 × 9.5, with the quotation (IV.2): "Then to Sylvia let us Sing, / That Sylvia is excelling."

LOCATION OF ORIGINAL: British Museum (Burney X, No. 5).

PROVENANCE: Bell sale Christie's, 27 March 1793 (lot 40); bought with other drawings in lot for £1 1s. by Gretton. In the sale catalog, the drawing is credited to Edwards and Roberts, perhaps meaning Edwards, after Roberts; probably it was the drawing that Edwards had prepared for the engraving.

RELATED: None.

Vernon acted Thurio in a revival of this play at Drury Lane Theatre on 21 December 1762.

# 69

## Sarah Ward (Mrs Thomas Achurch Ward)?  1756?–1838?
as Portia in *Julius Caesar*

ARTIST: J. H. Ramberg

ENGRAVER: C. Sherwin

DATE PUBLISHED: 24 June 1785

BELL EDITION: BS85–88.XVI

Full-length, standing to left, arms extended; wearing a long dress with sash around waist and a long veil hanging from the back of her head down over her right arm. Line engraving 9.5 × 6.7, for Bell's British Library, with Portia's line (II.1): "Dear my Lord, / Make me acquainted with your Cause of Grief."

LOCATION OF ORIGINAL: Unknown.

PROVENANCE: None.

RELATED: The same plate, with the engraver's name changed to R. Woodman, after Ramberg, was published by Cawthorn, 1807.

We believe this portrait to be of Mrs Thomas Achurch Ward, but possibly it is intended

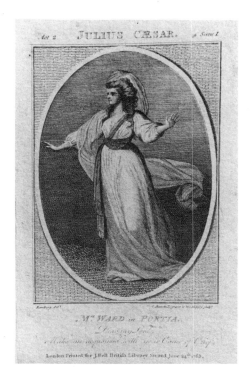

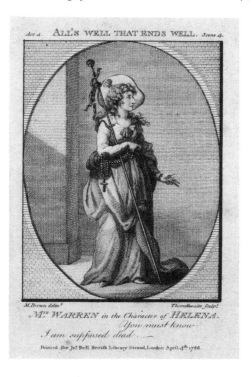

as a picture of Sarah Achurch Ward (1727–71), the wife of the actor Henry Ward (fl. 1734–58).

# 70

## Ann Warren   ca. 1761–1821
as Helena in *All's Well That Ends Well*

ARTIST: M. Brown
ENGRAVER: J. Thornthwaite
DATE PUBLISHED: 4 April 1786
BELL EDITION: BS85–88.VIII

Drawing, full-length, standing to right, holding a staff; wearing a long voluminous dress and wide-brimmed hat. Line engraving 8.9 × 6.7, for Bell's British Library, with Helena's line (IV.4): "You must know / I am supposed dead—."

LOCATION OF ORIGINAL: Unknown.

PROVENANCE: Bell sale, Christie's, 27 March 1793 (lot 95); bought with other drawings in lot for £1 by Gretton.

RELATED: None.

When the original drawing was sold at Christie's, the sitter was called, incorrectly, "Mrs" Powell. Miss Ann Powell (daughter of the actor William Powell) became Mrs Thomas Warren sometime between December 1785 and February 1786. In the caption to the engraving, she is called "Mrs Warren." She is not known to have acted Helena in London.

# 71

## Mary Wells   1762–1829
as Imogen in *Cymbeline*

ARTIST: J. H. Ramberg
ENGRAVER: C. Sherwin

DATE PUBLISHED: 28 February 1786

BELL EDITION: Issued Separately

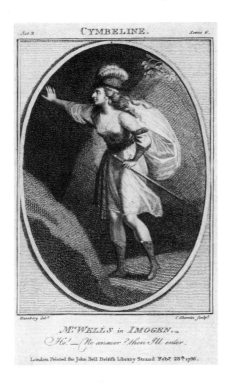

India ink and slight tint drawing (13 × 8.3), full-length, standing, head to right, entering cave, with her right arm outstretched, her left hand on hilt of sword at her left side; wearing a short dress with a sash at waist and a hat with feathers. Line engraving 9.5 × 6.7, for Bell's British Library, with the quotation (III.6): "Ho!—No answer? then I'll enter."

LOCATION OF ORIGINAL: British Museum (Burney X, No. 54)

PROVENANCE: Bell sale, Christie's, 27 March 1793 (lot 94); bought, with other drawings in lot, for £1 by Gretton.

RELATED: None.

The engraving was printed for J. Bell, 1786; it did not appear with any edition of the *Bell's Shakespeare* series. Mrs Wells acted Imogen for the first time in London on 19 November 1784, at Drury Lane Theatre.

# 72

## Mary Wells 1762–1829
as Lavinia in *Titus Andronicus*

ARTIST: W. Hamilton

ENGRAVER: J. Thornthwaite

DATE PUBLISHED: 24 August 1785

BELL EDITION: BS85–88.XVIII

Full-length, standing to front, looking to right, javelin in right hand; wearing a long dress; a tree behind. Line engraving 9.5 × 6.4, for Bell's British Library, with the line (II.3): "Under your patience gentle Empress."

LOCATION OF ORIGINAL: Unknown.

PROVENANCE: Unknown.

RELATED: None.

The published engraving credits Hamilton as the artist. In the sale of Bell's collection of drawings at Christie's on 27 March 1793 (lot 85), there were two drawings by J. H.

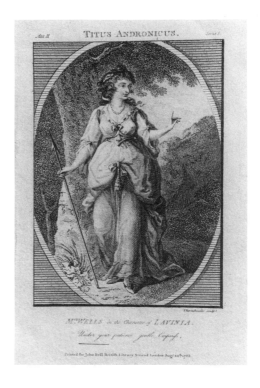

Ramberg of Mrs Wells as Lavinia. One of those drawings is now in the British Museum (india ink and slight tint). It shows Mrs Wells full-length to right, kneeling on her left knee—quite a different pose from the Hamilton. Mrs Wells never appeared as Lavinia; *Titus Andronicus* was not played in London in the eighteenth century after 1724.

# 73

## Thomas Weston   1737–1776
as Costard in *Love's Labour's Lost*

ARTIST: R. Dighton

ENGRAVER: C. Grignion

DATE PUBLISHED: 28 February 1776

BELL EDITION: BS75–78; BET92.IV

Drawing, india ink tinted with watercolor (16.5 × 10.5), full-length, standing to right, holding a hat in his left hand, pointing with his right hand; wearing breeches, shirt with puffed

sleeves, and a short cloak. Line engraving 14 × 9.2, with the quotation (I.1): "I was taken with none Sir, I was taken with a Damsel."

LOCATION OF ORIGINAL: British Museum (Burney X, No. 57).

PROVENANCE: John Bell.

RELATED: None.

Weston did not act this role in London; the play was not performed there in the eighteenth century.

# 74

## Henry Woodward   1714–1777
as Petruchio in *Catherine and Petruchio*

ARTIST: J. Roberts (or Sherwin?)

ENGRAVER: Anonymous

DATE PUBLISHED: 3 January 1776

BELL EDITION: BS75–78; BET92.VIII

Watercolor on vellum (10.8 × 7.6), full-length, standing, body to his right, face front, hands on hips; wearing long flowing cape, breeches, sash across waistcoat, broad hat with large

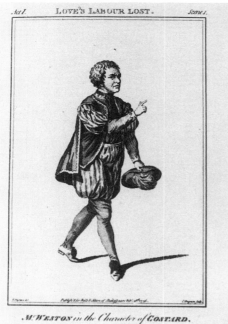

LOVE'S LABOUR LOST.

Mr WESTON in the Character of COSTARD.
— I was taken with none Sir, I was taken with a Damsel.

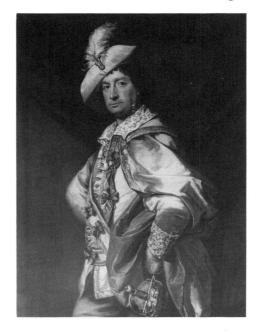

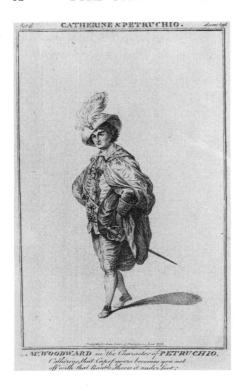

feather, sword at left side. Line engraving 15 × 9.2, with the quotation: "Catherine, that Cap of yours becomes you not, off with that Bauble, throw it under foot."

LOCATION OF ORIGINAL: British Museum (Burney X, No. 104)

PROVENANCE: This drawing was in the sale of the Bell collection at Christie's on 27 March 1793 (lot 40), when it was bought with three other drawings in the lot for £1 1s. by Gretton. In the sale catalog, the drawing is credited to Sherwin.

RELATED: This picture is a full-length adaptation of the oil painting by Benjamin Vandergucht (exhibited at the Royal Academy, 1774) that is now in the Yale Center for British Art. Another version is in the Garrick Club (Ash853, CKA27). A third version was in the Vandergucht sale at Christie's on 11 March 1796 (lot 9); its present location is unknown. Other engravings include by J. R. Smith, 1774 (34.6 × 26.7); S. Freeman, for

*The Cabinet*, 1 August 1807 (14.3 × 9.5, bust only).

Woodward acted Petruchio in the premiere of Garrick's farce-adaptation of Shakespeare's *The Taming of the Shrew* on 21 January 1756, at Drury Lane Theatre. Kitty Clive played Catherine.

# 75

## Mary Ann Wrighten   1751?–1796
as Katherine in *The Taming of the Shrew*

ARTIST: J. H. Ramberg

ENGRAVER: J. Thornthwaite

DATE PUBLISHED: 15 February 1786

BELL EDITION: BS85–88.VIII

Full-length, standing to left, face front; wearing hat with a plume and a long dress with sash at waist; in a room, with a window behind. Line engraving 8.9 × 7, for Bell's British Library.

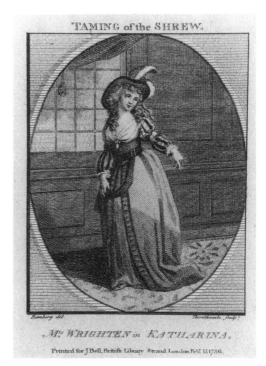

LOCATION OF ORIGINAL: Unknown.

PROVENANCE: Unknown.

RELATED: None.

Shakespeare's play was not performed in London during the period of Mrs Wrighten's career there. She did, however, act Catherine in Garrick's adaptation called *Catherine and Petruchio*, appearing in that role for the first time on 1 November 1780 at Drury Lane Theatre.

# 76

## Mary Ann Yates  1728–1787
as Isabella in *Measure for Measure*

ARTIST: J. Roberts

ENGRAVER: Anonymous

DATE PUBLISHED: 16 March 1776

BELL EDITION: BS75–78; BBT92.XI

Colored drawing on vellum (12.1 × 8.6), full-length, standing, looking left, her arms stretched out to her sides; wearing a pan-

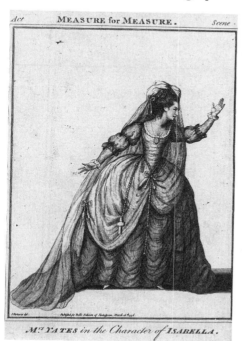

niered dress with overskirt, a crucifix hanging from a chain round her waist. Line engraving 14.6 × 9.8, without a quotation but with the caption "Mrs Yates in the Character of Isabella."

LOCATION OF ORIGINAL: British Museum (Burney X, No. 179).

PROVENANCE: Bell sale, Christie's, 27 March 1793 (lot 46).

RELATED: None.

Mrs Yates first acted Isabella in London at Covent Garden Theatre on 12 January 1771.

# 77

## Mary Ann Yates  1728–1787
as Volumnia in *Coriolanus*

ARTIST: E. F. Burney

ENGRAVER: J. Thornthwaite

DATE PUBLISHED: 22 August 1786

BELL EDITION: BS85–88.XV

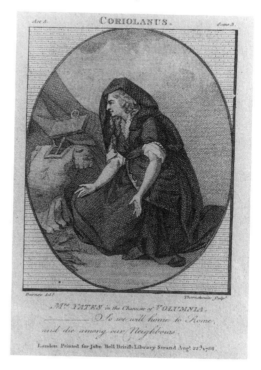

Full-length, kneeling; wearing a long and vo-
luminous dress with a shawl over her head.
Line engraving 8.9 × 7, for Bell's British Li-
brary, with the line (V.3): "—So we will
home to Rome, / and die among our Neigh-
bours."

LOCATION OF ORIGINAL: Unknown.

PROVENANCE: Bell sale, Christie's, 27 March
1793 (lot 103); bought, with other drawings in
lot, for £23 by Gretton.

RELATED: Another impression was pub-
lished by Cawthorn, 1807.

Mrs Yates did not appear in this role, either
in Shakespeare's *Coriolanus* (which was not
performed during her period on the London
stage) or in James Thomson's adaptation.

# 78

### Richard Yates   ca. 1706–1796
as Malvolio in *Twelfth Night*

ARTIST: W. Edwards?

ENGRAVER: Anonymous

DATE PUBLISHED: 14 February 1776

BELL EDITION: BS75–78

Colored drawing on vellum (10.5 × 7.9),
full-length, standing to right; wearing, hose,
breeches, long waistcoat, and long coat,
powdered wig, and holding an upraised
staff in his left hand. Line engraving 14 × 8.6,
with the quotation (III.4): "—Sweet Lady,
ha, ha."

LOCATION OF ORIGINAL: British Museum
(Burney X, No. 151), but see *Related* below.

PROVENANCE: Bell sale, Christie's, 27 March
1793 (lot 40); bought, with other drawings in
lot, for £1 1s. by Gretton.

RELATED: Garrick Club (No. 864) water-
color 11.1 × 8.25, either a copy of the BM ver-
sion or the original.

The drawing in the British Museum is attrib-
uted to James Roberts, but the catalog for the

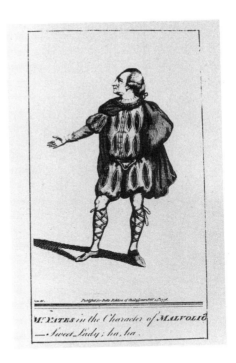

Mr. YATES in the Character of MALVOLIO
— Sweet Lady; ha, ha.

sale of Bell's collection of drawings at Christie's
states that it is by Edwards. The engraving does
not show the names of the artist or engraver.

Yates first acted Malvolio in London on
7 January 1751, at Drury Lane Theatre; pre-
viously his regular role in that comedy had
been the Clown.

Miss Younge. See Elizabeth Pope, Nos. 56,
57, 271–74, 276.

# 79

### Frances Abington   1737–1815
as Aurelia in *The Twin Rivals*

by George Farquhar

ARTIST: J. Roberts, Dated 1778

ENGRAVER: Anonymous

DATE PUBLISHED: 11 November 1777

BELL EDITION: BBT76–77 and 80.XVII

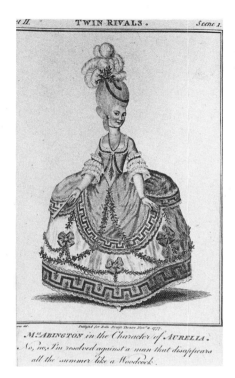

The drawing by Roberts is dated later than the BBT engraving. In the opinion of E. Croft-Murray (cited by J. F. Kerslake in *Catalogue of Theatrical Portraits in London Public Collections*), the drawing, the date, and the inscription are in Roberts's own hand; it is "suggested that they were added from memory later in life." Perhaps the drawing was done by Roberts for the 1780 edition.

Mrs Abington acted Aurelia for the first time on 5 April 1771 at Drury Lane Theatre, where Farquahar's comedy had not been acted the past sixteen years.

# 80

## Frances Abington 1737–1815
### as Estifania in *Rule a Wife and Have a Wife*

by John Fletcher

ARTIST: J. Roberts

ENGRAVER: Anonymous

DATE PUBLISHED: 20 May 1776

BELL EDITION: BBT76–77.IV

Colored drawing on vellum (12.4 × 7.9), full-length, standing to front, holding a rosary on a chain in her raised left hand; wearing a full-panniered embroidered dress and a hat with feathers. Line engraving 14 × 8.3, with the quotation: "And here's a Chain of Whitings Eyes for Pearls, / A Musell monger would have made a better."

LOCATION OF ORIGINAL: British Museum (Burney I, No. 26).

PROVENANCE: Bell sale, Christie's, 27 March 1793 (lot 1); bought, with four other drawings by Roberts of Mrs Abington, for £1 15s. 6d. by Bowden. In the lot was another drawing by Roberts of Mrs Abington as Estifania; see No. 81.

RELATED: See No. 81.

Other portraits of Mrs Abington as Estifania include an anonymous engraving published

---

Colored drawing on vellum (12.4 × 8.3), full-length, standing slightly to left, with a fan in her right hand held down at her right side, her left hand down at left side; wearing a richly decorated dress and pearl necklace, hair piled high, with feathers on top. Line engraving 12.7 × 8.9, with the quotation (II.1): "No, no, I'm resolved against a man that disappears all the summer like a Woodcock."

LOCATION OF ORIGINAL: British Museum (Burney I, No. 13).

PROVENANCE: Bell sale, Christie's, 27 March 1793 (lot 1); bought, with four other drawings by Roberts of Mrs Abington, for £1 15s. 6d. by Bowden.

RELATED: Two other engravings, both three-quarter length and the same, after Roberts, are in the Harvard Theatre Collection. One (line 12.4 × 9.5), by an anonymous engraver, has a quotation below from the *Diary* of Henry Crabbe Robinson; the other (16.8 × 12), engraved by E. Roffe 1778, is marked as by Roberts, 1775.

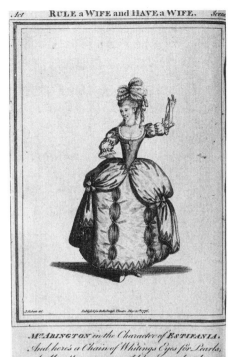

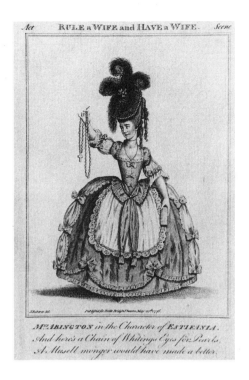

as a plate to the *Hibernian Magazine*, March 1773, and an anonymous engraving published by J. Smith and R. Sayer, 1771. She first acted the role at Drury Lane Theatre on 8 April 1766, for her benefit.

# 81

Frances Abington   1737–1815

as Estifania in *Rule a Wife and Have a Wife*

by John Fletcher

ARTIST: J. Roberts, dated 1778

ENGRAVER: Anonymous

DATE PUBLISHED: 20 May 1776

BELL EDITION: BBT80.IV; BET92.VI

Watercolor drawing on vellum (8.3 × 6.7), full-length, standing, holding a rosary in her raised right hand; wearing a headpiece and a dress more richly decorated than in No. 80. Line engraving 14.3 × 9.2, with the same quotation as No. 80.

LOCATION OF ORIGINAL: British Museum (Burney I, No. 23).

PROVENANCE: Bell sale, Christie's, 27 March 1793 (lot 1); bought, with four other drawings by Roberts of Mrs Abington, for £1 15s. 6d. by Bowden. In the lot was another drawing of Mrs Abington as Estifania; see No. 80.

RELATED: See No. 80.

This drawing is dated 1778, though the engraving bears the same date as the earlier engraving, 20 May 1776. This must be Roberts's second drawing, prepared for the second engraving, both of which are in reverse of the first drawing and engraving.

# 82

Frances Abington   1737–1815

as Margery Pinchwife in *The Country Wife*

by William Wycherley

ARTIST: J. Roberts

ENGRAVER: J. Thornthwaite

DATE PUBLISHED: 11 November 1777

BELL EDITION: BBT76–76 and 80.XVII

Colored drawing on vellum (11.4 × 6), full-length, standing to front, head slightly to left,

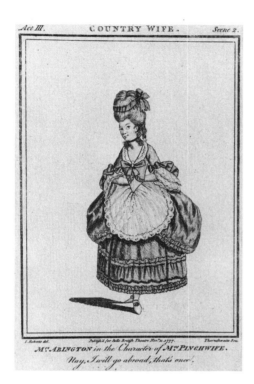

hands under bib; wearing dress with over-skirt, a lace apron, and a ribbon round her high-piled hair. Line engraving 13.7 × 4.5, with the quotation (III.2): "Nay, I will go abroad, that's once."

LOCATION OF ORIGINAL: British Museum (Burney I, No. 33).

PROVENANCE: Bell sale, Christie's, 27 March 1793 (lot 1); bought, with four other drawings in lot, for £1 15s. 6d. by Bowden.

RELATED: None.

Mrs Abington played Margery for the first time in London on 16 November 1767, at Drury Lane Theatre, in Garrick's adaptation called *The Country Girl*. That night she gave an "address to the Audience, by way of *Epilogue*," as the Country Girl.

# 83

## Frances Abington  1737–1815
as Miss Prue in *Love for Love*

by William Congreve

ARTIST: J. Roberts

ENGRAVER: J. Thornthwaite

DATE PUBLISHED: 1 January 1777

BELL EDITION: BBT76–77 and 80.VIII

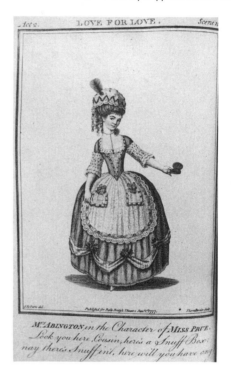

Colored drawing on vellum (10.2 × 7.9), full-length, standing, holding an open snuffbox in her extended left hand; wearing a dress with lace sleeves, a lace apron, and a hat with feather. Line engraving 14 × 8.9, with the quotation (II.2): "Look you here, Cousin, here's a Snuff Box; nay there's Snuff in't, here will you have any?"

LOCATION OF ORIGINAL: British Museum (Burney I, No. 10).

PROVENANCE: Bell sale, Christie's, 27 March 1793 (lot 1); bought, with four other drawings

by Roberts of Mrs Abington, for £1 15s. 6d. by Bowden.

RELATED: None.

Mrs Abington acted Miss Prue for the first time at Drury Lane Theatre on 23 December 1769. Probably the finest portrait of her is Reynolds's picture of her as Miss Prue, sitting in a chair; exhibited at the Royal Academy in 1771, it is now in the Yale Center for British Art (Paul Mellon Collection); an engraving by S. W. Reynolds was published in 1822.

# 84

### Frances Abington   1737–1815
as Widow Belmour in *The Way to Keep Him*

by Arthur Murphy

ARTIST: S. De Wilde

ENGRAVER: J. Thornthwaite

DATE PUBLISHED: 21 April 1792

BELL EDITION: BBT97.XVII

Full-length, standing in a room, holding a book in her raised left hand; wearing a dress with a long train and a hat with plumes. Line engraving 11.4 × 7.6, for Bell's British Library, with the line (III.1): "Oh blest with temper, whose unclouded ray, / Can make tomorrow as cheerful as today."

LOCATION OF ORIGINAL: Unknown.

PROVENANCE: Unknown.

RELATED: A line engraving in reverse (same size) by W. Esdell was also published.

Arthur Murphy's comedy *The Way to Keep Him* was first performed at Drury Lane Theatre on 24 January 1760, with Maria Macklin acting the Widow Belmour. Mrs Abington first played Widow Belmour at Drury Lane on 27 November 1765, upon her return to London after having acted six years in Ireland. Murphy was so pleased with her performance that he wrote a flattering letter and dedicated a new edition of the play to

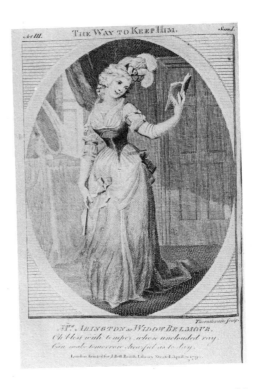

her. Johann Zoffany's portrait of her in this role is in the Egremont Collection at Petworth (the National Trust).

Frances Abington (as Clarinda). See also David Garrick, No. 165.

# 85

### Henry Angelo   1755–1835
as Mrs Cole in *The Minor*

by Samuel Foote

ARTIST: S. De Wilde

ENGRAVER: W. Leney

DATE PUBLISHED: 29 September 1792

BELL EDITION: BBT97.II

Oil on canvas (36.5 × 28), full-length, seated, full face; wearing a dress with lace skirt, bonnet, and shawl. Line engraving 10.16 × 7.62, for Bell's British Library, with the line (I):

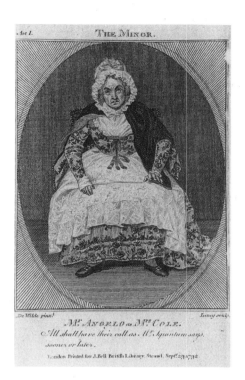

# 86

Giovanna Baccelli   d. 1801
Dancing in *Les Amans surpris*

by Louis Simonet

ARTIST: J. Roberts

ENGRAVER: J. Thornthwaite

DATE PUBLISHED: 15 May 1791

BELL EDITION: BBT97.XXI; BET92.XIV

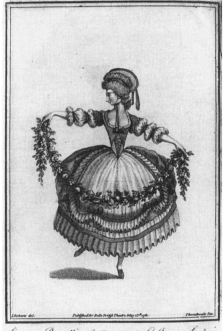

*Signora Baccelli in the Ballet (call'd) Les Amans Surpris*

"All shall have their call, as Mrs Squintum says, sooner or later."

LOCATION OF ORIGINAL: Garrick Club (Ash12, CKA253).

PROVENANCE: John Bell; Charles Mathews (No. 367).

RELATED: An anonymous engraving was printed for C. Cooke, 23 January 1809.

Henry Angelo, fencing master and amateur actor, played Mrs Cole (in his first and only appearance) on 29 March 1792 with the Drury Lane company at the King's Theatre. He was the son of Domenico Angelo, a riding and fencing master and a friend of Garrick. In his *Reminiscences* (1828), Henry offers information about the London theatres, especially his family's relationship to Garrick. The first performance of Foote's *The Minor* was at the Crow Street Theatre, Dublin, on 28 January 1760, with the author playing Mrs Cole; the London premiere was at the Haymarket Theatre on 28 June 1760, again with Foote playing Mrs Cole.

Full-length, head left, dancing, holding a garland of flowers; wearing a ribboned hat and a dress with panniered skirt with scalloped hem and narrow bodice. Stipple and line engraving 14.3 × 9.2, with the caption: "Signora Baccelli in the Ballet (call'd) Les Amans Surpris." In BET92.XIV, the engraving is placed before the text of *The Jovial Crew*.

LOCATION OF ORIGINAL: Unknown.

PROVENANCE: Unknown.

RELATED: None.

The Italian ballerina Giovanna Baccelli made her London debut at the King's Theatre on 8 November 1774 dancing in *Pirhame et Thisbe*. She continued to dance on the London stage until July 1788, and one of her last performances was in *Les Amans surpris* at the King's on 1 June 1786. She was the mistress of Frederick Sackville, Duke of Dorset, with whom she lived at Knole House, Kent. The full-length portrait of her dancing, by Gainsborough, once at Knole, came to the Tate Gallery in 1975.

# 87

Robert Baddeley   1733–1794
as Petulant in *The Way of the World*

by William Congreve

ARTIST: J. Roberts

ENGRAVER: J. Thornthwaite

DATE PUBLISHED: 5 April 1777

BELL EDITION: BBT76–77 and 80.XI

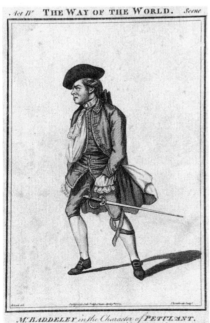

Mᴿ BADDELEY in the Character of PETULANT.
*Carry your Mistress's Monkey a Spider,
go flea Dogs and read romances,
I'll go to bed to my Maid.*

Full-length, striding to his right, sword at his left side; wearing breeches, waistcoat, coat, and hat. Line engraving 13.7 × 8.9, with the quotation (IV): "Carry your Mistress's Monkey a Spider, go flea Dogs and read romances, I'll go to bed to my Maid."

LOCATION OF ORIGINAL: Unknown.

PROVENANCE: Bell sale, Christie's, 27 March 1793 (lot 4); bought, with five other drawings in lot, for 12s. 6d. by C. Cooke.

RELATED: The version in the 1780 edition is engraved by Roberts.

Baddeley first acted Petulant in London on 9 January 1764 at Drury Lane Theatre.

# 88

Robert Baddeley   1733–1794
as Sir Harry Gubbin in *The Tender Husband*

by Richard Steele

ARTIST: S. De Wilde

ENGRAVER: P. Audinet

DATE PUBLISHED: 11 January 1791

BELL EDITION: BBT97.XX

Oil on canvas (34.3 × 26.35), full-length, standing to left, holding a cane in his right hand and a hat in his left, a table with papers and books on it at his right; wearing breeches, coat, and unbuttoned waistcoat. Line engraving 11.7 × 7.9, with the line (V.2): "Come, come, I wont be us'd thus."

LOCATION OF ORIGINAL: Garrick Club (Ash20, CKA264).

PROVENANCE: John Bell; Charles Mathews (No. 177).

RELATED: Another engraving by Audinet, dated 28 July 1791, is in the set of BBT97 at the Garrick Club. An anonymous engraving, after De Wilde, was printed for C. Cooke as a plate to *British Drama* (24 January 1807).

Ashton believes that the engraving was probably done from a drawing, not from the oil.

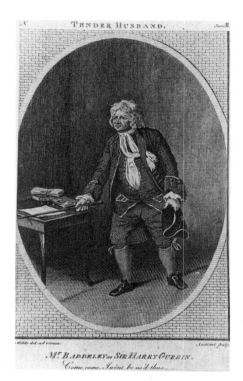

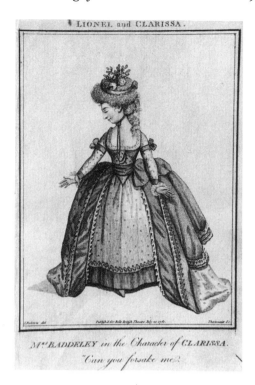

Baddeley first acted this role at Drury Lane Theatre on 6 April 1772.

# 89

## Sophia Baddeley 1745?–1786
as Clarissa in *Lionel and Clarissa*

by Isaac Bickerstaff

ARTIST: J. Roberts

ENGRAVER: J. Thornthwaite

DATE PUBLISHED: 20 July 1781

BELL EDITION: BBT80.XXI; BET92.XIV

Drawing, full-length, standing, profile to left, her arms extended downward at sides; wearing a richly embroidered panniered dress, a flat headpiece with small leaves on top, and profuse curly hair trailing down over her left shoulder. Line engraving 13.9 × 9.8, with the quotation: "Can you forsake me."

LOCATION OF ORIGINAL: Unknown.

PROVENANCE: Two drawings by Roberts of

Mrs Baddeley as Clarissa were in the sale of Bell's collection of original drawings at Christie's on 27 March 1793 (lot 4); bought with four other drawings in lot, for 12s. 6d. by C. Cooke.

RELATED: None.

Mrs Baddeley made her first appearance as Clarissa in Bickerstaff's comic opera on 8 February 1770 at Drury Lane Theatre.

# 90

## Sophia Baddeley 1745?–1786
as a Pastoral Nymph in *Comus*

by John Milton

ARTIST: J. Roberts

ENGRAVER: Not Engraved

DATE PUBLISHED: Not Published

Drawing, description unknown.

LOCATION OF ORIGINAL: Unknown.

PROVENANCE: A drawing of Mrs Baddeley described as a Pastoral Nymph in *Comus* was in the sale of Bell's collection of original drawings at Christie's on 27 March 1793 (lot 4); it was bought, with five other drawings in the lot, for 12s. 6d. by C. Cooke.

RELATED: None.

# 91

## Elizabeth Bannister   1757–1849
as Patty in *The Maid of the Mill*

by Isaac Bickerstaff

ARTIST: J. Roberts

ENGRAVER: J. Thornthwaite

DATE PUBLISHED: 29 March 1781

BELL EDITION: BBT80.XXI; BET92.XIV

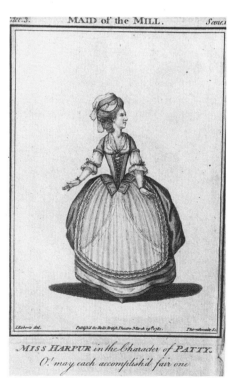

Drawing, full-length, standing, head in profile to right; wearing a full-skirted dress and a small hat with ribbon. Line engraving 14 ×

9.2, with the quotation (III.12): "O! may each accomplish'd fair one."

LOCATION OF ORIGINAL: Unknown.

PROVENANCE: Bell sale, Christie's, 27 March 1793 (lot 8); bought, with five other drawings in lot, for 15s. by C. Cooke.

RELATED: None.

While still Miss Harper, Elizabeth Bannister acted Patty the first time in London on 8 July 1778, at the Haymarket Theatre.

# 92

## John Bannister   1760–1836
as Ben in *Love for Love*

by William Congreve

ARTIST: S. De Wilde

ENGRAVER: W. Bromley

DATE PUBLISHED: 10 April 1791

BELL EDITION: BBT97.I

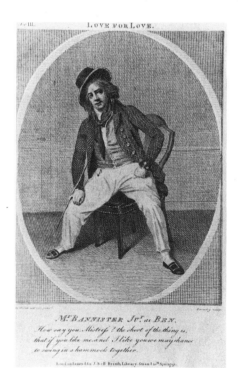

Colored drawing (4.5 × 6.8), full-length, seated to front, stick under his right arm; wearing a hat and a sailor's coat and trousers. Line engraving 11.4 × 7.9, for Bell's British Library, with Ben's line (III): "How say you, Mistress? the short of the thing is, that if you like me, and I like you we may chance to swing in a hammock together."

LOCATION OF ORIGINAL: British Museum (Burney I, No. 136).

PROVENANCE: John Bell.

RELATED: A stipple engraving (23.5 × 18.4) by J. Condé was also published by Bell, 1791.

Bannister acted Ben for the first time on 11 October 1788, at Drury Lane Theatre.

# 93

### John Bannister   1760–1836
as Gradus in *Who's the Dupe?*

by Hannah Cowley

ARTIST: S. De Wilde, 1795

ENGRAVER: E. Bell

DATE PUBLISHED: 1794

BELL EDITION: Issued Separately

Oil on canvas (74.5 × 56.5), full-length, standing to left, holding a black tricorn hat; wearing a black suit and a powdered wig. Mezzotint engraving 53.3 × 40.6.

LOCATION OF ORIGINAL: Garrick Club (Ash34).

PROVENANCE: E. Bell; Seymour Hicks; presented to the Garrick Club in 1987 by Francis Tufton.

RELATED: An engraving by C. Picart was published as a plate to the *Theatrical Inquisitor* (1 February 1782). An engraving (head and shoulders only) by Thomas Wright, after Thomas Charles Wageman, was published with Oxberry's *New English Drama* (1821).

This item does not seem to have been included by John Bell in his *British Theatre*.

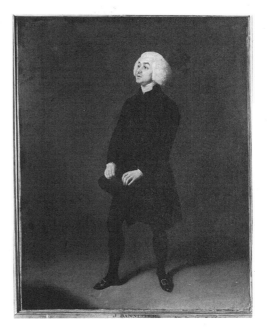

The painting, dated 1795, was done after the engraving appeared; the location of the drawing by De Wilde, from which the engraving would have been made, is unknown. Bannister first acted Gradus at Drury Lane Theatre on 22 October 1782. Mrs Cowley's comedy had its premiere at Drury Lane Theatre on 10 April 1779, when Thomas King acted Gradus.

# 94

### Caroline Barclay   [fl. 1792–1794]
as Olivia in *The Good-Natured Man*

by Oliver Goldsmith

ARTIST: S. De Wilde

ENGRAVER: W. Leney

DATE PUBLISHED: 8 September 1792

BELL EDITION: BBT97.XVII

Full-length, standing to right, her hands extended in gesture. Wearing a long dress with frilled collar and a sash around her waist. Wall flats in background. Line engraving 11.4 × 7.6, for Bell's British Library, with the

quotation (V): "I'm but too much the Cause of your suspicion."

LOCATION OF ORIGINAL: Unknown.

PROVENANCE: Unknown.

RELATED: None.

Miss Barclay seems never to have acted Olivia during her brief career on the London stage. After several appearances singing solo numbers, she made her debut in a singing role, Anna in *Dido, Queen of Carthage*, at Drury Lane Theatre on 23 May 1792. She had made only a few appearances when De Wilde used her for the subject of Olivia. In 1794 or soon after, she married a Mr Whalley and retired from the stage.

# 95

Ann Barry   1734–1801
as Athenais in *Theodosius*

by Nathaniel Lee

ARTIST: J. Roberts

ENGRAVER: J. Thornthwaite

DATE PUBLISHED: 12 December 1776

BELL EDITION: BBT76–77 and 80.VII; BET92.III

Full-length to front, standing to front, left profile, her arms extended to sides; wearing a small crown and feathers in her hair, and a richly decorated full-panniered dress. Line engraving 13.3 × 9.5, with the quotation (V.I): "So my Veranes till my death comes on, / Shall sad Eudosia my dear loss bemoan."

LOCATION OF ORIGINAL: Unknown.

PROVENANCE: Unknown.

RELATED: The reissue for BBT80 is dated March 1778 and does not name the engraver.

Born Ann Street at Bath in 1734, this actress married the provincial actor William Dancer in 1754. When Mrs Dancer, she made her debut in London as Desdemona on 8 August 1766 at the King's Theatre. On 19 September

M.ʳ and M.ʳˢ *Barry in the Character of* JAFFIER & BELVIDERA.
*Jaff: Hark the dismal Bell. Tolls out for Death.*

1766, at that theatre she acted Athenais. Sometime in the winter 1767–68, she married the fine actor Spranger Barry and became one of the leading actresses of the eighteenth century. After Barry's death in 1777, she married Thomas Crawford, a barrister turned actor, and performed as Mrs Crawford into the 1790s.

# 96

## Ann Barry 1734–1801 and Spranger Barry 1717?–1777
as Belvidera and Jaffeir in *Venice Preserv'd*

by Thomas Otway

ARTIST: J. Roberts

ENGRAVER: Collyer

DATE PUBLISHED: 10 April 1776

BELL EDITION: BBT76–77 and 80.I

Drawing, full-length, both standing, with profiles to left. Jaffeir, with legs apart and left

arm extended to his left with a dagger in his right hand, wears breeches and jacket and has a cloak draped from his left shoulder across the front of his body. Belvidera, with her right arm extended to her right, wears a long decorated dress and a feather in her headpiece. Line engraving 11.8 × 15.3, published with the quotation (V.2): "Jaff: Hark the dismal Bell Tolls out for Death."

LOCATION OF ORIGINAL: Unknown.

PROVENANCE: Bell sale, Christie's, 27 March 1793 (lot 2); bought with four other drawings of Mrs Barry by Roberts for 12s. 6d. by Serle.

RELATED: None.

Mrs Barry (when Mrs Dancer) first acted Belvidera in London on 13 August 1766 at the King's Theatre, with Barry as Jaffeir. Barry had first acted Jaffeir in London on 21 December 1752 at Drury Lane Theatre. In this role, Mrs Barry (later Mrs Crawford) was compared favorably to Mrs Siddons. The author of *A Review of Mrs Crawford and Mrs Siddons in the Character of Belvidera* pro-

claimed that "perhaps there never was a finer piece of acting seen, nor could Bedlam exhibit anything so superior" as her last moments in Belivdera, "when her hands are folded on her breasts, and she expires laughing." It was said that "no woman on the English stage possesses that exquisite manner of inflaming a lover's soul to vindicate her wrongs in so elevated a degree as Mrs Crawford."

## 97

Ann Barry  1734–1801
as Lady Randolph in *Douglas*

by John Home

ARTIST: J. Roberts

ENGRAVER: Not Engraved

DATE PUBLISHED: Not Published

Description unknown.

LOCATION OF ORIGINAL: Unknown.

PROVENANCE: A drawing by Roberts called "Mrs Barry as Lady Randolph" was in the sale of Bell's collections of drawings at Christie's on 27 March 1793 (lot 2); it was bought, with four other drawings of Mrs Barry by Roberts, for 12s. 6d. by Serle.

RELATED: None.

A portrait of Mrs Barry as Lady Randolph, engraved by Cook after Miller, was published as a plate to Lowndes's *New English Theatre* (1784), and an anonymous engraving of her as Lady Randolph was published by Harrison, 1780, as a plate to an edition of the play.

Ann Barry first acted Lady Randolph in London on 10 November 1768, at Drury Lane Theatre. It was one of her most effective roles, "which if not her theatrical chef d'oeuvre," wrote the *Morning Chronicle* of 3 June 1780, "is certainly one of her most capital exhibitions." According to James Boaden, her moments of passion as Lady Randolph "checked your breathing" and "made rows of spectators start from their seats."

## 98

Ann Barry  1734–1801
as Mariamne in *Herod and Mariamne*

by Elijah Fenton (after Samuel Pordage)

ARTIST: J. Roberts

ENGRAVER: J. Thornthwaite

DATE PUBLISHED: 14 August 1777

BELL EDITION: BBT76–77 and 80.XIV

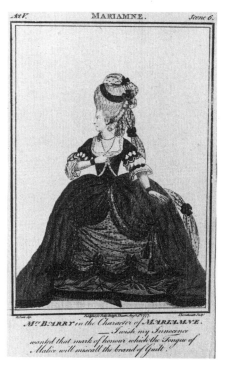

Full-length, standing to front, left profile, her right hand on breast, her hair piled high with ribbon round it at the top and a long scarf trailing from the back; wearing a panniered dress with skirt decorated with dots and ribbons. Line engraving 14.3 × 9.5, with the quotation (V.6): "I wish my Innocence wanted that mark of honour which the Tongue of Malice will miscall the brand of Guilt."

LOCATION OF ORIGINAL: Unknown.

PROVENANCE: Unknown.

RELATED: An engraving by W. Leney was published in BBT97. See No. 99.

Mrs Barry first acted Mariamne in London on 20 March 1770, to Barry's Herod, at Drury Lane Theatre.

# 99

## Ann Barry  1734–1801
as Mariamne in *Herod and Mariamne*

by Elijah Fenton (after Samuel Pordage)

ARTIST: J. Roberts

ENGRAVER: W. Leney

DATE PUBLISHED: 20 December 1794

BELL EDITION: BBT97.XXVI

Full-length, standing, left profile, her right hand on breast, wearing a full-skirted long dress with short sleeves and a shawl draped over her right arm, round the back of her neck, and down her left side. Line engrav-

ing 11.8 × 7.9, with the quotation (V.6): "I wish my Innocence."

LOCATION OF ORIGINAL: Unknown.

PROVENANCE: Unknown.

RELATED: An earlier engraving by Thornthwaite was published in BBT 76–77 and 80. See No. 98.

# 100

## Ann Barry  1734–1801
as Phaedra in *Phaedra and Hippolitus*

by Edmund Smith

ARTIST: J. Roberts

ENGRAVER: J. Thornthwaite

DATE PUBLISHED: 1 March 1777

BELL EDITION: BBT76–77 and 80.X

Drawing, full-length, standing to front, left profile, holding a sword in her right hand, her left arm upraised; wearing a wide and

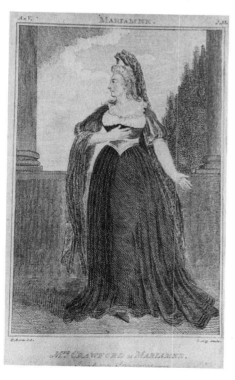

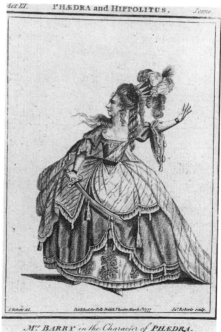

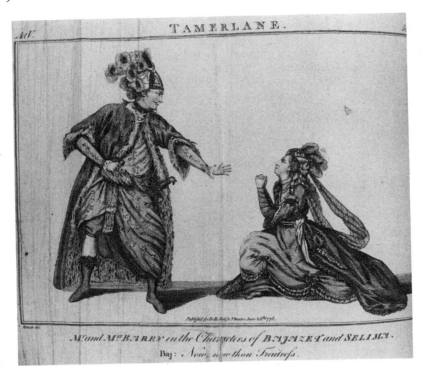

M.ʳ and M.ʳˢ BARRY in the Characters of BAJAZET and SELIMA.
Baj: *Now, now thou Traitress.*

richly decorated dress with several layers; there are tall feathers in her crown, which sits upon high-piled hair. Line engraving 14 × 9.5, with the quotation: "Now, all ye kindred Gods, look down and see / How I'll revenge you, and myself for Phaedra."

LOCATION OF ORIGINAL: Unknown.

PROVENANCE: Bell sale, Christie's, 27 March 1793 (lot 2); bought, with four other drawings in lot, for 12s. 6d. by Serle.

RELATED: None.

Mrs Barry first acted Phaedra in London on 21 April 1774, for her benefit, at Drury Lane Theatre.

# 101

## Ann Barry  1734–1801 and Spranger Barry  1717?–1777

as Selima and Bajazet in *Tamerlane*

by Nicholas Rowe

ARTIST: J. Roberts

ENGRAVER: J. Thornthwaite

DATE PUBLISHED: 24 June 1776

BELL EDITION: BBT76–77 and 80.III; BET92.I

Selima at right kneels before Bajazet, her hands clasped; she wears a long flowing dress and a feathered headpiece. Bajazet stands at left; he wears an Eastern costume, with feathered headpiece. Line engraving 13.7 × 19, with Bajazet's line (V): "Now, now thou Traitress."

LOCATION OF ORIGINAL: Unknown.

PROVENANCE: Unknown.

RELATED: None.

Ann Barry seems not to have acted Selima. When the play was performed at Drury Lane Theatre in the 1770s, her sister-in-law Jane Barry usually played the role. But, from the features of the woman's profile in this print, it appears that the artist—who did several other pictures of Ann Barry—intended to show her as Selima, probably because of her greater

popularity. Spranger Barry acted Bajazet for the first time in London on 4 November 1747, at Drury Lane. He had played the role in Dublin as early as 1745–46.

# 102

## Ann Barry　1734–1801
as Sophonisba in *Sophonisba*

by James Thomson

ARTIST: J. Roberts

ENGRAVER: J. Thornthwait

DATE PUBLISHED: 1 January 1778

BELL EDITION: BBT76–77 and 80.XVIII

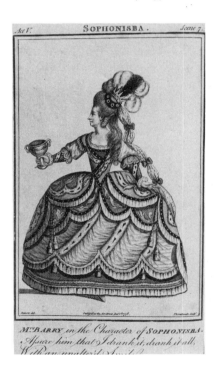

Drawing, full-length, standing to front, left profile, holding a goblet in her right hand; wearing a richly decorated dress, hair piled high, with crown and feathers. Line engraving 14.3 × 9.2, with the quotation (I.7): "Assure him that I drank it, drank it all, / With an unalter'd smile."

LOCATION OF ORIGINAL: Unknown.

PROVENANCE: Bell sale, Christie's, 27 March 1793 (lot 2); bought with four other drawings of Mrs Barry in lot for 12s. 6d. by Serle.

RELATED: None.

Mrs Barry did not play Sophonisba in London; the play was not performed there during her career.

**Spranger Barry.** See Ann Barry, Nos. 96, 101.

# 103

## Richard Barry, Seventh Earl of Barrymore,　1769–1793, and Captain George Wathen　1762–1849
as Scrub and Archer in *The Beaux' Stratagem*

by George Farquhar

ARTIST: S. De Wilde

ENGRAVER: P. Audinet

DATE PUBLISHED: 6 August 1791

BELL EDITION: BBT97.X

Full-length, in a room, seated beside each other on separate chairs; Scrub on left, with curly hair, his hands on thighs, is dressed in livery; Archer on right, legs crossed, with his right hand on Scrub's left shoulder, is dressed as a gentleman. Line engraving 11.7 × 8.9, with the quotation (III.3): "Archer . . . *But what ladies are those?*"

LOCATION OF ORIGINAL: Private collection, New York.

PROVENANCE: This painting was exhibited (but not offered for sale) at the sale of Bell's collection at Christie's on 27 March 1793.

RELATED: A large engraving (27.3 × 22.2) by W. Leney was published by Bell, 1791: "Engraved by Leney from the original Picture painted from Life by De Wilde . . . from the Comedy of the Beaux Stratagem in the Celebrated Edition of Bell's British Theatre which is now publishing Periodically."

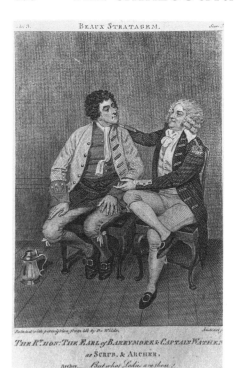

The eccentric and extravagant Seventh Earl of Barrymore, who had been part owner of the Royal Circus in St George's Fields in the 1780s and had appeared as Bobadil in *Every Man in His Humour* on the Brighton stage, opened his private theatre at Wargrave on 26 January 1789. On 7 August 1789, at Wargrave he acted Scrub, and Captain Wathen, another amateur, acted Archer. They appeared in the same roles in 1790 at a theatre in Savile Row that Barrymore had remodeled from Squib's Auction Rooms. See Sybil Rosenfeld, *Temples of Thespis: Some Private Theatres and Theatricals in England and Wales, 1700–1820* (London: Society for Theatre Research, 1978), pp. 16–33.

# 104

George Ann Bellamy   1731?–1788
as The Comic Muse

ARTIST: J. H. Ramberg (and F. Cotes)

ENGRAVER: F. Bartolozzi

DATE PUBLISHED: 5 June 1785

BELL EDITION: Issued Separately

Drawing, three-quarter length, standing beside drapery, holding a mask in her left hand;

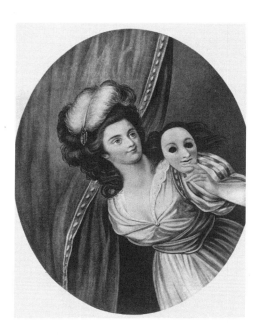

she has a feather in hair and wears a dress with V neck and a sash around the waist. Stipple engraving 9.2 × 7, "Printed for John Bell. British Library June 5th 1785."

LOCATION OF ORIGINAL: Unknown.

PROVENANCE: In the sale of Bell's drawings at Christie's on 27 March 1793 (lot 18) was a drawing of Mrs Bellamy by Ramberg; it was bought for £1 1s. by C. Cooke.

RELATED: Other engravings are by Sands (n.d.) and by MacKenzie, after Ramberg, and published by T. Hurst as a plate to *Eccentric Biography* (1 January 1803); an engraving in reverse by F. Maradan, after Benoist, was published with the title "Actrice du Theatre de Covent-Garden."

According to the Harvard Theatre Collection and British Museum catalogs of engraved portraits, a portrait by Cotes and Ramberg of Mrs Bellamy as the Comic Muse, 1785, was

published for *Bell's British Theatre*, but this engraving was issued separately and was published as a frontispiece to a play.

# 105

## Robert Bensley   1742–1817
as Busiris in *Busiris*

by Edward Young

ARTIST: J. Roberts

ENGRAVER: J. Thornthwaite

DATE PUBLISHED: 24 October 1777

BELL EDITION: BBT76–77 and 80.XVI; BET92.VII

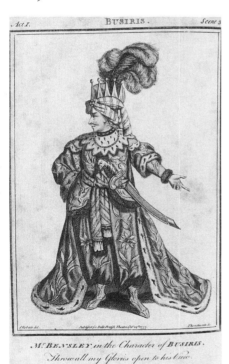

*Mr BENSLEY in the Character of BUSIRIS.*
*Throw all my Glories open to his View.*

Drawing full-length, standing to front, his left arm extended in gesture; wearing rich Eastern garb, a crown with tall feathers, and a sword at his left side. Line engraving 14 × 9.5, with the quotation (I.3): "Throw all my Glories open to his View."

LOCATION OF ORIGINAL: Unknown.

PROVENANCE: Bell sale, Christie's, 27 March 1793 (lot 3); bought with five other drawings by Roberts in lot for 11s. by C. Cooke.

RELATED: None.

An anonymous portrait of Bensley as Busiris was published by Harrison & Co, 1781. Edward Young's *Busiris* was not performed in London during the period of Bensley's career.

# 106

## Robert Bensley   1742–1817
as Harold in *The Battle of Hastings*

by Richard Cumberland

ARTIST: S. De Wilde

ENGRAVER: P. Audinet

DATE PUBLISHED: 23 February 1793

BELL EDITION: BBT97.VI

Oil on canvas (36.8 × 28.3), full-length, standing, with his legs crossed at ankles, and his

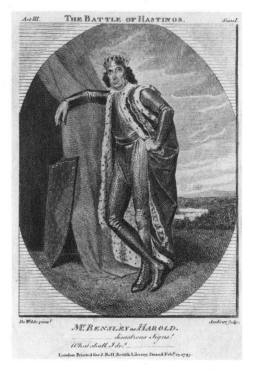

*Mr BENSLEY as HAROLD.*
*disastrous Signs!*
*What shall I do?*
London Printed for J. Bell, British Library, Strand Feb.y 23 1793

right arm resting on the outside of a royal tent; wearing a crown and a long ermine-trimmed cloak. Line engraving 11.4 × 9.5, with the quotation (III.1): "—Disastrous Signs! / What shall I do?—"

LOCATION OF ORIGINAL: Garrick Club (Ash55, CKA251).

PROVENANCE: John Bell; Charles Mathews (No. 181).

RELATED: None.

Bensley was the original Harold in the premiere of Cumberland's play at Drury Lane Theatre on 24 January 1778.

# 107

## Robert Bensley 1742–1817
as Mahomet in *Mahomet*

by James Miller

ARTIST: J. Roberts

ENGRAVER: J. Thornthwaite

DATE PUBLISHED: 1 December 1776

BELL EDITION: BBT76–77 and 80.VII; BET92.III

Drawing, full-length, standing, facing to his left, holding a scimitar in his right hand; wearing a long flowing fur-trimmed Eastern garb and a turban with tall feathers and pearls. Line engraving 13.3 × 9.5, with the quotation (V.5): "—Such be the fate of all who braves our Law." The two engravings are identical, except that in the BBT76–77 the publication date is "Dec^r 1^st 1776," and BBT80 prints "Dec 1.1776".

LOCATION OF ORIGINAL: Unknown.

PROVENANCE: Bell sale, Christie's, 27 March 1793 (lot 3); bought, with five other drawings in lot, for 11s. by C. Cooke.

RELATED: None.

A line engraving (13 × 8.6) by J. Collyer, after E. Edwards, of Bensley as Mahomet was published by Lowndes as a plate to *New English*

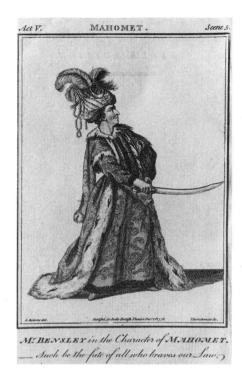

*MR BENSLEY in the Character of MAHOMET.*
*— Such be the fate of all who braves our Law.*

*Theatre* (1777). Bensley first acted Mahomet on 25 November 1765, at Drury Lane Theatre. He had made his debut at that theatre about seven weeks earlier, on 2 October 1765, as Pierre in *Venice Preserv'd*.

# 108

## Robert Bensley 1742–1817
as Oakly in *The Jealous Wife*

by George Colman the Elder

ARTIST: S. De Wilde

ENGRAVER: P. Audinet

DATE PUBLISHED: 27 October 1792

BELL EDITION: BBT97.XX

Oil on canvas (36 × 27.2), full-length, standing, looking to his left; wearing a coat, waistcoat, and breeches; interior background, fireplace to right. Line engraving 11.4 × 8.6, with Oakly's line (II.2): "—Lord this is the strangest Misapprehension. I am quite astonished."

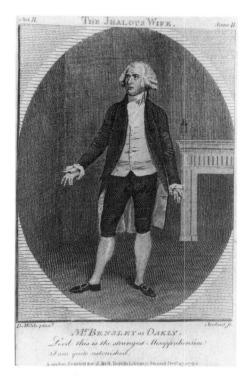

LOCATION OF ORIGINAL: Garrick Club (Ash56, CKA432).

PROVENANCE: John Bell; Charles Mathews (No. 174).

RELATED: An anonymous engraving was printed for C. Cooke, 2 April 1807, and was published in *British Drama* (1817); an engraving by Ferguson was published in Dublin by W. Jones.

Bensley acted Oakly at the Haymarket Theatre on 18 June 1779. Colman's *The Jealous Wife* had its premiere at Drury Lane Theatre on 12 February 1761, with David Garrick as Oakly.

# 109

### Robert Benson 1765–1796
as Timurkan in *The Orphan of China*

by Arthur Murphy

ARTIST: J. Graham

ENGRAVER: B. Reading

DATE PUBLISHED: 11 February 1797

BELL EDITION: BBT97.XIV

Full-length, standing, his right hand at breast; wearing Eastern garb, a feathered tur-

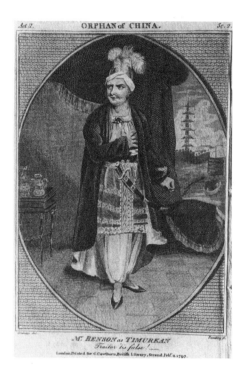

ban, and a sword at front waist; inside a large tent with ship in harbor seen through opening. Line engraving 12.4 × 8.9, for Cawthorn's British Library, with the quotation (II.2): "Traitor 'tis false!—"

LOCATION OF ORIGINAL: Unknown.

PROVENANCE: This portrait was in the sale of Bell's collection at Leigh & Sotheby's on 25 May 1805 (lot 269), when the actor was incorrectly called "Bensley."

RELATED: None.

Benson seems not to have acted Timurkan during his career on the London stage. Never a principal actor, Benson played a number of secondary roles in the London theatres between 1778 and 1790. In May of the latter year, in a fit of madness, he killed himself by

jumping from the top of a house in Bridges Street.

# 110

## John Bernard   1756–1828

as Jack Meggot in *The Suspicious Husband*

by Benjamin Hoadly

ARTIST: S. De Wilde

ENGRAVER: J. Corner

DATE PUBLISHED: 12 November 1791

BELL EDITION: BBT97.IV

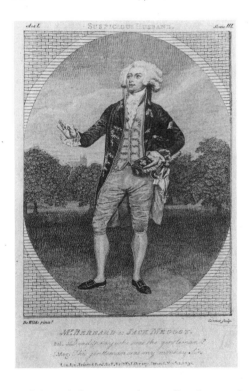

Full-length (36.2 × 26.7), standing in a park, looking to left, with a hat under his left arm and a snuffbox in his left hand; wearing a curly wig, also fine breeches, coat, and waistcoat. Line engraving 11.4 × 8, for Bell's British Library, with the quotation (I.3): "Bel. *Dead! pray who was the gentleman?* / J. Meg. *This gentleman was my monkey, Sir.*"

LOCATION OF ORIGINAL: Garrick Club (Ash64, CKA235).

PROVENANCE: John Bell; Charles Mathews (No. 386).

RELATED: An engraving by Maguire appeared as a plate to *British Theatre* (1794), published by W. Jones in Dublin; a copy was printed for C. Cooke, 20 January 1808, and was published as a plate to *British Drama* (1817).

Bernard first acted Jack Meggot in London on 2 January 1788 at Covent Garden Theatre. After a modest career in London, he went to America, in 1797, where he became a popular performer. His American experiences are chronicled in his two-volume *Retrospections of the Stage*, brought out by his son Bayle Bernard in 1830.

# 111

## Elizabeth Billington   1765 (or 1768)–1818

as Rosetta in *Love in a Village*

by Isaac Bickerstaff

ARTIST: R. Westall

ENGRAVER: J. Thornthwaite

DATE PUBLISHED: 28 September 1790

BELL EDITION: BBT97.XIII

Drawing (10.2 × 8) oval, full-length, standing in a park, with a fan in her left hand; wearing a long dress with overskirt. Line engraving 10.8 × 8, for Bell's British Library.

LOCATION OF ORIGINAL: Unknown.

PROVENANCE: Sotheby's, 20 June 1956 (lot 24).

RELATED: An engraving by Brocas was published in Dublin by W. Jones as a plate to *British Theatre* (1791); a similar picture, with a necklace added, engraved by Thornthwaite, and "Drawn by Westall R. A.," was printed for C. Cooke as a plate to *British Drama*

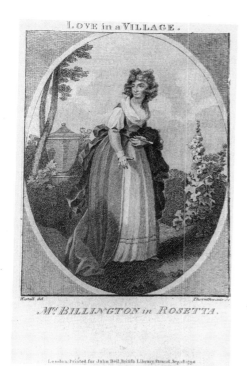

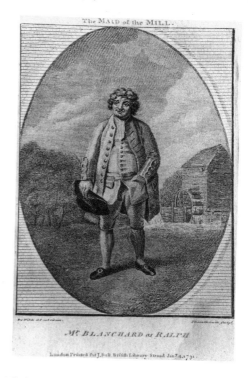

(1817), in decorated oval, with the quotation (I.2): "My heart's my own, my will is free / And so shall be my voice."

Mrs Billington made her first appearance in London in a dramatic role as Rosetta on 13 February 1786, at Covent Garden Theatre. Other portraits of Mrs Billington as Rosetta include an engraving by Alais published by J. Roach, 1801; an engraving by Alais, after Linsell, and published by J. Roach, 1802; and an anonymous engraving, undated.

# 112

## Thomas Blanchard 1760–1797
as Ralph in *The Maid of the Mill*

by Isaac Bickerstaff

ARTIST: S. De Wilde

ENGRAVER: J. Thornthwaite

DATE PUBLISHED: 4 January 1791

BELL EDITION: BBT97.VIII

Oil on canvas (36.5 × 28.2), full-length, standing to front, with a hat in his right hand, and his left hand in coat pocket; water mill and trees in background. Line engraving 10.8 × 8, for Bell's British Library.

LOCATION OF ORIGINAL: Garrick Club (Ash71, CKA258).

PROVENANCE: John Bell; then owned by Charles Mathews and No. 211 in the *Mathews Catalogue*. No. 374 in that catalog was a watercolor drawing by De Wilde of the same subject (37 × 23.5); that watercolor also is now in the Garrick Club (Ash72, CKA45E).

RELATED: An engraving by W. Leney was published by Bell, 29 May 1792: "Engraved by Leney, from the original Picture from life by De Wilde, from the Maid of the Mill by Bickerstaffe, in the Celebrated Edition of Bell's British Theatre, which is now publishing Periodically." An engraving by H. Brocas was published by W. Jones in Dublin.

This Thornthwaite engraving is the earliest dated plate for the De Wilde portraits for

*Bell's British Theatre.* Ashton believed that the original engraving by Thornthwaite was done from a drawing (probably Ash72 in the Garrick Club). Blanchard's name seems to have appeared in the bills for this role for the first time on 12 December 1789, at Covent Garden Theatre.

# 113

## Maria Theresa Bland   1770–1838
as Mary Ann in *The School for Guardians*

by Arthur Murphy

ARTIST: J. Graham

ENGRAVER: P. Audinet

DATE PUBLISHED: 21 January 1797

BELL EDITION: BBT97.XXXIII

Full-length, standing in a room with a sofa and a display of jars and plates; holding a cup and ball in her right hand and wearing a long

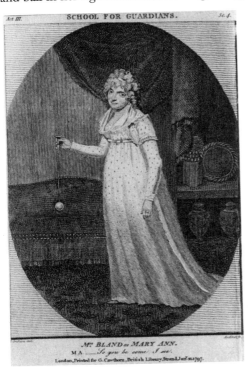

*Mʳˢ BLAND as MARY ANN.*
M A. — *So you be come! I see.*
London, Printed for G. Cawthorn, British Library, Strand, Janʸ 21, 1797.

dress decorated with dots. Line engraving 11.4 × 8.3, for Cawthorn's British Library, with Mary Ann's line (III.4): "—So you be come I see."

LOCATION OF ORIGINAL: Unknown.

PROVENANCE: Bell sale, Leigh & Sotheby's, 25 May 1805 (lot 281).

RELATED: None.

Mrs Bland did not perform this role in London; Murphy's play was not acted there in the eighteenth century after 1777. Maria Theresa Bland, née Tersi, began her stage career in 1773 at about the age of four. In October 1791, she married the actor George Bland. Described as "perfect as an English ballad-singer," she was a principal performer in musical dramas through 1821–22.

# 114

## Maria Theresa Bland   1770–1838
as Miss Notable in *The Lady's Last Stake*

by Colley Cibber

ARTIST: S. De Wilde

ENGRAVER: W. Leney

DATE PUBLISHED: 23 June 1795

BELL EDITION: BBT97.XXIV

Full-length, standing in a room, looking front, holding a fan in her left hand; wearing a bonnet with a tall feather and a long dress with a sash at the bodice. Line engraving 11.1 × 7.6, for Bell's British Library, with the quotation (III.1): "Miss Not . . . *So! this has been a day of business.*"

LOCATION OF ORIGINAL: Unknown.

PROVENANCE: Bell sale, Leigh & Sotheby's, 25 May 1805 (lot 278); possibly the portrait of Maria Bland that was in the Royal Dramatic College sale at Fairbrother, Lye, and Palmer on 24 February 1881 (lot 100C).

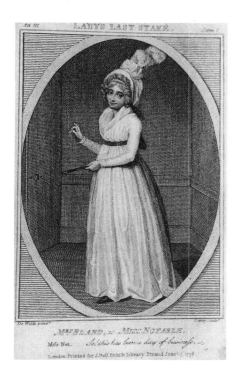

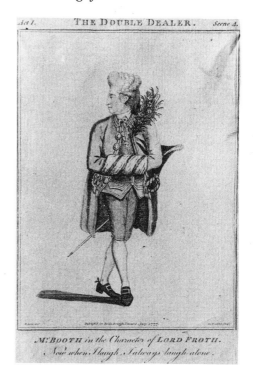

RELATED: None.

Mrs Bland did not perform this role in London.

# 115

## Cockran Joseph Booth d. 1789
as Lord Froth in *The Double Dealer*

by William Congreve

ARTIST: J. Roberts

ENGRAVER: D. Reading

DATE PUBLISHED: July 1777

BELL EDITION: BBT76–76 and 80.XIII; BET92.II

Drawing, full-length, standing with legs crossed at knees, head turned to his right, curled hairstyle, hands in muff; wearing a dandified suit, with a plume on the left shoulder of the coat. Line engraving 13.3 × 9.3,

with the quotation (I.4): "Now when I laugh, I always laugh alone."

LOCATION OF ORIGINAL: Unknown.

PROVENANCE: Bell sale, Christie's, 27 March 1793 (lot 3); bought, with five other drawings in lot, for 11s. by C. Cooke.

RELATED: A large copy (24.3 × 15.8) in pencil and watercolor by Sylvester Harding, after Roberts, is in the Garrick Club (Ash 84) (provenance: Charles Mathews).

Booth first acted Lord Froth in London on 5 March 1776 at Covent Garden Theatre. During Booth's career on the London stage between 1774 and 1789, he specialized in older characters in comedy. Though when Booth died, one critic wrote unkindly, "Whatever may be his loss to society as a man, the Stage would not suffer by his death as an actor," most obituary notices accounted him an actor of varied and respectable talents.

# 116

## William Brereton  1751–1787
as Don Alonzo in *The Revenge*

by Edward Young

ARTIST: J. Roberts

ENGRAVER: Anonymous

DATE PUBLISHED: June 1777

BELL EDITION: BBT76–76 and 80.XII

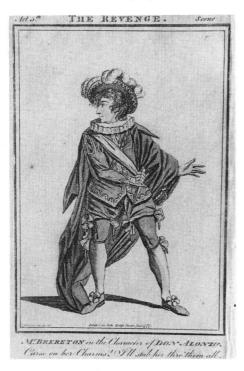

Drawing, full-length, standing, face almost profile left, holding dagger in right hand across his body, left hand extended to his left; wearing "Elizabethan costume," with long cloak and hat with feathers. Line engraving 14 × 8.9, with the quotation (V): "Curse on her Charms!" I'll stab her thro' them all."

LOCATION OF ORIGINAL: Unknown.

PROVENANCE: Bell sale, Christie's, 27 March 1793 (lot 3); bought, with five other drawings in lot, for 11s. by C. Cooke.

RELATED: None.

Brereton first acted Don Alonzo on 24 April 1783 at Drury Lane Theatre. Most reviews and commentary on Brereton's career indicate that he was an actor of little merit, whom William Hawkins labeled "inferior" and Francis Gentleman called a "cypher." Debilitated by drink and mental instability, Brereton died in a Hoxton asylum in 1787

Priscilla Brereton (Mrs William Brereton). See Priscilla Hopkins, No. 36.

# 117

## Mrs Brooks  [fl. 1786–1794]
as Leonora *The Revenge*

by Edward Young

ARTIST: S. De Wilde

ENGRAVER: J. Chapman

DATE PUBLISHED: 9 March 1793

BELL EDITION: BBT97.VIII

Full-length (37.7 × 28.4), walking, her arms extended to front; wearing a long dress with a sash at the waist, a ruff at the neck, and a long veil hanging down from the back of her head; a balustrade to right, with trees in background. Line engraving 10.8 × 8.6, for Bell's British Library, with the quotation (IV): "—Your sighs are mine, my Lord / And I shall feel them all."

LOCATION OF ORIGINAL: Garrick Club (Ash95, CKA241).

PROVENANCE: John Bell; Charles Mathews (No. 80).

RELATED: None.

Mrs Brooks did not play the role of Leonora in London during the summers she acted there, at the Haymarket Theatre, from 1786 to 1794. In the Garrick Club copy of BBT97, this engraving and *The Revenge* are bound in

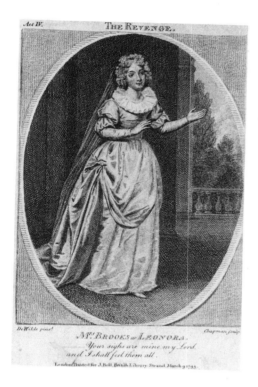

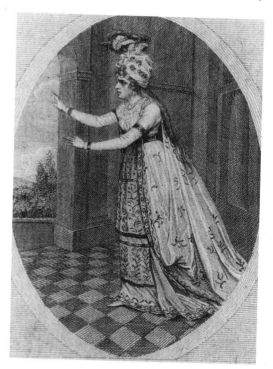

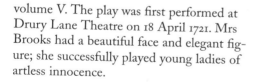

volume V. The play was first performed at Drury Lane Theatre on 18 April 1721. Mrs Brooks had a beautiful face and elegant figure; she successfully played young ladies of artless innocence.

**Miss Brown.** See Ann Cargill, No. 124.

# 118

## Anne Brunton   1769–1808
as Alzira in *Alzira*

by Aaron Hill

ARTIST: S. De Wilde

ENGRAVER: W. Leney

DATE PUBLISHED: 7 January 1792

BELL EDITION: BBT97.VII

Oil on canvas (35.5 × 27.3), full-length, walking to left toward an arch through which can be seen a landscape, hands outstretched; wearing a turban, dress, and mantle embroidered with flowers and leaves. Line engraving 10.8 × 7.6.

LOCATION OF ORIGINAL: Garrick Club (Ash96, CKA457).

PROVENANCE: John Bell; probably lot 67 in Thomas Harris sale, Robins, 12 July 1819; Charles Mathews (No. 91).

RELATED: None.

When Mrs Merry, she did not act this role in London; Hill's *Alzira* was not performed there after 1759 (the first performance was at Lincoln's Inn Fields Theatre on 18 June 1736, when Mrs Giffard played Alzira). Anne Brunton married the Della Cruscan poet Robert Merry on 22 August 1791. She retired from London in June 1792 but later was recruited by Thomas Wignell for his company in America, where she became a principal actress. In January 1803, she married Wignell and later in August 1806 married

the American actor-manager William Warren.

# 119

## Anne Brunton   1769–1808
as Calista in *The Fair Penitent*

by Nicholas Rowe

ARTIST: S. De Wilde

ENGRAVER: P. Audinet

DATE PUBLISHED: 17 March 1791

BELL EDITION: BBT97.III

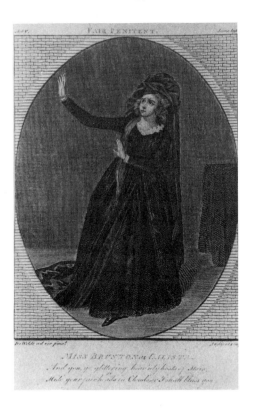

Full-length, standing, facing and looking left, her arms extended to her right, her hair hanging over her right shoulder; wearing a long dress with a train, and a hat from which hangs a long fabric down her back. Line engraving 11.1 × 7.6, for Bell's British Library, with Calista's line (V.1): "And you, ye glitt'ring heavenly host of stars, / Hide your fair heads in Clouds, or I shall blast you."

LOCATION OF ORIGINAL: Unknown.

PROVENANCE: Unknown.

RELATED: A larger copy (line 23.8 × 17.8), engraved by J. Corner, was published by J. Bell, 1792. A copy engraved by Brocas, after De Wilde, was published in Dublin by W. Jones.

After acting in Bristol and Bath in 1785, at the age of sixteen Anne Brunton made her debut at Covent Garden Theatre as Horatia in *The Roman Father* on 17 October 1785. She first acted Calista on 27 November 1786, at which time she was faulted by the critics as being too young to understand the role. See No. 118.

# 120

## Anne Brunton   1769–1808
as Horatia in *The Roman Father*

by William Whitehead

ARTIST: R. Cosway

ENGRAVER: W. Leney

DATE PUBLISHED: 20 October 1792

BELL EDITION: BBT97.III

Full-length, standing, her left hand pointing to a scarf in her right hand; wearing a long dress and feathered headpiece; columns behind her, and a sky is seen at left. Line engraving 10.8 × 7.6, for Bell's British Library, with the line (III.2): "Yes, thou dear pledge, design'd for happier hours."

LOCATION OF ORIGINAL: Unknown.

PROVENANCE: Unknown.

RELATED: This engraving is not included in the British Library set of BBT97, but it is found in the set of that edition in the Garrick

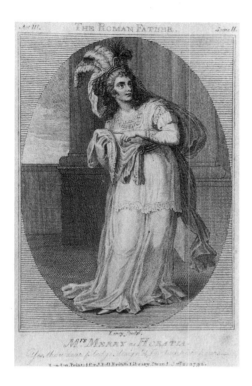

Club Library and in a randomly bound set at the Folger Library (PR1241, B46 cage). A similar engraving (9.3 × 7) by F. Bartolozzi, after Cosway, had been published by J. Bell in 1785, earlier than the Leney engraving. An engraving, in reverse (12.4 × 8.9), by D. Edwin was published as a plate to the *Philadelphia Monthly Magazine*, April 1798; another copy, by an anonymous engraver, similar to the preceding, was also issued.

Anne Brunton made her London debut in this character on 17 October 1785, at Covent Garden Theatre. She had played the role at Bath and Bristol the previous summer. John Haselwood in *Secret History of the Green Rooms* (1790) reported she was hailed as "a phenomenon in the theatrical hemisphere," and the *Thespian Dictionary* described her at her London debut—which was met with "incessant exclamations of rapture and applause"—as possessing "a voice of much sweetness, and eyes of great expression."

# 121

Mary Bulkley   1748–1792
as Angelina in *Love Makes a Man*

by Colley Cibber

ARTIST: J. Roberts

ENGRAVER: J. Thornthwaite

DATE PUBLISHED: 20 October 1776

BELL EDITION: BBT76–77 and 80.VI

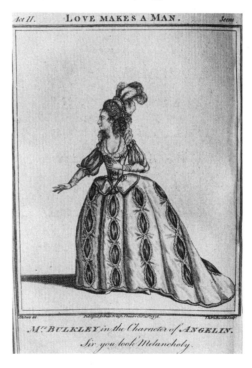

Full-length, standing, her right arm extended, her left hand in front touching a crucifix hanging from a chain around her neck; wearing a decorated full skirt and a hat spouting tall feathers. Line engraving 13.3 × 9.8, with the quotation (II): "Sir you look Melancholy."

LOCATION OF ORIGINAL: Unknown.

PROVENANCE: Unknown.

RELATED: The same engraving was published in April 1778 for BBT80.

Mrs Bulkley first acted Angelina on 16 December 1768 at Covent Garden Theatre. A spirited and talented actress, Mrs Bulkley was praised by Francis Gentleman in *The Dramatic Censor* (1770) in such roles as Angelina for her "very amiable appearance, easy deportment, and unaffected delivery."

# 122

## Mary Bulkley 1748–1792
as Lady Dainty *The Double Gallant*

by Colley Cibber

ARTIST: J. Roberts

ENGRAVER: J. Thornthwaite

DATE PUBLISHED: 17 July 1777

BELL EDITION: BBT76–77 and 80.XIII.

Colored drawing on vellum (11.4 × 7.6), full-length, standing, her right arm extended; wearing a long dress with a richly decorated full skirt, feathers in hair, with a chain of flowers hanging from hair and wrapped around her body. Line engraving 13.7 × 9.2, with the quotation (III.2): "An Ironmonger's Wife have the Spleen! thou might'st as well have said her husband was a fine Gentleman."

LOCATION OF ORIGINAL: British Museum (Burney II, No. 73).

PROVENANCE: Unknown.

RELATED: None.

Mary Bulkley seems not to have performed this character in London.

# 123

## Mary Bulkley 1748–1792
as Mrs Wilding in *The Gamesters*

by David Garrick, adapted from James Shirley

ARTIST: J. Roberts

ENGRAVER: J. Thornthwaite

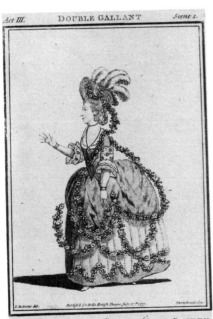

Mrs BULKLEY in the Character of LADY DAINTY.
An Ironmongers Wife have the Spleen! thou mightst as well have said her husband was a fine Gentleman.

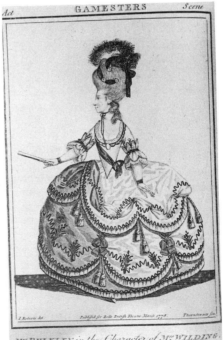

Mrs BULKLEY in the Character of Mrs WILDING

DATE PUBLISHED: March 1778

BELL EDITION: BBT76–77 and 80.XI

Full-length, standing, head turned to her right, holding a fan in her extended right hand; wearing a dress with a wide brocaded skirt, a plume in her high-piled hair. Line engraving 13.7 × 8.6.

LOCATION OF ORIGINAL: Unknown.

PROVENANCE: Unknown.

RELATED: An engraving by E. Roffe was done in 1878.

Mary Bulkley acted this role for the first time on 5 October 1782, at Drury Lane Theatre.

# 124

Ann Cargill    ca. 1759–1784
as Mandane in *Artaxerxes*

by Thomas Arne

ARTIST: J. Roberts

ENGRAVER: Not Engraved

DATE PUBLISHED: Not Published

Description unknown.

LOCATION OF ORIGINAL: Unknown.

PROVENANCE: A drawing called "Miss Brown as Mandane" in *Artxerxes* was in the sale of Bell's collection at Christie's on 27 March 1793 (lot 3); it and five other drawings in the lot were bought for 11s. by C. Cooke.

RELATED: None.

Ann Cargill (when Miss Brown) first sang Mandane on 31 January 1777 at Covent Garden Theatre, replacing Miss Catley in the role. This portrait by Roberts was not engraved. Bell did not publish the text of *Artaxerxes*; but in BBT80, a portrait of Miss Prudom as Arbaces in that piece was placed with the text of *Love in a Village*.

# 125

Ann Cargill    ca. 1759–1784
as Polly in *Polly*

by John Gay

ARTIST: J. Roberts

ENGRAVER: Anonymous

DATE PUBLISHED: February 1777

BELL EDITION: BBT76–77 and 80.IX

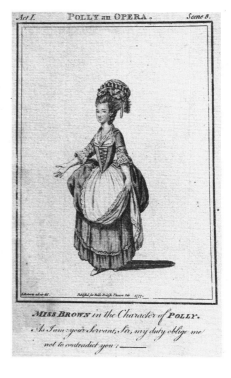

Drawing, standing, right hand extended to right; wearing a long apron and a laced bodice, with cap on top high-piled hair. Line engraving 13.3 × 8.9, with the quotation (I.8): "As I am your Servant, Sir, my duty oblige [*sic*] me not to contradict you:—"

LOCATION OF ORIGINAL: Unknown.

PROVENANCE: Bell sale, Christie's, 27 March 1793 (lot 3); bought, with five other drawings in lot, for 11s. by C. Cooke.

RELATED: None.

Gay's ballad opera *Polly*, a sequel to *The Beggar's Opera*, was refused a license by the Lord Chamberlain in 1729, evidently because of the vindictiveness of Robert Walpole, whom the piece satirized. The first performance of *Polly* was in the elder George Colman's alteration at the Haymarket Theatre on 19 June 1777, when Polly was played by Hester Colles. Ann Cargill never played the role, but (when Miss Brown) she first performed Polly in *The Beggar's Opera* in London on 22 April 1774 at Covent Garden Theatre. A portrait of her as Polly in *The Beggar's Opera*, with George Mattocks as Macheath, engraved by Walker, after Dighton, was published 25 August 1782 by T. Lowndes as a plate to *New English Theatre*. See also No. 134.

# 126

Ann Catley  1745–1789

as Euphrosyne in *Comus*

by John Milton

ARTIST: J. Roberts

ENGRAVER: J. Thornthwaite

DATE PUBLISHED: 26 February 1777

BELL EDITION: BBT76–77 and 80.IX

Colored drawing on vellum (10.8 × 8.3), full-length, standing to half right, her left hand extended; wearing a long dress decorated with leaves, a sash at midriff, and a long sash trailing from her unkempt hair in which there are flowers. The engraving in reverse bears the quotation (III.2): "All I hope of Mortal Man, / Is to Love me—whilst he can."

LOCATION OF ORIGINAL: British Museum (Burney II, No. 115).

PROVENANCE: Bell sale, Christie's, 27 March 1793 (lot 5); it and four other drawings in lot bought for 10s. by Gretton.

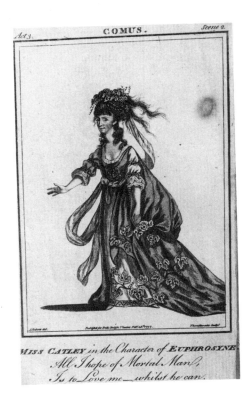

MISS CATLEY *in the Character of* EUPHROSYNE
*All I hope of Mortal Man,*
*Is to Love me—whilst he can.*

RELATED: None.

For other portraits of Ann Catley as Euphrosyne, see the *BDA*. She acted Euphrosyne for the first time in London on 17 October 1772 at Covent Garden Theatre. She had appeared as a "pastoral nymph" in that piece at that theatre on 8 October 1762.

# 127

Ann Catley  1745–1789

as Polly in *The Beggar's Opera*

by John Gay

ARTIST: J. Roberts

ENGRAVER: Not Engraved

DATE PUBLISHED: Not Published

Colored drawing on vellum (11.1 × 8.3), full-length, standing slightly to right, with face front, with her hands crossed in front, and

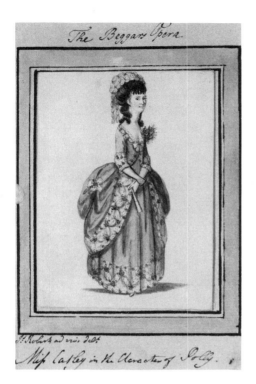

holding a fan in her left hand; wearing a hat with ribbons and a long dress decorated with embroidered flowers and ribbons. The drawing bears the inscriptions: "The Beggars Opera" (*top*); J^m Roberts ad viv del^t (*bottom left*); and "Miss Catley in the Character of Polly" (*bottom center*).

LOCATION OF ORIGINAL: British Museum (Burney II, No. 123).

PROVENANCE: A drawing by Roberts called "Miss Cately as Polly" in *The Beggar's Opera* was in the sale of Bell's collection at Christie's on 27 March 1793 (lot 5); it and four other drawings in the lot were bought for 10s. by Gretton.

Ann Catley first acted Polly at Smock Alley Theatre, Dublin, 23 December 1763, while in an advanced state of pregnancy. Her first appearance as Polly in London was on 13 October 1772 at Covent Garden Theatre. The portrait fronting *The Beggar's Opera* in the Bell 1776 and 1780 editions is of Vernon as

Macheath; in the Bell 1797 edition, it is of Mrs Crouch as Polly. See also No. 134.

# 128

## Ann Catley 1745–1789
as Rachel in *The Jovial Crew*

by Richard Brome

ARTIST: J. Roberts

ENGRAVER: J. Thornthwaite

DATE PUBLISHED: 10 May 1781

BELL EDITION: BBT80.XXI

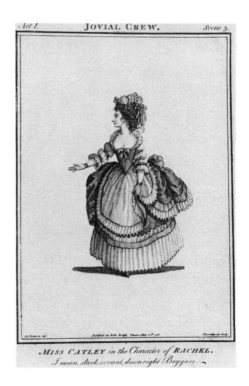

MISS CATLEY in the Character of RACHEL.
*I mean, stark, errant, downright Beggars.*

Colored drawing (9.5 × 8.9), full-length, standing to front, head turned to left, her right arm extended to side; wearing a small hat and a dress with a wide skirt and overskirt. Line engraving 14.6 × 9.8, with the quotation (I.3): "I mean, stark, errant, down right Beggars."

LOCATION OF ORIGINAL: British Museum (Burney II, No. 118).

PROVENANCE: Bell sale, Christie's, 27 March 1793 (lot 5); it and four other drawings in the lot were bought for 10s. by Gretton.

RELATED: None.

An engraving by Terry of Ann Catley as Rachel was published by Harrison as a plate to an edition of the play, 1780.

Ann Catley first acted Rachel on 22 October 1762 at Covent Garden Theatre, her second appearance on that stage. She had made her debut there on 8 October 1762 as a Pastoral Nymph in *Comus*.

# 129

Thomas Caulfield   1766–1815

as Arviragus in *Caractacus*

by William Mason

ARTIST: J. Graham

ENGRAVER: B. Reading

DATE PUBLISHED: 29 October 1796

BELL EDITION: BBT97.XXXI

Full-length, standing in a forest; wearing a fur garment, with a scimitar hanging from his belt; with bare shoulders, chest, and legs. Line engraving 11.7 × 7.9, for "G. Cawthorn. British Library," with the quotation: "—That now at Snowden's foot / full heavenly troops of hardy vetrans wait / to call my sire their leader."

LOCATION OF ORIGINAL: Unknown.

PROVENANCE: John Bell; Leigh & Sotheby's, 25 May 1805 (lot 275b).

RELATED: None.

Caulfield did not act this role in London; the play was not performed there during his career. A journeyman singing-actor in London during the 1790s, Caulfield went to America in 1806, making his debut in Boston on 31 October of that year as Rolla in *Pizarro*.

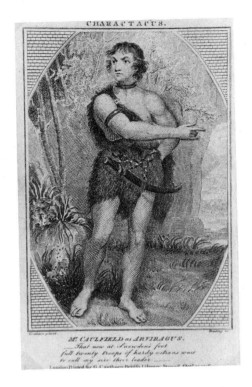

After engagements in Providence, Charleston, New York, and Cincinnati, according to a letter in the O. Smith Collection in the British Library, he "fell down in a fit on the Kentucky Stage, and expired" in 1815.

# 130

Thomas Caulfield   1766–1815

as Mirabel in *The Inconstant*

by George Farquhar

ARTIST: S. De Wilde

ENGRAVER: W. Leney

DATE PUBLISHED: 26 September 1795

BELL EDITION: BBT97.XXXII

Oil on canvas (37 × 28.5), walking in profile to left, his right hand stretched out before him; wearing a black college gown; a stone building behind. Line engraving 11.1 × 7.6, for "G. Cawthorn, British Library, Strand," with

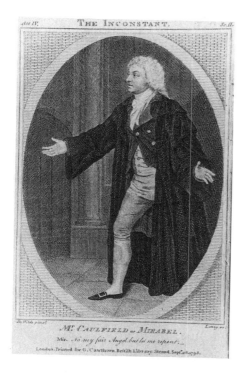

Mirabel's line (IV.2): "No my fair Angel, but let me repent."

LOCATION OF ORIGINAL: Garrick Club (Ash104, CKA209).

PROVENANCE: Bell sale, Leigh & Sotheby's, 25 May 1805 (lot 284), bought by Mathews; Charles Mathews (No. 388).

RELATED: None.

Caulfield did not act Mirabel. In the 1790s, at Drury Lane Theatre the role was acted by Richard Wroughton. The cast list in the text in the Bell edition has Alexander Pope in the role.

# 131

## Charlotte Jane Chapman   1762–1805
as Augusta Aubrey in *The Fashionable Lover*

by Richard Cumberland

ARTIST: S. De Wilde

ENGRAVER: J. Thornthwaite

DATE PUBLISHED: 19 January 1793

BELL EDITION: BBT97.XVIII

Oil on canvas (36.5 × 28), full-length, walking in profile to left, right arm extended and

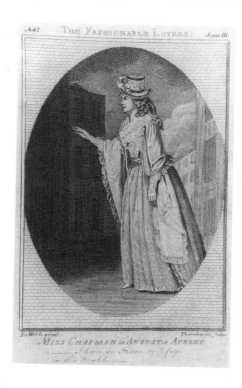

raised; wearing a dress with a sash at the waist, a hat, and gloves; buildings and clouds in background. Line engraving 11.7 × 8.3, for Bell's British Library, with Augusta's line (I.3): "—I have no Friend or refuge in this World—." The scene designated on the engraving is a mistake for III.1.

LOCATION OF ORIGINAL: Garrick Club (Ash108, CKA207).

PROVENANCE: John Bell; Charles Mathews (No. 88).

RELATED: None.

Miss Chapman seems not to have acted Augusta Aubrey in London. Ann Barry created the role at Drury Lane Theatre on 20 January 1772. Though born in America,

Charlotte Chapman spent most of her career in London between 1788 and 1801. At Covent Garden Theatre, she played a number of significant roles in comedies, mostly those "trim walking ladies whom Decency guides."

# 132

## Susanna Maria Cibber    1714–1766
as Monimia in *The Orphan*

by Thomas Otway

ARTIST: J. Roberts

ENGRAVER: J. Thornthwaite

DATE PUBLISHED: 1 September 1776

BELL EDITION: BBT76–77 and 80.V; BET92.V

Full-length, standing, profile right, her left arm extended at side; wearing a richly decorated dress with a wide skirt, and feathers in her hair. Line engraving 13 × 9.2, with the

quotation (V.6): "Read'st thou not something in my face that speaks / wonderful Change and Horror from within me?" The BBT76–77 engraving states "Painted from a Picture now in the Possession of D. Garrick Esq." Neither the artist nor engraver is noted on the BBT80 engraving.

LOCATION OF ORIGINAL: Unknown.

PROVENANCE: David Garrick; unknown.

RELATED: A copy of the engraving is found on a delftware tile in the Thomas Greg Collection, Manchester City Art Galleries.

Mrs Cibber, one of the greatest actresses of her century, first played Monimia on 15 March 1737 at Drury Lane Theatre. In 1751, the anonymous author of *A Guide to the Stage* dubbed her "Monimia." She last acted that role on 23 October 1764. Possibly when he was a youth, Roberts saw Mrs Cibber act.

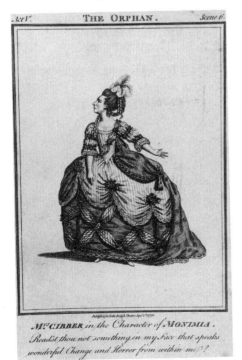

MRS CIBBER *in the Character of* MONIMIA.
*Read'st thou not something in my face that speaks wonderful Change and Horror from within me?*

# 133

## Matthew Clarke    d. 1786
as Procles in *Eurydice*

by David Mallet

ARTIST: J. Roberts

ENGRAVER: R. Pollard

DATE PUBLISHED: 17 October 1777

BELL EDITION: BBT76–77 and 80.XVI

Colored drawing on vellum (10.8 × 7.6), full-length, standing, body front, head to his right, hands extended at sides; wearing a richly brocaded Roman costume and a wreath in his hair. Engraving 12.4 × 9.2, with the quotation (II.5): "Thou Queen of Souls! Thou rapture of my Vows! what means this pensive Mood?"

LOCATION OF ORIGINAL: British Museum (Burney II, No. 171).

PROVENANCE: Bell sale, Christie's, 27 March

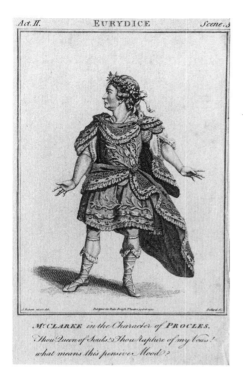

M.ʳ CLARKE *in the Character of* PROCLES.
*Thou Queen of Souls! Thou Rapture of my Vows!
what means this pensive Mood?*

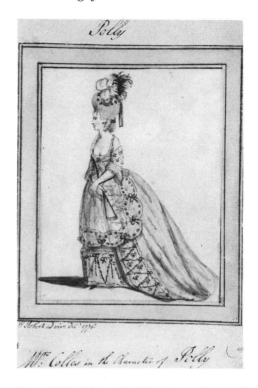

1793 (lot 5); bought, with four other drawings in lot, for 10s. by Gretton.

RELATED: None.

Clarke did not act this role in London.

# 134

## Hester Colles   [fl. 1776–1780]
as Polly in *Polly*

by John Gay

ARTIST: J. Roberts

ENGRAVER: Not Engraved

DATE PUBLISHED: Reproduced in the *BDA*

Colored drawing on vellum (11.4 × 7.6), full-length, standing to half left, her hair with curls, and holding a closed fan in her right hand; wearing a headpiece with feathers and bows and a long dress decorated with ribbons and bows. The drawing bears the inscrip-tions: "Polly" (*above*), "Jˢ Roberts ad viv delᵗ 1776" (*below left*), and "Mʳˢ Colles in the Character of Polly" (*bottom*).

LOCATION OF ORIGINAL: British Museum (Burney II, No. 194).

PROVENANCE: A drawing by Roberts called "Mrs Colles as Polly" in *Polly* was in the sale of Bell's collection at Christie's on 27 March 1793 (lot 5); it and four other drawings by Roberts in this lot were bought for 10s. by Gretton.

RELATED: None.

Gay's ballad opera *Polly*, a sequel to *The Beggar's Opera*, was refused a license in 1729 and did not receive its first performance until 19 June 1777, in an alteration by George Colman the Elder. At that time, Polly was played by Hester Colles, née Boyde. She was described as a "Gentlewoman" in the first bills, but she was identified in the press as the Miss Boyde who had been a utility player at

Drury Lane Theatre the previous season. On 21 June 1777, the *Morning Chronicle* reported that she had "lately married" and was now Mrs Colles. For the seventh performance of *Polly*, she was named as Mrs Colles in the bills.

The drawing by Roberts was not engraved. In the Bell sale at Christie's on 27 March 1793 also was a drawing by Roberts of Ann Cargill (Miss Brown) as Polly in *Polly* (lot 3); this latter drawing was engraved and was published in BBT 76–77 and 80. But the text of *Polly* was not included in BBT97. See Nos. 125 and 127.

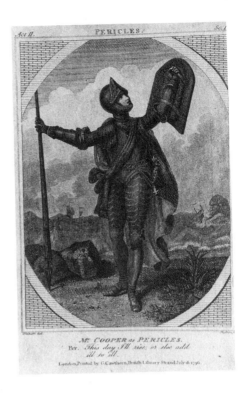

MR. COOPER as PERICLES.
Per. This day I'll rise, or else add ill to ill.
London, Printed by G. Cawthorn, British Library Strand July 16 1796.

# 135

## Thomas Abthorpe Cooper   1775–1849
as Pericles in *Pericles*

by William Shakespeare

ARTIST: J. Graham

ENGRAVER: W. Skelton

DATE PUBLISHED: 16 July 1796

BELL EDITION: BBT97.XXIX

Full-length, standing, looking up; wearing armor, with a shield on his raised left arm and a spear in his right hand. Line engraving 11.1 × 7.6, printed by "G. Cawthorn. British Library," with the quotation (II.2): "Per. This day I'll rise, or else add ill to ill" (actually the last line of II.1, in Shakespeare's version).

LOCATION OF ORIGINAL: Unknown.

PROVENANCE: Bell sale, Leigh & Sotheby's, 25 May 1805 (lot 269).

RELATED: None.

*Pericles* was not acted in London in the eighteenth century after 4 August 1738, when it was played at Covent Garden Theatre in Lillo's adaptation. Cooper made his first appearance on 19 October 1795 at Covent Garden as Hamlet. The following year, he was acting at the Chestnut Street Theatre in Philadelphia and then enjoyed a prominent career in America.

Mrs Crawford. See Ann Barry, Nos. 95 and 96.

# 136

## Anna Maria Crouch   1763–1805
as Emily in *The Double Disguise*

by Harriet Horncastle Hook

ARTIST: Anonymous

ENGRAVER: T. Cook

DATE PUBLISHED: 20 March 1784

BELL EDITION: Issued Separately

Full-length, standing, her right arm in front at waist, her left hand extended; wearing a long dress with overskirt, a broad ribbon belt

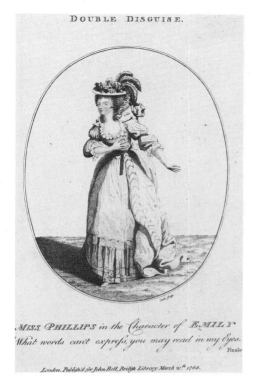

DOUBLE DISGUISE.

*MISS PHILLIPS in the Character of EMILY.*
'*What words can't express, you may read in my Eyes.*'
Finale

*London. Publish'd for John Bell, British Library March 20th 1784.*

at waist, and a hat with feathers. Line engraving 10.8 × 8.3, for Bell's British Library, with the caption: "MISS PHILLIPS in the Character of Emily 'What words can't express, you may read in my Eyes.' Finale"

LOCATION OF ORIGINAL: Unknown.

PROVENANCE: Unknown.

RELATED: None.

While still Miss Phillips, Anna Maria Crouch acted Emily in the premiere of *The Double Disguise* at Drury Lane Theatre on 8 March 1784.

# 137

## Anna Maria Crouch   1763–1805
as Polly in *The Beggar's Opera*

by John Gay

ARTIST: S. De Wilde

ENGRAVER: J. Thornthwaite

DATE PUBLISHED: 2 February 1791

BELL EDITION: BBT97.XI

Oil on canvas (43 × 28.5), full-length, standing, looking front, her right arm extended

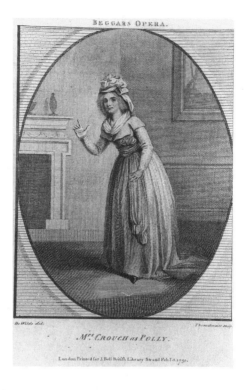

BEGGARS OPERA.

*Mrs CROUCH as POLLY.*

*London Printed for J. Bell British Library Strand Feb.i.1791.*

and raised; wearing a dress with a sash at waist, a mob cap over her powdered hair; interior background, with fireplace to left and picture to right. Line engraving 11.4 × 7.9, for Bell's British Library.

LOCATION OF ORIGINAL: Garrick Club (Ash140, CKA482)

PROVENANCE: Charles Mathews (No. 179)

RELATED: Engraving by W. Esdall for W. Jones's *British Theatre* (1791).

Anna Maria (when Miss Phillips) made her debut at Liverpool as Polly on 11 June 1781. She appeared in the role in London for the first time at Drury Lane Theatre on 16 April 1784.

# 138

## Anna Maria Crouch   1763–1805
as Pythia in *Creusa, Queen of Athens*

by William Whitehead

ARTIST: J. Graham

ENGRAVER: W. Leney

DATE PUBLISHED: 4 March 1797

BELL EDITION: BBT97.XXXIV

Full-length, standing, her right arm extended, left hand on breast; wearing a long dress with

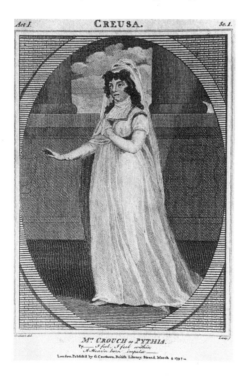

lace collar round neck, with a hat from which a long sash trails down her back; a wall with columns and clouds behind her. Line engraving 11.1 × 7.6, for "G. Cawthorn. British Library," with Pythia's line (I.1): "I feel, I feel within / A Heavin [*sic*] born impulse—."

LOCATION OF ORIGINAL: Unknown.

PROVENANCE: Bell sale, Leigh & Sotheby's, 25 May 1805 (lot 281), when the character was

identified as Creusa. Also in that sale was a picture (lot 270b) attributed to John Graham, of Creusa and Alcestes (IV. 1), but with no performers named. See plate 9, appendix 1.

RELATED: None.

*Creusa* was not performed during Mrs Crouch's career on the London stage.

# 139

## Mary Ann Davenport   1759–1843
as Miss Winifred Evans in *The School for Rakes*

by Elizabeth Griffith

ARTIST: J. Roberts

ENGRAVER: W. Leney

DATE PUBLISHED: 21 November 1795

BELL EDITION: BBT97.XXX

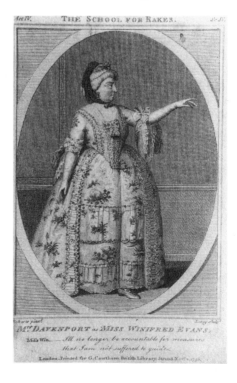

Full-length, standing to right in a room, her left arm extended; wearing a richly brocaded dress with a full skirt and a small hat with a

short sash. Line engraving 11.1 × 7.6, for Cawthorn's British Library, with Winifred's line (IV.4): "I'll not longer be accountable for measures that I am not suffered to guide."

LOCATION OF ORIGINAL: Unknown.

PROVENANCE: Bell sale, Leigh & Sotheby's, 25 May 1805 (lot 282).

RELATED: None.

Mrs Davenport did not act this role in London during the 1790s; the play was not performed there from the time of her debut in 1794 through the end of the century. She was a serviceable actress of second-line roles at Covent Garden Theatre from 1794–95 through 1829–30.

**Miss De Camp.** See Maria Theresa Kemble, Nos. 222 and 223.

# 140

## Vincent De Camp   1779–1839
as Hengo in *Bonduca*

by George Colman the Elder, adapted from John Fletcher

ARTIST: J. Roberts

ENGRAVER: P. Audinet

DATE PUBLISHED: 3 February 1795

BELL EDITION: BBT97.XXXIII

Full-length, as a youth, standing with legs crossed; wearing armor, with a battle-ax in his right hand; tents and ominous sky in background. Line engraving 11.1 × 7.9, for Cawthorn's British Library, with Hengo's line (II.3): "Why I dare fight with these!"

LOCATION OF ORIGINAL: Unknown.

PROVENANCE: Bell sale, Leigh & Sotheby's, 25 May 1805 (lot 260).

RELATED: None.

The only performance of Fletcher's *Bonduca*—in Colman's adaptation—during De Camp's youth was at Covent Garden Theatre on

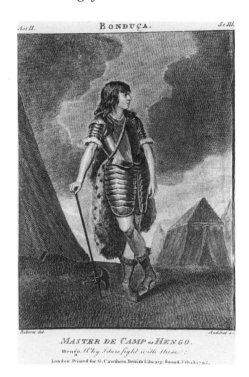

24 April 1795, when the role of young Hengo was played by Miss Standen.

# 141

## William Wyatt Dimond   d. 1812
as Don Felix in *The Wonder*

by Susannah Centlivre

ARTIST: S. De Wilde

ENGRAVER: P. Audinet

DATE PUBLISHED: 21 July 1792

BELL EDITION: BBT97.XXI

Oil on canvas (36.2 × 26.7), full-length, standing with his legs apart, holding a plumed hat in his left hand, with powdered hair; wearing breeches, waistcoat, coat, and ruff; an opening in the wall behind reveals the sky. Line engraving 11.4 × 8.9, for Bell's British Library, with the quotation (IV): "Either my eye deceived me or I saw a man within."

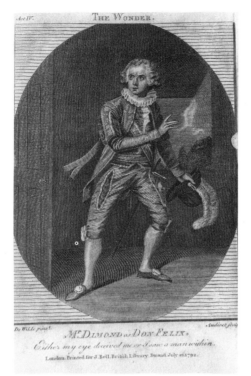

LOCATION OF ORIGINAL: Garrick Club (Ash159, CKA252).

PROVENANCE: John Bell; Harris sale, Robins, 12 July 1819 (lot 10); Charles Mathews (No. 382).

RELATED: An anonymous engraving was published by C. Cooke, 1809, and an engraving by Grignion was published in Dublin by W. Jones as a plate to *British Drama* (1817).

Dimond seems not to have acted this role in London, where he appeared infrequently in 1772–73, the summer of 1775, and 1778–79. He spent most of his long career on the Bath stage, where he also was manager.

# 142

## William Wyatt Dimond   d. 1812
as Philaster in *Philaster*

by Francis Beaumont and John Fletcher, altered by George Colman the Elder

ARTIST: S. De Wilde

ENGRAVER: P. Audinet

DATE PUBLISHED: 7 September 1791

BELL EDITION: BBT97.XVIII

Watercolor drawing, full-length, standing in a wood before a tent, his right hand holding a rapier pointed at his chest; wearing breeches, jerkin, ruff, and cloak with ermine trim. Line engraving 11.4 × 7.9, for Bell's British Library, with Philaster's line (IV.2): "Dear Arethusa, do but take this Sword, / And search how temperate a heart I have."

LOCATION OF ORIGINAL: Harvard Theatre Collection.

PROVENANCE: Unknown.

RELATED: None.

Dimond did not act this role in London.

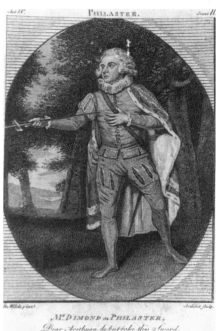

# 143

James William Dodd   1740?–1796

as Abel Drugger in *The Alchymist*

by Ben Jonson

ARTIST: S. De Wilde

ENGRAVER: J. Thornthwaite

DATE PUBLISHED: 10 May 1791

BELL EDITION: BBT97.I

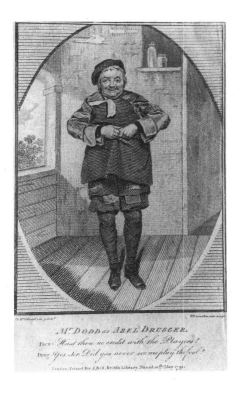

Pencil and watercolor (37 × 23.5), full-length, standing in his shop, facing front, hands together; wearing hose, breeches, jacket, with an apron over; bushes are seen through an open window left. Line engraving 11.4 × 7.6, printed for Bell's British Library, with the quotation (IV.3): "*Face*—Hast thou no credit with the Players? / *Drug*—Yes, Sir. Did you never see me play the fool?"

LOCATION OF ORIGINAL: Garrick Club (Ash161, CKA66a).

PROVENANCE: Charles Mathews (No. 315).

RELATED: None.

Dodd first acted this role on 21 March 1782, at Drury Lane Theatre. The last performance of the play that century was on 10 April 1787 at Drury Lane, when Dodd played the role for his benefit.

# 144

James William Dodd   1740?–1796

as Campley in *The Funeral*

by Richard Steele

ARTIST: J. Roberts

ENGRAVER: R. Godfrey

DATE PUBLISHED: 5 December 1794

BELL EDITION: BBT97.XXVII

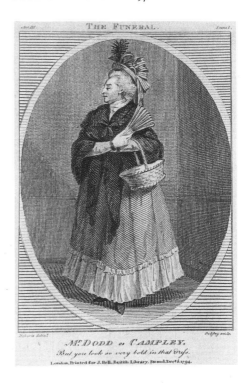

Full-length, standing in a room; wearing female attire, including a hat with feathers, and holding a basket on his left arm and a fan in

right hand. Line engraving 11.1 × 7.6, for Bell's British Library, with the quotation (III.1): "But you look so very bold in that Dress."

LOCATION OF ORIGINAL: Unknown.

PROVENANCE: Unknown.

RELATED: None.

Dodd first acted this role at Drury Lane Theatre on 3 April 1770.

# 145

## James William Dodd   1740?–1796
as Lord Foppington in *The Careless Husband*

by Colley Cibber

ARTIST: J. Roberts

ENGRAVER: J. Thornthwaite

DATE PUBLISHED: 1 January 1776

BELL EDITION: BBT76–77 and 80.VIII

Pen and gray ink with touches of watercolor drawing (9.9 × 7), full-length, standing, his

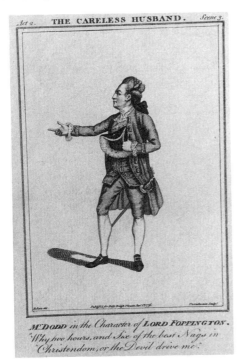

right arm extended, holding a hat in his left hand over his chest; wearing breeches, coat, and waistcoat. Line engraving 13.3 × 9.2, with the quotation (III.3): "Why two hours, and Six of the best Nags in Christendom, or the Devil drive me."

LOCATION OF ORIGINAL: Garrick Club (Ash165, CKA560d).

PROVENANCE: In the 1888 Garrick Club inventory.

RELATED: The reissue for BBT80 is dated 1 January 1778 and names no engraver.

The picture was previously called "an unknown man," by Roberts. Dodd played Lord Foppington in Cibber's *The Careless Husband* for the first time on 16 May 1767, at Drury Lane Theatre. He acted that character in R. B. Sheridan's *A Trip to Scarborough* at Drury Lane on 24 February 1777; a watercolor drawing by Robert Dighton of Dodd as Lord Foppington in Sheridan's play is in the Garrick Club (Ash162, CKA550k). One of the Garrick Club drawings was sold by Clough at Foster's 28 September 1819 (lot 168), and was bought by W. Penly, when it was called an anonymous portrait of Dodd as Lord Foppington. Dodd established himself in a line of fops, coxcombs, and country boobies, which he acted for some thirty-one years on the London stage.

# 146

## James William Dodd   1740?–1796
as Tinsel in *The Drummer*

by Joseph Addison

ARTIST: J. Roberts

ENGRAVER: Unknown (Roberts?)

DATE PUBLISHED: 5 May 1777

BELL EDITION: BBT76–77 and 80.XI

Colored drawing on vellum (10.8 × 7.9), full-length, to left, kneeling on his left knee, his right arm outstretched; wearing breeches, waistcoat, and a coat with a large sprig on the

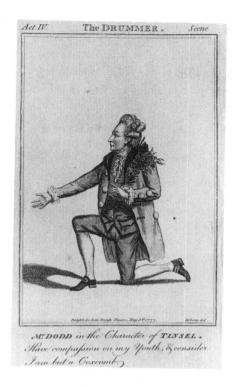

Mr DODD *in the Character of* TINSEL.
*Have compassion on my Youth, & consider
I am but a Coxcomb.*

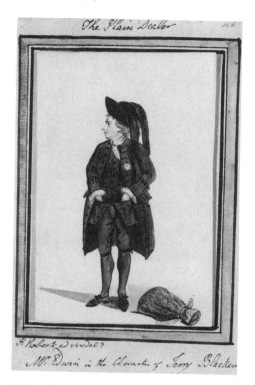

Mr Edwin *in the Character of* Jerry Blackacre

shoulder; his hair in curls. Line engraving
10.8 × 8.6, with the quotation (IV): "Have
compassion on my Youth, & consider I am
but a Coxcomb."

LOCATION OF ORIGINAL: British Museum (Burney III, No. 99).

PROVENANCE: Bell sale, Christie's, 27 March
1793 (lot 6); bought with three other drawings
by Roberts for 10s. by Gretton.

RELATED: None.

Dodd first acted Tinsel at Drury Lane Theatre on 6 November 1771.

# 147

## John Edwin the Elder 1749–1790

as Jerry Blackacre in *The Plain Dealer*

by William Wycherley

ARTIST: J. Roberts

ENGRAVER: Not Engraved

DATE PUBLISHED: Not Published

Colored drawing on vellum (11.7 × 7.9), full-
length, standing, body to front with head to
left, with his hands in the pockets of a long
waistcoat; he also wears breeches, hosiery, a
long coat, stock, and wig under a black hat.
A sack is on the ground right. With the
inscriptions: "The Plain Dealer" (*top*); "J.
Roberts ad viv: Del" (*below left*); "Mr
Edwin in the Character of Jerry Blackacre"
(*below*).

LOCATION OF ORIGINAL: British Museum (Burney III, No. 146).

PROVENANCE: Bell sale, Christie's 27 March
1793 (lot 6); it and three other drawings in lot
were bought for 10s. by Gretton.

RELATED: None.

Edwin acted this role for the first time at
Covent Garden Theatre on 18 April 1786.
Though in Bell's collection of drawings by
Roberts, this portrait was not published. *The
Plain Dealer* was not included in BBT 76–77
and 80; it was printed in the 1797 edition,
with a plate depicting Dorothy Jordan as

Fidelia. A portrait of Edwin as Jerry Blackacre was engraved by W. Angus, after C. R. Ryley, and was published by Lowndes as a plate to *New English Theatre* (1788).

# 148

### John Edwin the Elder   1749–1790
as Justice Woodcock in *Love in a Village*

by Isaac Bickerstaff

ARTIST: J. Roberts, 1775

ENGRAVER: Not Engraved

DATE PUBLISHED: Not Published

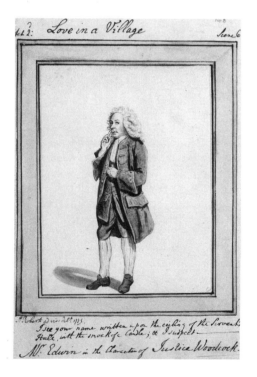

Colored drawing (11.4 × 7.6), full-length, standing to left, with head and eyes slightly to front; wearing breeches, a long coat with large pockets, a waistcoat, stock, and a shoulder-length powdered wig. With inscriptions: "Act 2ᵈ Love in a Village Scene 6" (*top*); "Jˢ Roberts ad viv: delᵗ 1775" (*below left*); "I see

your name written upon the ceiling of the Servant's Hall, with the smoak of a Candle; & I suspect—Mʳ Edwin in the Character of Justice Woodcock" (*below*).

LOCATION OF ORIGINAL: British Museum (Burney III, No. 148).

PROVENANCE: Bell sale Christie's, 27 March 1793 (lot 6); it and three other drawings in the lot were bought for 10s. by Gretton.

RELATED: A drawing by Roberts of Edwin in this character is in the Harvard Theatre Collection; it was acquired, with many other drawings by Roberts of actors and actresses, from Thomas Agnew, London, 1976.

Though in the Bell collection of drawings by Roberts, this portrait was never published. *Love in a Village* was not included in BBT76–77; it was printed in BBT80 with a plate of Mrs Wrighten as Madge (see No. 335) and in BBT97 with a plate of Mrs Billington as Rosetta (see No. 111).

The drawing in the British Museum Department of Prints and Drawings is hand-marked in ink "J. Roberts 1775," but that notation may be an error, because Edwin—who was a favorite at Bath—did not make his debut in London until the summer of 1776. He acted Justice Woodcock for the first time in London on 12 August 1777, at the Haymarket Theatre. Another portrait of Edwin in this role was painted by Thomas Beach and is now in the Garrick Club.

# 149

### Harriet Esten   1765?–1865
as Belvidera in *Venice Preserv'd*

by Thomas Otway

ARTIST: S. De Wilde

ENGRAVER: J. Thornthwaite

DATE PUBLISHED: 9 March 1791

BELL EDITION: BBT97.XV

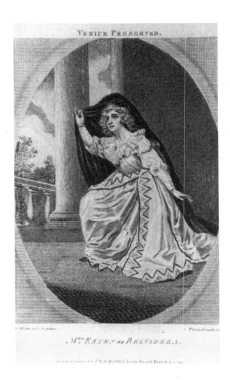

VENICE PRESERVED.

Mʳˢ ESTEN as BELVIDERA.

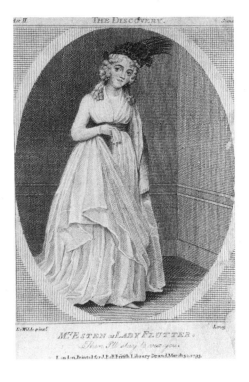

Mʳˢ ESTEN as LADY FLUTTER.

ENGRAVER: W. Leney

DATE PUBLISHED: 30 March 1793

BELL EDITION: BBT97.V

Oil on canvas (36.2 × 27.9), full-length, standing, facing front, with curls to shoulders; wearing a long dress and plumed hat and

holding a glove in her right hand at waist, gloved left hand at side. Line engraving 11.1 × 8.3, for Bell's British Library, with the quotation (II.1): "Then I'll stay to vex you."

LOCATION OF ORIGINAL: Garrick Club (Ash201, CKA441).

PROVENANCE: Charles Mathews (No. 89).

RELATED: None.

Mrs Esten seems not to have acted Lady Flutter in London in the eighteenth century. In the Garrick Club set of BBT97, this engraving and *The Discovery* are bound in volume VIII.

Full-length, kneeling to left, her right hand holding up a stole that drapes over her head and body; wearing a long and full-skirted dress; column and balustrade behind. Line engraving 11.1 × 8.3, printed for Bell's British Library.

LOCATION OF ORIGINAL: Unknown.

PROVENANCE: Unknown.

RELATED: None.

After a notable career in Bath and Edinburgh, Mrs Esten made her debut at Covent Garden Theatre on 20 October 1790 as Rosalind in *As You Like It*. She first played Belvidera at Covent Garden on 23 November 1790.

# 150

## Harriet Esten   1765?–1865
as Lady Flutter in *The Discovery*

by Frances Sheridan

ARTIST: S. De Wilde

# 151

## Elizabeth Farren   1762–1829

as Penelope in *The Gamesters*

by David Garrick, adapted from James Shirley

ARTIST: S. De Wilde

ENGRAVER: J. Neagle

DATE PUBLISHED: 3 June 1792

BELL EDITION: BBT97.VI

Oil on canvas (34.9 × 26.7), full-length, standing to left, facing front; wearing a dark dress with a sash at waist, which also trails down her back, and a ruff at neckline; an open window behind shows trees and sky. Line engraving 10.8 × 7.6, printed for *Bell's British Theatre*, with Penelope's line (II.1): "I will not take it on such conditions."

LOCATION OF ORIGINAL: Paul Dyson, London.

PROVENANCE: John Bell; exhibited (but not offered for sale) at the sale of Bell's collection at Christie's on 27 March 1793; Webster's, Wellington, N.Z.; bought 1996 from an unnamed London dealer by Paul Dyson.

RELATED: A copy was printed by C. Cooke, 1808.

Elizabeth Farren acted this role for the first time in London 13 March 1779, at Drury Lane Theatre.

# 152

## William Farren the Elder   (1754–1795)

as Sir Charles Easy in *The Careless Husband*

by Colley Cibber

ARTIST: S. De Wilde

ENGRAVER: J. Thornthwaite

DATE PUBLISHED: 15 October 1791

BELL EDITION: BBT97.VIII

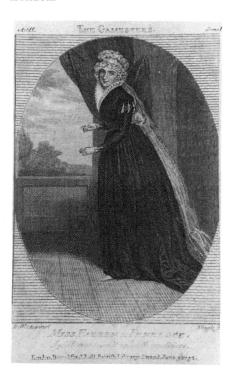

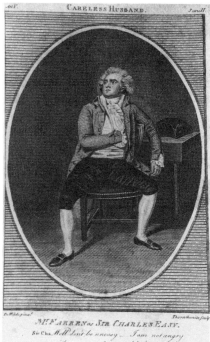

Watercolor drawing (35.6 × 27.9), full-length, seated, his left arm over back of chair, his right hand inserted under his light-blue coat worn over black trousers; his hat is on a table behind. Line engraving 11.7 × 7.6, printed for *Bell's British Theatre*, with Sir Charles's line (V.2): "Well, don't be uneasy— I am not angry with you now—Come and kiss me."

LOCATION OF ORIGINAL: Don Wilmeth, Brown University.

PROVENANCE: Randolph Gunter, New York.

RELATED: An engraving in reverse by Houston was published in Dublin by W. Jones, 1793.

Farren acted this role for the first time at Covent Garden Theatre on 31 March 1787.

# 153

## William Farren the Elder   1754–1795
as Orestes in *The Distrest Mother*

by Ambrose Philips

ARTIST: S. De Wilde

ENGRAVER: J. Thornthwaite

DATE PUBLISHED: 19 August 1791

BELL EDITION: BBT97.VI

Oil on canvas (37.5 × 28.3), full-length, standing, advancing slightly to right, a sword in his right hand, his left hand raised; wearing engraved breast armor; door ajar to left. Line engraving 10.5 × 7.6, for Bell's British Library, with Orestes' line (V.1): "Madam, 'tis done; your orders are obey'd. / The tyrant lies expiring at the altar."

LOCATION OF ORIGINAL: Garrick Club (Ash209, CKA231).

PROVENANCE: John Bell; Charles Mathews (No. 100).

RELATED: None. But see No. 274.

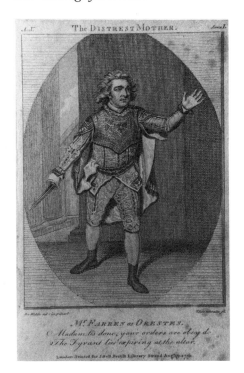

Farren does not seem to have played this role in London.

# 154

## John Fawcett the Younger   1768–1837
as Jack Nightshade in *The Choleric Man*

by Richard Cumberland

ARTIST: S. De Wilde

ENGRAVER: J. Corner

DATE PUBLISHED: 16 February 1793

BELL EDITION: BBT97.IV

Oil on canvas (40 × 29.8), full-length, standing in a room, head turned to his right, holding a purse in his right hand, money in left; wearing boots, breeches, waistcoat, long coat, and hat. Line engraving 11.7 × 7.9, for Bell's British Library, with Jack's line (I.2):

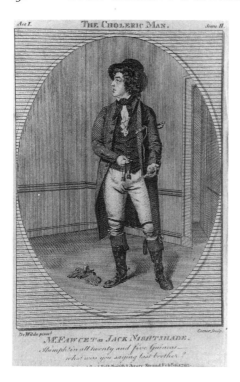

"Humph! in all twenty and five guineas—
what was you saying last, brother?"

LOCATION OF ORIGINAL: National The-
atre, London.

PROVENANCE: Maugham Bequest; earlier
offered at Christie's on 20 January 1917 (lot
16), from the collection of J. Rochelle
Thomas, but not sold.

RELATED: None.

Fawcett acted Jack Nightshade for the first
time on 19 December 1774, at Drury Lane
Theatre.

# 155

John Fawcett the Younger    1768–1837
as Mawworm in *The Hypocrite*

by Isaac Bickerstaff (after Colley Cibber)

ARTIST: S. De Wilde

ENGRAVER: P. Audinet

DATE PUBLISHED: 30 June 1792

BELL EDITION: BBT97.XXI

Full-length, standing, full-face front, holding
a tricorn hat; wearing breeches, waistcoat,

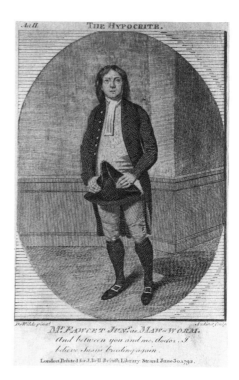

and long coat; wall of room behind. Line and
stipple engraving 11.1 × 7.6, for Bell's British
Library, with the quotation (II): "And be-
tween you and me, doctor, I believe Susy's
breeding again."

LOCATION OF ORIGINAL: Unknown.

PROVENANCE: Unknown; possibly the por-
trait in the Royal Dramatic College sale at
Fairbrother, Lye, and Palmer on 24 February
1881 (lot 100F).

RELATED: None.

Fawcett did not play Mawworm between the
time of his first appearance on the London
stage in 1791–92 and the end of the eigh-
teenth century. De Wilde's portrait of him in
this role was published nine months after

Fawcett made his debut at Covent Garden Theatre on 21 September 1791 as Caleb in *He Wou'd Be a Soldier.*

# 156

Samuel Foote   1721–1777
as Fondlewife in *The Old Bachelor*

by William Congreve

ARTIST: J. Roberts

ENGRAVER: J. Thornthwaite

DATE PUBLISHED: 4 June 1776

BELL EDITION: BBT76–76 and 80.II

Colored drawing on vellum (11.4 × 8.9), full-length, standing, with a cane in one hand, his other hand slightly raised; wearing a coat, long waistcoat, and curled wig. Line engraving 13 × 9.2, printed for *Bell's British Theatre*, with the quotation (IV.4): "Speak, I say have you consider'd what it is to Cuckold your Husband."

LOCATION OF ORIGINAL: British Museum (Burney IV, No. 17).

PROVENANCE: Bell sale, Christie's, 27 March 1793 (lot 7); bought, with four drawings of Garrick in lot, for 15s. by Mitchell.

RELATED: See No. 157, another version by Roberts for BBT97.

Foote acted Fondlewife in Congreve's play for the first time in London on 15 December 1747 at Covent Garden Theatre. He had appeared in a character of that name in a farce called *The Credulous Husband* (taken from Congreve) at the Capel Street Theatre in Dublin on 9 February 1745 and at the Haymarket Theatre in London on 22 April 1747. Foote received high praise from Arthur Murphy in *Gray's Inn Journal* (1753) for his acting of this character, but Thomas Davies, who did not like Foote, in *Dramatic Miscellanies* (1783–84) remembered that "in the course of the first scene he drew the attention of the audience, and merited, and gained, much applause; but in the progress of the part he for-

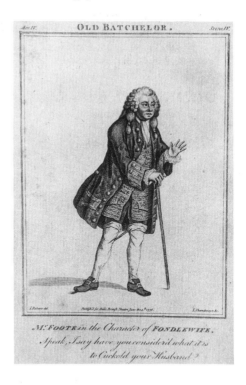

M.<sup>r</sup> FOOTE in the Character of FONDLEWIFE.
*Speak, I say have you consider'd what it is to Cuckold your Husband?*

got his exemplar [Colley Cibber] and degenerated into buffoonery." The *BDA* sums up Foote's acting talents: "While often guilty of overly vicious lashing, his keen eye for character and skill with witty dialogue allowed him to provide brilliant sketches of contemporary manners. As a mimic he was unequalled in his day, except perhaps by Wilkinson, whom he had taught."

Foote was also pictured as Fondlewife in a an engraving 13.3 × 8.9) by W. Walker, after J. Barralet, published as a plate to Lowndes's *New English Theatre* (1776).

# 157

Samuel Foote   1721–1777
as Fondlewife in *The Old Bachelor*

by William Congreve

ARTIST: J. Roberts

ENGRAVER: J. Thornthwaite

DATE PUBLISHED: 15 May 1796

BELL EDITION: BBT97.XXVIII

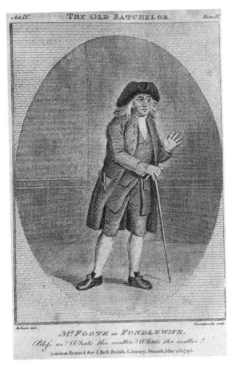

Full-length, standing, holding a cane in his right hand; dressed more simply than in No. 156, in a long coat, waistcoat, and breeches, with a hat on his head over longish hair. Line engraving 11.7 × 7.6, for Bell's British Library, with the quotation (IV.4): "Bless us! What's the matter? What's the matter?"

LOCATION OF ORIGINAL: Unknown.

PROVENANCE: Unknown.

RELATED: See No. 156, another version by Roberts, for BBT76–76 and 80.II.

# 158

David Garrick    1717–1779
as Abel Drugger in *The Alchemist*

as Ben Jonson

ARTIST: J. Roberts

ENGRAVER: J. Thornthwaite

DATE PUBLISHED: 29 December 1777

BELL EDITION: BBT76–77 and 80.XVII

Line and watercolor drawing (10.2 × 7.6), full-length, standing to left, fists clenched, in pugilistic attitude; wearing breeches, tight jacket, and unkempt hair. Line engraving 14 × 9.5.

LOCATION OF ORIGINAL: British Museum (BM. LB. 65).

PROVENANCE: Bell sale, Christie's, 27 March 1793 (lot 7); bought, with four other drawings in lot, for 15s. by Mitchell.

RELATED: None.

For other portraits of Garrick as Abel Drugger, see the *BDA*. Garrick first acted Abel Drugger, one of his greatest and most popular comic roles, at Drury Lane Theatre on 23 March 1743.

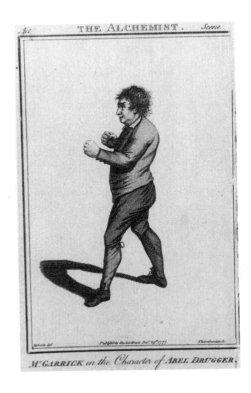

# 159

David Garrick   1717–1779

as Bayes in *The Rehearsal*

by George Villiers, Duke of Buckingham

ARTIST: J. Roberts

ENGRAVER: R. Pollard

DATE PUBLISHED: 16 September 1777

BELL EDITION: Issued Separately

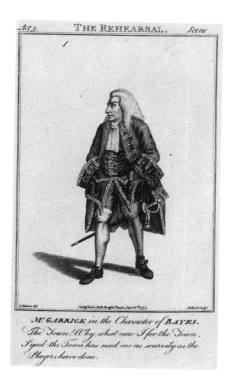

Line and watercolor drawing (11.7 × 7.6), full-length, standing to left, with his hands in the pockets of a long waistcoat; his elaborate and richly decorated costume also includes a long coat, breeches, stock, a long wig, and a sword hanging behind his legs. Line engraving 12 × 8.9, with the caption: "Mʳ GARRICK in the Character of BAYES. The Town! Why what care I for the Town. I'gad the Town has used me as scurvily as the Players have done" (V).

LOCATION OF ORIGINAL: British Museum (BM. LB. 69).

PROVENANCE: Bell sale, Christie's, 27 March 1793 (lot 7); bought, with four other drawings in lot, for 15s. by Mitchell.

RELATED: None.

Although the engraving was published for *Bell's British Theatre*, it did not appear in the collections of 1776–77 or 1780. A portrait of John Henderson as Bayes, also by Roberts and Pollard and published on the same day, was bound into the BBT texts of *The Rehearsal* (vol. XV); see No. 187.

Garrick first acted Bayes, during his initial London season, at Goodman's Fields Theatre on 3 February 1742, when the popularity of his portrayal was so great that *The Rehearsal* was acted seven consecutive nights. He was also pictured as Bayes in an anonymous engraving published by Wenman, 1777.

# 160

David Garrick   1717–1779

as Demetrius in *The Brothers*

by Edward Young

ARTIST: J. Roberts

ENGRAVER: J. Thornthwaite

DATE PUBLISHED: 6 September 1777

BELL EDITION: BBT76–78 and 80.XIV; BET92.I

Line and watercolor drawing (12.7 × 8.3); full-length, standing to front, his left hand on hip, right hand outstretched; wearing Roman costume, breastplate, cape, and helmet with tall feathers. Line engraving 14 × 9.2, with the quotation (I.3): " 'tis they presume who know not to deserve."

LOCATION OF ORIGINAL: British Museum (BM. LB. 66).

PROVENANCE: Bell sale, Christie's, 27 March

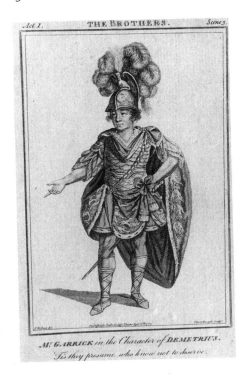

Mʳ GARRICK in the Character of DEMETRIUS.
'Tis they presume who know not to deserve.

1793 (lot 7); bought, with four other drawings in lot, for 15s. by Mitchell.

RELATED: See No. 260.

Garrick appears as Demetrius, with George Anne Bellamy as Erixene, in an engraving by J. Collyer, after Dodd, published by Lowndes as a plate to *New English Theatre* (1777); a copy in reverse was engraved by L. Darcis (rare example in the Harvard Theatre Collection). An anonymous engraving of Garrick as Demetrius was published by Wenman as a plate to an edition of *The Brothers* (1778). Garrick created the role of Demetrius in the premiere of Edward Young's *The Brothers* at Drury Lane Theatre on 3 March 1753.

# 161

David Garrick   1717–1779
as Sir John Brute in *The Provok'd Wife*

by John Vanbrugh

ARTIST: J. Roberts

ENGRAVER: Anonymous

DATE PUBLISHED: 1 June 1776

BELL EDITION: BBT76–76 and 80.II

Line and watercolor (12.7 × 10.2), full-length, standing to front; in woman's clothes (full-

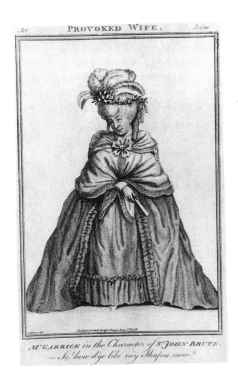

Mʳ GARRICK in the Character of Sʳ JOHN BRUTE.
— So! how d'ye like my Shapes now?

skirted dress, cape, headpiece with feathers), hands together at waist, holding fan. Line engraving 15.6 × 9.8, with the quotation: "—So! how d'ye like my Shapes now?"

LOCATION OF ORIGINAL: British Museum (BM. LB. 68).

PROVENANCE: Bell sale, Christie's, 27 March 1793 (lot 7); bought, with four other drawings in lot, for 15s. by Mitchell.

RELATED: See also No. 162, De Wilde's copy of Roberts's picture. A watercolor drawing (quarter-length) by an unknown artist is also in the British Museum (BM. E.e. 3-174).

For other portraits of Garrick as Sir John Brute, see the *BDA*. He first played the role on 16 November 1744, at Drury Lane Theatre.

The character was one of his most popular comic creations. On 31 October 1775, the night that Garrick first introduced the extravagant headpiece, his prompter Hopkins wrote in his diary, "Mr G. never play'd better & when he was in Woms Cloths he had a head drest with Feathers Fruit & etc. as extravagn as possible to Burlesque the present mode of dressing—it had a monstrous Effect."

# 162

## David Garrick 1717–1779
as Sir John Brute in *The Provok'd Wife*

by John Vanbrugh

ARTIST: S. De Wilde (after J. Roberts)

ENGRAVER: J. Thornthwaite

DATE PUBLISHED: 5 November 1794

BELL EDITION: BBT97.XXVII

Full-length, standing to front; wearing woman's clothes, hands crossed, holding fan. Line engraving 11.7 × 7.9.

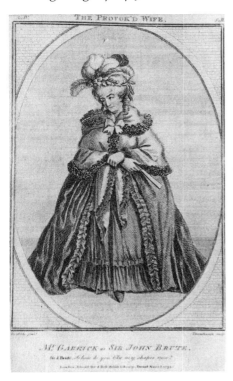

LOCATION OF ORIGINAL: Unknown, but see No. 161.

PROVENANCE: Unknown.

RELATED: See No. 161, Roberts's original drawing.

This picture by De Wilde is a copy of the one by J. Roberts.

# 163

## David Garrick 1717–1779 and Mary Ann Yates 1728–1787
as Lusignan and Zara in *Zara*

by Aaron Hill

ARTIST: J. Roberts

ENGRAVER: W. Walker

DATE PUBLISHED: 10 April 1776

BELL EDITION: BBT76–77 and 80.I

Lusignan is seated in a chair left, his left hand extended, and is wearing a royal robe; Zara stands right, her right hand offering a crucifix on a chain, and is wearing a richly decorated panniered dress and a headpiece with feathers and with a long train down her back. Line engraving 11.4 × 16.5, published with the lines (II.3): "*Lusignan.* Would you confide it to my trembling hands. *Zara.* To what new Wonder am I now reserv'd. Oh! Sir what mean you?—" On the BBT80 engraving the name of the engraver is not given.

LOCATION OF ORIGINAL: Unknown.

PROVENANCE: Unknown.

RELATED: None.

Garrick first acted Lusignan (with Mrs Cibber as Zara) in a revival of the play (after seventeen years) at Drury Lane Theatre on 25 March 1754. Mrs Yates's first appearance as Zara was on 22 April 1758, with Garrick as Lusignan. Garrick was also pictured as Lusignan, with Miss Younge as Zara, with two other figures, in an engraving by

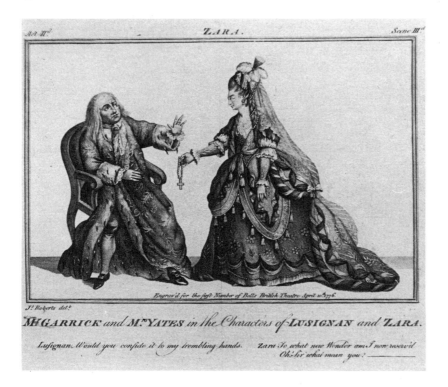

J. Collyer, published as a plate to Lowndes's
*New English Theatre* (1777).

# 164

## David Garrick  1717–1779
as Periander in *Eurydice*

by David Mallet

ARTIST: J. Roberts

ENGRAVER: J. Wilson

DATE PUBLISHED: 31 October 1795

BELL EDITION: BBT97.XXVI

Watercolor drawing on vellum (12 × 10.8),
full-length, standing to right on a shore, with
his left hand outstretched; wearing classical
skirt and tunic, with cape. Line engraving
12 × 9.5, for Cawthorn's British Library, with
Periander's line (II.1): "Ha! By the moon's sad
beams, I can descry / The towers that hold
this Author of my shame."

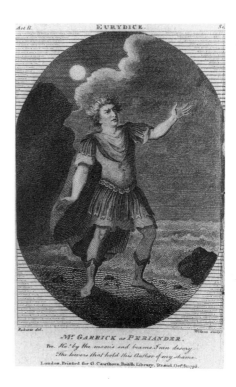

LOCATION OF ORIGINAL: British Museum (BM. LB. 67).

PROVENANCE: Unknown.

RELATED: None.

A small drawing by T. Stothard of Garrick as Periander is in the Victoria and Albert Museum (Dyce 9.10). He was also pictured in an anonymous engraving published by Harrison & Co as a plate to an edition of the play, 1781. Garrick acted Periander in a revival of Mallet's play (after thirty-four years) at Drury Lane Theatre on 3 March 1759.

# 165

## David Garrick  1717–1779 and
## Frances Abington  1737–1815

as Ranger and Clarinda in *The Suspicious Husband*

by Benjamin Hoadly

ARTIST: J. Roberts

ENGRAVER: J. Thornthwaite

DATE PUBLISHED: 21 August 1776

BELL EDITION: BBT76–77 and 80.IV

Full-length, both standing, turned away from each other; Garrick is dressed as a fine gentleman with breeches, waistcoat, and coat, and a powdered curly wig; Mrs Abington wears a richly decorated dress with wide overskirt, and feathers in hair. Line engraving 13.3 × 19.4, with the lines (IV.4): "Ranger. *Clarinda. Clarinda. Ha! Ha! Your Servant Cousin Ranger, ha! ha!*"

LOCATION OF ORIGINAL: Unknown.

PROVENANCE: Unknown.

RELATED: None.

Garrick created the role of Ranger in the premiere of Benjamin Hoadley's *The Suspicious Husband* at Covent Garden Theatre on 12 February 1767, with Mrs Pritchard as Clarinda. Mrs Abington acted Clarinda for the first time at Drury Lane Theatre on 23 May 1776, with Garrick, during Garrick's last round of characters before his retirement. That night the prompter Hopkins wrote in

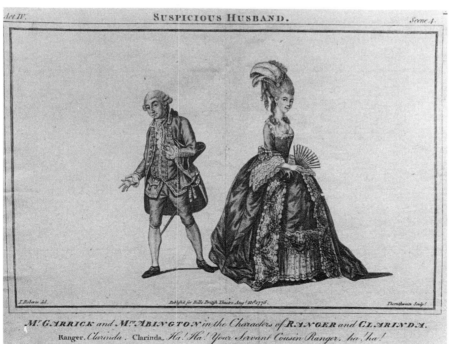

Act IV.    SUSPICIOUS HUSBAND.    Scene 4.

J. Roberts del.    Publish'd for Bell's British Theatre Aug.r 21st 1776.    Thornthwaite Sculp.t

M.r GARRICK and M.rs ABINGTON in the Characters of RANGER and CLARINDA.
Ranger. Clarinda . Clarinda. Ha! Ha! Your Servant Cousin Ranger. ha! ha!

his diary that "she was very easy and like the Character. Mr. G. as Usual play'd finely."

One of the finest pictures of Garrick is in this role, with Mrs Pritchard as Clarinda, painted by Francis Hayman in 1747; the original is at the London Museum, and a copy is at the Yale Center for British Art. See the *BDA*.

# 166

David Garrick   1717–1779 and
Elizabeth Pope   ca. 1750–1797
as Tancred and Sigismunda in *Tancred and Sigismunda*

by James Thomson

ARTIST: J. Roberts

ENGRAVER: J. Thornthwaite

DATE PUBLISHED: 10 September 1776

BELL EDITION: BBT76.V

Full-length, both standing, facing each other; Garrick, with his left arm extended and his right arm by side, wears Hussar's costume; Miss Younge, on his right, wears a richly decorated dress with panniered skirt, and feathers in hair. Line engraving 13.7 × 17.8, with the quotation (V.5): "Sigismunda: '*O Heavens! My Lord the King.*' Tancred: '*Be not alarmed my Love!*' "

LOCATION OF ORIGINAL: Unknown.

PROVENANCE: Unknown.

RELATED: See No. 167. For portraits of Garrick as Tancred by other artists, see the *BDA*.

Garrick acted Tancred in the premiere of Thomson's play at Drury Lane Theatre on 18 March 1754, with Mrs Cibber as Sigismunda. Elizabeth Pope (when Miss Younge) made her debut at Drury Lane in 1768–69; she never acted Sigismunda with Garrick. During the 1770s until his retirement in 1776, Garrick's usual partner in the title roles was Ann Barry.

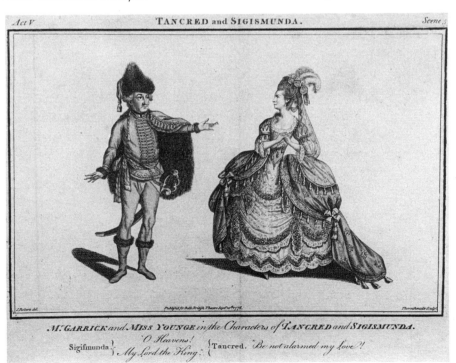

MR GARRICK and MISS YOUNGE in the Characters of TANCRED and SIGISMUNDA.
Sigismunda. '*O Heavens! My Lord the King.*' Tancred. '*Be not alarmed my love!*'

# 167

David Garrick  1717–1779
as Tancred in *Tancred and Sigismunda*

by James Thomson

ARTIST: J. Roberts

ENGRAVER: J. Thornthwaite

DATE PUBLISHED: February 1778

BELL EDITION: BBT80.V; BET92.V

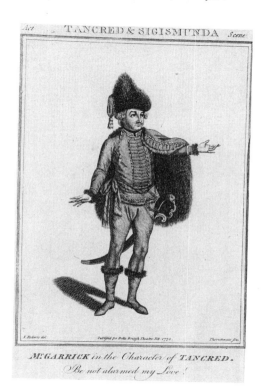

Full-length, standing, with his left arm ex-
tended, and his right arm by side, in the
same pose and costume as in No. 166. Line
engraving 13.3 × 9.55, with Tancred's line
(V.5): "Be not alarmed my Love!" The
BET92 engraving was printed "at the Shake-
speare Press, by Etherington; / For J. Bell, at
the British Library, / in the Strand, / 1779."

LOCATION OF ORIGINAL: Unknown.

PROVENANCE: Unknown.

RELATED: See also No. 166, with Miss
Younge.

# 168

Maria Gibbs  b. 1770
as Miss Hoyden in *The Relapse*

by John Vanbrugh

ARTIST: S. De Wilde

ENGRAVER: J. Wilson

DATE PUBLISHED: 3 October 1795

BELL EDITION: BBT97.XXVI

Full-length, standing to left in a room, her
arms extended to side; wearing a dress with

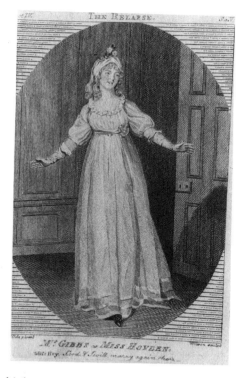

high-waisted skirt, and flowers in hair. Line
engraving 12 × 8.3, for Cawthorn's British Li-
brary, with Miss Hoyden's line (IV.6): "Ecod,
& I will marry again then."

LOCATION OF ORIGINAL: Unknown.

PROVENANCE: Unknown; possibly the signed and dated portrait by De Wilde that was in the Dramatic College sale at Fairbrother, Lye, and Palmer on 24 February 1881 (lot 100B).

RELATED: None.

Maria Gibbs made her stage debut on 18 June 1783, at the Haymarket Theatre, as Sally in *Man and Wife*. *The Relapse* was not performed during the period of her career on the London stage, and she did not appear in the adaptations of it by John Lee (*The Man of Quality*) or Richard B. Sheridan (*A Trip to Scarborough*).

# 169

## Charlotte Goodall   1765–1830
as Sir Harry Wildair in *The Constant Couple*

by George Farquhar

ARTIST: S. De Wilde

ENGRAVER: W. Leney

DATE PUBLISHED: 2 June 1792

BELL EDITION: BBT97.XVI

Oil on canvas (36.5 × 28), full-length, standing; wearing military coat, breeches, and a tricorn, with her left hand on a sword by her side and her right arm raised and extended. Line engraving 10.8 × 7.6, for Bell's British Library, with Wildair's line (V.1): "Ah, the delights of love and burgundy!"

LOCATION OF ORIGINAL: Garrick Club (Ash267, CKA217).

PROVENANCE: Charles Mathews (No. 92).

RELATED: An anonymous engraving was printed for C. Cooke 30 October 1806 and was published as a plate to *British Drama* (1817).

Charlotte Goodall first acted Sir Harry Wildair in London on 30 July 1789, at the Haymarket Theatre, when it was reported

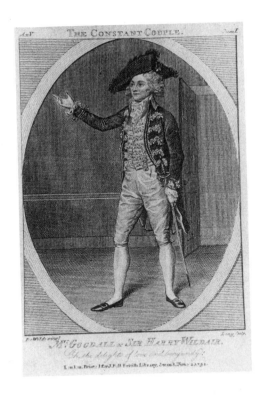

that she had shown off "the beautiful symmetry of her person" in that breeches role.

# 170

## Catherine Gough   1765–1829
as Zenobia in *Zenobia*

by Arthur Murphy

ARTIST: J. Graham

ENGRAVER: W. Leney

DATE PUBLISHED: 4 March 1796

BELL EDITION: BBT97.XXXIII

Full-length, standing in front of a tent with a dead figure on the ground behind her; wearing a crown with a veil attached and a long dress with a broad sash down front. Line engraving 10.8 × 7.6, for Cawthorn's British Library, with Zenobia's line (V.2): "Yes tyrant

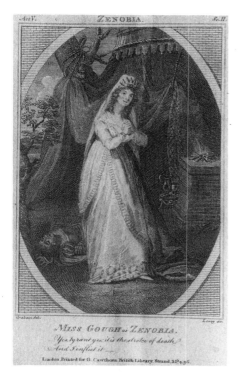

MISS GOUGH as ZENOBIA.
*Yes tyrant yes, it is the stroke of death / And I inflict it.*
London. Printed for G. Cawthorn. British Library. Strand. A.D. 4.96.

yes; it is the stroke of death / And I inflict it—."

LOCATION OF ORIGINAL: Unknown.

PROVENANCE: In sale of Bell paintings at Leigh & Sotheby's, 25 May 1805 (lot 279).

RELATED: None.

Catherine Gough made her debut in London as Alicia in *Jane Shore* on 22 October 1795, at Covent Garden Theatre, several months before Graham pictured her as Zenobia. She did not act Zenobia in London, where Murphy's play was not performed during the last decade of the eighteenth century.

# 171

## Susan Greville   d. 1802
as Sir Harry Wildair in *Sir Harry Wildair*

by George Farquhar

ARTIST: J. Roberts

ENGRAVER: J. Thornthwaite

DATE PUBLISHED: 17 September 1777.

BELL EDITION: BBT76–77 and 80.XV

Full-length, standing; wearing breeches, waistcoat, coat, and wig, with a rapier at her

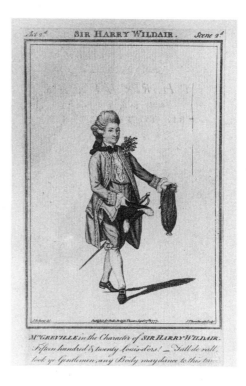

Mr GREVILLE in the Character of SIR HARRY WILDAIR.
*Fifteen hundred & twenty Louis-dors! — Fall de rall, look ye Gentlemen, any Body may dance to this tune.*

left side, holding a hat in right hand and a cloth bag in her left. Line engraving 13.3 × 8.6, with the quotation (II.2): "Fifteen hundred & twenty Louis-dors!—Fall de rall, look ye Gentlemen, any Body may dance to this tune."

LOCATION OF ORIGINAL: Unknown.

PROVENANCE: Unknown.

RELATED: None.

Farquhar's *Sir Harry Wildair*, his sequel to *The Constant Couple*, was not performed during the time of Mrs Greville's career in London. She did, however, act Sir Harry Wildair in *The Constant Couple* at Drury Lane The-

atre on 8 May 1776, when the prompter Hopkins wrote in his diary that she was "very bad."

# 172

George Davies Harley    d. 1811

as Caled in *The Siege of Damascus*

by John Hughes

ARTIST: S. De Wilde

ENGRAVER: J. Wilson

DATE PUBLISHED: 1 June 1793

BELL EDITION: BBT97.XII

Oil on canvas (37 × 28.5), full-length, standing outdoors in front of tent; wearing Eastern costume, with feathered turban, his right arm across chest and holding a saber. Line engraving 11.4 × 7.9, for Bell's British Library, with the quotation (V.3): "What, dost thou frown too!"

LOCATION OF ORIGINAL: Garrick Club (Ash285, CKA255).

PROVENANCE: John Bell; Thomas Harris sale, Robins, 12 July 1819; Charles Mathews (No. 178).

RELATED: None.

Harley did not perform this role in London. The last performance of the play in London was at Covent Garden Theatre on 28 February 1785, when John Henderson acted Caled.

Harley had been tutored by Henderson. After acting at Norwich he made his debut at Drury Lane Theatre on 25 September 1789 as Richard III. He imitated Henderson's speech and action, according to one press report, but he was wanting "in the mind—the passion—and truth." After ten years in London, Harley returned to the provinces. F. G. Waldron found him "a performer of great assiduity and no inconsiderable degree of talent," yet one with many deficiencies.

# 173

George Davies Harley    d. 1811

as Lusignan in *Zara*

by Aaron Hill

ARTIST: S. De Wilde

ENGRAVER: W. Bromley

DATE PUBLISHED: 2 April 1791

BELL EDITION: BBT97.XVII

Full-length, seated, pointing with his right hand to a crucifix and chain in his left hand; wearing breeches and a fur-trimmed robe. Line engraving 10.5 × 7.9, for Bell's British Library, with Lusignan's line (II): "Yes, yes, 'tis she! / This little Cross I know it by sure marks!"

LOCATION OF ORIGINAL: Unknown.

PROVENANCE: Charles Mathews (No. 365), but not located at the Garrick Club.

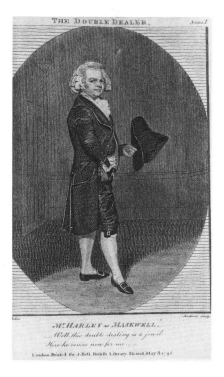

RELATED: An anonymous engraving was printed for C. Cooke, 7 July 1807, and was published as a plate to *British Drama* (1817).

Harley did not act Lusignan on the London stage.

# 174

George Davies Harley   d. 1811
as Maskwell in *The Double Dealer*

by William Congreve

ARTIST: S. De Wilde

ENGRAVER: P. Audinet

DATE PUBLISHED: 8 May 1795

BELL EDITION: BBT97.XXVIII

Full-length, standing, turned to his left, facing front, hat in his left hand; wearing a long coat, ruffled stock, and curly wig. Line engraving 11.4 × 8.3, for Bell's British Li-brary, with the quotation: "—Well, this double-dealing is a jewel / Here he comes now for me.—"

LOCATION OF ORIGINAL: Unknown.

PROVENANCE: Unknown.

RELATED: None.

Harley did not act Maskwell in London. *The Double Dealer* was not performed on the London stage during the period of Harley's career.

Miss Harper. See Elizabeth Bannister, No. 91.

# 175

Elizabeth Hartley   1750?–1824
as Almeyda in *Don Sebastian*

by John Dryden

ARTIST: J. Roberts (1778)

ENGRAVER: B. Reading

DATE PUBLISHED: 1 June 1777

BELL EDITION: BBT 76–77 and 80.XII

Colored drawing on vellum (11.1 × 8.3), full-length, standing to right, arms raised, holding

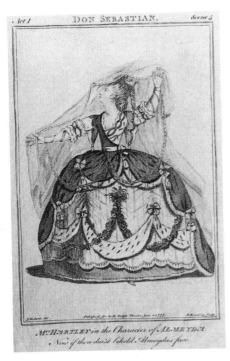

a transparent veil over her head and shoulders; wearing a very wide panniered dress with bows, ribbons, and swathes. Line engraving 14 × 8.9, with the quotation (I.5): "Now if thou dar'st behold Almeydas face."

LOCATION OF ORIGINAL: British Museum (Burney IV, No. 146).

PROVENANCE: Bell sale, Christie's, 27 March 1793 (lot 9); bought, with five other drawings in lot, for 16s. by Gretton.

RELATED: None.

The drawing by Roberts is dated later than the engraving. In the opinion of E. Croft-Murray (cited by J. F. Kerslake in *Catalogue of Theatrical Portraits in London Public Collections*), the drawing, the date, and the inscription are in Roberts's own hand; it is "suggested that they were added from memory

later in life." Mrs Hartley first acted Almeyda at Covent Garden Theatre on 22 March 1774. A great beauty, she was painted by Reynolds, Zoffany, and Kauffmann.

# 176

## Elizabeth Hartley    1750?–1824
as Cleopatra in *All for Love*

by John Dryden

ARTIST: J. Roberts

ENGRAVER: J. Thornthwaite

DATE PUBLISHED: 12 August 1776

BELL EDITION: BBT 76–77 and 80.V; BET 92

Full-length, standing, facing left profile, holding a dagger in her raised right hand; wearing a panniered dress decorated with floral wreaths. Line engraving 13.7 × 9.8, with the quotation (V.1): "I'll die, I will not bear it."

LOCATION OF ORIGINAL: Unknown.

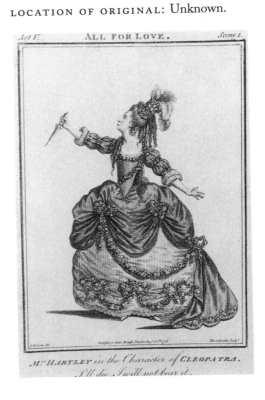

PROVENANCE: Unknown.

RELATED: The copy (13.3 × 9.5) in BBT80 and BET92 was engraved by Page but carries the same date.

An anonymous engraving of Mrs Hartley as Cleopatra was published by J. Wenman as a plate to an edition of the play, 1778. Mrs Hartley first acted Cleopatra at Covent Garden Theatre on 28 April 1773.

# 177

## Elizabeth Hartley   1750?–1824
as Elfrida in *Elfrida*

by William Mason

ARTIST: J. Roberts

ENGRAVER: W. Leney

DATE PUBLISHED: 12 November 1796

BELL EDITION: BBT97.XXXIV

Full-length, standing in a garden picking flowers; wearing a dress with low neckline

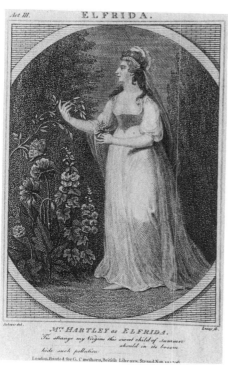

and a hat with a veil trailing down the back. Line engraving 11.4 × 7.6, for Cawthorn's British Library, with the quotation (III): " 'Tis strange my Virgins, this sweet child of summer / —should in the bosom / hide such pollution—."

LOCATION OF ORIGINAL: Unknown.

PROVENANCE: Bell sale, Leigh & Sotheby's, 25 May 1805 (lot 265).

RELATED: None.

For other portraits of Mrs Hartley as Elfrida, see the *BDA*. She acted the role at Covent Garden Theatre for the first time on 21 November 1772.

# 178

## Elizabeth Hartley   1750?–1824
as Elvira in *Elvira*

by David Mallet

ARTIST: J. Roberts

ENGRAVER: J. Thornthwaite

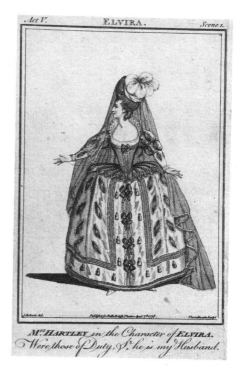

DATE PUBLISHED: 7 April 1778

BELL EDITION: BBT76–77 and 80.XX; BET92.IX

Colored drawing on vellum (10.8 × 7.9), full-length, standing to front, head to right, hands slightly to sides; wearing a very narrow-waisted panniered dress decorated with bows and other designs, feathers and long veil atop high-piled hair. Line engraving 13.2 × 9.5, with the quotation (V.1): "Were those of Duty, Sᵣ he is my Husband."

LOCATION OF ORIGINAL: British Museum (Burney IV, No. 147).

PROVENANCE: Bell sale, Christie's, 27 March 1793 (lot 9); bought, with five other drawings in lot, for 16s. by Gretton.

RELATED: None.

Mrs Hartley did not act Elvira in London; the play was not performed there during the second half of the eighteenth century.

# 179

## Elizabeth Hartley   1750?–1824

as Imoinda in *Oroonoko*

by Thomas Southerne

ARTIST: J. Roberts

ENGRAVER: J. Thornthwaite

DATE PUBLISHED: 1 March 1777

BELL EDITION: BBT76–77 and 80.X

Colored drawing on vellum (10.8 × 8.3), full-length, standing to front, head to right, holding a bow in her left hand; wearing a richly decorated dress, feathers atop high-piled hair. Line engraving 14 × 9.5, with the quotation (IV): "I fear no danger; life, or death, I will enjoy with you."

LOCATION OF ORIGINAL: British Museum (Burney IV, No. 151).

PROVENANCE: Bell sale, Christie's, 27 March 1793 (lot 9); bought, with five other drawings, for 16s. by Gretton.

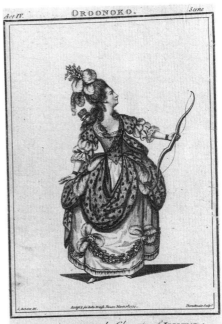

RELATED: The copy printed in BBT80 is dated November 1777. A likeness, after Roberts, is on a delftware tile in the Manchester City Art Galleries.

Early biographers state that Mrs Hartley made her first appearance in London in 1769 as Imoinda, under Foote's management at the Haymarket Theatre, but there is no record of that performance in *The London Stage*. She did not play the role in London before this engraving was published.

# 180

## Elizabeth Hartley   1750?–1824

as Jane Shore in *Jane Shore*

by Nicholas Rowe

ARTIST: J. Roberts

ENGRAVER: Anonymous

DATE PUBLISHED: 10 April 1776

BELL EDITION: BBT76–77.I

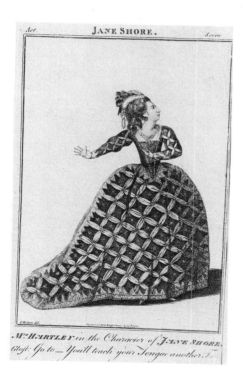

# 181

Elizabeth Hartley 1750?–1824
as Jane Shore in *Jane Shore*

by Nicholas Rowe

ARTIST: J. Roberts

ENGRAVER: J. Thornthwaite

DATE PUBLISHED: 7 November 1777

BELL EDITION: BBT80.I

Colored drawing on vellum (11.2 × 9.2), full-length, standing, head turned in profile to

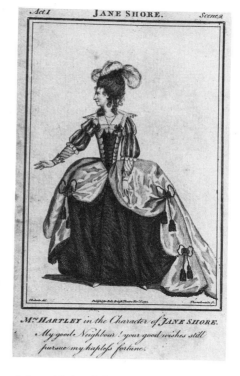

Colored drawing on vellum (12 × 9.5), full-length, standing, head to right, her right hand extended; wearing a panniered dress with ribbons in a crisscross pattern. Line engraving 14.3 × 9.5, in reverse, with Gloster's line: "Go to—You'll teach your Tongue another Tale."

LOCATION OF ORIGINAL: British Museum (Burney IV, No. 148).

PROVENANCE: Bell sale, Christie's, 27 March 1797 (lot 9); bought, with five other drawings in lot, for 16s. by Gretton.

RELATED: Another drawing by Roberts of Mrs Hartley as Jane Shore was in the Bell sale at Christie's; see No. 181.

After a season at Edinburgh, Mrs Hartley acted Jane Shore for her debut at Bristol in the summer of 1772. She also made her Covent Garden Theatre debut in that role on 5 October 1772, when the critic in the *Town and Country Magazine* found her deserving "of much praise."

right, with her left arm extended; wearing a panniered dress, with an overskirt decorated with bows and tassels, and a hat with feather. Line engraving 13.7 × 8.9, in reverse, with the quotation (I.2): "My good Neighbour! your good wishes still pursue my hapless fortune."

LOCATION OF ORIGINAL: British Museum (Burney IV, No. 149).

PROVENANCE: Bell sale, Christie's, 27 March

1793 (lot 9); bought, with five other drawings in lot, for 16s. by Gretton.

RELATED: Another drawing by Roberts of Mrs Hartley as Jane Shore was in the Bell sale at Christie's; see No. 180.

# 182

## Elizabeth Hartley   1750?–1824
as Lady Jane Gray in *Lady Jane Gray*

by John Banks

ARTIST: J. Roberts

ENGRAVER: J. Thornthwaite

DATE PUBLISHED: 26 December 1776

BELL EDITION: BBT76–77 and 80.VII; BET92.III

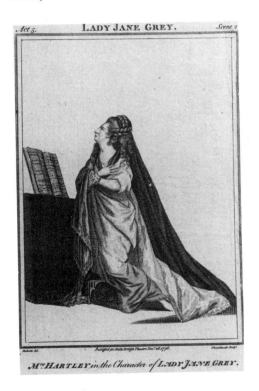

Full-length, kneeling left on a stool, before table and book, her arms crossed over chest; wearing a long dress with a veil trailing from the back of her head down her back. Line engraving 14.2 × 9.5 (V.2).

LOCATION OF ORIGINAL: Unknown.

PROVENANCE: Unknown.

RELATED: The copy (13.3 × 9.2), in reverse, published in BBT80 was engraved by Page and bears the same date. A likeness, after Roberts, appears on a delftware tile in the Manchester City Art Galleries.

An engraving of Mrs Hartley as Lady Jane Gray by C. Sherwin was published by Lowndes as a plate to *New English Theatre* (1777), and an anonymous engraving was published by J. Wenman as a plate to an edition of the play, 1778. Mrs Hartley first acted the role at Covent Garden Theatre on 7 May 1773.

# 183

## Elizabeth Hartley   1750?–1824
as Mary Queen of Scots in *The Albion Queens*

by John Banks

ARTIST: J. Roberts

ENGRAVER: J. Thornthwaite

DATE PUBLISHED: 4 August 1777

BELL EDITION: BBT76–77 and 80.XIV

Colored drawing on vellum (10.8 × 8.6), full-length, standing, head to left, looking at a mirror held in her raised right hand extended left, her left arm extended downward at left side; wearing a crown atop high-piled hair and a dress with ermine trim. Line engraving 14 × 8.9, with the quotation (II.5): "These Cheeks are none of mine, the Roses look like Tempest-beaten lillies as mine should."

LOCATION OF ORIGINAL: British Museum (Burney IV, No. 150).

PROVENANCE: Bell sale, Christie's, 27 March 1793 (lot 9); bought, with five other drawings in lot, for 16s. by Gretton.

RELATED: None.

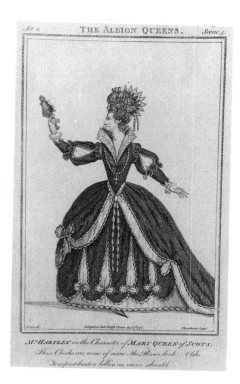

Mrs Hartley acted this role in her first season at Edinburgh, 1771–72. Her first appearance in that role in London was on 20 May 1779, at Covent Garden Theatre.

# 184

## Elizabeth Hartley   1750?–1824
as Rosamond in *Henry the Second*

by Thomas Hull

ARTIST: J. Roberts

ENGRAVER: J. Pegg

DATE PUBLISHED: 24 May 1795

BELL EDITION: BBT97.XXVIII

Full-length, standing in a chapel, face in profile, her right arm extended; wearing a hat with feathers and a dress with darker overskirt. Line engraving 10.8 × 7.6, for Bell's British Library, with the quotation (IV.2): "Oh, did I ever think I would refuse what Henry asked—."

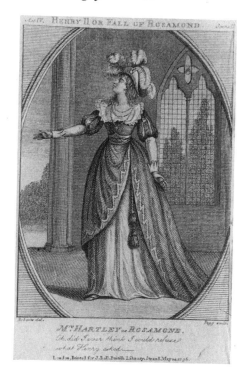

LOCATION OF ORIGINAL: Unknown.

PROVENANCE: Unknown.

RELATED: None.

Mrs Hartley acted Rosamond in the premiere of Hull's play at Covent Garden Theatre on 1 May 1773. When Garrick saw her in the role in May 1774 he pronounced her "make" as "perfect" and wrote in a letter to Peter Fountain that he had never seen "a finer creature."

# 185

## Elizabeth Heard   b. ca. 1775
as Aurelia in *The Twin Rivals*

by George Farquhar

ARTIST: J. Roberts

ENGRAVER: J. Wilson

DATE PUBLISHED: 7 February 1796

BELL EDITION: BBT97.XXXII

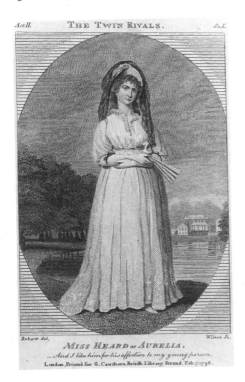

Full-length, standing in a landscape with trees and a pond in background, her arms crossed in front, holding a fan in her right hand; wearing a hat, beneath which fall long curls, and a dress with sash at waist. Line engraving 12 × 7.9, for Cawthorn's British Library, with the quotation (II.1): "—And I like him for his affection to my young person."

LOCATION OF ORIGINAL: Unknown.

PROVENANCE: Unknown.

RELATED: None.

Elizabeth Heard is not known to have played Aurelia in London. At the age of six, she made her debut at Drury Lane Theatre on 26 December 1782 as a Page in *The Orphan*. Over the next nineteen years, until June 1801, she developed as a "solid and useful" actress, who, according to Thomas Dutton in *Dramatic Censor*, possessed "from nature a refined sensibility of soul, strictly congenial with the character she represented."

# 186

## Elizabeth Heard   b. ca. 1775
### as Celia in *The School for Lovers*

by William Whitehead

ARTIST: S. De Wilde

ENGRAVER: P. Audinet

DATE PUBLISHED: 26 January 1793

BELL EDITION: BBT97.VII

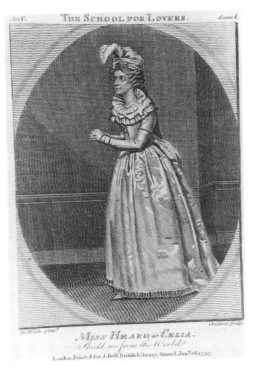

Full-length, standing in a room, facing to her right with her hands clasped before her; wearing a dress with ruff at neck and a turban feather on her head. Line engraving 11.4 × 9.5, for Bell's British Library, with Celia's line (I.1): "Shield me from the World."

LOCATION OF ORIGINAL: Unknown.

PROVENANCE: Thomas Harris sale at Robins, 12 July 1819 (lot 64), bought by Charles Mathews.

RELATED: None.

Elizabeth Heard is not known to have played Celia in London. Her mother, who acted in London between 1766 and 1797, did not play this role either.

# 187

## John Henderson   1747–1785
### as Bayes in *The Rehearsal*

by George Villiers, Duke of Buckingham

ARTIST: J. Roberts

ENGRAVER: R. Pollard

DATE PUBLISHED: 16 September 1777

BELL EDITION: BBT76–77 and 80.XV

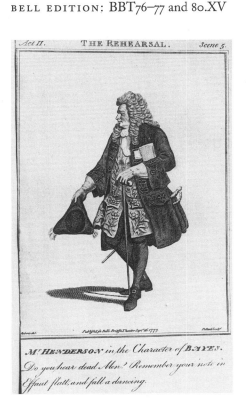

Drawing, full-length, standing to left, holding a hat in his right hand, a book under his left arm, and a stick in his left hand; wearing a long wig, long coat, and embroidered undercoat. Line engraving 14 × 8.6, with the quotation (II.5): "Do you hear dead Men? Remember your note in Effaut flatt, and fall a dancing."

LOCATION OF ORIGINAL: Unknown.

PROVENANCE: Bell sale Christie's, 27 March 1793 (lot 8); bought, with five other drawings in lot, for 15s. by C. Cooke.

RELATED: None.

This engraving was published on the same date as Pollard's engraving of Roberts's portrait of Garrick as Bayes; see No. 159. Henderson first acted Bayes in London on 25 August 1777, at the Haymarket Theatre. During his short career on the London stage—from 1777 to his premature death in 1785—Henderson was regarded by many as second only to Garrick.

# 188

## John Henderson   1747–1785
### as Don John in *The Chances*

by John Fletcher

ARTIST: J. Roberts

ENGRAVER: J. Thornthwaite

DATE PUBLISHED: 24 September 1777

BELL EDITION: BBT76–77 and 80.XV.

Full-length, standing, profile right, hands on hips; wearing breeches, doublet, jacket, and hat with tall feathers. Line engraving 13.3 × 8.9, with the quotation (II): "Not look upon her! I smell an old Dog Trick Don Frederick."

LOCATION OF ORIGINAL: Unknown.

PROVENANCE: Unknown.

RELATED: None.

Henderson first acted Don John at Bath on 27 October 1773. He appeared in that role in London for the first time on 19 August 1777,

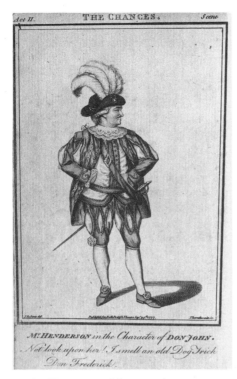

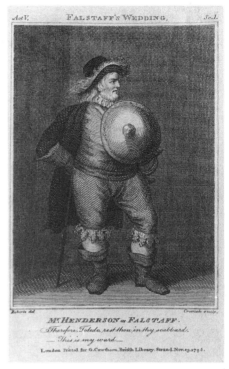

at the Haymarket Theatre. An engraving by Terry of Henderson in this role, carrying a child, was printed as a plate to an edition of the play published by J. Harrison, 1780.

# 189

John Henderson   1747–1785
as Falstaff in *Falstaff's Wedding*

by William Kenrick

ARTIST: J. Roberts

ENGRAVER: R. H. Cromek

DATE PUBLISHED: 29 November 1795

BELL EDITION: BBT97.XXXI

Red chalk drawing (11.4 × 8.9), full-length to right, holding a round shield in left hand and leaning on a stick in his right hand; wearing a hat with fringed brim, a ruff, cloak, breeches, tunic, and boots. Line engraving 11.4 × 7.9, for Cawthorn's British Library,

with the line: "Therefore, Toledo, rest thou in thy scabbard."

LOCATION OF ORIGINAL: British Museum (BM. LB. 1).

PROVENANCE: Unknown.

RELATED: None.

Henderson did not appear in Kenrick's *Falstaff's Wedding* during his career on the London stage, but see No. 31.

# 190

Joseph George Holman   1764–1817
as Alexander in *The Rival Queens*

by Nathaniel Lee

ARTIST: S. De Wilde

ENGRAVER: J. Chapman

DATE PUBLISHED: 19 April 1793

BELL EDITION: BBT97.I

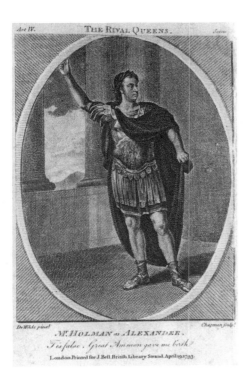

New York. He died in America, on Long Island in August 1817. An actor of some merit and talent, Holman failed to fulfill his promise, mainly because of his mannerisms and lack of judgment in interpretation.

# 191

## Joseph George Holman   1764–1817
as Chamont in *The Orphan*

by Thomas Otway

ARTIST: S. De Wilde

ENGRAVER: J. Thornthwaite

DATE PUBLISHED: 23 June 1791

BELL EDITION: BBT97.IX

Oil on canvas (33.55 × 27.3), full-length, standing in a room, drawing sword; wearing a blue military coat and breeches. Line engraving 11.4 × 7.6, for Bell's British Library, with Chamont's line (IV): "—curse on thy scandal-

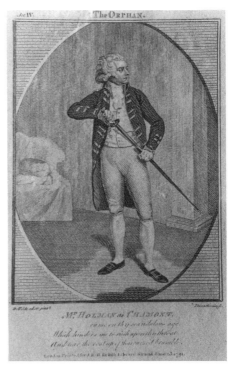

Full-length oil painting (37.3 × 28.4), standing, facing front, his right hand raised, holding his mantle with left; wearing pseudoclassic costume and armor and a wreath of bay leaves; columns and sky to left. Line engraving 10.8 × 7.9, for Bell's British Library, with the quotation (IV): " 'tis false. Great Ammon gave me birth."

LOCATION OF ORIGINAL: Garrick Club (Ash302, CKA243).

PROVENANCE: John Bell; Charles Mathews (No. 180).

RELATED: A watercolor drawing by De Wilde, dated 1814, similar to the engraving, is in the Harvard Theatre Collection.

Holman first played Alexander in London on 12 April 1792, for his benefit at Covent Garden Theatre. Between 1784 and 1800, Holman acted in London. He was at Edinburgh in the first decade of the nineteenth century and then went to America, making his debut in October 1812 at the Park Street Theatre in

ous age, / Which hinders me to rush upon thy throat, / And tear the root up of that cursed bramble."

LOCATION OF ORIGINAL: Garrick Club (Ash303, CKA266)

PROVENANCE: John Bell; Charles Mathews (No. 93).

RELATED: A painting (40.6 × 29.8) by De Wilde, ca. 1785, in the Museum of London (A7463) depicts Holman in the same costume but in a different pose, with right arm extended and without drawn sword. Other engravings are by P. Audinet (11.1 × 7.9) for Bell's British Library, 1791, and by R. Godfrey (23.2 × 17.8) published by Bell, June 1792; the large engraving by Godfrey is "from the original Picture which was painted from life by De Wilde from the Orphan by Otway, in the Celebrated Edition of Bell's British Theatre, which is now Publishing Periodically." Also by an anonymous engraver for *British Drama*, printed for C. Cooke, 29 August 1807; a reversed copy of the preceding was done by an anonymous engraver.

Holman first acted Chamont at Covent Garden Theatre on 4 February 1785.

# 192

## Joseph George Holman   1764–1817
as Cyrus in *Cyrus*

by John Hoole

ARTIST: S. De Wilde

ENGRAVER: J. Wilson

DATE PUBLISHED: 30 June 1795

BELL EDITION: BBT97.XXIV

Oil painting (37 × 28.8), full-length, standing to front in a forest, head to left, curly hair, holding a tall white staff in his left hand; wearing a tiger-skin mantle. Line engraving 11.7 × 8.9, for Bell's British Library, with Cyrus's line (I.2): "Can it be possible?—"

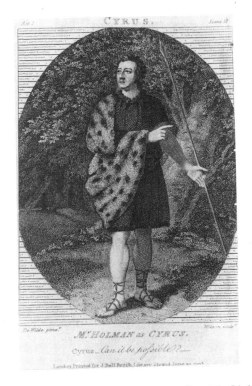

LOCATION OF ORIGINAL: Garrick Club (Ash304, CKA257).

PROVENANCE: Bell sale, Leigh & Sotheby's, 25 May 1805 (lot 280); Charles Mathews (374), when it was said to be by Harlow.

RELATED: Engraving (11.4 × 8.3) by P. Audinet, same date 30 June 1795, also for Bell's British Library.

Holman acted Cyrus in Hoole's *Cyrus* once, on 30 May 1794, at Covent Garden Theatre.

# 193

## Joseph George Holman   1764–1817
as Young Norval (Douglas) in *Douglas*

by John Home

ARTIST: S. De Wilde

ENGRAVER: W. Bromley

**DATE PUBLISHED:** 7 April 1791

**BELL EDITION:** BBT97.III

Oil on canvas (37.2 × 28.7), full-length, standing to right, head to left, hands raised to

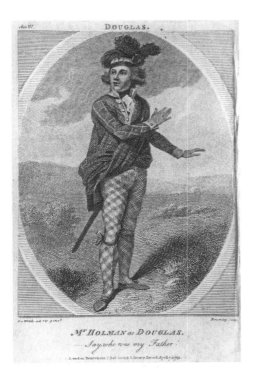

M.<sup>r</sup> HOLMAN as DOUGLAS.
*Say who was my Father!*

right; wearing a plumed hat, tartan coat, and trews. Line engraving 10.8 × 7.6, for Bell's British Library, with Douglas's line (IV): "Say who was my Father!"

**LOCATION OF ORIGINAL:** Garrick Club (Ash305, CKA221).

**PROVENANCE:** John Bell; Charles Mathews (No. 175).

**RELATED:** The same plate was published by C. Cooke, *British Drama* (1807); an engraving by Ferguson, after De Wilde, was published in Dublin by W. Jones as a plate to *British Theatre* (1792).

Holman seems not to have acted Douglas in London before this engraving was published.

His only appearance in the role was at Covent Garden Theatre on 20 December 1792.

# 194

Joseph George Holman   1764–1817
as Edward in *Albina, Countess of Raimond*

by Hannah Cowley

**ARTIST:** J. Graham

**ENGRAVER:** J. Thomson

**DATE PUBLISHED:** 8 April 1797

**BELL EDITION:** BBT97.XXIX

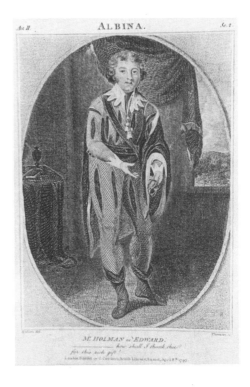

M.<sup>r</sup> HOLMAN as EDWARD.
*...how shall I thank thee
for this Ark gift!*

Full-length, standing to front in a room with drapery and window behind, holding a purse in left hand; wearing boots, trousers, and cloak with slashes. Line engraving 11.1 × 7.6, printed for Cawthorn's British Library, with

the quotation (II.2): "—how shall I thank thee for this rich gift?"

LOCATION OF ORIGINAL: Unknown.

PROVENANCE: Bell sale, Leigh & Sotheby's, 25 May 1805 (lot 271), in gilt frame.

RELATED: None.

Holman did not act this role in London. The role was played by Dimond in the premiere of the play at the Haymarket Theatre on 31 July 1779.

# 195

## Joseph George Holman  1764–1817
as Hippolitus in *Phaedra and Hippolitus*

by Edmund Smith

ARTIST: J. Graham

ENGRAVER: W. Leney

DATE PUBLISHED: 20 August 1796

BELL EDITION: BBT97.XXVIII

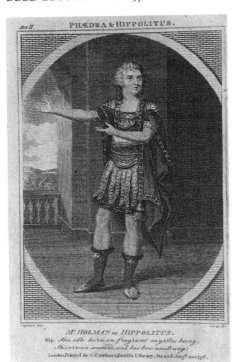

Full-length, standing before a wall and balustrade, almost full-face, arms extended to left; wearing classical dress, armor, and cape. Line engraving 11.1 × 7.6, for Cawthorn's British Library, with the Hippolitus's line (II): "His idle horn on fragrant myrtles hung, / His arrows scatter'd, and his bow unstrung."

LOCATION OF ORIGINAL: Unknown.

PROVENANCE: Bell sale, Leigh & Sotheby's, 25 May 1805 (lot 271).

RELATED: None.

Holman first acted Hippolitus on 3 March 1785 at Covent Garden Theatre.

# 196

## Joseph George Holman  1764–1817
as Tancred in *Tancred and Sigismunda*

by James Thomson

ARTIST: S. De Wilde

ENGRAVER: J. Matthieu

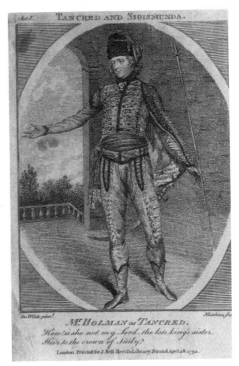

DATE PUBLISHED: 28 April 1792

BELL EDITION: BBT97.XIV

Full-length, standing, right arm extended, holding a spear in his left hand; wearing pseudo-Hussar's costume and fur hat; arch and landscape behind left. Line engraving 10.8 × 7.6, for Bell's British Library, with the quotation (I): "How! is she not, my Lord, the late king's sister? / Heir to the crown of Sicily?"

LOCATION OF ORIGINAL: Unknown.

PROVENANCE: Unknown.

RELATED: The same picture appeared in an engraving (11.4 × 7.9) by J. Thornthwaite, 1791, and as a plate to *British Theatre* (1817), published by W. Jones in Dublin.

Holman first acted Tancred at Covent Garden Theatre on 21 December 1791.

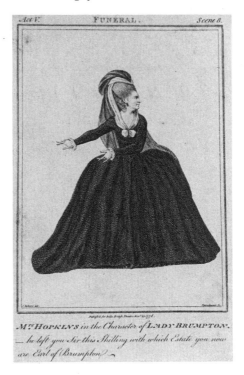

Mrs HOPKINS in the Character of LADY BRUMPTON.
— he left you Sir this Shilling with which Estate you now are Earl of Brumpton —

# 197

## Elizabeth Hopkins (Mrs William Hopkins) 1731–1801
as Lady Brumpton in *The Funeral*

by Richard Steele

ARTIST: J. Roberts

ENGRAVER: J. Thornthwaite

DATE PUBLISHED: 23 November 1776

BELL EDITION: BBT76–77 and 80.VIII

Drawing, full-length, standing, profile right, both arms extended to her right; wearing a headdress with a long veil down the back and a dark dress with wide skirt. Line engraving 13.3 × 9.2, with the quotation (V.8): "—he left you, Sir, this Shilling, with which Estate you now are Earl of Brumpton."

LOCATION OF ORIGINAL: Unknown.

PROVENANCE: Bell sale, Christie's, 27 March 1793 (lot 8); bought, with five other drawings in lot, for 15s. by C. Cooke.

RELATED: The second engraving, for the 1780 edition, is dated November 1777, and neither the artist nor engraver is stated. It is a copy of the earlier one.

Mrs Hopkins first acted Lady Brumpton at Drury Lane Theatre on 3 April 1770. The wife of the Drury Lane prompter William Hopkins, she had a busy career at that theatre for thirty-four years.

# 198

## Elizabeth Hopkins (later Mrs Michael Sharp) b. 1756
as Arethusa in *Philaster*

by Francis Beaumont and John Fletcher, altered by Geroge Colman the Elder

ARTIST: J. Roberts

ENGRAVER: J. Thornthwaite

DATE PUBLISHED: 1 January 1778

BELL EDITION: BBT76–77 and 80.XVIII

Colored drawing on vellum (10.8 × 8.3), full-length to front, head to left, arms extended to her left; wearing a richly brocaded dress with panniered skirt and a hat with a plume. Line engraving 13.3 × 9.2, with the quotation (I.6): "Yes—I must have thy Kingdoms—must have thee!"

LOCATION OF ORIGINAL: British Museum (Burney IV, No. 259).

PROVENANCE: Unknown.

RELATED: None.

An engraving by Terry of Elizabeth Hopkins as Arethusa was published by Harrison as a plate to an edition of the play, 1780. Miss Hopkins first acted the role at Drury Lane Theatre on 6 May 1773.

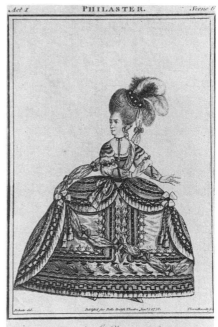

# 199

Elizabeth Hopkins (later Mrs Michael Sharp)   b. 1756
as Irene in *Barbarossa*

by John Brown

ARTIST: J. Roberts

ENGRAVER: J. Thornthwaite

DATE PUBLISHED: 1 March 1777

BELL EDITION: BBT76–77 and 80.X

Full-length, standing, as though walking to her right, arms extended to sides; wearing a richly brocaded dress with a long train and a feathered hat with fabric trailing from it. Line engraving 14 × 9.5, with the quotation (III.2): "Blest is Irene! Blest if Selim lives!"

LOCATION OF ORIGINAL: Unknown.

PROVENANCE: Unknown.

RELATED: The engraving for BBT80 is dated May 1778.

Elizabeth Hopkins did not act the role of Irene in London. Her mother, Elizabeth Hopkins, however, did act Irene at Drury Lane Theatre on 21 November 1761.

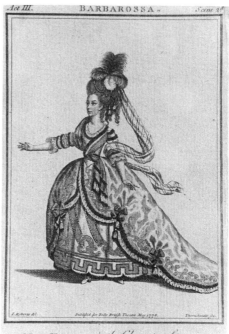

# 200

Priscilla Hopkins (later Mrs John
Philip Kemble)   1758–1854
as Aura in *The Country Lasses*

by Charles Johnson

ARTIST: J. Roberts

ENGRAVER: R. Pollard

DATE PUBLISHED: 1 January 1779

BELL EDITION: BBT76–77 and 80.XIX

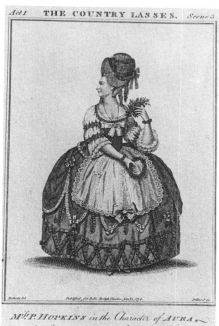

Drawing, full-length, standing, holding a
wreath in her right hand, flowers in left; wear-
ing a dress with panniered decorated skirt.
Line engraving 12.7 × 8.9, with the quotation
(I.3): "Yes Sir they will tell you what will hap-
pen to you Exactly—good Evening."

LOCATION OF ORIGINAL: Unknown.

PROVENANCE: Bell sale, Christie's, 17 March
1793 (lot 4); bought, with five other drawings
in lot, for 12s. 6d. by C. Cooke.

RELATED: None.

Miss Hopkins did not act Aura in London.
She began to play soubrettes in 1775–76. She
married the actor William Brereton in 1777,
and after Brereton's death in 1787, she mar-
ried John Philip Kemble later that year. Mrs
Kemble retired after the season 1795–96. Pos-
sessed of a pretty face and agreeable figure,
she was moderately successful in sentimental
comedies.

# 201

Priscilla Hopkins (later Mrs John
Philip Kemble)   1758–1854
as Miss Notable in *The Lady's Last Stake*

by Colley Cibber

ARTIST: J. Roberts

ENGRAVER: J. Thornthwaite

DATE PUBLISHED: February 1778

BELL EDITION: BBT76–77 and 80.XIX

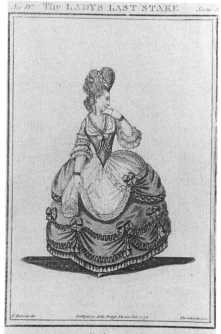

Drawing, full-length, standing, left forefinger to lips; wearing high-piled hair and a panniered dress with ribbons and frills on skirt. Line engraving 13.8 × 9.2, with the quotation (IV.5): "I have been so abused! so affronted!"

LOCATION OF ORIGINAL: Unknown.

PROVENANCE: Bell sale, Christie's, 27 March 1793 (lot 4); bought, with five other drawings in lot, for 12s. 6d. by C. Cooke.

RELATED: None.

Miss Hopkins did not act Miss Notable in London.

# 202

## Thomas Hull   1728–1808
in Private Character

ARTIST: J. Graham

ENGRAVER: W. Leney

DATE PUBLISHED: 10 January 1797

BELL EDITION: Issued Separately

Oil on canvas (50.15 × 41.25), seated left, head to right, holding a book in left hand, silver-rimmed spectacles in right; wearing white stockings, yellow breeches, a dark blue jacket with a red collar, and a red waistcoat. The items on the table include a bust of Shakespeare. Stipple engraving 9.8 × 7.6, oval.

LOCATION OF ORIGINAL: Garrick Club (Ash311, CKA121 as by unknown artist). The engraving by Leney, published by Cawthorn in 1797, is marked "Graham fecit."

PROVENANCE: John Bell; Bell sale, Leigh & Sotheby's, 25 May 1805 (lot 279), "Mr Hull of Covent Garden"; Charles Mathews

After engagements in Dublin and Bath, Hull made his debut at Covent Garden Theatre in October 1759. In London, he acted an extensive repertoire of more than two hundred twenty-five characters through December 1807. In the *Dramatic Censor* (1770), Francis Gentleman described Hull as "a respectable

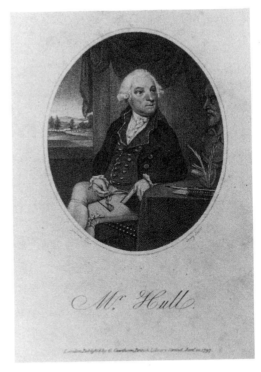

performer" of "tender sensibility" who was fitted for the "graver parts of comedy."

# 203

## Thomas Hull   1728–1808
as Gloster in *Edward and Eleanora*

by James Thomson,
altered by Thomas Hull

ARTIST: J. Roberts

ENGRAVER: W. Leney

DATE PUBLISHED: 12 December 1795

BELL EDITION: BBT97.XXXII

Full-length, standing in a field with tents behind, face in profile left, his right arm extended, left hand on hip; wearing breeches, doublet, a cape with ermine trim, and a hat with plume. Line engraving 11.1 × 7.6, for Cawthorn's British Library, with Gloster's line (IV.4): "Yon guilty Towers."

LOCATION OF ORIGINAL: Unknown.

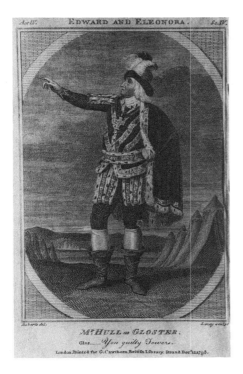

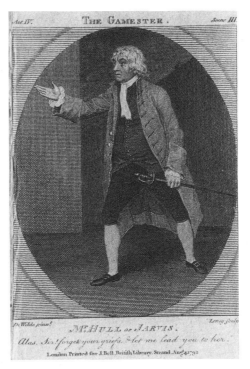

PROVENANCE: Bell sale, Leigh & Sotheby's, 25 May 1805 (lot 273).

RELATED: None

Hull's alteration of James Thomson's *Edward and Eleanora* was first performed at Covent Garden Theatre on 18 March 1775, for Mrs Barry's benefit, with Hull playing Gloster.

# 204

Thomas Hull 1728–1808
as Jarvis in *The Gamester*

by Edward Moore

ARTIST: S. De Wilde

ENGRAVER: W. Leney

DATE PUBLISHED: 4 August 1792

BELL EDITION: BBT97.X

Oil on canvas (36.8 × 28.4), full-length, advancing half-left, a sword in left hand, his right arm stretched forward, left hand on sword; wearing a coat, waistcoat, and breeches. Line engraving 10.5 × 7.6, for Bell's British Library, with the quotation (IV.3): "Alas, Sir! forget your griefs & let me lead you to her."

LOCATION OF ORIGINAL: Garrick Club (Ash310, CKA261).

PROVENANCE: Charles Mathews (No. 349).

RELATED: A copy by an anonymous engraver was published in *British Drama* (1817).

Hull first acted Jarvis at Covent Garden Theatre on 4 January 1781.

# 205

Thomas Hull 1728–1808
as King Charles in *King Charles I*

by William Havard

ARTIST: J. Roberts

ENGRAVER: B. Reading

DATE PUBLISHED: 1 May 1777

BELL EDITION: BBT76–77 and BBT80.XII

Drawing, full-length, standing, his left arm extended to right; wearing breeches, a jacket with sash at waist, a hat with feathers, and a wide lace collar. Line engraving 14 × 8.6, with the line (IV): "Deny'd to speak! why have I lived to this?"

LOCATION OF ORIGINAL: Unknown.

PROVENANCE: Bell sale, Christie's, 27 March 1793 (lot 8), bought, with other drawings in lot, for 15s. by C. Cooke.

RELATED: None.

The only time that this play was performed while Hull was at Covent Garden Theatre was on 2 April 1781, when Hull played the role of Bishop Juxon.

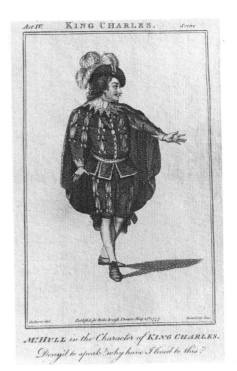

# 206

Thomas Hull    1728–1808

as Voltore in *Volpone*

by Ben Johnson

ARTIST: J. Roberts

ENGRAVER: R. Pollard

DATE PUBLISHED: 16 October 1777

BELL EDITION: BBT76–77 and 80.XIX

Drawing, full-length, front, his right hand pointing to a plate under his left arm; wearing a long coat with train, and a long wig. Line engraving 12.7 × 8.9, with the quotation (III.3): "would to heaven I could as well give health to you as to this Plate."

LOCATION OF ORIGINAL: Unknown.

PROVENANCE: Bell sale, Christie's, 27 March 1793 (lot 8); bought with other drawings in lot for 15s. by C. Cooke.

RELATED: None.

Hull acted Voltore for the first time at Covent Garden Theatre on 26 November 1771.

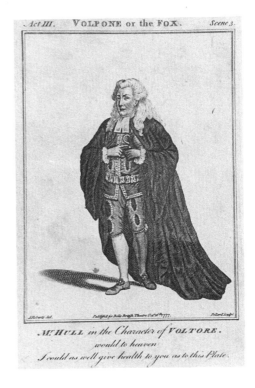

# 207

Maria Hunter [fl. 1774–1779]
as Mrs Belville *The School for Wives*

by Hugh Kelly

ARTIST: S. De Wilde

ENGRAVER: J. Thornthwaite

DATE PUBLISHED: 5 January 1792

BELL EDITION: BBT97.VII

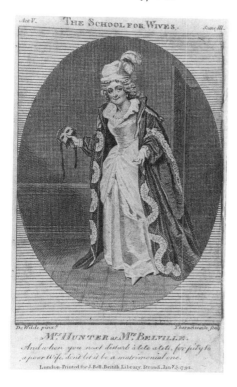

Full-length, standing in a room, holding a mask in her right hand; wearing a hat with feathers and an embroidered cloak-coat over a long dress. Line engraving 11.5 × 7.6, for Bell's British Library, with the quotation (V.3): "And when you next disturb a tete a tete, for pity to a poor wife, don't let it be a matrimonial one."

LOCATION OF ORIGINAL: Unknown.

PROVENANCE: Unknown.

RELATED: An anonymous engraving, after De Wilde, of Mrs Hunter as Mrs Belville was published by C. Cook, 1808.

Maria Hunter seems not to have acted Mrs Belville in London. She made her debut at Covent Garden Theatre on 21 October 1774 as Mrs Oakly in *The Jealous Wife*. Though over the years she had several engagements in London, mainly she worked in the provinces. She was not engaged in London at the time this picture of her as Mrs Belville was published, but she had been at Covent Garden Theatre during the period the pictures of her as Penelope and Boadicea were brought out in BBT76–77 and 80. Tate Wilkinson, for whom she acted on the York circuit, wrote in his *Wandering Patentee* that she had pleasing talents offstage, but onstage, her fallible memory was "a great bar to her stage success." "At a table," wrote Wilkinson, "Mrs. Hunter was a woman of great good-breeding, sense and conviviality, and knew how to dissect with a grace and point."

# 208

Maria Hunter [fl. 1774–1779]
as Boadicea in *Boadicea*

by Richard Glover

ARTIST: J. Roberts

ENGRAVER: J. Thornthwaite

DATE PUBLISHED: April 1778

BELL EDITION: BBT76–77 and 80.XX

Drawing, full-length, standing, body to front, head turned to her right, holding a spear in her right hand; wearing a crown with feathers and a panniered dress with long decorated (ermine?) sash wrapped around it. Line engraving 13.7 × 9.2.

LOCATION OF ORIGINAL: Unknown.

PROVENANCE: Bell sale, Christie's, 27 March 1793 (lot 8); bought, with five other drawings by Roberts for 15s. by C. Cooke.

RELATED: None.

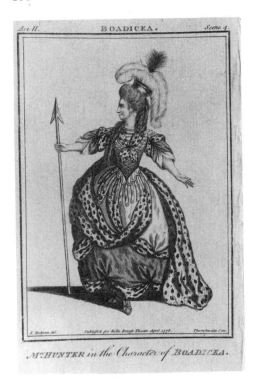

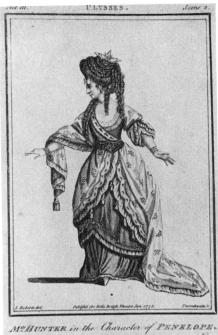

Richard Glover's *Boadicea* was not performed on the London stage during the period of Maria Hunter's career.

# 209

## Maria Hunter   [fl. 1774–1779]
as Penelope in *Ulysses*

by Nicholas Rowe

ARTIST: J. Roberts

ENGRAVER: J. Thornthwaite

DATE PUBLISHED: January 1778

BELL EDITION: BBT76–77 and 80.XVIII

Full-length (17.8 × 10.8), standing, body to front, head to left, arms extended to sides, and curls down to her shoulders; wearing a small crown and earrings and a dress with overskirt and train. Line engraving 14 × 9.2, with the quotation (III.2): "And see! the shade of my much injured Lord starts up to blast me!"

LOCATION OF ORIGINAL: Unknown.

PROVENANCE: Unknown.

RELATED: Harvard Theatre Collection, half-length sketch, with Thomas Agnew in 1976.

Mrs Hunter seems not to have acted the role of Penelope in London.

# 210

## Elizabeth Inchbald   1753–1821
as Lady Jane Gray in *Lady Jane Gray*

by John Banks

ARTIST: S. De Wilde

ENGRAVER: P. Audinet

DATE PUBLISHED: 26 November 1791

BELL EDITION: BBT97.XV

Oil on canvas (36.8 × 27.3), looking upward to right, arms extended to either side, holding a book in her right hand; wearing a fine dress

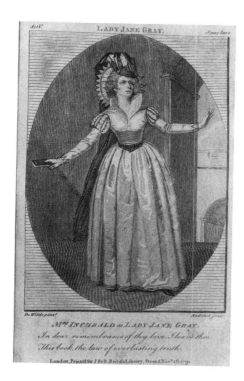

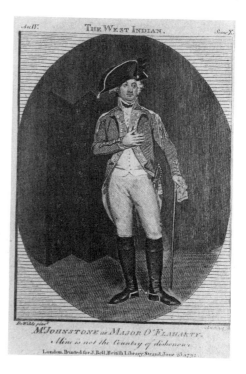

DATE PUBLISHED: 23 June 1792

BELL EDITION: BBT97.XIX

Full-length, standing to front, with his right hand on chest and a cane in his left hand;

and a headdress with a long black veil over and falling behind. Line engraving 11.1 × 7.9, for Bell's British Library, with the quotation (V): "In dear remembrance of thy love, I leave thee / This book, the law of everlasting truth."

LOCATION OF ORIGINAL: Garrick Club (Ash313, CKA233).

PROVENANCE: Charles Mathews (No. 372).

RELATED: None.

Mrs Inchbald never acted this role in London. She did play it at Glasgow, when in West Digges's company, in the spring of 1773.

# 211

## John Henry Johnstone 1749?–1828
as Major O'Flaherty in *The West Indian*

by Richard Cumberland

ARTIST: S. De Wilde

ENGRAVER: P. Audinet

wearing an officer's uniform. Line engraving 11.4 × 8.9, for Bell's British Library, with the Major's line (IV.10): "Mine is not the Country of dishonour."

LOCATION OF ORIGINAL: Unknown.

PROVENANCE: Unknown; possibly the portrait by De Wilde, signed and dated, of Johnstone as Major O'Flaherty that was in the Royal Dramatic College sale at Fairbrother, Lye, and Palmer on 24 February 1881 (lot 100D).

RELATED: A copy engraved by S. Close was published in Dublin by W. Jones as a plate to *British Theatre* (1795); another copy, by an anonymous engraver, was printed for C. Cooke, 1808.

A watercolor by De Wilde in the Garrick Club has been called "Johnstone as Major

O'Flaherty," but in the new catalog of Garrick Club portraits, Ashton states that the sitter is William Lovegrove as Captain Rattan in *The Beehive*.

Possessed of a handsome face and an air of gentlemanly dignity, Johnstone was regarded as one of the best portrayers of Irish characters. Cumberland's *The West Indian* had its premiere at Drury Lane Theatre on 19 January 1771, when John Moody acted Major O'Flaherty. Johnstone first acted the role at Covent Garden Theatre on 5 October 1785.

# 212

## Dorothy Jordan   1761–1816
as Fidelia in *The Plain Dealer*

by William Wycherley

ARTIST: J. Roberts

ENGRAVER: P. Audinet

DATE PUBLISHED: 11 July 1796

BELL EDITION: BBT79.XXIII

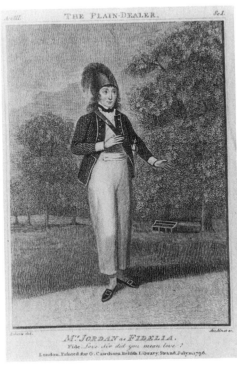

THE PLAIN-DEALER.

M.ʳ JORDAN as FIDELIA.
Vide Love Sir did you mean love ?
London, Printed for G. Cawthorn British Library Strand July 11. 1796.

Full-length, standing in a wooded park, her right hand at front of body, left hand outstretched; wearing a soldier's attire. Line engraving 11.1 × 7.9, for Cawthorn's British Library, with Fidelia's line (III.1): "Love Sir did you mean love?"

LOCATION OF ORIGINAL: Unknown.

PROVENANCE: Bell sale, Leigh & Sotheby's, 25 May 1805 (lot 268).

RELATED: A copy was published as a plate to Cawthorn's *British Drama* (1798).

Dorothy Jordan acted Fidelia at Drury Lane Theatre on 27 February 1796, in an adaptation by J. P. Kemble of Wycherley's play. A very popular actress, Mrs Jordan was called by Hazlitt "the child of nature." She became a star performer in leading female roles in farce and comedy, especially in "breeches" parts. For nearly twenty years, she lived with (but did not marry) William, Duke of Clarence, by whom she had ten children.

# 213

## Dorothy Jordan   1761–1816
as Peggy in *The Country Girl*

by David Garrick

ARTIST: S. De Wilde

ENGRAVER: W. Bromley

DATE PUBLISHED: 15 July 1791

BELL EDITION: BBT97.XIII

Oil on canvas (35.55 × 26.7cm), full-length, standing, her left hand raised to her head; wearing a simple dress with apron. Line engraving 10.5 × 7.9, for Bell's British Library, with the quotation (V.I): "Why do you marry me then? 'tis the same thing Bud."

LOCATION OF ORIGINAL: Garrick Club (Ash342, CKA203).

PROVENANCE: John Bell; Charles Mathews (No. 387).

RELATED: None.

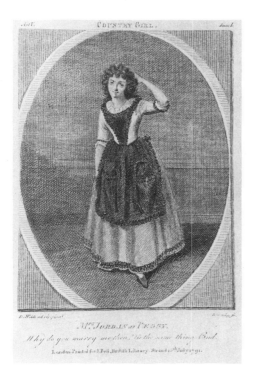

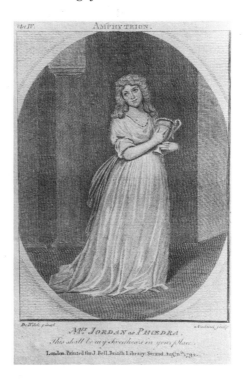

For other portraits of Mrs Jordan as Peggy, see the *BDA*, s.v.. She made her London debut in this role on 18 October 1785 at Drury Lane Theatre and became an instant stage favorite.

# 214

Dorothy Jordan 1761–1816
as Phaedra in *Amphitryon*

by John Dryden

ARTIST: S. De Wilde

ENGRAVER: P. Audinet

DATE PUBLISHED: 11 August 1792

BELL EDITION: BBT97.XXI

Oil on canvas (35.6 × 27.3), full-length, standing, head slightly to left, carrying a gold cup in left arm; wearing a simple white classical dress; columns in background. Line engraving 11.4 × 7.9, for Bell's British Library, with

Phaedra's line (IV): "This shall be my Sweetheart in your Place."

LOCATION OF ORIGINAL: Garrick Club (Ash343, CKA223).

PROVENANCE: John Bell; Charles Mathews (No. 383).

RELATED: None.

Mrs Jordan never acted Phaedra in London.

# 215

Michael Kelly 1762–1826
as Cymon in *Cymon*

by David Garrick

ARTIST: S. De Wilde

ENGRAVER: W. Leney

DATE PUBLISHED: 15 August 1795

BELL EDITION: BBT97.XXIII

Oil on canvas (37 × 29), full-length, standing before trees, head to left, flowers in extended

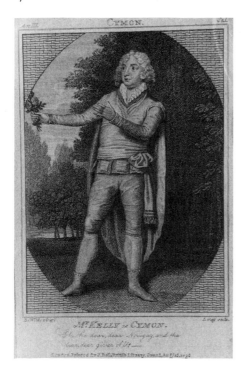

right hand; wearing breeches, tunic with a ruff, and a cloak. Line engraving 11.1 × 7.7, for Bell's British Library, with the quotation (III.1): "Oh, the dear, dear nosegay and the dear, dear giver of it—."

LOCATION OF ORIGINAL: Garrick Club (Ash364, GC239).

PROVENANCE: Bell sale, Leigh & Sotheby's, 25 May 1805 (lot 260); Charles Mathews (No. 79).

RELATED: None.

Kelly first performed Cymon, at the age of fifteen, at the Crow Street Theatre, Dublin, in June 1777. He played the role for the first time in London on 31 December 1791, with the Drury Lane company acting at the King's Theatre. He was a principal vocalist and composer in London between 1787 and 1820. Though he was neither a good actor nor a strong singer, Kelly's style, technique, and excellent stage instincts allowed him to be very successful in English music drama. A small anonymous vignette engraving of Kelly as Cymon, full-length, wearing a hat and coat,

with arms down at side, without background, was also issued.

# 216

## Charles Kemble   1775–1854
### as Young Wilmot in *The Fatal Curiosity*

by George Lillo

ARTIST: J. Roberts

ENGRAVER: P. Audinet

DATE PUBLISHED: 3 September 1796

BELL EDITION: BBT97.XXIII

Full-length, standing before a landscape; wearing East Indian habit and shoes with curled toes. Line engraving 11.1 × 7.9, for Cawthorn's British Library, with Wilmot's line (I.3): "—O England! England! Thou seat of plenty, liberty & health."

LOCATION OF ORIGINAL: Unknown.

PROVENANCE: Bell sale, Leigh & Sotheby's, 25 May 1805 (lot 273).

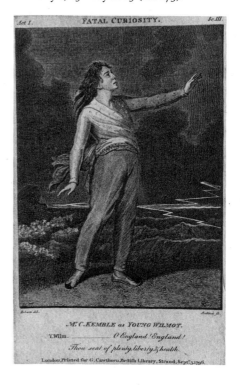

RELATED: In the same sale at Leigh & Sotheby's, there was a picture by John Graham of Young Wilmot and Charlotte in *The Fatal Curiosity* (II.1), but with no performers named. The seller was John Bell.

Charles Kemble did not act this role in London before the end of the century. He did appear as Randall in this play at Drury Lane Theatre on 1 May 1797, when Barrymore acted Young Wilmot.

Kemble had made his London debut in April 1794 under his brother John Philip Kemble's management at the new Drury Lane Theatre.

He was regularly engaged there through the remainder of the century and then played for several decades at Covent Garden Theatre, where he also managed in the 1820s. He performed very successfully in America with his daughter Fanny between 1832 and 1834 and then returned for a final round of performances at Covent Garden in the autumn of 1836.

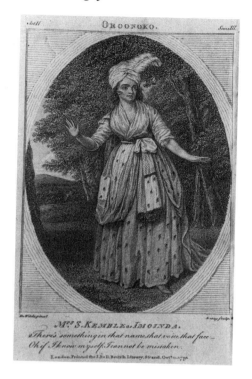

MRS. S. KEMBLE as IMOINDA.
*There's something in that name, that voice, that face—*
*Oh, if I know myself, I cannot be mistaken.*

# 217

## Elizabeth Kemble (Mrs Stephen Kemble) 1762?–1841

as Imoinda in *Oroonoko*

by Thomas Southerne

ARTIST: S. De Wilde

ENGRAVER: P. Audinet

DATE PUBLISHED: 21 October 1791

BELL EDITION: BBT97.XIX

Oil on canvas (36.5 × 28), full-length, standing before trees, with her arms extended from sides; wearing a white plumed turban on her brown hair and a sash on her decorated dress. Line engraving 10.8 × 7.9, for Bell's British Library, with Imoinda's line (II.3): "There's something in that name, that voice, that face— / Oh if I know myself, I cannot be mistaken."

LOCATION OF ORIGINAL: Garrick Club (Ash371, GC219).

PROVENANCE: Charles Mathews (No. 385).

RELATED: None.

It is likely that Elizabeth Kemble never played Imoinda in London, though De Wilde pictured her in the role. A Miss Kemble acted Imoinda at Drury Lane Theatre on 17 March 1783 and 1 January 1784, and that was Frances Kemble (later Mrs Twiss), sister of Sarah Siddons. The Elizabeth, who in November 1783 married Stephen Kemble (also Sarah Siddons's brother), was at that time still performing as Miss Satchell, at Covent Garden Theatre.

**Elizabeth Kemble.** See Elizabeth Whitlock, No. 333.

**Frances Kemble.** See Elizabeth Kemble, No. 217.

# 218

## John Philip Kemble   1757–1823
as Cato in *Cato*

by Joseph Addison

ARTIST: R. Westall

ENGRAVER: P. Audinet

DATE PUBLISHED: 25 June 1791

BELL EDITION: BBT97.III

Watercolor drawing, full-length, standing in front of a classical building, with his right hand on his breast, his left hand extended; wearing Roman toga and large cloak. Line engraving 12 × 8.3, with Cato's line (II): Presumptuous Man! The gods take care of Cato." A copy of the engraving, in an embellished frame, was published by W. Jones in August 1807.

LOCATION OF ORIGINAL: Harvard Theatre Collection.

PROVENANCE: Unknown.

RELATED: A painting credited to Westall of J. P. Kemble as Cato was listed in the *Mathews Catalogue* but is not in the Garrick Club. Lawrence's oil portrait (109.85 × 73.7) of Kemble as Cato is in the Garrick Club (Ash386, CKA397).

John Philip Kemble, accounted one of the great actors in the pantheon of the English stage, played Cato for the first time in London on 28 April 1784, at Drury Lane Theatre. When William C. Macready saw him act the role on 25 October 1816 at Covent Garden Theatre, he wrote that "imagination could not supply a grander or more noble presence."

# 219

## John Philip Kemble   1757–1823
as Edward in *Edward the Black Prince*

by William Shirley

ARTIST: W. Hamilton

ENGRAVER: P. Audinet

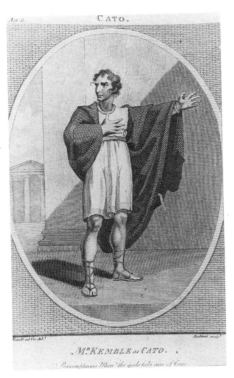

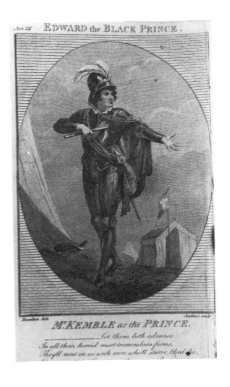

DATE PUBLISHED: 26 August 1791

BELL EDITION: BBT97.IX

Full-length, standing before tents, facing and looking right, his left hand extended, his right hand holding a baton in front of him; wearing a helmet with plume, armor, and a sword at his left side. Line engraving 12 × 8.3, for Bell's British Library, with Edward's lines (III): "—Let them both advance, / In all their horrid most tremendous forms. / They'll meet in us with men who'll starve, bleed, die / E're wrong their Country, or their own Renoun."

LOCATION OF ORIGINAL: Unknown.

PROVENANCE: Unknown.

RELATED: None.

Kemble acted this role in London for the first time on 20 October 1783, his second role at Drury Lane Theatre after his debut there as Hamlet. His performance was received with mixed feelings; the *Morning Herald* found that the character was "very unequally sustained by Mr. Kemble."

# 220

## John Philip Kemble  1757–1823
as King Charles I in *King Charles I*

by William Havard

ARTIST: S. De Wilde

ENGRAVER: P. Audinet

DATE PUBLISHED: 18 April 1793

BELL EDITION: BBT97.XIX

Full-length, seated in armchair, with his left hand on his knee, and holding a stick in his right hand; dressed in a dark suit with cape and tall hat. Line engraving 11.4 × 8.3, for Bell's British Library, with the King's line (IV.2): "—by what law have you created this pretended Court?"

LOCATION OF ORIGINAL: Unknown.

PROVENANCE: Unknown.

RELATED: None.

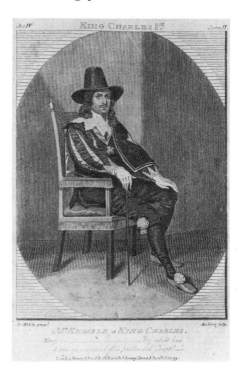

Kemble seems not to have played this role in London.

# 221

## John Philip Kemble  1757–1823
as Oedipus in *Oedipus*

by John Dryden

ARTIST: S. De Wilde

ENGRAVER: J. Thornthwaite

DATE PUBLISHED: 17 December 1791

BELL EDITION: BBT97.XV

Watercolor drawing, full-length, standing on a stone patio with a balustrade and wall and dark clouds behind, holding a dagger in his right hand and a lamp in his left; wearing Greek dress. Line engraving 11.7 × 7.6, for Bell's British Library, with Cato's line (I): "I challenge Fate to find another wretch / Like Oedipus."

LOCATION OF ORIGINAL: Harvard Theatre Collection.

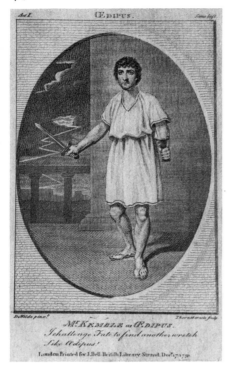

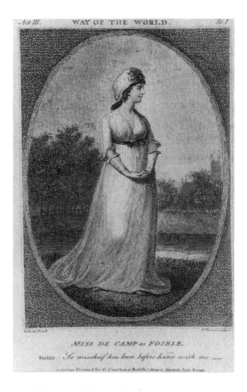

PROVENANCE: Unknown.

RELATED: None.

Kemble did not act this role in London.

# 222

## Maria Theresa Kemble (Mrs Charles Kemble) 1775–1838
as Foible in *The Way of the World*

by William Congreve

ARTIST: J. Roberts

ENGRAVER: P. Thomson

DATE PUBLISHED: 8 July 1796

BELL EDITION: BBT97.XXXIII

Full-length, standing outdoors before trees and castle, with hands clasped; wearing a long dress and turban. Line engraving 11.4 × 7.6, for Cawthorn's British Library, with

Foible's line (III.1): "So mischief has been be-fore-hand with me—."

LOCATION OF ORIGINAL: Unknown.

PROVENANCE: Bell sale, Leigh & Sotheby's, 25 May 1805 (lot 263).

RELATED: None.

Pictured when Miss De Camp. She did not act this role in London. In 1703, at the age of eight, Maria Theresa De Camp began her stage career in London as a dancer. She continued as a singing-actress and dancer through the rest of the eighteenth century and into the next, until her marriage in 1806 to Charles Kemble. As Mrs Kemble, she performed off and on until her retirement in June 1819. She was described in Waldron's *Candid and Impartial Strictures on the Performers* (1795): "Her person is exceedingly good; and her action in general graceful; but sometimes, in apeing the manners of the Italians in her singing, has an appearance of affecta-tion." Waldron correctly predicted that "she will never do much more than she has al-

ready done as a vocal performer; and we think her forte in acting lies in a certain cast of sprightly parts in genteel comedy."

# 223

## Maria Theresa Kemble (Mrs Charles Kemble) 1775–1838
as Miss Rivers in *False Delicacy*

by Hugh Kelly

ARTIST: J. Roberts

ENGRAVER: P. Audinet

DATE PUBLISHED: 28 May 1795

BELL EDITION: BBT97.XXX

Colored drawing (12.7 × 8.6), full-length, standing by river, holding a book in her right hand; wearing a long dress and a turban hat. Line engraving 11.4 × 7.6, for Bell's British Library, with the quotation (IV.2): "I wish he was come."

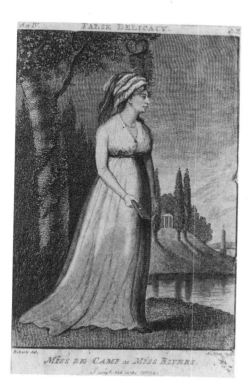

ready done as a vocal performer; and we think her forte in acting lies in a certain cast of sprightly parts in genteel comedy."

LOCATION OF ORIGINAL: British Museum (Burney V, No. 179).

PROVENANCE: John Bell.

RELATED: None.

Pictured when Miss De Camp. She did not act this role in London; the play was not performed there during the last several decades of the century.

## Priscilla Kemble (Mrs John Philip Kemble). See Priscilla Hopkins, Nos. 200 and 201.

# 224

## Stephen Kemble 1775–1854
as Bajazet in *Tamerlane*

by Nicholas Rowe

ARTIST: S. De Wilde

ENGRAVER: P. Audinet

DATE PUBLISHED: 14 April 1792

BELL EDITION: BBT97.XXII

Oil on canvas (37.1 × 28.8), full-length, standing before a tent with a maroon curtain, arms folded and manacled; wearing a white turban and a blue gown edged with white fur. Line engraving 11.4 × 7.9, for Bell's British Library, with Bajazet's line (II.2): "—tho' Fortune / Has stript me of the train and pomp of greatness, / Yet still my Soul is free—."

LOCATION OF ORIGINAL: Garrick Club (Ash393, CKA227).

PROVENANCE: Charles Mathews (No. 184).

RELATED: An anonymous engraving was printed for C. Cooke as a plate to *British Drama* (1808).

Stephen Kemble first played Bajazet on 4 November 1783, at Covent Garden Theatre. Coming from engagements in Dublin and Edinburgh, he had made his debut at Covent

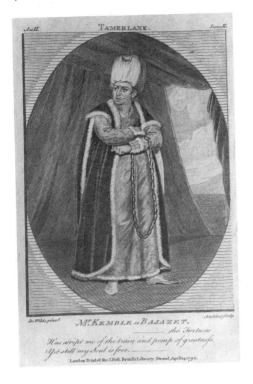

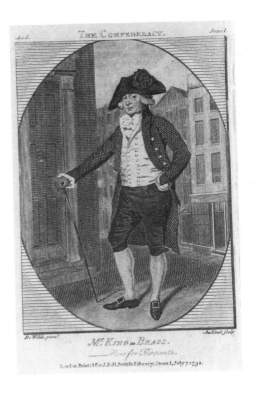

Garden on 24 September 1783 as Othello. The *Thespian Review* (1783) found him an actor of "feeling and judgment." A competent actor, his career in London was modest. He enjoyed greater success as manager of the Edinburgh Theatre Royal and the theatres on the Newcastle circuit. The Kemble in this picture has incorrectly been identified in the *BDA* and Harvard catalog as John Philip.

# 225

Thomas King   1730–1805
as Brass in *The Confederacy*

by John Vanbrugh

ARTIST: S. De Wilde

ENGRAVER: P. Audinet

DATE PUBLISHED: 7 July 1792

BELL EDITION: BBT79.XXII

Full-length, standing in a street before houses, holding a cane in his right hand, his left hand on his hip; wearing breeches, waistcoat, coat, and tricorn hat. Line engraving 11.1 × 7.6, for Bell's British Library, with Brass's line (I.1): "—Now for Flippanta."

LOCATION OF ORIGINAL: Unknown.

PROVENANCE: Unknown.

RELATED: The same picture, by an anonymous engraver, was printed by C. Cooke in 1806, but undated.

An anonymous engraver also depicted King as Brass, standing, legs apart, hand in trouser pocket. King acted Brass for the first time in London on 27 October 1759, at Drury Lane Theatre. He had played the role in Ireland prior to coming to London in 1759. King became one of the most eminent actors of the century, an intensely professional and intelligent performer with great comic powers. "His features," wrote F. G. Waldron in his *Candid*

*and Impartial Strictures on the Performers*
(1795), "have an archness that peculiarly fitted
him for all the sprightly parts of comedy."

# 226

## Thomas King 1730–1805
as Lissardo in *The Wonder*

by Susannah Centlivre

ARTIST: J. Roberts

ENGRAVER: Anonymous [J. Roberts?]

DATE PUBLISHED: 10 August 1776

BELL EDITION: BBT76–77 and 80.VIII;
BET92.VI

Drawing, full-length, standing, facing left,
holding a hat with plume in his left hand,
held under his left arm, his right arm ex-
tended left; wearing seventeenth-century
breeches, jerkin, and coat. Line engraving
13 × 9.8, with the quotation (II.2): "—'me-

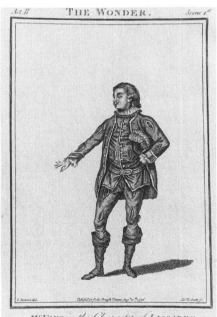

thinks a Diamond Ring is a Vast addition to
the little Finger of a Gentleman."

LOCATION OF ORIGINAL: Unknown.

PROVENANCE: Bell sale, Christie's, 27 March
1793 (lot 10); bought, with six other drawings
in lot, for 15s. by C. Cooke.

RELATED: An engraving (12.7 × 8.6) by
Roberts of his own picture, also dated 10 Au-
gust 1776, was published in BBT80. The por-
trait appears on a delftware tile; an example is
in the Manchester City Art Galleries.

King acted this role for the first time in Lon-
don on 25 October 1768, at Drury Lane Theatre.

# 227

## Thomas King 1730–1805
as Lord Ogleby in *The Clandestine Marriage*

by George Colman the Elder and David Gar-
rick

ARTIST: S. De Wilde

ENGRAVER: J. Thornthwaite

DATE PUBLISHED: 29 December 1792

BELL EDITION: BBT97.XIV

Oil on canvas, full-length, standing outdoors
before trees, a snuffbox in his left hand, a hat
under his left arm; wearing a richly embroi-
dered coat, breeches, and powdered curly wig.
Line engraving 11.7 × 7.9, with the quotation
(IV.2): "I'll not be left among your Sterlings,
your Heidelburgs, and Devilburgs.—"

LOCATION OF ORIGINAL: Yale Center for
British Art.

PROVENANCE: Exhibited, but not offered for
sale, at the Bell sale, Christie's, 27 March 1793.

RELATED: An engraving by Clayton was
published in Dublin as a plate to W. Jones's
*British Theatre* (1792); an anonymous engrav-
ing was published as a plate to *British Drama*
(1794); an anonymous engraving was pub-
lished by C. Cooke, 1806. Another canvas

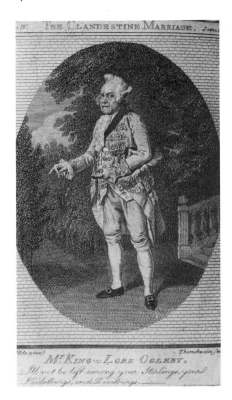

Mr KING as LORD OGLEBY.
I'll not be left among your Stirlings, your
Fiddleburgs, and Devilburgs.

(23 × 19) by De Wilde of King as Lord
Ogleby is in the Garrick Club (Ash398,
CKA285) but is different from the Yale ver-
sion.

For other portraits of King as Lord Ogleby,
see the *BDA*. He acted the role at the pre-
miere at Drury Lane on 20 February 1766;
and his portrayal remained one of his finest.

# 228

## Thomas King   1730–1805
as Marplot in *The Busy Body*

by Susannah Centlivre

ARTIST: J. Roberts

ENGRAVER: J. Thornthwaite

DATE PUBLISHED: 20 January 1777

BELL EDITION: BBT76–77 and 80.VIII;
BET92.V

Drawing, full-length to right, standing, with
his left hand extended, his right arm at back;
wearing long coat, waistcoat, breeches, tricorn
hat, and a sword at his left side. Line engrav-
ing 13 × 9.2, with the quotation (I): "There he
goes."

LOCATION OF ORIGINAL: Unknown.

PROVENANCE: Bell sale, Christie's, 27 March
1793 (lot 10); bought, with six other drawings
in lot, for 15s. by C. Cooke.

RELATED: A head-and-shoulders version by
Roberts was offered at Christie's on 6 No-
vember 1973 (lot 48).

A picture of King as Marplot, by an anony-
mous engraver, was published by Wenman as
a plate to an edition of the play, 1777. King
acted Marplot for the first time in London
on 22 May 1765, at Drury Lane Theatre.

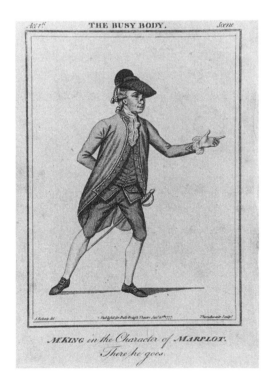

Mr KING in the Character of MARPLOT.
There he goes.

# 229

## Thomas Knight   d. 1820
as Jacob Gawkey in *The Chapter of Accidents*

by Sophia Lee

ARTIST: S. De Wilde (after J. Roberts)

ENGRAVER: J. Fittler

DATE PUBLISHED: 27 February 1796

BELL EDITION: BBT97.XXXIV

Oil on canvas (36.8 × 28.5), full-length, doing a dance step to his left, with his left foot raised, holding the ends of his long coat. Line engraving 11.4 × 7.6, for Cawthorn's British Library, with Jacob's line (III.2): "—and dancing all round the room, zoa.—"

LOCATION OF ORIGINAL: Garrick Club (Ash409, CKA205).

PROVENANCE: Bell sale, Leigh & Sotheby's, 25 May 1805 (lot 276b); Charles Mathews (No. 376b).

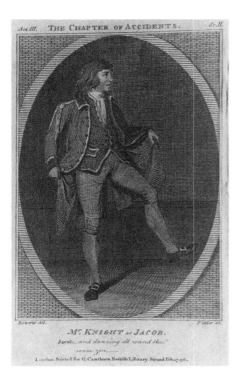

RELATED: In the same sale (lot 276a) was Roberts's drawing.

The engraving by Fittler is inscribed "Roberts del," but it is very similar to the De Wilde portrait in the Garrick Club.

Knight acted Jacob Gawkey during his first season at Bath, 1787–88. He made his London debut in the role on 25 September 1795, at Covent Garden Theatre, when his rustic simplicity untainted with buffoonery drew the applause of a charmed audience. The role remained one of his superior parts.

Also in the same Bell sale (lot 272a) was a picture by John Graham of the characters Governor Harcourt and Bridget in a scene (V.1) of this play, but no performers were named.

# 230

## Elizabeth Leak   b. ca. 1778
as Peggy in *The Gentle Shepherd*

by Allan Ramsey

ARTIST: J. Roberts

ENGRAVER: J. Wilson

DATE PUBLISHED: January 1796

BELL EDITION: BBT97.XXV

Full-length, standing by a riverbank, turned slightly to left; wearing a country costume, apron, bonnet with scarf around head and neck. Line engraving 12 × 8.3, for Cawthorn's British Library, with the quotation (I.2): "Between twa birks out o'er a little lin, / The water fa's and makes a singard din."

LOCATION OF ORIGINAL: Unknown.

PROVENANCE: Bell sale, Christie's, 25 May 1805 (lot 280); in gilt frame.

RELATED: None.

Miss Leak acted Peggy for the first time in London on 8 June 1796, at Covent Garden Theatre. She had begun her London career by performing in the oratorios at the King's Theatre in February 1793. She continued to

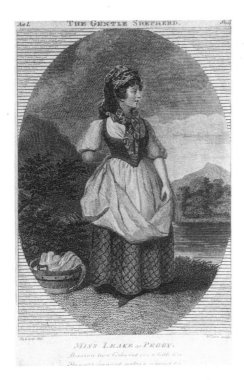

THE GENTLE SHEPHERD.

MISS LEAKE as PEGGY.

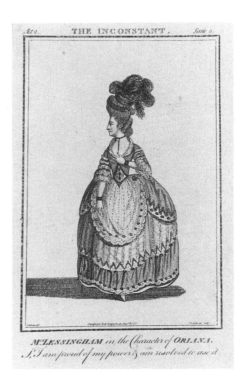

THE INCONSTANT.

M.ᵣˢ LESSINGHAM in the Character of ORIANA.
S.ʳ I am proud of my power & am resolved to use it.

appear in oratorios and light musical pieces until she retired in 1800. F. G. Waldron in his *Candid and Impartial Strictures on the Performers* (1795) described her as "a bewitching little syren, and a very pretty actress, as well as a sprightly, agreeable woman."

# 231

Jane Lessingham   1739?–1803
as Oriana in *The Inconstant*

by George Farquhar

ARTIST: James Roberts

ENGRAVER: J. Thornthwaite

DATE PUBLISHED: 1 June 1777

BELL EDITION: BBT76 and BBT80.XIII

Full-length, standing, turned left, her left hand at breast; wearing a tall feathered headdress and a richly decorated panniered dress. Line engraving 13.7 × 8.9, with the quotation (II.2): "Sᵣ I am proud of my power & I am resolved to use it."

LOCATION OF ORIGINAL: Unknown.

PROVENANCE: Unknown.

RELATED: None.

An anonymous india ink drawing of Jane Lessingham as Oriana is in the British Museum; an engraving of it was published by Wenman, August 1777. She acted this role for the first time at Covent Garden Theatre on 27 May 1768.

# 232

Catharine Lewes (Mrs Charles Lee Lewes)   d. 1796
as Lady Sadlife in *The Double Gallant*

by Colley Cibber

ARTIST: S. De Wilde

ENGRAVER: J. Thornthwaite

DATE PUBLISHED: 10 November 1792

BELL EDITION: BBT97.X

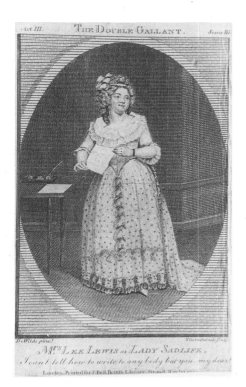

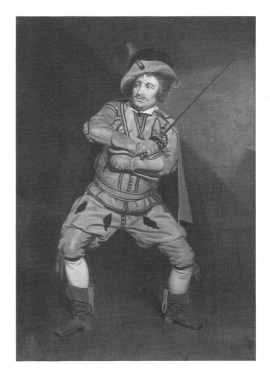

# 233

Charles Lee Lewes 1740–1803
as Bobadil in *Every Man in His Humour*

by Ben Jonson

ARTIST: S. De Wilde

ENGRAVER: W. Leney

DATE PUBLISHED: 24 August 1791

BELL EDITION: BBT97.IV

Oil on canvas (43.7 × 31.2), full-length, standing, legs spread, and in a slight crouch, his

Full-length, standing, holding a paper, a writing table at her right; wearing a long dress with dots, her hair in curls. Line engraving 11.7 × 7.9, for Bell's British Library, with the quotation (III.3): "I can't tell how to write to anybody but you, my dear!"

LOCATION OF ORIGINAL: Unknown.

PROVENANCE: Unknown.

RELATED: None.

Mrs Lewes is not known to have played this role either in London or in Edinburgh. A pencil drawing by J. Roberts of Mrs Lewes is in the Harvard Theatre Collection. The third wife of the comedian Charles Lee Lewes, she never rose to eminence, evidently because of the liabilities of a bad figure and voice.

She appeared in London only twice, for her husband's benefits at Covent Garden Theatre on 16 July 1790 and at the Haymarket Theatre on 7 March 1791. Most of her career was passed in Edinburgh from 1792 to 1795.

arms at breast, holding a foil in his right hand; wearing boots, a cape, and a hat with feathers. Line engraving 11.4 × 7.6, for Bell's British Library, with the quotation (I): "Oh you disorder your point most irregularly."

LOCATION OF ORIGINAL: Garrick Club (Ash421, CKA249).

PROVENANCE: Charles Mathews (No. 366).

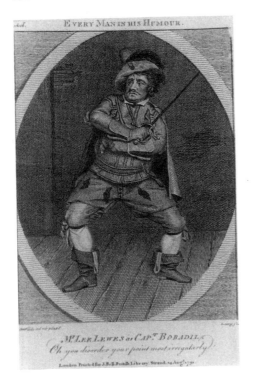

RELATED: A pencil and watercolor drawing (35.6 × 22.2) by De Wilde, similar to the painting, is also in the Garrick Club (Ash422, CKA66F). An engraving (10.5 × 7.3) by H. Brocas was published in Dublin by W. Jones as a plate to *British Theatre* (1792).

Lewes, regularly engaged at Covent Garden Theatre from 1767–68 through 1782–83 and at Drury Lane Theatre in 1783–84, was "a thriving and pleasant comedian," who had a considerable potential, according to William Hawkins in *Miscellanies in Prose and Verse*. But he damaged his career by a sense of self-importance. He acted Bobadil for his first and only time at Covent Garden on 1 October 1779 and was severely criticized (in a press clipping in the Enthoven Collection at the Theatre Museum) for his portrayal, which was dismissed at "totally inadequate"—"He neither attempted to adopt the extravagant solemnity of bombast and parade, which is the vital principle of the character; nor did he

intimate . . . that he possessed a proper understanding of the part."

# 234

## William Thomas Lewis   ca. 1746–1811
as Copper Captain in *Rule a Wife and Have a Wife*

by John Fletcher

ARTIST: S. De Wilde

ENGRAVER: J. Thornthwaite

DATE PUBLISHED: 27 April 1791

BELL EDITION: BBT97.VIII

Full-length, standing to right in a room with an open door at right, his right hand on his

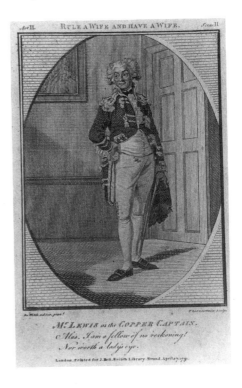

hip, and holding a hat in left hand; wearing military dress. Line engraving 10.8 × 7.6, for Bell's British Library, with the Captain's line

(II.2): "Alas, I am a fellow of no reckoning! Nor worth a lady's eye."

LOCATION OF ORIGINAL: Unknown.

PROVENANCE: Unknown.

RELATED: Engravings, after De Wilde, include a large stipple (23.2 × 10.1) by J. Condé, published by Bell, 1791; by Clayton (11.4 × 7.6), published in Dublin as a plate to W. Jones's *British Theatre* (1792); and by an anonymous engraver, published by C. Cooke as a plate to *British Drama* (1817).

An engraving by Alais of Lewis as the Copper Captain was published by Roach, 1808. Lewis acted this role for the first time in London on 25 January 1780, at Covent Garden Theatre. In his *Memoirs of Mrs Siddons*, James Boaden related that in the last act Lewis "exceeded all expectations, even from spirits like his own," and "the convulsive joy of his *laugh*, frequently renewed, . . . was one of the most brilliant exploits of the comedian."

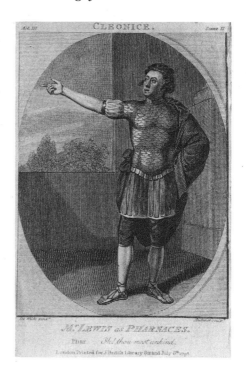

# 235

## William Thomas Lewis   ca. 1746–1811
as Pharnaces in *Cleonice*

by John Hoole

ARTIST: S. De Wilde

ENGRAVER: P. Audinet

DATE PUBLISHED: 6 July 1795

BELL EDITION: BBT97.XXIV

Oil on canvas (37.5 × 28.5), full-length, standing to front in a room with a window at left through which are seen trees, head to left, right hand extended to left; wearing armor, with a cloak over left shoulder. Line engraving 11.4 × 8.3, for Bell's British Library, with Pharnaces's line (II.2): "Oh! thou most unkind."

LOCATION OF ORIGINAL: Garrick Club (Ash426, CKA201).

PROVENANCE: Bell sale, Leigh & Sotheby's, 25 May 1805 (lot 284); Charles Mathews (No. 186), as by Harlow.

RELATED: None.

Lewis acted Pharnaces in the premiere of John Hoole's tragedy at Covent Garden Theatre on 2 March 1775. When Lewis made his debut at Covent Garden as Belcour in *The West Indian* on 15 October 1773, he was described in the *Covent Garden Magazine* as having "an excellent stage figure, not tall, but neat and well-proportioned. He has a pair of lively eyes, and a very pleasing countenance." Lewis was a superior actor at Covent Garden for twenty-one years, through 1802–3. G. F. Cooke called him "the unrivalled favourite of the comic muse in all that was gay, humorous, whimsical, and at the same time elegant." Dubbed "Gentleman Lewis," he was "an eminently attractive actor of fashionable and flippant characters" (*BDA*). But ill health ravaged that "fashionable playfulness and

spirit," and when the actress Dorothy Jordan saw him at Edinburgh in September 1809—three years before his death—she wrote that she "never saw a man so broke; he is shrunk to nothing and can hardly hobble across the stage."

# 236

## William Thomas Lewis   ca. 1746–1811

as Zamor in *Alzira*

by John Hill

ARTIST: James Roberts

ENGRAVER: J. Thornthwaite

DATE PUBLISHED: 1 March 1777

BELL EDITION: BBT76 and BT80.X

Watercolor drawing, full-length, standing, right profile, holding a hat with large feathers in his right hand and the hilt of his sword at his waist in his left hand; wearing an ermine-

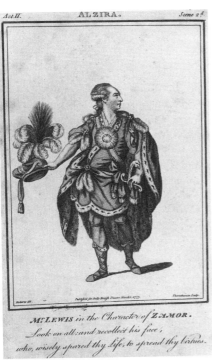

trimmed tunic and cloak. Line engraving 14 × 8.9, with the quotation (II.2): "Look on all, and recollect his face, who, wisely spared thy Life, to spread thy virtues."

LOCATION OF ORIGINAL: Unknown.

PROVENANCE: Bell sale, Christie's 27 March 1793 (lot 10); the lot, consisting of seven items, was bought for 15s. by C. Cooke.

RELATED: None.

Lewis did not act Zamor in London; Hill's *Alzira* was not performed in London after 1759.

# 237

## Charles Macklin   1699–1797

ARTIST: John Opie

ENGRAVER: J. Condé

DATE PUBLISHED: July 1792

BELL EDITION: (See Below)

Oil on canvas (89.5 × 69.2), holding paper in left hand; white quill and silver inkwell;

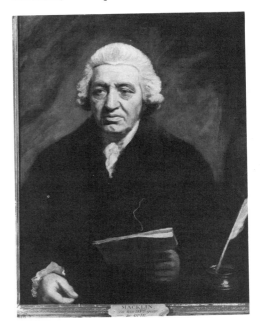

Macklin, not in character but as an author, wears a dark coat and powdered wig. Stipple engraving 17.8 × 14 (see comment below).

LOCATION OF ORIGINAL: Garrick Club (Ash449, CKA16).

PROVENANCE: John Bell; Thomas Harris sale, Robins, 12 July 1819 (lot 35); Charles Mathews (No. 4).

RELATED: National Portrait Gallery (No. 1319), oil 90.8 × 70.5.

The engraving by Condé was published as a plate to Arthur Murphy's edition of Macklin's *Works*, with the inscription: "Charles Macklin / Comedian / in his 93rd Year," published by J. Bell, 1792; an engraving (stipple 10.2 × 7.3) by Freeman was published in 1806; another (stipple and line 14.6 × 9.5) by J. Hopwood was published as a plate to *The Cabinet* (1 August 1808).

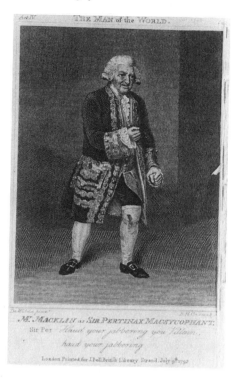

# 238

Charles Macklin   1699–1797

as Sir Pertinax Macsycophant in *The Man of the World*

by Charles Macklin

ARTIST: S. De Wilde, 1794

ENGRAVER: R. H. Cromek

DATE PUBLISHED: 9 July 1795

BELL EDITION: BBT97.XXVII

Oil on canvas (43.8 × 44.5), full-length, standing slightly to left, clinching his fists; wearing an embroidered coat and powdered wig. Line engraving 11.4 × 7.9, for Cawthorn's British Library, with Sir Pertinax's line (IV): "Haud your jabbering you Villain, haud your jabbering."

LOCATION OF ORIGINAL: Garrick Club (Ash448, CKA476).

PROVENANCE: John Bell; exhibited in the Bell sale at Christie's, 27 March 1793, but not offered for sale. Bell sale, Leigh & Sotheby's, 25 May 1805 (lot 286), in gilt frame; bought by Charles Mathews (No. 369).

RELATED: A similar version (40 × 30) by De Wilde is in the National Gallery of Ireland (No. 307), acquired 1881 and is probably the painting sold at Christie's in 1871 from John Green's collection. A copy (10.1 × 7.6) of Cromek's engraving by an anonymous engraver was published by Cawthorn, 1795.

An engraving by W. Gardiner, after S. Harding, of Macklin in this role was published by E. Harding, 1786.

Macklin acted this role in the premiere of this comedy at Covent Garden Theatre on 10 May 1781; *The Man of the World* was an expanded version of Macklin's *The True-Born Irishman*, a comedy that had its premiere at the Crowe Street Theatre, Dublin, on 10 July 1764.

# 239

## Charles Macklin   1699–1797
as Sir Gilbert Wrangle in *The Refusal*

by Colley Cibber

ARTIST: J. Roberts

ENGRAVER: J. Thornthwaite

DATE PUBLISHED: 5 April 1777

BELL EDITION: BBT76–77.XI

Colored drawing on vellum (10.8 × 8.3), full-length, standing to front, looking to left,

*M.ᵣ MACKLIN in the Character of Sᵣ GILBERT WRANGLE.*
*Nay, I have them from all Nations, here's one now,*
*from an Irish Relation of my own.*

holding letters and a cane in his left hand; wearing a coat with papers stuffed in pockets, waistcoat, breeches, and powdered wig, Line engraving 14 × 8.9, with the quotation (I.1): "Nay, I have them from all Nations, here's one now, from an Irish Relation of my own."

LOCATION OF ORIGINAL: British Museum (Burney VI, No. 46).

PROVENANCE: Bell sale, Christie's, 27 March 1793 (lot 11); bought with six other drawings in lot, for £1 by Gretton.

RELATED: See also No. 240.

Macklin acted this role for the first time in London in a revival of Colley Cibber's *The Refusal* at Drury Lane Theatre on 28 November 1746.

# 240

## Charles Macklin   1699–1797
as Sir Gilbert Wrangle in *The Refusal*

by Collley Cibber

ARTIST: S. De Wilde

ENGRAVER: J. Thornthwaite

DATE PUBLISHED: 3 November 1792

BELL EDITION: BBT97.II

Full-length, standing, holding a paper in his left hand, similar to Roberts's drawing, No.

*De Wilde pinx.ᵗ                    Thornthwaite sculp*
*M.ᵣ MACKLIN as SIR GILBERT WRANGLE.*
*Here's one now, from an Irish Relation of my own.*
*London. Printed for J. Bell British Library Strand, Nov.ʳ 3 1792.*

239, but with fewer papers and with the hat under left arm. Line engraving 11.4 × 8.9, for Bell's British Library, with the quotation: "Here's one now, from an Irish Relation of my own."

LOCATION OF ORIGINAL: Unknown.

PROVENANCE: Unknown.

RELATED: See also No. 239.

# 241

## Maria Macklin   ca. 1733–1781
as Camillo in *The Mistake*

by John Vanbrugh

ARTIST: J. Roberts

ENGRAVER: J. Thornthwaite

DATE PUBLISHED: 1 January 1778

BELL EDITION: BBT76–77 and 80.XIX; BET92.II

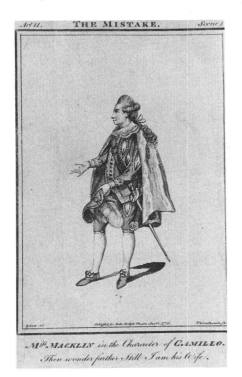

239, but with fewer papers and with the hat under left arm. Line engraving 11.4 × 8.9, for

Colored drawing on vellum (10.8 × 7.3), full-length, standing, left profile; wearing male attire, a sword at her left side, and a hat in her left hand. Line engraving 13.7 × 9.2, with the quotation (II.1): "The wonder farther Still I am his Wife."

LOCATION OF ORIGINAL: British Museum (Burney VI, No. 56).

PROVENANCE: Bell sale, Christie's, 27 March 1793 (lot 11); bought, with six other drawings in lot, for £1 by Gretton.

RELATED: Two pencil drawings by Roberts of Maria Macklin are in the Harvard Theatre Collection, acquired with other drawings by Roberts from Thomas Agnew in 1976.

Maria Macklin acted Camillo for the first time at Covent Garden Theatre on 6 February 1766.

# 242

## Gertrude Mahon   b. 1751
as Fanny in *The Accomplished Maid*

by Niccolo Piccini

ARTIST: J. Roberts

ENGRAVER: J. Thornthwaite

DATE PUBLISHED: 27 April 1781

BELL EDITION: BBT80.XXI; BET92.XIV

Drawing, full-length, standing, facing left, holding a watering pot in right hand; wearing a hat with flowers and a large lace-edged apron over a panniered dress with bows. Line engraving 14.3 × 9.2, with the quotation (I.1): "How bountiful has providence been, in allotting me such humane benefactors."

LOCATION OF ORIGINAL: Unknown.

PROVENANCE: Bell sale, Christie's, 27 March 1793 (lot 10); bought, with seven other drawings in lot, for 15s. by C. Cooke.

RELATED: None.

Gertrude Mahon, known as the Bird of Paradise, never sang in Piccini's comic opera in

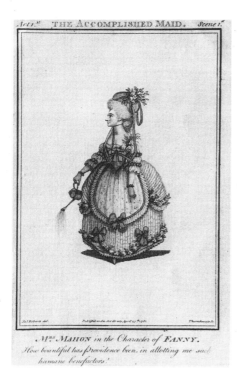

Act 1st.    THE ACCOMPLISHED MAID,    Scene 1st.

Mrs. MAHON in the Character of FANNY.
How beautiful has Providence been, in allotting me such
humane benefactors.'

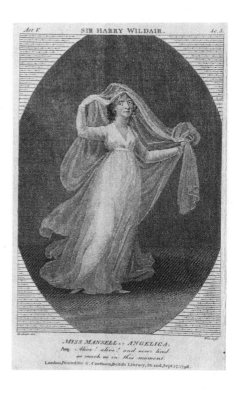

Act V    SIR HARRY WILDAIR.    Sc. 5.

MISS MANSELL as ANGELICA.
Ang. Alive! alive! and never lived
so much as in this moment.
London, Printed for G. Cawthorn, British Library, Strand, Sept.17.1796

London. After making her debut as Elvira in *The Spanish Fryar* at Covent Garden Theatre in December 1780, she appeared only a few other times before the end of the season. A subject of considerable newspaper gossip, she seems to have entertained the town much more by accounts of her relentless amorous escapades than by her acting.

# 243

Elizabeth Mansel   d. 1848
as Angelica in *Sir Harry Wildair*

by George Farquhar

ARTIST: J. Graham

ENGRAVER: J. Wilson

DATE PUBLISHED: 17 September 1796

BELL EDITION: BBT97.XXXI

Full-length, standing, turned slightly to her left; wearing a long flowing dress and holding

a long veil over her head. Line engraving 11.7 × 7.6, for Cawthorn's British Library, with Angelica's line (V.5): "Alive! alive! and never lived so much as in this moment."

LOCATION OF ORIGINAL: Unknown.

PROVENANCE: Bell sale, Leigh & Sotheby, 25 May 1805 (lot 283).

RELATED: None.

Elizabeth Mansel did not act this role in London.

# 244

Elizabeth Mansel   d. 1848
as Leonora in *The Mistake*

by John Vanbrugh

ARTIST: J. Roberts

ENGRAVER: J. Fittler

DATE PUBLISHED: 23 January 1795

BELL EDITION: BBT97.XXV

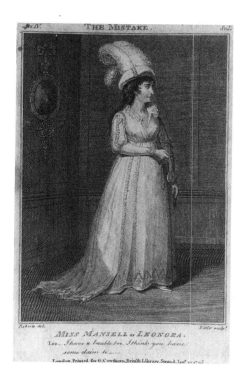

Full-length, standing in a corner of a room, with her right arm across waist, and holding a chain and locket in her right hand; wearing a long dress and a hat with tall feathers. Line engraving 11.1 × 8.9, for Cawthorn's British Library, with Leonora's line (IV.1): "I have a bauble too, I think you have some claim to—."

LOCATION OF ORIGINAL: Unknown.

PROVENANCE: Unknown.

RELATED: None.

Miss Mansel made her debut in London at Covent Garden Theatre on 8 October 1795, when, introduced as a young lady making her first appearance on any stage, she acted Sophia in *The Road to Ruin*. The engraving of her as Leonora in *The Mistake* was published about ten months before her debut in London; she had been acting at Liverpool. In 1799, she became the wife of the prolific playwright Frederick Reynolds. Vanbrugh's *The Mistake* was not performed in London after 1786, but Thomas King's adaptation called

*Lovers' Quarrels* was brought out at Covent Garden on 11 February 1792 and received occasional performances through 1799–1800. Miss Mansel did not act the role in London.

# 245

Margaret Martyr   d. 1807
as Aura in *The Country Lasses*

by Charles Johnson

ARTIST: S. De Wilde

ENGRAVER: W. Leney

DATE PUBLISHED: 21 January 1792

BELL EDITION: BBT97.IX

Full-length, standing in field with trees behind, dressed in an officer's uniform. Line en-

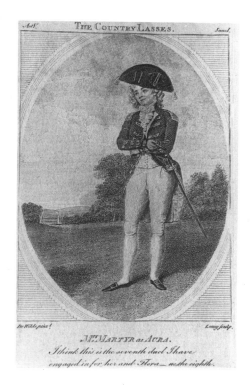

graving 10.8 × 7.6, with the quotation (V.1): "I think this is the seventh duel I have engaged in for her and Flora—no the eighth."

LOCATION OF ORIGINAL: Unknown.

PROVENANCE: Unknown.

RELATED: None.

Mrs Martyr did not play Aura in London. When Miss Thornton, she made her debut at Covent Garden Theatre on 13 February 1779 as Rosetta in *Love in a Village*. For twenty-five years (except 1779–80), she remained constantly at Covent Garden as a busy and popular performer in comic operas and pantomime and in choruses and entr'acte entertainments.

# 246

## Margaret Martyr   d. 1807
as Rose in *The Recruiting Officer*

by George Farquhar

ARTIST: S. De Wilde

ENGRAVER: P. Audinet

DATE PUBLISHED: 12 May 1792

BELL EDITION: BBT97.XIII

Oil on canvas (35.65 × 26.7), full-length, standing in a street with a house in background, holding a basket in her left hand;

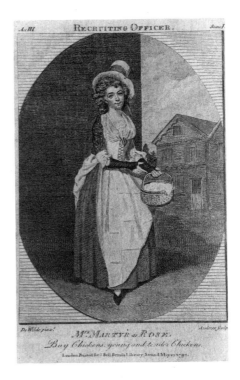

Mrs MARTYR as ROSE.
Buy Chickens, young and tender Chickens.

wearing a tall hat, fichu and apron, and mittens. Line engraving 11.1 × 7.6, for Bell's British Library, with Rose's line (III.1): "Buy Chickens, young and tender Chickens."

LOCATION OF ORIGINAL: Garrick Club (Ash458, CKA211).

PROVENANCE: Charles Mathews (No. 195).

RELATED: A copy was printed for C. Cooke, 5 July 1806. A pencil and watercolor drawing by De Wilde, similar to his painting, is also in the Garrick Club (Ash459, CKA66C).

Mrs Martyr did not act this role in London.

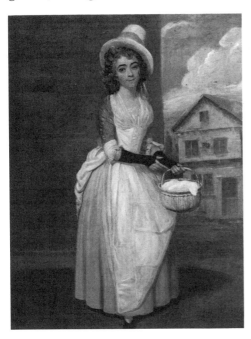

# 247

## Mrs E. Massey   [fl. 1776–1783]
as Christina in *Gustavus Vasa*

by Henry Brooke

ARTIST: J. Roberts

ENGRAVER: Unknown

DATE PUBLISHED: February 1778

BELL EDITION: BBT76–76 and 80.XVIII

Drawing, full-length, standing, left profile, her arms extended in front of her; wearing an

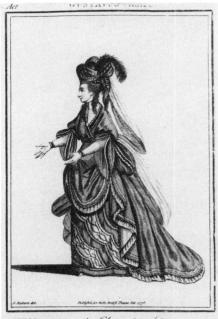

*M.ͬ MASSEY in the Character of CHRISTINA.*
*—— don't you know me Sir?*
*My father, look upon me, look my Father.*

embroidered dress with full skirt, a hat with feathers, with a cloth trailing from behind. Line engraving 14 × 9.2, with the quotation: "—don't you know me Sir? My father, look upon me, look my Father!"

LOCATION OF ORIGINAL: Unknown.

PROVENANCE: Bell sale, Christie's, 27 March 1793 (lot 10); bought with six other drawings in lot for 15s. by C. Cooke.

RELATED: None.

There is no record of Mrs Massey having played the role of Christina in London. *The London Stage* lists no performances of this play in the eighteenth century. On 17 March 1739, Henry Brooke wrote in the *Morning Post* that he had applied for a license for the play but had been denied. A pencil and water-

color drawing by Sylvester Harding of Mrs Massey as Christina is in the Garrick Club (Ash 461) but is not similar to the Roberts portrait. Brooke's *Gustavus Vasa* seems to have been the first play denied a license after the passing of the Liscensing Act of 1737. A company of French actors headed by Francisque Moylin, however, performed a piece called *Gustavus Vasa; or, Gustavus the Great, King of Sweden*, credited to Alexis Piron, at the Haymarket Theatre on 5 February 1735.

# 248

## George Mattocks   1735–1804
### as Achilles in *Achilles*

by John Gay

ARTIST: J. Roberts

ENGRAVER: J. Thornthwaite

DATE PUBLISHED: 1 February 1777

BELL EDITION: BBT76–77 and 80.IX

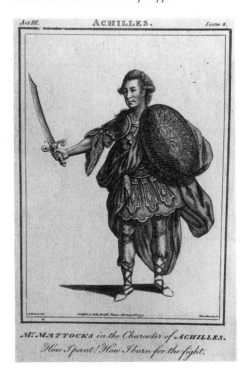

*M.ͬ MATTOCKS in the Character of ACHILLES.*
*How I pant! How I burn for the fight.*

Drawing, full-length; wearing Roman military costume, holding a shield with his left hand and a sword in his raised right hand. Line engraving 13.4 × 8.9, with the quotation (III.8): "How I pant! How I burn for the fight."

LOCATION OF ORIGINAL: Unknown

PROVENANCE: Bell sale, Christie's, 27 March 1793 (lot 10); bought with six other drawings in lot for 15s. by C. Cooke.

RELATED: None.

An engraved portrait by Terry of Mattocks as Achilles was published with an edition of the libretto in 1779. Mattocks did not appear in Gay's opera.

# 249

## Isabella Mattocks   1746–1826
as Elvira in *The Spanish Fryar*

by John Dryden

ARTIST: J. Roberts

ENGRAVER: J. Thornthwaite

DATE PUBLISHED: 11 July 1777

BELL EDITION: BBT76–77 and 80.XIII

Full-length, standing, looking to left, her right hand holding up a veil; wearing a richly decorated dress with panniered skirt. Line engraving 13.7 × 8.9, with the quotation (I.9): "—but however I will not stand with you for a Sample."

LOCATION OF ORIGINAL: Unknown.

PROVENANCE: Unknown.

RELATED: The BBT80 version by an anonymous engraver was published in reverse. See also De Wilde's version, No. 250.

Mrs Mattocks was born Isabella Hallam, one of the children of the elder Lewis Hallam (1714?–56?). Her father led a company of players to America in 1752, leaving Isabella behind; the Hallams became America's first important theatrical dynasty. Isabella was considered a "universal and judicious" actress

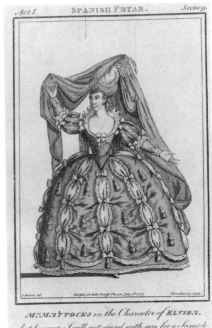

*Act I.*   SPANISH FRYAR.   *Scene 9.*

*M.ᵣˢ MATTOCKS in the Character of ELVIRA.*
*—but however I will not stand with you for a Sample.*

in London and, according to the actor Francis G. Waldron, "the best of all good speakers of an epilogue."

# 250

## Isabella Mattocks   1746–1826
as Elvira in *The Spanish Fryar*

by John Dryden

ARTIST: S. De Wilde

ENGRAVER: J. Corner

DATE PUBLISHED: 12 August 1791

BELL EDITION: BBT97.II

Drawing (34.9 × 26.7), full-length, standing in a room, her right hand holding up a veil attached to her feathered hat; wearing a dress with a train. Line engraving 11.7 × 8.9, printed for Bell's British Library, with the line (I.9): "—but, however I will not stand with you for a sample."

LOCATION OF ORIGINAL: Paul Dyson, London.

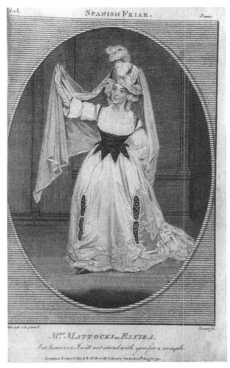

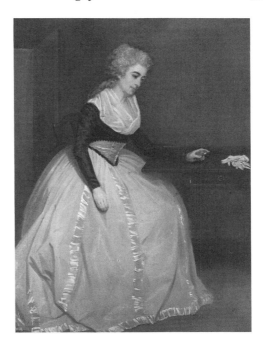

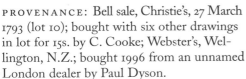

PROVENANCE: Bell sale, Christie's, 27 March 1793 (lot 10); bought with six other drawings in lot for 15s. by C. Cooke; Webster's, Wellington, N.Z.; bought 1996 from an unnamed London dealer by Paul Dyson.

RELATED: See No. 249, Roberts's version.

Mrs Mattocks acted Elvira for the first time in London on 19 April 1774, at Covent Garden Theatre.

# 251

Isabella Mattocks   1746–1826
as Lady Restless in *All in the Wrong*

by Arthur Murphy

ARTIST: S. De Wilde

ENGRAVER: P. Audinet

DATE PUBLISHED: 5 May 1792

BELL EDITION: BBT97.XII

Oil painting (36.2 × 27.3), full-length, seated

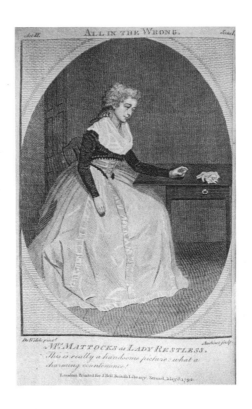

in a room, nearly in profile to right, looking at a miniature in her left hand, which rests on table; wearing a dress with full skirt. Line engraving 11.1 × 7.9, for Bell's British Library, with the quotation (II.1): "This is really a handsome picture: what a charming countenance!" An engraving by Clayton, after De Wilde, was published in Dublin by W. Jones.

LOCATION OF ORIGINAL: Garrick Club (Ash596, CKA250).

PROVENANCE: John Bell; Charles Mathews (No. 182).

RELATED: None.

Mrs Mattocks's name first appeared in the bills as Lady Restless on 26 April 1776 at Covent Garden Theatre.

Anne Merry. See Ann Brunton, No. 118.

# 252

James Middleton   ca. 1769–1799

as Artaxerxes in *The Ambitious Stepmother*

by Nicholas Rowe

ARTIST: J. Roberts

ENGRAVER: W. Leney

DATE PUBLISHED: 8 January 1795

BELL EDITION: BBT97.XXV

Full-length, standing, holding a sword in his right hand; wearing a long coat with braid, a shorter braided coat under, and Eastern-style trousers to ankles; columns and sky behind. Line engraving 10.8 × 7.6, for Cawthorn's British Library, with the quotation (V.2): "—And see, this weapon shall shield me from it.—"

LOCATION OF ORIGINAL: Unknown.

PROVENANCE: Bell sale, Leigh & Sotheby's, 25 May 1805 (lot 268).

RELATED: None.

Middleton did not play this role in London, as Rowe's play was not performed there after

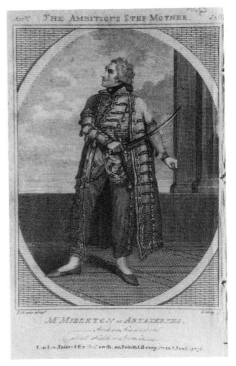

1759. He made his debut at Covent Garden Theatre on 22 September 1788 as Romeo. In the 1790s, he acted a number of supporting roles, but his career did not prosper, and he suffered from drink and bouts with insanity. On 18 October 1799, he died in "inebriated senselessness."

# 253

James Middleton   ca. 1769–1799

as Eumenes in *Merope*

by Aaron Hill

ARTIST: S. De Wilde

ENGRAVER: J. Chapman

DATE PUBLISHED: 10 January 1795

BELL EDITION: BBT97.XXIII

Full-length, standing, arms extended left and right and connected by shackles; wearing a short tunic, legs bare. Line engraving 10.5 × 7.6, for Bell's British Library, with Eumenes's line (IV.1): "Heavens did I hear that rightly."

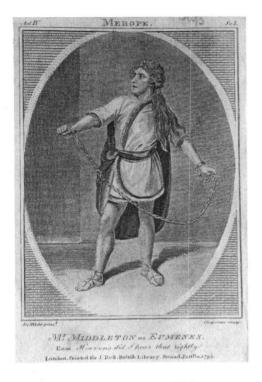

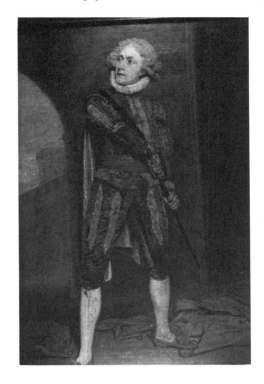

LOCATION OF ORIGINAL: Unknown.

PROVENANCE: Bell sale, Leigh & Sotheby's, 25 May 1805 (lot 274).

RELATED: None.

Middleton did not play this role in London; he did act Narbas in a performance of Hill's play at Drury Lane Theatre on 29 November 1797.

# 254

James Middleton   ca. 1769–1799
as Salisbury in *The Countess of Salisbury*

by Hale Hartson

ARTIST: S. De Wilde

ENGRAVER: P. Audinet

DATE PUBLISHED: 9 February 1793

BELL EDITION: BBT97.XVIII

Oil on canvas (36.2 × 26.5), full-length, standing, with legs apart and drawing his sword;

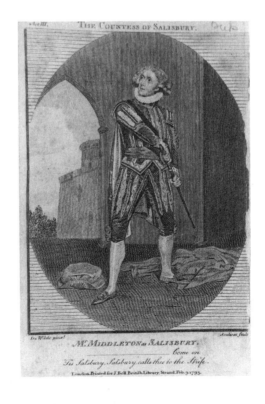

wearing "Elizabethan" costume, his hat and cloak on paved floor at feet; arch behind through which is seen a castle wall. Line engraving 11.4 × 8.3, for Bell's British Library, with Salisbury's line (III): "—Come on / 'Tis Salisbury, Salisbury calls thee to the Strife."

LOCATION OF ORIGINAL: Garrick Club (Ash602, GC254).

PROVENANCE: John Bell. Presented to the Garrick Club in 1843 by West.

RELATED: A pencil and watercolor drawing (38.5 × 28) by De Wilde is in the National Portrait Gallery (Reserve D21).

Middleton did not perform this role in London.

# 255

## Anne Miller   d. 1805
as Zaphira in *Barbarossa*

by John Brown

ARTIST: S. De Wilde

ENGRAVER: W. Leney

DATE PUBLISHED: 8 June 1795

BELL EDITION: BBT97.XXVI

Full-length, standing; wearing a long dress with a cord belt hanging from right side, her left arm across waist, her right arm raised; columns and sky behind. Line engraving 11.4 × 7.6, for Bell's British Library, with the quotation (II.1): "Oh! my heart / Can I bear this / Inhuman Tyrant! Curses on thy head."

LOCATION OF ORIGINAL: Unknown.

PROVENANCE: Bell sale, Leigh & Sotheby's, 25 May 1805 (lot 282).

RELATED: None.

Anne Miller did not play this role in London. Between 1794 and 1799, she acted important secondary roles and occasional leads at Drury Lane Theatre.

# 256

## John Moody   1727–1812
as Commodore Flip in *The Fair Quaker of Deal*

by Edward Thompson, adapted from Charles Shadwell

ARTIST: S. De Wilde

ENGRAVER: P. Audinet

DATE PUBLISHED: 2 January 1792

BELL EDITION: BBT97.XIV

Oil on canvas (36.2 × 26.2), full-length, standing, his right hand in the pocket of his breeches, his left hand raised; wearing a cocked hat, an open shirt, a loose neck cloth, and a long coat. Line engraving 11.1 × 7.9, for Bell's British Library, with the quotation (IV): "This lady is dispos'd of, and her inclinations are moor'd to my affections."

LOCATION OF ORIGINAL: Garrick Club (Ash610, GC270).

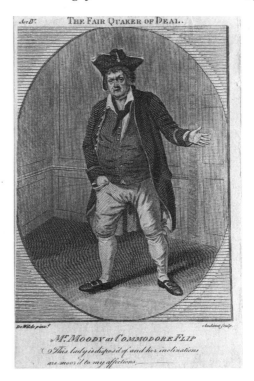

PROVENANCE: John Bell. Presented to the Garrick Club in 1843 by West.

RELATED: None.

Moody acted this role in the premiere of Edward Thompson's play on 9 November 1773 at Drury Lane Theatre. He was a very popular and serviceable actor for thirty-seven years at Drury Lane until he retired in June 1796.

# 257

## John Moody 1727–1812
as Teague in *The Commitee*

by Robert Howard

ARTIST: J. Roberts

ENGRAVER: Walker

DATE PUBLISHED: 1 July 1776

BELL EDITION: BBT76–77 and 80.II; BET92.II

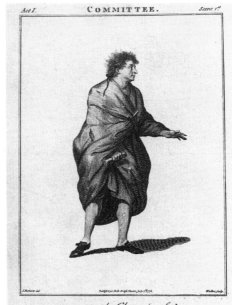

Colored drawing on vellum (10.2 × 7.3); full-length, head profile to right, his left hand outstretched; wearing a large cloak that covers his body. Line engraving 12.7 × 9.2, with the quotation (I.1): "A poor Irishman &. Christ save me, & save you all. I pr'ythee give me a Sixpence good Masters."

LOCATION OF ORIGINAL: British Museum (Burney VI, No. 165).

PROVENANCE: Bell sale, Christie's, 27 March 1793 (lot 11); bought, with six other drawings in lot, for £1 by Gretton.

RELATED: In BBT80, the engraving is anonymous and in reverse; BET92 is a copy of BBT80.

For other portraits of Moody as Teague, see the *BDA*. Moody acted this role for the first time at Drury Lane Theatre on 29 December 1760; it became one of his most successful portrayals and earned him a reputation as a comic Irishman.

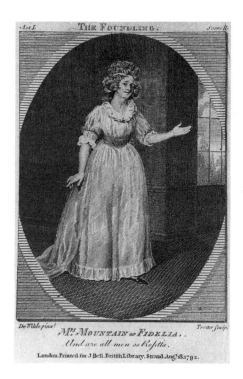

# 258

## Rosemond Mountain   ca. 1768–1814
as Fidelia in *The Foundling*

by Edward Moore

ARTIST: S. De Wilde

ENGRAVER: T. Trotter

DATE PUBLISHED: 8 August 1792

BELL EDITION: BBT97.XI

Full-length, standing in a room with a window right, her left arm extended right, her right arm by side; wearing a dress with a ruff and a sash at waist, a ribbon band around hair. Line engraving 11.1 × 7.9, for Bell's British Library, with Fidelia's line (I.2): "And are all men so Rosetta."

LOCATION OF ORIGINAL: Unknown.

PROVENANCE: Unknown.

RELATED: None.

Rosamond Mountain acted this role for the first time in London on 4 October 1786 at Covent Garden Theatre. A fellow actor, Francis G. Waldron, described her as "a pretty singer with an engaging regularity of features and easy deportment."

# 259

## Joseph S. Munden   1758–1832
as Sir Francis Gripe in *The Busy Body*

by Susannah Centlivre

ARTIST: S. De Wilde

ENGRAVER: J. Thornthwaite

DATE PUBLISHED: 7 June 1791

BELL EDITION: BBT97.XVI

Full-length, standing before trees, with a tower in background, holding up a purse in his right hand, a stick in left, a hat under his arm; wearing a long coat and powdered curly wig. Line engraving 10.5 × 7.3, for Bell's British Library, with the quotation (I): "Well, Sir

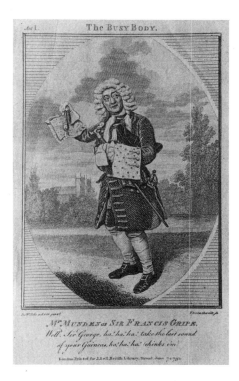

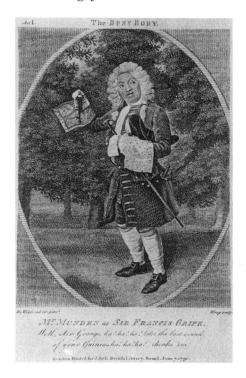

George, ha! ha! ha! take the last sound of your Guineas ha! ha! ha! (chinks 'em)."

LOCATION OF ORIGINAL: Unknown.

PROVENANCE: Unknown.

RELATED: A copy engraved (10.5 × 7.6) by Wray was also published for Bell's British Library, with the same quotation and date, but the background varies, with the trees much closer behind and no sky seen. An anonymous engraving was published by C. Cooke 10 June 1806 and as a plate to *British Drama* (1817); a similar portrait, engraved by J. Rogers, after Kennerley, was published as a plate to Oxberry's *Dramatic Biography* (1825). For other portraits of Munden as Sir Francis Gripe, see the *BDA*.

Munden made his Covent Garden Theatre debut in this role on 2 December 1790. In the 1790s, he developed a low-comedy line that earned him popularity. James Boaden called his style "broad and voluptuous." Hazlitt found his acting too full of grimaces and caricatures.

# 260

Charles Murray 1754–1821
as Demetrius in *The Brothers*

by Edward Young

ARTIST: [J. Roberts?]

ENGRAVER: W. Leney

DATE PUBLISHED: 18 March 1797

BELL EDITION: BBT97.XXX

Full-length, standing, drawing sword from scabbard; wearing Roman uniform and helmet with feathers. Line engraving 10.5 × 8.1, for Cawthorn's Bell's British Library, with Demetrius's line (IV): "I beg, I challenge, I provoke my death."

LOCATION OF ORIGINAL: Unknown.

PROVENANCE: Unknown.

RELATED: In the Bell sale at Leigh & Sotheby's on 5 May 1805 was a picture (lot 270), attributed to John Graham, of De-

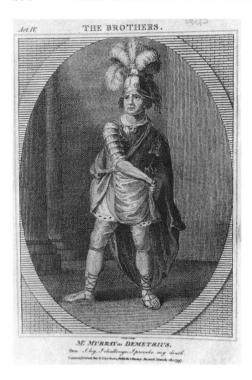

metrius and Erixine in a scene (V) from *The Brothers*, but no performers were named.

After spending more than twenty years acting in the provinces, at the age of forty-two, Murray made his debut at Covent Garden Theatre on 2 September 1796 as Shylock. He did not play Demetrius in London; probably he was chosen to depict the role in this engraving because he was a new actor in town. The *Monthly Mirror* (October 1796) judged him better suited for the roles of older tragic figures "than any actor we remember to have seen."

# 261

John Palmer   1744–1798
as Don Carlos in *Ximena*

by Colley Cibber

ARTIST: S. De Wilde

ENGRAVER: J. Thornthwaite

DATE PUBLISHED: 24 March 1792

BELL EDITION: BBT97.XV

Full-length, standing, his right fist extended, holding a hat in his left hand; wearing boots, coat-cape, ruff, and curled wig; a wall behind

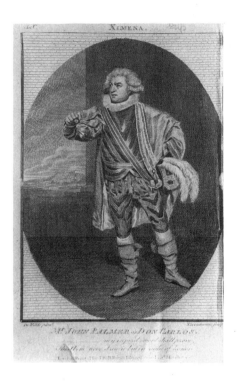

with window showing sky. Line engraving 11.7 × 7.9, for Bell's British Library, with Don Carlos's line (I): "—my injur'd sword shall prove, / This Arm ne'er drew it but in right of honor."

LOCATION OF ORIGINAL: Unknown.

PROVENANCE: Unknown.

RELATED: None.

Palmer did not act this role in London; the only performance of *Ximena* in London in the second half of the eighteenth century was at Covent Garden Theatre on 21 March 1772, when the part was played by Smith. John Palmer was an extremely versatile actor, described by the *Morning Chronicle* (2 August 1779) as "one of the best comedians living."

# 262

John Palmer  1744–1798
as Don John in *The Chances*

by John Fletcher

ARTIST: S. De Wilde

ENGRAVER: J. Thornthwaite

DATE PUBLISHED: 22 July 1791

BELL EDITION: BBT97.XI

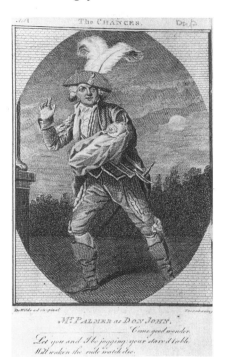

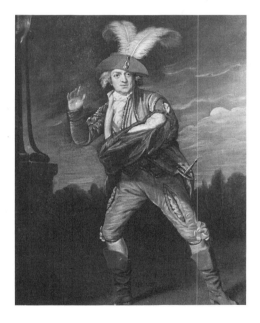

Oil on canvas (36.2 × 27.3), dated 1791, full-length, standing outdoors, facing front, legs apart; wearing a Vandyke costume, with a hat with two tall feathers, a sword at his left side; holding a babe in his left arm, his right hand raised. Line engraving 10.8 × 7.6, for Bell's British Library, with Don John's line (I): "— Come good wonder. / Let you and I be jogging: your starv'd treble / Will waken the rude watch else."

LOCATION OF ORIGINAL: National Theatre, London.

PROVENANCE: W. Somerset Maugham.

RELATED: An engraving by C. Cooke was published as a plate to Cumberland's *British Theatre* (1808); another copy by an unknown engraver was published as a plate to *British Drama* (1817).

An engraving by J. Rogers, after J. Kennerley, of Palmer as Don John was published as a plate to Oxberry's *Dramatic Biography* (1817). Palmer first acted Don John on 14 May 1782, at Drury Lane Theatre.

# 263

John Palmer  1744–1798
as Stukeley in *The Gamester*

by Edward Moore

ARTIST: J. Roberts

ENGRAVER: B. Reading

DATE PUBLISHED: 22 May 1776

BELL EDITION: BBT76–77 and 80.XII

Colored drawing on vellum (10.8 × 7.3), full-length, standing to front, head to left, with his right hand on top of a cane, his left hand

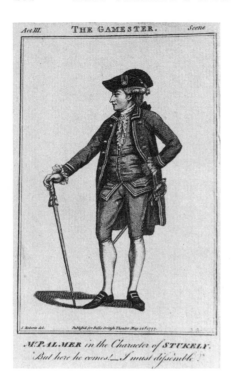

on hip; wearing breeches, coat, waistcoat, and tricorn hat, with a sword at his left side. Line engraving 13.3 × 9.2, with the quotation (III): "But here he comes!—I must dissemble."

LOCATION OF ORIGINAL: British Museum (Burney VI, No. 255).

PROVENANCE: Bell sale, Christie's, 27 March 1793 (lot 12); bought, with six other drawings in lot, for 14s. by Gretton.

RELATED: None.

Palmer acted this role in a revival of Edward Moore's play at Drury Lane Theatre on 16 March 1771.

# 264

### John Palmer   1776–1809
as George Barnwell in *The London Merchant*

by George Lillo

ARTIST: S. De Wilde

ENGRAVER: P. Audinet

DATE PUBLISHED: 23 June 1792

BELL EDITION: BBT97.XIV

Full-length, seated, facing front, his legs in irons, his right hand resting on a book on table; wearing a dark coat, waistcoat, and breeches. Line engraving 11.4 × 8.3, for Bell's British Library.

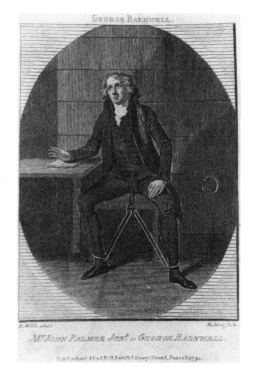

LOCATION OF ORIGINAL: Unknown.

PROVENANCE: Unknown.

RELATED: A copy by an unknown engraver was printed by C. Cooke, 1807, and was published as a plate to *British Drama* (1817). Another portrait by De Wilde of Palmer as George Barnwell (oil on canvas 72.4 × 60.3) was sold at Christie's on 22 March 1974. The picture, reproduced in the sale catalog, depicts Palmer full-length, standing in a cell, with irons on his legs and holding a glass.

The younger John Palmer did not act this role in London.

# 265

Robert L. Palmer   1757–1817
as Bonario in *Volpone*

by Ben Jonson

ARTIST: J. Graham?

ENGRAVER: Not Engraved

DATE PUBLISHED: Not Published

Description unknown.

LOCATION OF ORIGINAL: Unknown.

PROVENANCE: Original painting for *Bell's British Theatre*, sold at Leigh & Sotheby's, 25 May 1805 (lot 285a), when attributed to W. Hamilton.

RELATED: None.

This unlocated picture was not engraved and thus was not published in any of the Bell volumes. Robert Palmer acted Bonario for the first time at the Haymarket Theatre on 12 September 1783.

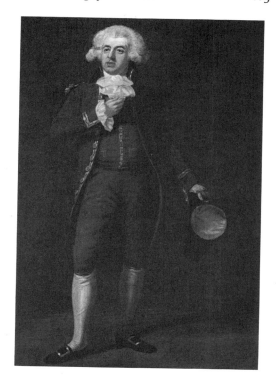

# 266

Robert L. Palmer   1757–1817
as Tom in *The Conscious Lovers*

by Richard Steele

ARTIST: S. De Wilde

ENGRAVER: J. Corner

DATE PUBLISHED: 28 September 1791

BELL EDITION: BBT97.XIII

Oil on canvas (35.55 × 26.9), full-length, standing in a room, his right hand on his breast, holding a cocked hat in his left hand; he wears a costume somewhat grand for a servant: a pretentious wig, green waistcoat and breeches, a brown coat trimmed with gold, and a high white stock with frills. Line engraving 11.4 × 7.9, for Bell's British Library, with the Tom's line (III.1): "—I would not be a bit wiser, a bit richer, a bit taller, a bit shorter than I am at this Instant."

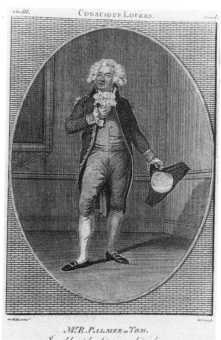

LOCATION OF ORIGINAL: Garrick Club (Ash654, GC262).

PROVENANCE: John Bell; Charles Mathews (No. 185).

RELATED: A copy by an unknown engraver was printed by C. Cooke, 1807, and as a plate to *British Drama* (1817); another copy was published in Dublin by W. Jones.

One of the Palmers acted this role at Drury Lane Theatre on 7 October 1783. Though Robert Palmer was in the company that season, that actor probably was John Palmer, Robert's brother, who played the role again on 13 July 1786 at the Haymarket Theatre. Usually, Robert Palmer was designated by his first initial in the bills.

Tom is a gentleman's gentleman, whose pretentious costume reflects his inflated opinion of himself.

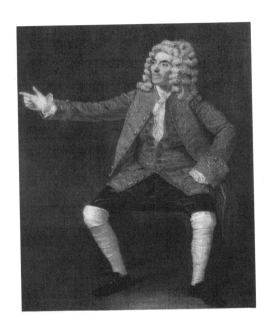

# 267

William Parsons   1736–1795
as Colonel Oldboy in *Lionel and Clarissa*

by Isaac Bickerstaff

ARTIST: S. De Wilde

ENGRAVER: J. Corner

DATE PUBLISHED: 27 January 1791

BELL EDITION: BBT97.XXI

Oil on canvas (36.5 × 28.5), full-length, seated in a room, his right hand extended, his left hand on thigh; wearing a long wig, coat, waistcoat, and breeches. Line engraving 11.7 × 8.3, for Bell's British Library, with a fireplace added.

LOCATION OF ORIGINAL: Garrick Club (Ash657, CKA267).

PROVENANCE: John Bell. Presented to the Garrick Club in 1854 by William A. Commerell.

RELATED: A copy by an anonymous engraver was published by C. Cooke as a plate to *British Drama* (1805); an engraving by

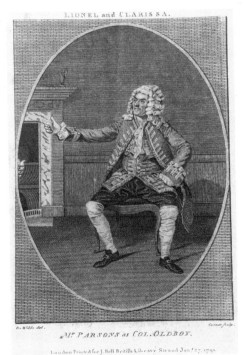

LIONEL and CLARISSA.

Mr PARSONS as Col. OLDBOY.

London Printed for J. Bell British Library Strand Jan 27 1791

A. Ferguson was published in Dublin as a plate to W. Jones's *British Theatre* (1794).

Parsons acted Colonel Oldboy for the first time in London on 8 February 1770 at Drury

Lane Theatre and later on 18 June 1785 at the Haymarket Theatre. During his thirty-two seasons at Drury Lane, Parsons demonstrated great comic powers, especially in preposterous and foolish old characters.

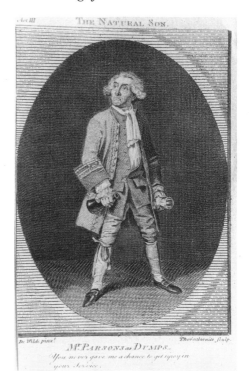

# 268

William Parsons   1736–1795
as Dumps in *The Natural Son*

by Richard Cumberland

ARTIST: S. De Wilde, 1791

ENGRAVER: J. Thornthwaite

DATE PUBLISHED: 29 September 1792

BELL EDITION: BBT97.XX

Oil on canvas (41.3 × 32.4), signed and dated "De Wilde 1791," full-length, standing, holding a bottle in his right hand and a wineglass in left; wearing an unbuttoned waistcoat and a long coat with broad cuffs. Line engraving 11.7 × 7.9, for *Bell's British Theatre*, with

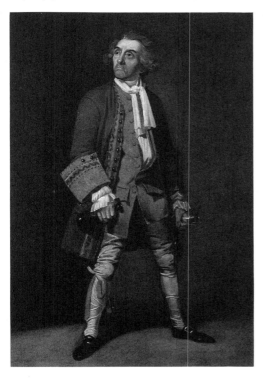

Dumps's line (III): "You never gave me a chance to get tipsy in your Service."

LOCATION OF ORIGINAL: Garrick Club (Ash656, CKA437).

PROVENANCE: This picture was exhibited in the Bell sale at Christie's on 27 March 1793 but was not offered for sale; Charles Mathews (No. 368).

RELATED: None.

Parsons acted this role in the premiere of Cumberland's play at Drury Lane Theatre on 22 December 1784.

# 269

William Parsons   1736–1795
as Periwinkle in *A Bold Stroke for a Wife*

by Susannah Centlivre

ARTIST: J. Roberts

ENGRAVER: J. Thornthwaite

DATE PUBLISHED: 20 October 1776

BELL EDITION: BBT76–77 and 80.VI

Colored drawing on vellum (10.8 × 7.6), dated 1778, full-length, standing to front,

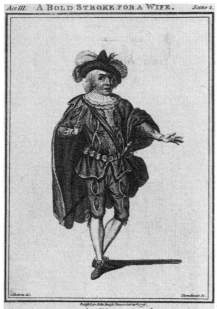

Mr PARSONS in the Character of PERIWINKLE.
Oh, Mr Sackbut why do you name the Devil, when perhaps he may be at your Elbow?

hands outstretched; wearing breeches, coat, cloak, and hat with feathers. Line engraving 13.3 × 9.2, with the quotation (III.2): "Oh, Mr Sackbut why do you name the Devil, when perhaps he may be at your Elbow?"

LOCATION OF ORIGINAL: British Museum (Burney VII, No. 113).

PROVENANCE: Bell sale, Christie's, 27 March 1793 (lot 12); bought, with six other drawings in lot, for 14s. by Gretton.

RELATED: A copy of the engraving by Thornthwaite was issued in BBT80 with J. Roberts (not Thornthwaite) named as the engraver, but with the same date.

The drawing by Roberts is dated later than the engraving. In the opinion of E. Croft-Murray (cited by J. F. Kerslake in *Catalogue of Theatrical Portraits in London Public Collec-*

*tions*), the drawing together with the date and inscription are in Roberts's own hand; it is "suggested that they were added from memory later in life."

Parsons appeared as Periwinkle for the first time in London on 27 December 1762, at Drury Lane Theatre.

**Miss Phillips.** See Anna Maria Crouch, No. 19.

# 270

### Alexander Pope   1762–1835
as Varanes in *Theodosius*

by Nathaniel Lee

ARTIST: S. De Wilde

ENGRAVER: J. Corner

DATE PUBLISHED: 13 April 1793

BELL EDITION: BBT97.X

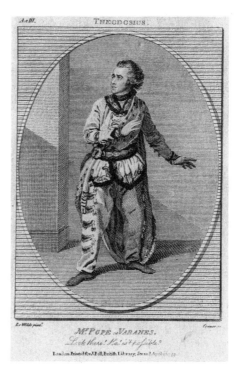

Mr POPE as VARANES.

London Printed for J. Bell, British Library, Strand, April

Full-length, standing, facing left, with his left arm extended and his right arm across his chest; wearing loose trousers, a coat with sash at waist, and a long ermine-trimmed cloak. Line engraving 11.7 × 8.9, for Bell's British Library, with the quotation (III): "Look there! Ha! is't possible?"

LOCATION OF ORIGINAL: Unknown.

PROVENANCE: Thomas Harris, sold by him at Robins 12 July 1819 (lot 65), and bought by Charles Mathews. Though once in Mathews's collection, the picture is not in the Garrick Club.

RELATED: None.

Pope appeared as Varanes for the first time in London on 23 February 1786, at Covent Garden Theatre. Pope was a serviceable actor on the London stage for some forty-four years. He had many critics, who, like Leigh Hunt, found him an actor "without face, expression, or delivery," but others praised his fine mellow voice and handsome noble features.

# 271

## Elizabeth Pope   ca. 1740–1797
as Angelica in *Love for Love*

by William Congreve

ARTIST: J. Roberts

ENGRAVER: J. Roberts

DATE PUBLISHED: 1781

BELL EDITION: Published Separately?

Full-length, standing, body front with her head to right; wearing a dress and long pleated overskirt and a hat with ruffles. Line engraving 12 × 8.5, with the quotation (V.9): "Had I the world to give you, it could not make me worthy of so generous & faithful a Passion."

LOCATION OF ORIGINAL: Unknown.

PROVENANCE: Unknown.

RELATED: None.

Elizabeth Pope (when Miss Younge) first

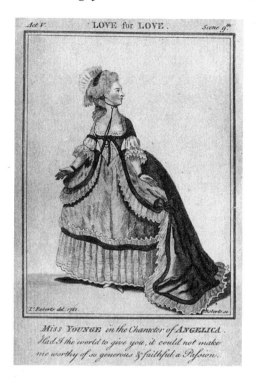

MISS YOUNGE *in the Character of* ANGELICA.
*Had I the world to give you, it could not make me worthy of so generous & faithful a Passion.*

acted Angelica on 23 December 1769. The engraving seems to have been issued without publication details. It is not noted in the catalogs of engravings in the Harvard Theatre Collection or British Museum. The example noted here is from the collection of Jennie Walton. It seems to have been bound at some time in a volume of the play.

# 272

## Elizabeth Pope   ca. 1740–1797
as Artemisa in *The Ambitious Step-Mother*

by Nicholas Rowe

ARTIST: J. Roberts

ENGRAVER: J. Thornthwaite

DATE PUBLISHED: 17 October 1777

BELL EDITION: BBT76–77 and 80.XVI

Watercolor drawing on vellum (11.7 × 7.3), full-length, standing, her left arm outstretched; wearing a dress trimmed with er-

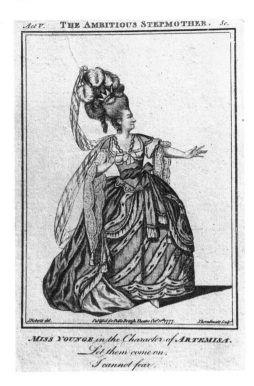

mine and a small crown with large feathers on her piled hair. Line engraving 14.6 × 9.5, with the quotation (V): "Let them come on, / I cannot fear."

LOCATION OF ORIGINAL: British Museum (Burney VII, No. 76).

PROVENANCE: Bell sale, Christie's, 27 March 1793 (lot 15); lot, including three other drawings, bought for 11s. by Gretton.

RELATED: None.

She (when Miss Younge) did not act this role in London; the play was not performed during the time of her career there. One of the leading performers in London until her death in 1797, Elizabeth Pope was an extremely versatile and flexible actress, who possessed a wide range of leading characters. According to the *Monthly Mirror* of March 1797, she was especially strong in sentimental wives and daughters in comedies where "Her elegance, her playfulness, her understanding" allowed her to excel.

# 273

Elizabeth Pope   ca. 1740–1797
as Creusa in *Creusa, Queen of Athens*

by William Whitehead

ARTIST: J. Roberts

ENGRAVER: J. Thornthwaite

DATE PUBLISHED: April 1778

BELL EDITION: BBT76–77 and 80.XX

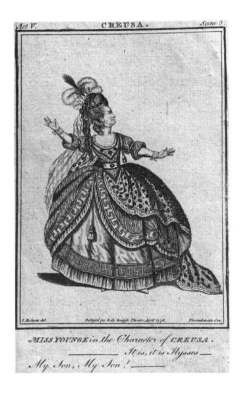

Watercolor drawing on vellum (11.4 × 8.9); full-length, standing to right, her arms extended from sides; wearing a panniered dress with a richly decorated skirt and underskirt, a headpiece with feathers. Line engraving 13.7 × 9.5, with the quotation (V.5): "—It is, it is Ulysses— / My Son, My Son!—"

LOCATION OF ORIGINAL: British Museum (Burney VII, No. 81).

PROVENANCE: Bell sale, Christie's, 27 March

1793 (lot 15); bought, with three other drawings in lot, for 11s. by Gretton.

RELATED: None.

She (when Miss Younge) did not appear in this role in London; *Creusa* was not performed there during her career.

# 274

## Elizabeth Pope   ca. 1740–1797
as Hermione in *The Distrest Mother*

by Ambrose Philips

ARTIST: J. Roberts

ENGRAVER: Anonymous [J. Roberts?]

DATE PUBLISHED: 17 May 1776

BELL EDITION: BBT76–77 and 80.I

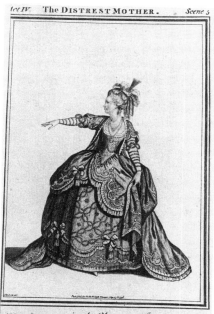

MISS YOUNGE *in the Character of* HERMIONE.
"Be gone! the Priest expects you at the Altar,
"But Tyrant, have a Care I come not thither."

Watercolor drawing on vellum (12.7 × 9.5), full-length, standing to right, with her right arm outstretched and her left arm at side;

wearing a richly embroidered dress with a wide skirt, two strands of pearls around her neck, and a small cap with feathers on her head. Line engraving 14.3 × 9.8, with the quotation (IV.5): "Be gone! the Priest expects you at the Altar, / But Tyrant have a Care I come not thither."

LOCATION OF ORIGINAL: British Museum (Burney VII, No. 79).

PROVENANCE: Bell sale, Christie's, 27 March 1793 (lot 15); bought, with three other drawings in lot, for 11s. by Gretton. See also No. 138.

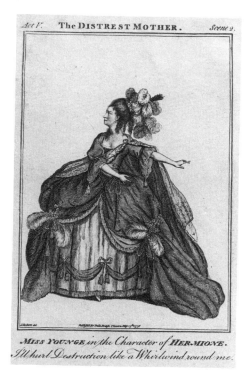

MISS YOUNGE *in the Character of* HERMIONE.
*I'll hurl Destruction like a Whirlwind round me.*

RELATED: The BBT76 engraving (with pearls around her neck) is of the drawing in the British Museum. The engraving in BBT80 (no pearls) bears the same date but depicts her with both arms extended to right, wearing a similar dress but with different decoration, and with the quotation (V.2): "I'll hurl Destruction like a Whirlwind round me." In the Bell sale at Leigh & Sotheby's on 5 May 1805 was a picture (lot 285b), attributed

to John Graham, of the characters Hermione and Orestes in a scene (V. 4) from this play, but no performers named. Possibly this picture was a preparation for one of the engravings relating to No. 274 and No. 153.

She (when Miss Younge) acted Hermione for the first time in London on 4 January 1775, at Drury Lane Theatre.

# 275

Elizabeth Pope   ca. 1740–1797 and
William Smith   1730?–1819?
as Phaedra and Hippolitus in *Phaedra and Hippolitus*

by Edmund Smith

ARTIST: J. Roberts

ENGRAVER: Not Engraved

DATE PUBLISHED: Not Published

Watercolor on vellum (11.4 × 16.9). Phaedra stands full-length, left side of drawing, body front, facing right, with a saber in her right hand; she wears a full-skirted dress trimmed in ermine, with a long train to left, and a large headdress with feathers and small crown. Hippolitus stands full-length, right side of drawing, head left, with his right hand extended toward Phaedra, and his left hand at side, wrists manacled; he wears a Roman toga and a coronet with flowers. Inscriptions: "Miss Young. Phedra" (*top left*); "M$^r$ Smith. Hippolytus" (*top right*).

LOCATION OF ORIGINAL: British Museum (Burney VIII, No. 206).

PROVENANCE: Bell sale at Leigh & Sotheby's, 25 May 1805 (lot 25).

In the catalog of the Bell sale, this picture is called a scene from *Phaedra and Hippolitus*, but no actors are named, nor is the artist given. This picture was not engraved. Neither Elizabeth Pope nor Smith acted these roles in London. The role of Phaedra was usually acted by Mrs Barry when occasional performances of this play were given during the last quarter of the century. A portrait of Ann Barry as

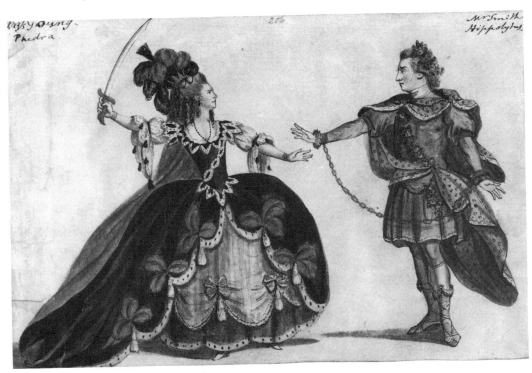

Phaedra, engraved by Thornthwaite, was published in BBT76 and BBT80. The original was sold in the Bell sale at Christie's on 27 March 1793 (lot 2); see No. 100. See also No. 195 for a portrait of Holman as Hippolitus.

# 276

## Elizabeth Pope   ca. 1740–1797
as Zara in *The Mourning Bride*

by William Congreve

ARTIST: J. Roberts

ENGRAVER: J. Thornthwaite

DATE PUBLISHED: 15 July 1776

BELL EDITION: BBT76–77 and 80.XIII

Full-length, standing to front, looking to her right, hands in manacles; wearing a full and richly decorated dress and a hat with small crown and feathers. Line engraving 14 × 10.2, with Zara's line (I.6): "—But when I feel / These Bonds, I look with loathing on myself."

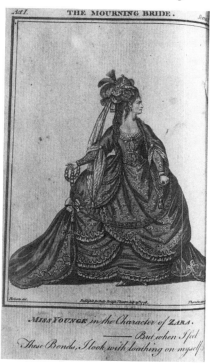

BBT76 has no engraver named, but BBT80 names Thornthwaite and is printed in reverse.

LOCATION OF ORIGINAL: Unknown.

PROVENANCE: Bell sale, Christie's, 27 March 1793 (lot 15); bought, with three other drawings in lot, for 11s. by Gretton.

RELATED: See also No. 277.

Elizabeth Pope (when Miss Younge) appeared as Zara for the first time in London on 11 April 1772, at Drury Lane Theatre. Earlier, on 30 October 1769, she had appeared as Almeria in this play.

Elizabeth Pope possessed a wide and flexible range of characters. Growing more beautiful with maturity, she was exalted by one admirer as coming "nearer to the description of the Grecian Arpasia" than any woman he had ever known—"and he had been acquainted with the first women in most of the countries of Europe" (*Monthly Mirror*, 1779).

# 277

## Elizabeth Pope   ca. 1740–1797
as Zara in *The Mourning Bride*

by William Congreve

ARTIST: S. De Wilde

ENGRAVER: J. Thorthwaite

DATE PUBLISHED: 15 April 1791

BELL EDITION: BBT97.XIX

Full-length, standing before a pillar and a sky behind, with her hands in manacles; wearing long dress, a sash hanging from shoulders, and a turban headdress with pearls and feathers. Line engraving 11.4 × 7.3, for Bell's British Library, with the quotation (I): "—but when I feel / These Bonds, I look with loathing on myself." The same engraving by Thornthwaite was published 20 April 1791.

LOCATION OF ORIGINAL: Unknown.

PROVENANCE: Unknown.

RELATED: An engraving (24.1 × 17.8) by

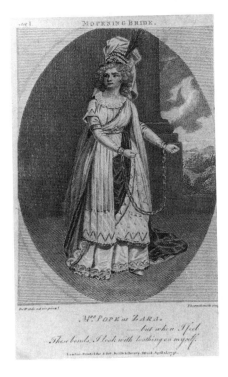

Saillier—"from the original Picture, which was painted from life by De Wilde"—was published for Bell's British Library, 1791. An engraving by Esdall was published in reverse by W. Jones, Dublin.

Engravings, after J. Roberts, of Elizabeth Pope (when Miss Younge) as Zara were published in *Bell's British Theatre* (1776–77, 1780); see No. 276. At Christie's on 2 April 1791 (lot 100), two drawings called "Mrs Siddons in Tragic Poses" were offered. One of the drawings, however, is of Mrs Pope as Zara.

Elizabeth Pope (as Sigismunda).
See David Garrick, No. 166.

# 278

Jane Pope   1744?–1818
as Biddy Tipkin in *The Tender Husband*

by Richard Steele

ARTIST: J. Roberts

ENGRAVER: J. Thornthwaite

DATE PUBLISHED: 16 January 1776

BELL EDITION: BBT76 and 80.VIII

Watercolor drawing on vellum (10.2 × 8.3), full-length, seated, holding a fan in her right hand, high-piled hair decorated with feathers; wearing a panniered dress with rich embroidery and lace. Line engraving 13.3 × 9.2, with the quotation (IV.4): "I'll be drawn thus if you please Sir?" BBT80, with same date, does not bear the engraver's name.

LOCATION OF ORIGINAL: British Museum (Burney VII, No. 53).

PROVENANCE: Bell sale, Christie's, 27 March 1793 (lot 11); bought with six other drawings in lot for £1 by Gretton.

RELATED: A pencil drawing by Roberts in the Harvard Theatre Collection is a study for this portrait.

Jane Pope first appeared as Biddy Tipkin in London on 27 March 1770, at Drury Lane Theatre.

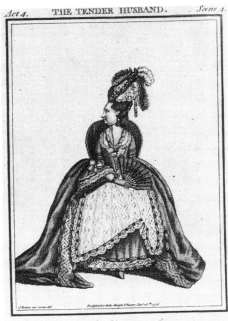

# 279

Jane Pope  1744?–1818
as Corinna in *The Confederacy*

by John Vanbrugh

ARTIST: J. Roberts

ENGRAVER: R. Pollard

DATE PUBLISHED: 12 September 1777

BELL EDITION: BBT76–77 and 80.XV

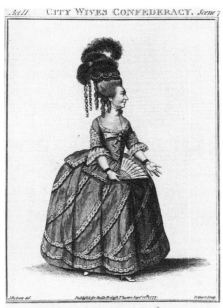

.*MISS* **POPE** *in the Character of* **CORINNA**.
*Why he cant touch a Groat of my Portion;do you k*
*that Flippanta?*

Watercolor on vellum (12.7 × 8.3), full-length,
standing to right, holding a fan in her right
hand; wearing a panniered dress with braided
decoration, hat with feathers atop high-piled
hair. Line engraving 12.7 × 9.2, with the quo-
tation (II.7): "Why he cant touch a Groat of
my Portion; do you know that Flippanta?"

LOCATION OF ORIGINAL: British Mu-
seum (Burney VII, No. 63).

PROVENANCE: Bell sale, Christie's, 27 March
1793 (lot 11); bought with six other drawings
in lot for £1 by Gretton.

RELATED: None.

A portrait of Jane Pope as Corinna was en-
graved (14 × 9.2) by J. Goldar, after
R. Dighton, and published as a plate to *New
English Theatre* (1777). Jane Pope made her
adult debut at Drury Lane Theatre in this
role on 2 October 1759, when she was adver-
tised as "a Young Gentlewoman." Her career
on the London stage spanned fifty-two years.

# 280

Jane Pope  1744?–1818
as Dorcas Zeal in *The Fair Quaker of Deal*

by Edward Thompson,
adapted from Charles Shadwell

ARTIST: J. Roberts

ENGRAVER: J. Thornthwaite

DATE PUBLISHED: November 1777

BELL EDITION: BBT76–77 and 80.XVII

Watercolor on vellum (10.2 × 8.3), full-length,
standing to left, wrists crossed in front of

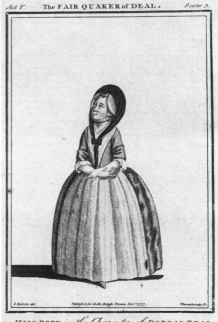

*MISS* **POPE** *in the Character of* **DORCAS ZEAL**.
*— Thou love & cherish me!*

waist; wearing a hat with head shawl, a dress with a large apron. Line engraving 14 × 9.2, with the quotation (V.3): "—Thou love & cherish me!"

LOCATION OF ORIGINAL: British Museum (Burney VII, No. 56).

PROVENANCE: Bell sale, Christie's, 27 March 1793 (lot 11); bought with six other drawings in lot for £1 by Gretton.

RELATED: None.

Jane Pope appeared as Dorca Zeal in a version of this play by Thompson at Drury Lane Theatre on 9 November 1773.

# 281

Jane Pope   1744?–1818
as Laetetia in *The Old Bachelor*

by William Congreve

ARTIST: J. Roberts

ENGRAVER: J. Roberts

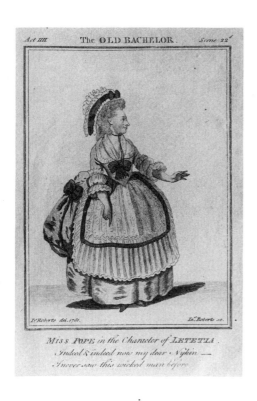

DATE PUBLISHED: 1781

BELL EDITION: Published Separately?

Full-length, standing, her head right, her left hand extended to her side, and her right hand on front of dress; wearing a dress with bustle and bow, a decorated pleated overskirt (or apron) with a bow at the bodice, and a hat with a broad ribbon and ruffles. Line engraving 12 × 8.5, with the quotation (IV.22): "Indeed & indeed now my dear Nykin—I never saw this wicked man before."

Jane Pope first acted Letetia on 9 October 1777, at Drury Lane Theatre. The engraving seems to have been issued without publication details, It is noted in the Harvard Theatre Collection catalog. The example reproduced here is in the collection of Jennie Walton. It seems to have been bound at some time in a volume, perhaps of the play.

# 282

Jane Pope   1744?–1818
as Rosetta in *The Foundling*

by Edward Moore

ARTIST: J. Roberts

ENGRAVER: J. Thornthwaite

DATE PUBLISHED: 1 July 1777

BELL EDITION: BBT76–77 and 80.XIII

Watercolor drawing on vellum (11.4 × 8.9), full-length, standing to front, head to right, holding a fan in her right hand, with her left arm across body, high-piled hair decorated with feathers; wearing a dress with an embroidered pattern over hips. Line engraving 14 × 9.2, with the quotation (I.3): "—Is it not very polite, Colonel?"

LOCATION OF ORIGINAL: British Museum (Burney VII, No. 59).

PROVENANCE: Bell sale, Christie's, 27 March 1793 (lot 11); bought with six other drawings in lot for £1 by Gretton.

RELATED: None.

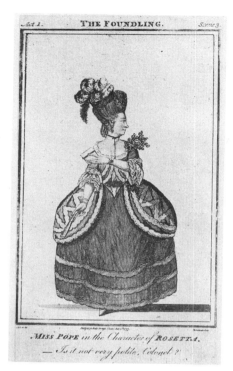

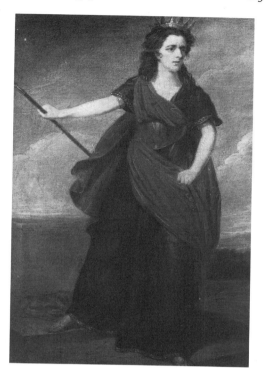

Jane Pope appeared as Rosetta for the first time in London on 10 April 1764, at Drury Lane Theatre.

Ann Powell. See Ann Warren, No. 70.

# 283

Jane Powell   ca. 1761–1831

as Boadicea in *Boadicea*

by Richard Glover

ARTIST: S. De Wilde

ENGRAVER: J. Thornthwaite

DATE PUBLISHED: 21 October 1791

BELL EDITION: BBT97.II

Oil on canvas (36.8 × 28.4), full-length, standing outdoors with a stone altar behind her, holding a spear in her extended right hand; wearing a crown, a circlet on loose long hair to shoulders, and a long dress. Line engraving 11.4 × 7.6, for Bell's British Library, with

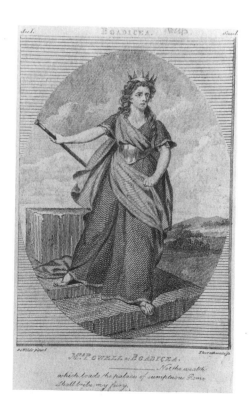

Boadicea's line (I.1): "—Not the wealth which loads the palaces of sumptuous Rome Shall bribe my fury."

LOCATION OF ORIGINAL: Garrick Club (Ash689, CKA215).

PROVENANCE: John Bell; Charles Mathews (No. 176).

RELATED: None.

Jane Powell, who made her London debut at the Haymarket Theatre as Alicia in *Jane Shore* on 29 August 1786, did not perform Boadicea in London. The original Boadicea in the premiere of Richard Glover's tragedy on 1 December 1753 at Drury Lane Theatre was Mrs Pritchard. Mrs Powell joined the Drury Lane company in the autumn of 1788 and remained with that theatre until 1810. She was a tall and elegant woman, whose acting was marked "by judgment, excellent vocal quality and control, and a flexible face capable of expressing a range of emotions" (*BDA*).

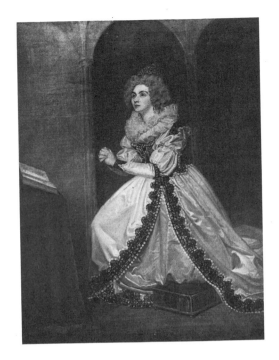

# 284

Jane Powell   ca. 1761–1831
as Mary Queen of Scots in *The Albion Queens*

by John Banks

ARTIST: S. De Wilde

ENGRAVER: W. Leney

DATE PUBLISHED: 25 June 1791

BELL EDITION: BBT97.XXII

Oil on canvas (36.8 × 27.3), full-length, kneeling in prayer, a book is on the cloth-covered altar; wearing a small crown, a dress with braided edges and a long skirt, and a crucifix. Line engraving 10.8 × 7.6, for Bell's British Library, with Douglas's line (V.3): "Behold her kneeling!"

LOCATION OF ORIGINAL: Garrick Club (Ash690, CKA256).

PROVENANCE: John Bell; Charles Mathews (No. 98).

RELATED: None.

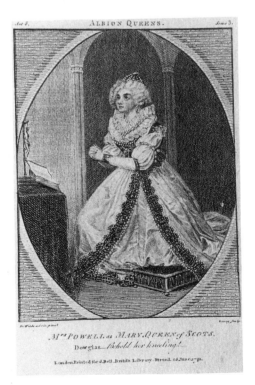

Jane Powell did not perform this role in Banks's play in London. She did act Lady Douglas in John St John's *Mary Queen of Scots* with the Drury Lane company at the King's Theatre on 13 March 1792, when the title role was acted by Mrs Siddons.

# 285

## Maria Prudom   d. 1783
as Arbaces in *Artaxerxes*

by Thomas Arne

ARTIST: J. Roberts

ENGRAVER: J. Thornthwaite

DATE PUBLISHED: 21 April 1782

BELL EDITION: BBT80.XXI

Watercolor drawing on vellum (12 × 7.3), full-length, head slightly to left; wearing Eastern male garb, a long cloak trimmed with ermine, and a turban with feathers. Line engraving 13.6 × 9.2.

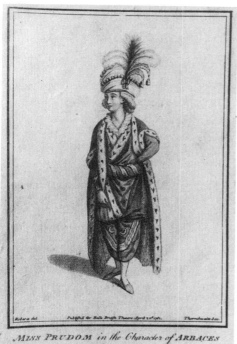

*MISS PRUDOM in the Character of ARBACES in ARTAXERXES.*

LOCATION OF ORIGINAL: British Museum (Burney VII, No. 113).

PROVENANCE: Bell sale, Christie's, 27 March 1793 (lot 12); bought, with five other drawings in the lot for 14s. by Gretton.

RELATED: None.

The play is not found in BBT80 volume. The engraving is placed before the text of *Love in a Village*. Maria Prudom acted Arbaces in London for the first time on 11 November 1780. She sang at Drury Lane Theatre and the King's Theatre between November 1776 until illness forced her from the stage in December 1781.

## John Griffen Pulley. See Mary Ann Yates, No. 346.

# 286

## John Quick   1748–1831
as Alderman Smuggler in *The Constant Couple*

by George Farquhar

ARTIST: J. Roberts

ENGRAVER: J. Thornthwaite

DATE PUBLISHED: 17 September 1777

BELL EDITION: BBT76–77 and 80.XV

Full-length, standing, hands raised with palms to front; wearing extravagant female dress. Line engraving 14 × 9.2, with the quotation (II.9): "Ashamed of! O Lord, Sir, I'am an honest old Woman, that never was ashamed of any thing."

LOCATION OF ORIGINAL: Unknown.

PROVENANCE: Unknown.

RELATED: None.

Quick acted this role for the first time in London on 30 September 1789, at Covent Garden Theatre. He spent thirty-one consecutive years at Covent Garden, playing

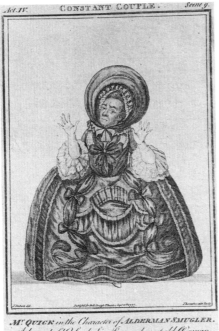

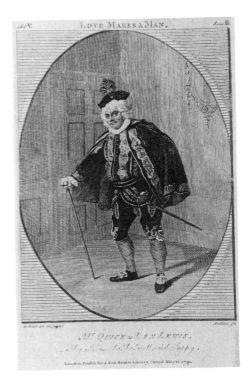

more than seventy roles, and was regarded as one of the finest comedians of his day, ranking with Parsons, Edwin, Shuter, and Munden.

# 287

### John Quick  1748–1831
as Don Lewis in *Love Makes a Man*

by Colley Cibber

ARTIST: S. De Wilde

ENGRAVER: P. Audinet

DATE PUBLISHED: 10 May 1791

BELL EDITION: BBT97.VII

Full-length, standing in the corner of a room with a mirror on the wall behind him and a door at his right, holding a cane in his right hand; wearing a cape, feathered hat, breeches, boots, and doublet; a sword hangs from his left side. Line engraving 11.1 × 7.6, for Bell's British Library, with the quotation (V.2): "—Thy House ha! ha! well said Puppy."

LOCATION OF ORIGINAL: Unknown.

PROVENANCE: Unknown.

RELATED: A version (10.5 × 7.9) engraved by A. Smith was also published for Bell's British Library on 10 May 1791; a copy of that engraving appears in BBT97.VII at the Garrick Club. A large engraving (23.8 × 18.4), by J. Condé, a copy of the De Wilde, with the date of Quick's death, was published by T. Palser. And an engraving by H. Brocas, after De Wilde, was published by W. Jones in Dublin.

Quick acted this role for the first time in London on 25 November 1779, at Covent Garden Theatre.

# 288

### John Quick  1748–1831
as Judge Gripus in *Amphitryon*

by John Dryden

ARTIST: J. Roberts

ENGRAVER: B. Reading

DATE PUBLISHED: 25 April 1777

BELL EDITION: BBT76–77 and 80.XI

Colored drawing on vellum (10.5 × 7.6), full-length, standing to front, holding a chalice in his right hand; wearing a judge's robe and wig. Line engraving 13.3 × 8.6, with the quotation (V.1): "'Tis my proper Chattel, and, I'll have it."

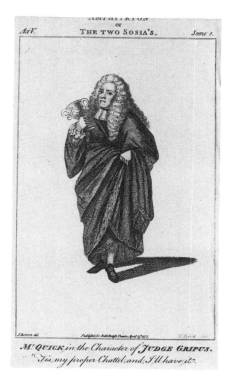

LOCATION OF ORIGINAL: British Museum (Burney VII, No. 132).

PROVENANCE: Bell sale, Christie's, 27 March 1793 (lot 12); bought, with five other drawings in the lot, for 14s. by Gretton.

RELATED: The BBT80 engraving (13.7 × 8.6) is by C. Cooke and is dated 28 July 1779. A pencil drawing by Roberts of Quick as Judge Gripus (probably a study) is in the Harvard Theatre Collection, acquired from Thomas Agnew, 1976.

Quick acted this role in London for the first time on 6 May 1776.

# 289

## John Quick   1748–1831
as Tony Lumpkin in *She Stoops to Conquer*

by Oliver Goldsmith

ARTIST: S. De Wilde

ENGRAVER: P. Audinet

DATE PUBLISHED: 17 December 1791

BELL EDITION: BBT97.IX

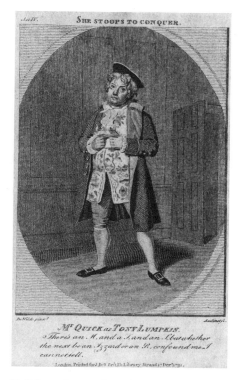

Full-length, standing, holding a letter; wearing a long coat, embroidered waistcoat, and hat. Line engraving 11.4 × 7.9, for Bell's British Library, with Tony's line (IV): "There's an M, and a T, and an S, but whether the next be an izzard or an R, confound me, I cannot tell."

LOCATION OF ORIGINAL: Unknown.

PROVENANCE: Unknown.

RELATED: A copy by an anonymous engraver was published by C. Cooke, 1808.

Quick was the original Tony Lumpkin in the premiere of Goldsmith's play at Covent Garden Theatre on 15 March 1773.

A portrait by T. Parkinson of Quick as Tony Lumpkin, with Jane Green as Mrs Hardcastle and Edward Shuter as Mr Hardcastle, is in the Robertson Davies Collection. It was exhibited in the "Royal Opera House Retrospective" at the Royal Academy, December 1982–February 1983.

# 290

John Quick   1748–1831
as Vellum in *The Drummer*

by Joseph Addison

ARTIST: S. De Wilde

ENGRAVER: J. Thornthwaite

DATE PUBLISHED: 8 December 1792

BELL EDITION: BBT97.XXII

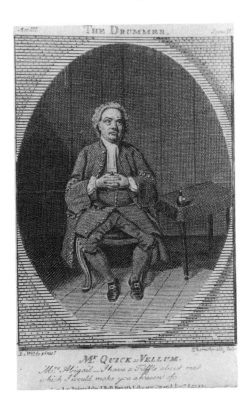

Full-length, seated in a room with table at his left, full face, with his hands clasped over belly; wearing breeches, waistcoat, and coat. Engraving 10.8 × 7.9, for Bell's British Library, with Vellum's line (III.2): "Mrs Abigal—I have a Triffle about me which I would make you a present of."

LOCATION OF ORIGINAL: Unknown, but see below.

PROVENANCE: Unknown.

RELATED: A drawing of Quick as Vellum, signed and dated December 1805 by De Wilde, is in the Harry R. Beard Collection, the Theatre Museum, London. This drawing seems to be a copy by De Wilde of his original drawing, unless it is misdated and is the original.

Quick acted this role in London for the first time on 24 April 1786, for his benefit at Covent Garden Theatre.

# 291

Samuel Reddish   1735–1785
as Young Beville in *The Conscious Lovers*

by Richard Steele

ARTIST: J. Roberts

ENGRAVER: J. Thornthwaite

DATE PUBLISHED: 30 July 1776

BELL EDITION: BBT76–77 and 80.IV; BET92.VI

Colored drawing on vellum (10.2 × 9.5), full-length, seated, legs crossed, holding a book in his left hand; wearing breeches, coat, waistcoat, and wig. Line engraving 13.3 × 9.5, with the quotation (I.2): "These moral Writers practise Virtue after Death."

LOCATION OF ORIGINAL: British Museum (Burney VII, No. 170).

PROVENANCE: Bell sale, Christie's, 27 March 1793 (lot 12); bought with five other drawings in the lot for 14s. by Gretton.

RELATED: The plate for the Thornthwaite engraving that was published in 1776 was re-

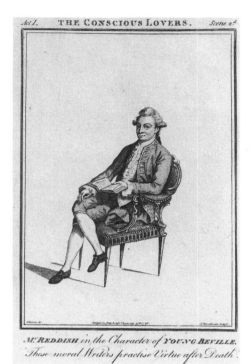

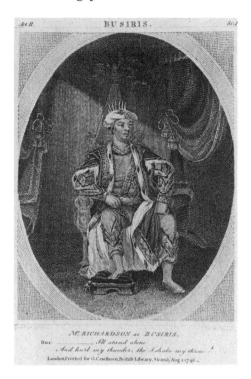

touched and reissued 30 July 1777 and later used for BBT80. The original engraving dated 30 July 1776 was used for BET92.

Reddish acted this role in London for the first time on February 1770, at Drury Lane Theatre.

# 292

John Richardson   d. 1811
as Busirus in *Busirus*

by Edward Young

ARTIST: J. Graham

ENGRAVER: J. G. Walker

DATE PUBLISHED: 1 August 1796

BELL EDITION: BBT97.XXIX

Full-length, seated with his right foot on a footstool; wearing royal robes and a small crown atop his turban. Line engraving 11.1 × 8.3, for Cawthorn's British Library, with

Busirus's line (II.1): "—I'll stand alone / And hurl my thunder, tho' I shake my throne."

LOCATION OF ORIGINAL: Unknown.

PROVENANCE: Bell sale, Leigh & Sotheby's, 25 May 1805 (lot 283).

RELATED: None.

This play was not performed during Richardson's career on the London stage. After making his debut in London at Covent Garden Theatre on 12 November 1793 as Don Caesar in *The Castle of Andalusia*, Richardson was engaged at Covent Garden through 1795–96 and then returned to the provinces, acting mainly at Bristol and Bath until 1809, two years before his death.

# 293

Mary Robinson   1758–1800
Amanda in *Love's Last Shift*

by Colley Cibber

ARTIST: J. Roberts

ENGRAVER: J. Thornthwaite

DATE PUBLISHED: December 1777

BELL EDITION: BBT76–77 and 80.XVII

Colored drawing on vellum (12.4 × 9.2), full-length, standing, holding a fan in her right

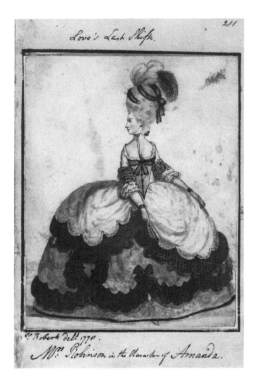

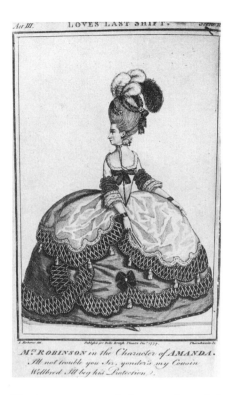

Her beauty captured the attention of the young Prince of Wales, with whom she had a notorious affair for about a year and a half. Portraits of her were painted by many prominent artists, including Cosway, Gainsborough, Hoppner, and Reynolds.

hand; wearing a headdress of feathers and a dress with a very wide and greatly decorated skirt. Line engraving 14.3 × 13.7, with the quotation (II.10): "I'll not trouble you Sir, yonder's my Cousin Wellbred. I'll beg his Protection."

LOCATION OF ORIGINAL: British Museum (Burney VII, No. 211).

PROVENANCE: Bell sale, Christie's, 27 March 1793 (lot 12); bought, with six other drawings in lot, for 14s. by Gretton.

RELATED: None.

Mary Robinson did not act this role in London. She was known by the sobriquet "Perdita" because of her success in that role in Garrick's alteration of *The Winter's Tale*.

# 294

### Edward Anthony Rock   d. 1815
as Teague in *The Committee*

by Robert Howard

ARTIST: S. De Wilde

ENGRAVER: J. Thornthwaite

DATE PUBLISHED: 28 July 1792

BELL EDITION: BBT97.XX

Full-length, front, standing in street; wearing high boots and a large cloak and holding a hat in his right hand and a paper in his left, begging. Line engraving 11.7 × 8.9, for Bell's

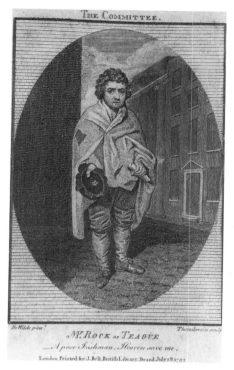

British Library, with Teague's line: "—A poor Irishman, Heaven save me."

LOCATION OF ORIGINAL: Unknown.

PROVENANCE: Unknown.

RELATED: None.

Rock did not play this role in London, though his main line during his career in London from 1786–87 through 1795–96 was Irish characters.

# 295

Mrs Edward Anthony Rock   [fl. 1776–1793]

as Viletta in *She Wou'd and She Wou'd Not*

by Colley Cibber

ARTIST: S. De Wilde

ENGRAVER: J. Thornthwaite

DATE PUBLISHED: 27 October 1791

BELL EDITION: BBT97.V

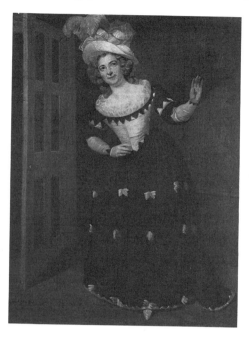

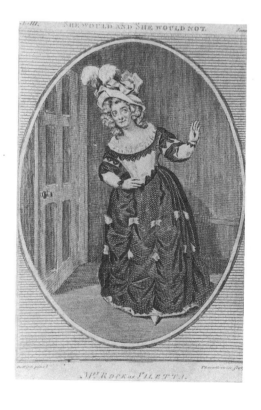

Oil on canvas (37.1 × 28.5), full-length, standing in a room with a door at her right, her torso and head bent to left, her left hand raised; wearing a broad-brimmed hat with feathers and a dress with tucks on the skirt. Line engraving 11.4 × 8.9, for Bell's British Library, with the quotation (III.1): "Indeed my friend, you are too ugly for me; tho's I am not handsome myself, I love to play with those that are."

LOCATION OF ORIGINAL: Garrick Club (Ash724, CKA225).

PROVENANCE: John Bell, Charles Mathews (No. 382).

RELATED: None.

Mrs Rock did not act the role of Viletta in London. In her one appearance in the play, at Covent Garden Theatre on 6 July 1790, she played Rosa.

# 296

## David Ross   1728–1790
as Essex in *The Earl of Essex*

by Henry Jones

ARTIST: J. Roberts

ENGRAVER: J. Thornthwaite

DATE PUBLISHED: 8 July 1776

BELL EDITION: BBT76–77 and 80.III; BET92.I

Full-length, standing to front, head turned slightly to his left, holding a truncheon in his right hand, left hand at hip; a cloak drapes over his right arm and around back into left arm, and he wears a pseudo-Elizabethan costume that includes a plumed hat, breeches, a coat, and a ruff. Line engraving 13.7 × 9.8, with Essex's line (III.3): "Am I not your General? and was I not so by Virtue of this Staff?"

LOCATION OF ORIGINAL: Unknown.

PROVENANCE: Unknown.

RELATED: A watercolor drawing of Ross by

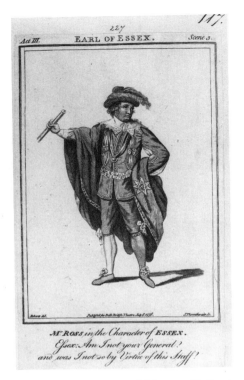

M.ʳ ROSS in the Character of ESSEX.
Essex: Am I not your General?
and was I not so by Virtue of this Staff?

Roberts in the Harvard Theatre Collection may be a study for this portrait.

Ross was first noticed as an actor at the Smock Alley Theatre, Dublin, in May 1749, and over the next two years acted some forty-three roles there. He made his debut at Drury Lane Theatre on 3 October 1751 as Young Bevil in *The Conscious Lovers*. He first acted Essex in London on 20 April 1752, at Drury Lane. Later, he made his debut at Covent Garden Theatre in this role, on 3 October 1757. A very handsome and charming man, Ross became an early favorite in London, but he was negligent in his art and gave way "to a slothful stillness, dissipating his talents and skill by lack of will" (*BDA*). Over the years, he had engagements in and out of London and ended his career in the minor theatres of the provinces. The provincial manager, Tate Wilkinson, called Ross "the Prince of Negligence."

## Elizabeth Sharp (Mrs Michael Sharp).
See Miss Elizabeth Hopkins, Nos. 198, 199.

# 297

Thomas Sheridan 1719–1788
as Cato in *Cato*

by Joseph Addison

ARTIST: J. Roberts

ENGRAVER: A. Walker

DATE PUBLISHED: 16 July 1776

BELL EDITION: BBT76–77 and 80.III

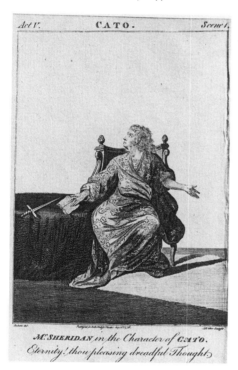

*Act V.* CATO. *Scene 1.*

M.ʳ SHERIDAN *in the Character of* CATO.
*Eternity! thou pleasing dreadful Thought.*

Drawing, seated, full-length, left profile looking upward, with his hands extended in a gesture; wearing a long robe wrapped around his body; a book and dagger on the table. Line engraving 13.1 × 9.2, with the quotation (V.1): "Eternity! thou pleasing dreadful Thought."

LOCATION OF ORIGINAL: Unknown (British Museum?).

PROVENANCE: Bell sale, Christie's, 27 March 1793 (lot 14); bought with eleven other drawings in lot, for £1 10s. by Bowden.

RELATED: There were two drawings by Roberts of Sheridan as Cato in lot 12 of the Bell sale at Christie's. One of these was the above; the other was probably the drawing in india ink now at the British Museum cataloged as by an unknown artist (Burney VIII, No. 89). The latter drawing was engraved by an anonymous engraver and published by I. Wenman, 1776; a copy was published by Harrison, 1779, as a plate to an edition of the play. It shows Sheridan full-length, standing, looking at books in left hand, with dagger on table right. It is reproduced in the *BDA*.

Sheridan acted Cato for the first time at Smock Alley Theatre, Dublin, on 7 July 1743. When he was to play the role again on 14 July, he discovered that his robe for the character was missing, and he accused the visiting actor Theophilus Cibber of hiding it in order to embarrass him. Sheridan refused to go on, so Cibber went on to play the role, book in hand. Sheridan's supporters from Trinity College caused a riot against Cibber at Smock Alley on 21 July. Sheridan acted the role in London for the first time at Covent Garden Theatre on 27 November 1754.

# 298

Thomas Sheridan 1719–1788
as Oedipus in *Oedipus*

by John Dryden

ARTIST: J. Roberts

ENGRAVER: B. Reading

DATE PUBLISHED: 7 June 1777

BELL EDITION: BBT76–77 and 80.XII

Full-length, standing, turned right, left arm extended, right arm by side; wearing Roman costume, with a cloak, and on his head a small crown with plumes. Line engraving 13 × 8.6, with the quotation (III.6): "What mean these exclamations on my Name?"

LOCATION OF ORIGINAL: Unknown.

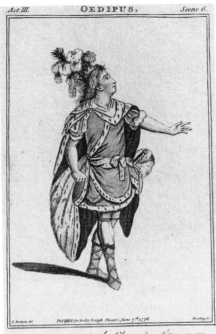

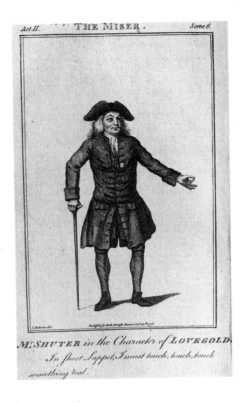

PROVENANCE: None.

RELATED: Unknown.

Sheridan acted this role in Dryden's version of *Oedipus* at London for the first time on 10 January 1755, at Covent Garden Theatre.

# 299

## Edward Shuter   1728?–1776
as Lovegold in *The Miser*

by Henry Fielding

ARTIST: J. Roberts

ENGRAVER: Anonymous [J. Roberts]

DATE PUBLISHED: 20 October 1776

BELL EDITION: BBT76–77 and 80.VI

Colored drawing on vellum (10.8 × 7.6), full-length, standing to front, his left hand extended to side, his right hand on a stick;

wearing a long coat and hat. Line engraving 12.7 × 7.9, with the quotation (II.6): "In short Lappet, I must touch, touch, touch something real."

LOCATION OF ORIGINAL: British Museum (Burney VIII, No. 10).

PROVENANCE: Bell sale, Christie's. 27 March 1793 (lot 14); bought, with twelve other drawings in lot, for £1 1s. by Bowden.

RELATED: None.

This drawing by Roberts is dated 1797, later than the engraving. In the opinion of E. Croft-Murray (cited by J. F. Kerlake in *Catalogue of Theatrical Portraits in London Public Collections*) the drawing, date, and inscription are in Roberts's own hand; it is "suggested that they were added from memory later in life." BBT76–77 does not indicate an engraver, but BBT80 cites Roberts.

Shuter first acted this role in Fielding's comedy in London on 17 September 1753, for his

first appearance at Covent Garden Theatre. He was often criticized for indulging in outrageous comic tricks and often was drunk but was, according to the author of *The Present State of the Stage in Great-Britain and Ireland* (1753), "as great in low Comedy, as it is possible for Man to conceive."

# 300

## Sarah Siddons   1755–1831
as Cleone in *Cleone*

by Robert Dodsley

ARTIST: W. Hamilton

ENGRAVER: J. Thornthwaite

DATE PUBLISHED: 3 March 1792

BELL EDITION: BBT97.V

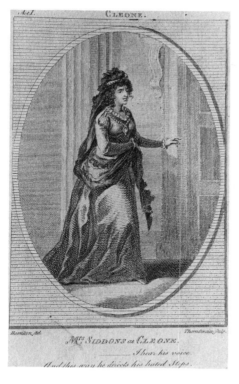

Full-length, standing to right, long hair, her right arm across waist, her left hand extended, a scarf hanging from the back of her

head and attached to her right wrist; wearing a long dress, necklace, and medallion; a door at her left, pillar behind. Line engraving 11.4 × 7.9, for Bell's British Library, with Cleone's line (I): "—I hear his voice. / And this way he directs his hated Steps."

LOCATION OF ORIGINAL: Unknown.

PROVENANCE: Unknown.

RELATED: None.

Mrs Siddons first acted this role in London on 22 November 1786, at Drury Lane Theatre.

# 301

## Sarah Siddons   1755–1831
as Euphrasia in *The Grecian Daughter*

by Arthur Murphy

ARTIST: S. De Wilde

ENGRAVER: W. Leney

DATE PUBLISHED: 19 May 1792

BELL EDITION: BBT97.IV

Pen and sepia wash drawing (33 × 22.9), full-length, standing, looking upward, holding a dagger in her raised hand, a long scarf hanging from the back of her head; wearing a dress with sash around waist and a wig with curls. Line engraving (13.5 × 8), for Bell's British Library, with Euphrasia's line (V.2): "—In a dear Father's Cause / A Woman's vengeance tow'rs above her Sex."

LOCATION OF ORIGINAL: Victoria Art Gallery, Bath.

PROVENANCE: Unknown.

RELATED: A copy (10.8 × 7.6) was engraved by Condé, for Bell's British Library, same date; Condé's engraving is found in the Garrick Club copy of BBT97.IV; a copy was published by C. Cooke, 1806.

Signed by De Wilde and dated 1792. For other pictures of Mrs Siddons as Euphrasia, see the *BDA*. Mrs Siddons acted Euphrasia

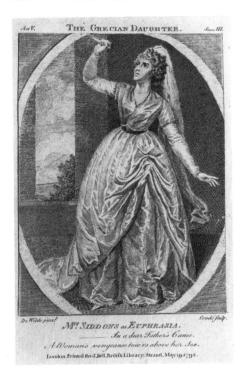

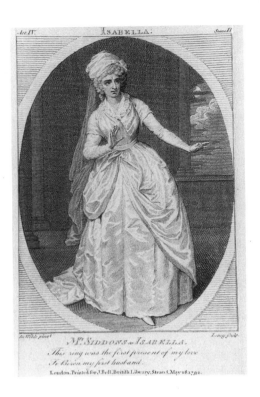

for her debut at York on 15 April 1777. When she acted the role for the first time in London on 30 October 1782, she drew "shrieks and sobs" from the Drury Lane Theatre audience.

# 302

## Sarah Siddons   1755–1831
as Isabella in *Isabella*

by David Garrick, Adapted from Thomas Southerne

ARTIST: S. De Wilde

ENGRAVER: W. Leney

DATE PUBLISHED: 26 May 1792

BELL EDITION: BBT97.V

Oil on canvas (35.6 × 26.7); full-length, standing to front, holding a ring in her left hand; wearing a dress with a long train and a hat

with a scarf behind. Line engraving (in reverse) 11.1 × 8.9, for Bell's British Library, with the Isabella's line (IV.2): "This ring was the first present of my love / To Biron my first husband."

LOCATION OF ORIGINAL: Unknown.

PROVENANCE: This portrait was exhibited (but not offered for sale) in the Bell sale at Christie's on 27 March 1793. It appeared at Christie's on 2 April 1971 (lot 100) and was bought for 400 guineas by Nash, with a portrait of Mrs Pope as Zara.

RELATED: None.

Mrs Siddons appeared in this role for her triumphant reappearance at Drury Lane Theatre on 10 October 1782. Her portrayal was "infinite" reported the next *Morning Chronicle*, "and when Isabella expired her death was rendered glorious by the theatre's resounding with thundering applause for more than a minute."

# 303

Sarah Siddons 1755–1831
as Ismena in *Timanthes*

by John Hoole

ARTIST: J. Roberts

ENGRAVER: P. Audinet

DATE PUBLISHED: 23 October 1796

BELL EDITION: BBT97.XXXIV

Full-length, standing outdoors on a stone
patio, her right arm outstretched; wearing a

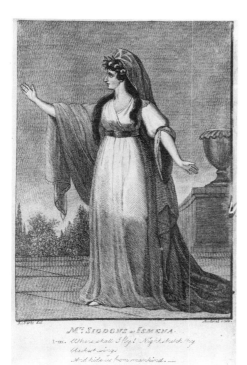

veil on the back of her head and a long dress
with sash at bodice. Line engraving 11.1 × 7.6,
for Cawthorn's British Library, with the quo-
tation (o.o): "*Tim.* Where shall I fly! Night
stretch thy blackest wings / And hide us from
mankind.—"

LOCATION OF ORIGINAL: Unknown.

PROVENANCE: Bell sale, Leigh &
Sotheby's, 25 May 1805 (lot 278), when attrib-
uted to John Graham.

RELATED: None.

Mrs Siddons did not act this role in London;
John Hoole's play was not performed there af-
ter 1775.

# 304

Sarah Siddons 1755–1831
as Jane Shore in *Jane Shore*

by Nicholas Rowe

ARTIST: W. Hamilton

ENGRAVER: W. Leney

DATE PUBLISHED: 2 September 1791

BELL EDITION: BBT97.III

Watercolor drawing, oval (24.1 × 15.9), full-
length, standing by a door at her right, with a

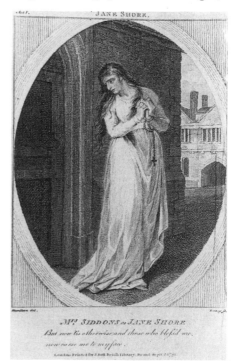

street in background, her hands clasped in front, and a crucifix hanging from waist; wearing a long dress, with long hair falling over her shoulders. Line engraving 10.8 × 7.9, for Bell's British Library, with Jane's line (V): "But now 'tis otherwise; and those who bless'd me, now curse me to my face." A copy engraved by Houston was published by W. Jones in Dublin.

LOCATION OF ORIGINAL: Victoria and Albert Museum (Dyce Collection).

PROVENANCE: Unknown.

RELATED: See the *BDA*.

The drawing in the Victoria and Albert Museum is credited to William Hamilton, 1791. Mrs Siddons first acted Jane Shore at Drury Lane Theatre on 8 November 1782. According to Thomas Campbell, her early biographer (1836), Mrs Siddons's realistic portrayal made men sob and women fall into hysterics, and "fainting spells were long and frequent in the house."

# 305

Sarah Siddons  1755–1831
as Matilda in *The Carmelite*

by Richard Cumberland

ARTIST: W. Hamilton

ENGRAVER: J. that

DATE PUBLISHED: 12 November 1791

BELL EDITION: BBT97.XVI

Full-length, kneeling at an altar in a chapel; wearing a long dress and cap with long train. Line engraving 10.8 × 7.6, for Bell's British Library, with the quotation (V.1): "When discovered kneeling at the altar, decorated with the Funeral Trophies of Saint Valori."

LOCATION OF ORIGINAL: Unknown.

PROVENANCE: Unknown.

RELATED: None.

Mrs Siddons acted this role in the premiere

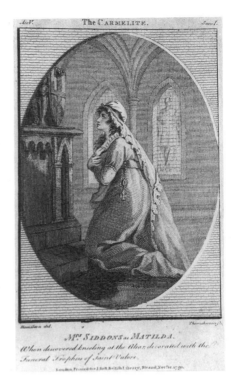

of Richard Cumberland's play on 2 December 1784; the author proclaimed her performance "inimitable."

# 306

Sarah Siddons  1755–1831
as Medea in *Medea*

by Richard Glover

ARTIST: S. De Wilde

ENGRAVER: J. Thornthwaite

DATE PUBLISHED: 18 February 1792

BELL EDITION: BBT97.VI

Full-length, standing, with a sea behind and dark clouds above and a child beside her, looking upward to left; wearing a long dress and a large shawl draped from back of her head to over her raised right arm. Line engraving 11.7 × 7.6, for Bell's British Library, with Medea's line (III.1): "I once had

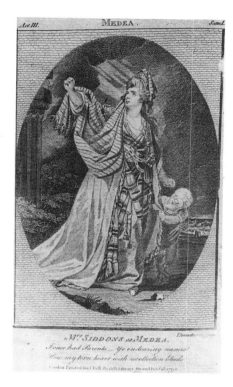

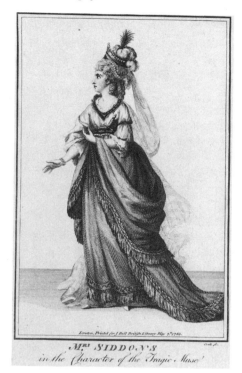

Parents—Ye endearing names! / How my torn heart with recollection bleeds!"

LOCATION OF ORIGINAL: Unknown.

PROVENANCE: Unknown.

RELATED: None.

Mrs Siddons did not act this role in London.

# 307

## Sarah Siddons 1755–1831
as The Tragic Muse

ARTIST: J. Roberts

ENGRAVER: T. Cook

DATE PUBLISHED: 7 May 1783

BELL EDITION: Issued Separately

Full-length, standing, facing right, her right arm extended down to left; wearing a crown, with feathers and pearls in her hair, and a voluminous dress decorated with fringe, the

overskirt of which hangs over her left arm. Line engraving 14.9 × 9.5, "Printed for J. Bell British Library May 7th 1783 (Price One [*sic*] Shillings)," with caption: "M^rs SIDDONS in the Character of the Tragic Muse."

LOCATION OF ORIGINAL: Unknown.

PROVENANCE: Bell sale, Christie's, 27 March 1793 (lot 16); bought, with three other drawings in lot, for 9s. by Mitchell.

RELATED: None.

For other portraits of Mrs Siddons as the Tragic Muse—especially the one by Reynolds—see the *BDA*.

# 308

## Adelaide Simonet [fl. 1776–1791]
as Princess Ninette in *Ninette à la cour*

by Gaetan Appoline Balthazar Vestris

ARTIST: J. Roberts

ENGRAVER: J. Thornthwaite

DATE PUBLISHED: 28 April 1781

BELL EDITION: BBT80.XXI

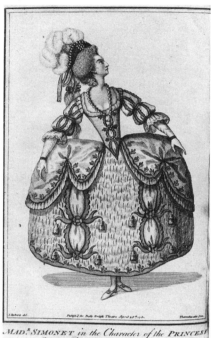

MAD.ᵉ SIMONET in the Character of the PRINCESS
in the Grand Ballad (called) Ninnette à la Cour.

Drawing, full-length, standing in ballet position, body front, head turned to her left; wearing a richly decorated dress and a hat with a large plume of feathers. Line engraving 14.6 × 9.5.

LOCATION OF ORIGINAL: Unknown.

PROVENANCE: Bell sale, Christie's, 27 March 1793 (lot 16); bought, with three other drawings in lot, for 9s. by Mitchell.

RELATED: None.

Mme Simonet first danced in this ballet for its debut in London on 22 February 1781. The engraving by Thornthwaite published in BBT80 is bound into volume XXI before the text of *The Jovial Crew*.

# 309

## William Smith   1730–1819
as Alexander in *Alexander the Great*
(*The Rival Queens*)

by Nathaniel Lee

ARTIST: J. Roberts

ENGRAVER: J. Thornthwaite

DATE PUBLISHED: 23 November 1776

BELL EDITION: BBT76–77 and 80.VII; BET92.III

Drawing, full-length, standing, his right arm extended upward, holding a spear in his left

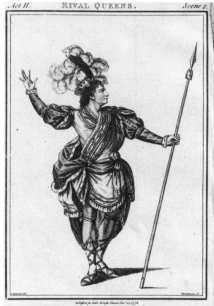

*Act II.*    RIVAL QUEENS.    *Scene 2.*

M.ʳ SMITH in the Character of ALEXANDER.
When Glory like the dazling Eagle stood
Perch'd on my Beaver in the Granick Flood

hand; wearing a hat with plumes and a togalike costume with a large sash wrapped around. Line engraving 11.4 × 9.2, with Alexander's line (II.2): "When Glory like the dazling Eagle stood / Perch'd on my Beaver in the Granick Hood."

LOCATION OF ORIGINAL: Unknown.

PROVENANCE: Bell sale, Christie's, 27 March 1793 (lot 13); it and five other drawings of Smith were bought for 15s. by C. Cooke.

RELATED: The copy (14 × 9.2) for the 1780 edition was engraved by Page, November 1777. The Thornthwaite engraving was also published in BBT92.

Smith acted this role for the first time in London on 23 March 1767, at Covent Garden Theatre, for his benefit. On the London stage from 1753 to 1788 and known as "Gentleman" Smith, he was said to have portrayed "the manners of a *finished gentleman* with more delicacy and characteristic propriety, than any actor of his day."

# 310

## William Smith   1730–1819
as Archer in *The Beaux' Stratagem*

by George Farquhar

ARTIST: J. Roberts

ENGRAVER: Anonymous

DATE PUBLISHED: 28 May 1776

BELL EDITION: BBT76–77 and 80.II

Drawing, full-length, standing, with a hat under his right arm and his left hand extended; wearing a gentleman's suit and a wig with curls. Line engraving 14 × 9.2, with Archer's line (III): "My Lady Howd'ye; the last Mistress I serv'd call'd me up one Morning & told me, Martin, to go to my Lady all night with my humble Service."

LOCATION OF ORIGINAL: Unknown

PROVENANCE: Bell sale, Christie's, 27 March 1793 (lot 13); it and five other drawings of Smith were bought for 15s. by C. Cooke.

RELATED: A copy in reverse (13.3 × 9.2), dated March 1777, was engraved by J. Edwards for the 1780 edition.

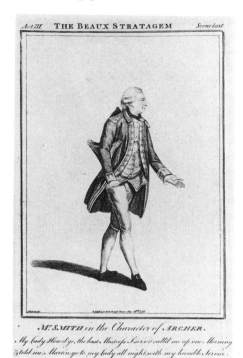

*Mr S.MITH in the Character of ARCHER.*
*My lady How'd ye, the last Mistress I serv'd call'd me up one Morning & told me, Martin, go to my lady all night, with my humble Service.*

Smith acted Archer for the first time in London on 27 April 1756, at Covent Garden Theatre.

# 311

## William Smith   1730–1819
as Montezuma in *Montezuma*

by Henry Brooke

ARTIST: J. Roberts

ENGRAVER: ?

DATE PUBLISHED: ?

Description unknown.

LOCATION OF ORIGINAL: Unknown.

PROVENANCE: In the Bell sale at Christie's, 27 March 1793, a picture called "Smith as Montezuma," by Roberts, was in lot 13; it and five other drawings in the lot of Smith by Roberts were bought for 15s. by C. Cooke.

RELATED: None.

This play by Henry Brooke was never acted.

This picture does not seem to have appeared in any of the several editions of Brooke's *Poems and Plays*, 1778, 1789, and 1792.

Evidently if there was a picture of Smith in this character, it was never published.

# 312

## William Smith   1730–1819
as Phocyas in *The Siege of Damascus*

by John Hughes

ARTIST: J. Roberts

ENGRAVER: Anonymous

DATE PUBLISHED: 6 May 1776

BELL EDITION: BBT76–77 and 80.I; BET92.I

Drawing, full-length, standing, left profile, his left arm extended and his right hand on his

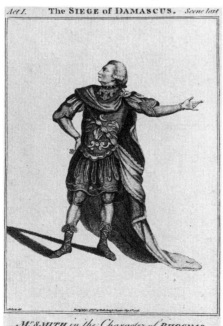

*Act I.*   The SIEGE of DAMASCUS.   *Scene last*

M.ͬ SMITH *in the Character of* PHOCYAS.
*Now to the field to gain the glorious prize.*

hip; wearing Roman costume and a long cape. Line engraving 13 × 9.2, with Phocyas's line (I): "Now to the field to gain the glorious prize."

LOCATION OF ORIGINAL: Unknown.

PROVENANCE: Bell sale, Christie's, 27 March 1793 (lot 13); it and five other drawings of Smith by Roberts were bought in the lot for 15s. by C. Cooke.

RELATED: The BBT80 engraving (13 × 8.9), bearing the same date of 6 May 1776, is reversed.

Other portraits of Smith as Phocyas were done by anonymous engravers and published by Wenman in 1778 and by J. Hand. Smith first acted Phocyas in London on 24 March 1772 for his benefit at Covent Garden Theatre. William Hawkins in his *Miscellanies* (1775) stated that Phocyas was one of the roles in which Smith was "inimitable."

# 313

## William Smith   1730–1819
as Piercy in *Ann Bullen*

by John Banks

ARTIST: J. Roberts

ENGRAVER: J. Thornthwaite

DATE PUBLISHED: 1 August 1777

BELL EDITION: BBT76–77 and 80.XIV.; BET92.VII

Full-length, standing, right profile; wearing a hat with feathers, early Elizabethan costume, with a sword at his left side. Line engraving 14 × 9.2, with Piercy's line (II): "Married! my Anna Bullen false & married."

LOCATION OF ORIGINAL: Unknown.

PROVENANCE: Unknown.

RELATED: None.

Smith acted this role in London for the first time on 10 April 1758, at Covent Garden Theatre.

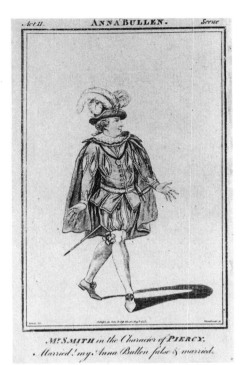

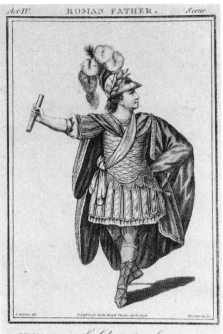

# 314

William Smith   1730–1819
as Publius in *The Roman Father*

by William Whitehead

ARTIST: J. Roberts

ENGRAVER: J. Thornthwaite

DATE PUBLISHED: April 1778

BELL EDITION: BBT76–77 and 80.XX

Drawing, full-length, standing to front, holding a truncheon in his right hand, left hand on his hip; wearing a Roman costume and a helmet with plume. Line engraving 14.3 × 9.2.

LOCATION OF ORIGINAL: Unknown.

PROVENANCE: Bell sale, Christie's, 27 March 1793 (lot 13); it and five other drawings of Smith in the lot were bought for 15s. by C. Cooke.

RELATED: None.

Smith acted this role in London for the first time on 18 November 1767, at Covent Garden Theatre.

William Smith. See also Elizabeth Pope, No. 275, and Mary Ann Yates, No. 348.

# 315

Ann Storace   1768–1817
as Euphrosyne in *Comus*

by John Milton

ARTIST: S. De Wilde

ENGRAVER: J. Thornthwaite

DATE PUBLISHED: 31 January 1791

BELL EDITION: BBT97.I

Full-length, standing before a wooded background, holding a glass of wine in her left hand; wearing a long dress and garlands of vine leaves around head and body. Line engraving

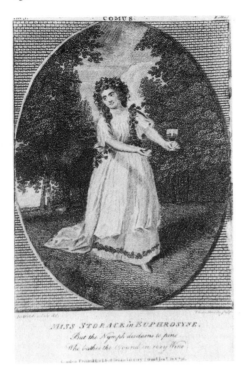

11.4 × 7.6, for Bell's British Library, with the ballad quotation (III): "But the Nymph disdains to pine. / Who bathes the Wound in rosy Wine."

LOCATION OF ORIGINAL: Unknown.

PROVENANCE: Unknown.

RELATED: An engraving (23.8 × 18.4) by Condé—"from the original Picture which was painted from life by De Wilde"—was published by Bell, 1791; another, engraved by Thomas, was also issued; and an engraving by H. Brocas was published by W. Jones at Dublin. A different, but somewhat similar picture, by an anonymous engraver, was published by C. Cooke, 1809. An engraving (10.5 × 7.6) by Thornthwaite, after Corbauld, of Ann Storace as Euphrosyne was also published by Bell, 1791 (see No. 316).

Ann Storace did not perform this role in London, though she was a very popular singer at Drury Lane Theatre, having made her debut there in November 1789 after two seasons at the King's Theatre.

# 316

## Ann Storace   1768–1817
as Euphrosyne in *Comus*

by John Milton

ARTIST: R. Corbauld

ENGRAVER: J. Thornthwaite

DATE PUBLISHED: 1791

BELL EDITION: Published Separately

Full-length, standing, facing and looking to left, with her feet in ballet position, holding a

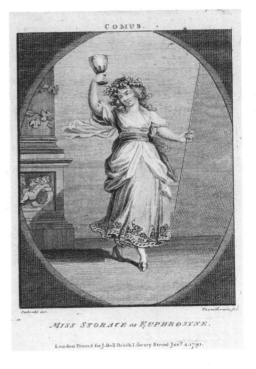

wand in her left hand and a goblet in her upraised right hand; wearing a flowing dress with a broad sash at the waist and a garland of flowers in her curly hair.

LOCATION OF ORIGINAL: Unknown.

PROVENANCE: Unknown.

RELATED: See No. 315.

# 317

## Richard Suett   ca. 1758–1805
as Bayes in *The Rehearsal*

by George Villiers, Duke of Buckingham

ARTIST: J. Graham

ENGRAVER: W. Skelton

DATE PUBLISHED: 8 October 1796

BELL EDITION: BBT97.XXIX

Oil on canvas (54.6 × 43.8), full-length, standing in a street before houses, left hand on

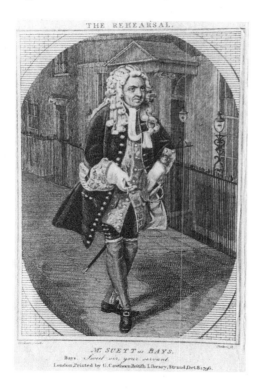

THE REHEARSAL.

*M. SUETT as BAYS.*
Bays. *Sweet sir, your servant.*
London, Printed by G. Cawthorn, British Library, Strand, Oct. 8, 1796.

hip; wearing seventeeth-century gentleman's dress and a long curled wig. Line engraving 11.1 × 7.6, for Cawthorn's British Library, with Bayes's line (I.2): "Sweet Sir, your servant."

LOCATION OF ORIGINAL: Theatre Museum, London.

PROVENANCE: Bell sale, Leigh & Sotheby's, 25 May 1805 (lot 277); George Daniel, Rev Alexander Dyce, Dyce Bequest to Victoria and Albert Museum 1869.

RELATED: None.

Kerslake, *Catalogue of Theatrical Portraits in London Public Collections*, states that the artist is unknown, but Graham's name is on the engraved version. An engraving (6.8 × 5.05) by J. Rogers, after J. Smith, showing Suett half-length, was published by G. Vertue on 12 November 1825 in Oxberry's *Dramatic Biography*.

Suett seems not to have acted Bayes in London. He was a very popular actor of an extensive array of low-comedy characters and Shakespearean clowns.

# 318

## Mr Toms   [fl. 1790–1807]
as Titus in *Lucius Junius Brutus*

by Nathaniel Lee

ARTIST: J. Graham

ENGRAVER: J. Wilson

DATE PUBLISHED: 3 December 1796

BELL EDITION: BBT97.XXXI

Full-length, to right, standing in a forest, his left arm upraised, right hand on breast; wearing Roman costume. Line engraving 11.4 × 7.6, for Cawthorn's British Library, with Titus's line (II.1): "Forgive me, blood and duty, all respects due to my Father's name, not to Toramintas!"

LOCATION OF ORIGINAL: Unknown.

PROVENANCE: Bell sale, Leigh & Sotheby's, 25 May 1805 (lot 271).

RELATED: None.

Toms did not act this role in London, as Nathaniel Lee's play was not performed there in the eighteenth century. He was probably

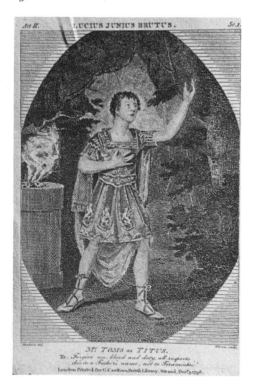

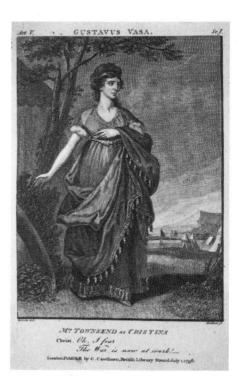

Full-length, to front, standing before a tree and tents; wearing a high-waisted dress with the train of the overskirt draped over her left forearm. Line engraving 11.1 × 7.9, for

depicted in this BBT engraving because he was a new actor in town, having made his "debut" at Covent Garden Theatre on 21 September 1795 as Romeo. (He had appeared once before there, on 4 October 1790, as Douglas, but then retreated to the provinces for five years.) Toms's London career was relatively brief; after playing supporting roles for three seasons, in 1798, he joined Tate Wilkinson's company on the York circuit.

# 319

## Elizabeth Townsend   [fl. 1789–1837]
as Christina in *Gustava Vasa*

by Henry Brooke

ARTIST: J. Roberts

ENGRAVER: P. Audinet

DATE PUBLISHED: 1 July 1796

BELL EDITION: BBT97.XXXII

Cawthorn's British Library, with Christina's line (V.1): "O, I fear / The War is now at work!—"

LOCATION OF ORIGINAL: Unknown.

PROVENANCE: Bell sale, Leigh & Sotheby's, 25 May 1805 (lot 263).

RELATED: None.

Elizabeth Townsend did not act this role in London, as the play was not performed there. Brooke had been refused a license, the first known instance of a play being banned under the Licensing Act of 1737. Probably, she was depicted in this BBT engraving because she was a new actress in town, having made her debut at Covent Garden Theatre on 8 May 1795 as Angelina in *Love Makes a Man*.

# 320

## Joseph Vernon   ca. 1731?–1782
as Macheath in *The Beggar's Opera*

by John Gay

ARTIST: J. Roberts

ENGRAVER: J. Thornthwaite

DATE PUBLISHED: 1 February 1777

BELL EDITION: BBT76–77 and 80.IX

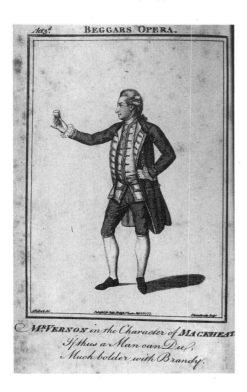

Drawing, full-length, standing, holding a glass in his extended right hand, left hand on hip; wearing a long coat, waistcoat, and breeches. Line engraving 13 × 7.9, with Macheath's line: "If thus a Man can Die, / Much bolder with Brandy."

LOCATION OF ORIGINAL: Unknown.

PROVENANCE: Bell sale, Christie's, 27 March 1793 (lot 14); it and twelve other drawings in the lot were bought for £1 10s. by Bowden.

RELATED: The copy for BBT80 was engraved (13 × 8.9) by Roberts.

A drawing by an unknown artist of Vernon as Macheath is in the British Museum (Burney X, No. 7); an anonymous engraving of it was published by Wenman, 1777. As a young man, Vernon made his first appearance in London at Drury Lane Theatre singing in *Queen Mab* on 26 December 1750. In 1758–59, he was engaged in Dublin. He first played Macheath in London on 21 September 1762, after having returned from a five-year stint in Ireland. Vernon performed a great number of singing and acting roles at Drury Lane until 1780–81, but he was not regarded as a performer of the first rank.

# 321

## Gaetan Appoline Balthazar Vestris 1729–1808
as the Prince in *Ninette à la cour*

by Gaston Appoline Balthazar Vestris

ARTIST: J. Roberts

ENGRAVER: J. Thornthwaite

DATE PUBLISHED: 9 April 1781

BELL EDITION: BBT80.XXI

Drawing, full-length, standing, left profile, his right arm extended; wearing a hat with a plume of feathers, breeches, coat with braids and a sash at waist, and a cloak. Line engraving 14.6 × 9.5, with the caption: "SIGNOR VESTRIS Sen$^r$ in the Character of the PRINCE in the Grand Pantomime Ballet (call'd) NINNETTE à la Cour."

LOCATION OF ORIGINAL: Unknown.

PROVENANCE: Bell sale, Christie's, 27 March 1793 (lot 16); it and three other drawings in lot were bought for 9s. by Mitchell.

RELATED: None.

A ballet master at the Paris Opéra, Vestris came to London in 1780–81 and made his

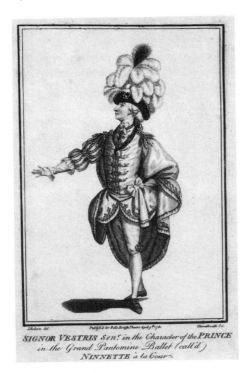

SIGNOR VESTRIS Sen.ʳ in the Character of the PRINCE
in the Grand Pantomime Ballet (call'd)
NINNETTE à la Cour

first appearance at the King's Theatre on 22 February 1781 in his ballet, with his son dancing the role of Colas. Horace Walpole wrote in his *Diary*: "Last Thursday was the benfit [*sic*] of Vestris and son; the house could not receive and contain the multitudes that presented themselves. Their oblations amounted to fourteen hundred pounds." After Edward Pigott saw the elder Vestris in another ballet on 3 April 1781, he wrote in his diary (now at Yale): "the dance performed by Vestris the Father is not of the capring kind, every action is the most graceful, therefore undescribable." He was called the "God of the Dance" by his followers.

# 322

## Marie Jean Augustin Vestris   1760–1842
### Dancing in *Les Amans surpris*

by Louis Simonet

ARTIST: J. Roberts

ENGRAVER: J. Thornthwaite

DATE PUBLISHED: 20 July 1782

BELL EDITION: BBT80.XXI

Drawing, full-length, dancing, with his arms extended, holding a wreath in his right hand; wearing breeches, tunic, a short jacket trimmed with ribbons, and a hat with plumes. Line engraving 14 × 9.5, with the caption: "MONSᴿ VESTRIS JUNᴿ in the favorite Ballet (call'd) LES AMANS SURPRIS."

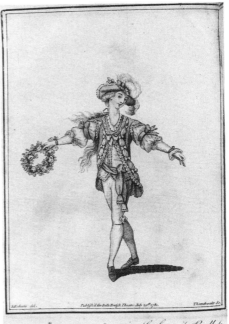

MONS.ʳ VESTRIS Jun.ʳ in the favorite Ballet
(call'd) LES AMANS SURPRIS.

LOCATION OF ORIGINAL: Unknown.

PROVENANCE: When in the Bell sale at Christie's on 27 March 1793 (lot 16) the original drawing by Roberts was said to be of Vestris in *Ninette à la cour*; it and three other drawings in the lot were bought for 9s. by Mitchell.

RELATED: None.

Marie Vestris was a dancer at the Paris Opéra where his father was ballet master. He accompanied his father to London in 1780–81 and made his debut at the King's Theatre in *Les Amans surpris* on 16 December 1780. Though

he spent his career primarily at the Opéra, he returned to London several times to perform during the 1780s and 1790s. Henry Angelo wrote in his *Reminiscences* that in *Les Amans surpris* "Young Vestris astonished John Bull more by his ability than his grace, and some have been known to count the number of times he turned like a tee-totum. This may be called *les tours des jambes*—not dancing."

# 323

## Charles Vincent   [fl. 1777–1795]
as Dorilas in *Merope*

by Aaron Hill

ARTIST: J. Roberts

ENGRAVER: Anonymous

DATE PUBLISHED: 12 February 1777

BELL EDITION: BBT76–77 and 80.X; BET92.I

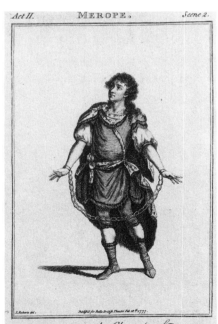

Full-length, standing, hands in manacles; wearing Roman costume. Line engraving 12.7 × 8.6, with the quotation (II.2): "—now answer / Am I Mycenes Monarch?—"

LOCATION OF ORIGINAL: Unknown.

PROVENANCE: Unknown.

RELATED: The copy for the 1780 edition is dated November 1777 and is engraved by B. Reading.

Charles Vincent played Dorilas for his debut at Drury Lane Theatre on 22 January 1777, when he was billed as a "young Gentleman." In his *Wandering Patentee*, Tate Wilkinson wrote, "taken for all in all, it was one of the best first performances I thought I ever witnessed."

# 324

## Tryphosa Jane Wallis   1774–1848
as Aspasia in *Irene*

by Samuel Johnson

ARTIST: J. Roberts

ENGRAVER: P. Audinet

DATE PUBLISHED: 16 June 1796

BELL EDITION: BBT97.XXV

Full-length, standing to right outdoors before a tree, with her left elbow on pedestal and her hand to chin; wearing a long dress with a sash at breast line and holding a scarf in her right hand. Line engraving 11.1 × 8.3, for Cawthorn's British Library, with Aspasia's line (V.1): "This calm, these joys, dear Innocence! are thine."

LOCATION OF ORIGINAL: Unknown.

PROVENANCE: Bell sale, Leigh & Sotheby's, 25 May 1805 (lot 265); the sale catalog incorrectly identified the original as a painting of Miss Wallis as Irene.

RELATED: None.

Miss Wallis did not act in *Irene*; Johnson's play was not performed during the period of

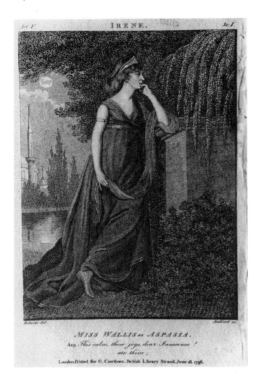

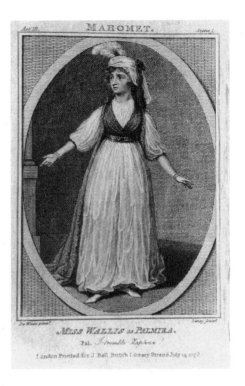

her career on the London stage. She made her debut at Covent Garden Theatre on 10 January 1789 as Sigismunda in *Tancred and Sigismunda*. After five years at Bath, she returned to Covent Garden in October 1797, but after several seasons, she left London for Scotland, where she acted a number of years. A very pretty woman—whose portrait was painted by Dupont and Romney—she never achieved her promise as an actress. The *Monthly Mirror* of September 1798 called her an "entirely artificial actress."

# 325

## Tryphosa Jane Wallis   1774–1848
as Palmira in *Mahomet the Imposter*

by James Miller

ARTIST: S. De Wilde

ENGRAVER: W. Leney

DATE PUBLISHED: 14 July 1795

BELL EDITION: BBT97.XXIII

Full-length, standing, with her arms outstretched, and looking to left; wearing a hat with feathers and a dress with a sash around waist. Line engraving 11.1 × 7.6, for Bell's British Library, with Palmira's line (III.1): "I tremble Zaphna!"

LOCATION OF ORIGINAL: Unknown.

PROVENANCE: Bell sale, Leigh & Sotheby's, 25 May 1805 (lot 274).

RELATED: None.

Miss Wallis did not play Palmira during her career in London.

# 326

## Sarah Ward (Mrs Thomas Achurch Ward)   1756?–1838?
as Octavia in *All for Love*

by John Dryden

ARTIST: S. De Wilde

ENGRAVER: P. Audinet

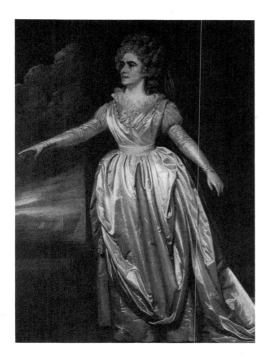

DATE PUBLISHED: 24 March 1792

BELL EDITION: BBT97.XVI

Oil on canvas (37 × 28.4), full-length, standing, looking to left, her right hand extended in gesture; wearing a long dress with a sash around waist and a high wig with tight curls and ringlets behind neck. Line engraving 11.1 × 7.9, for Bell's British Library, with Octavia's line (III): "A Roman! / A name that makes and can unmake a Queen."

LOCATION OF ORIGINAL: Garrick Club (Ash833, CKA269).

PROVENANCE: John Bell; Thomas Harris sale, Robins, 12 July 1819(lot 66); then Charles Mathews (No. 380).

RELATED: None.

Mrs Ward acted this role for the first time at Drury Lane Theatre on 13 November 1780.

# 327

## Sarah Ward (Mrs Thomas Achurch Ward)  1756?–1838?
as Rodogune in *Ethelinda; or, The Royal Convert*

by Nicholas Rowe

ARTIST: J. Roberts

ENGRAVER: J. Thornthwaite

DATE PUBLISHED: 20 October 1776

BELL EDITION: BBT76–77 and 80.VII

Full-length, standing, left profile; wearing a headpiece with feathers and a dress with highly decorated panniered skirt. Line engraving 13.3 × 9.8, with Rodogune's line (III.3): "—Ye Gods!—'tis he himself—."

LOCATION OF ORIGINAL: Unknown.

PROVENANCE: Unknown.

RELATED: A copy (13.3 × 9.8) by an anonymous engraver, dated November 1777, was published in BBT80 and in BET92.III. A

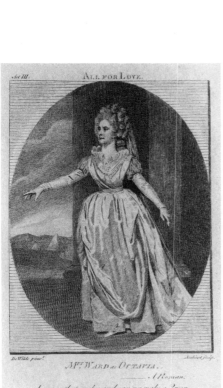

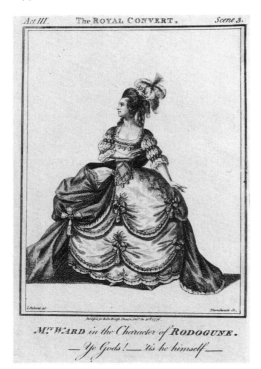

See also No. 328. Mrs Ward played Rodogune for her debut at Covent Garden Theatre on 14 November 1776.

# 328

## Sarah Ward (Mrs Thomas Achurch Ward) 1756?–1838?

as Rodogune in *Ethelinda; or, The Royal Convert*

by Nicholas Rowe

ARTIST: J. Roberts

ENGRAVER: R. Godfrey

DATE PUBLISHED: 27 December 1794

BELL EDITION: BBT97.XXVII

Full-length, standing on a terrace with a view of a river behind, left profile, right hand raised; wearing a headpiece with feathers and a dress with an overskirt. Line engraving 11.4 × 7.6, for Bell's British Library, with Rodogune's line (III.3): "—Ye God! 'tis he himself."

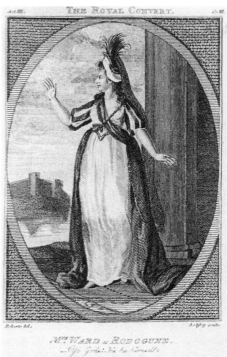

pencil study by Roberts is in the Harvard Theatre Collection, acquired with many drawings of actors by Roberts from Thomas Agnew in 1976. Roberts's picture is also found on a delftware tile, an example of which is in the Thomas Greg Collection, Manchester City Art Galleries.

LOCATION OF ORIGINAL: Unknown.

PROVENANCE: Unknown.

RELATED: See No. 327.

Captain George Wathen. See Richard Barry, Seventh Earl of Barrymore, No. 103

# 329

Mrs R[ichard?] Webb  d. 1793
as Lady Dove in *The Brothers*

by Richard Cumberland

ARTIST: S. De Wilde

ENGRAVER: P. Audinet

DATE PUBLISHED: 22 September 1792

BELL EDITION: BBT97.XII

Oil on canvas (37.2 × 28.5), full-length, standing, with her right hand extended left, her left hand down at side, curly hair; wearing a

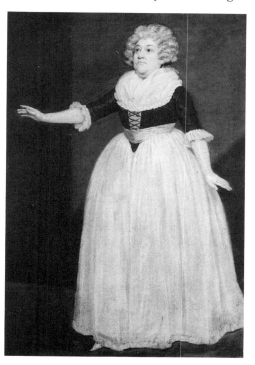

long dress with a short dark jacket laced at the bodice and a white collar. Line engraving 11.1 × 8, for Bell's British Library, with the quotation (II): "I insist upon your turning that old porpoise out of the house."

LOCATION OF ORIGINAL: Garrick Club (Ash384, CKA237).

PROVENANCE: John Bell; Charles Mathews (No. 373).

RELATED: None.

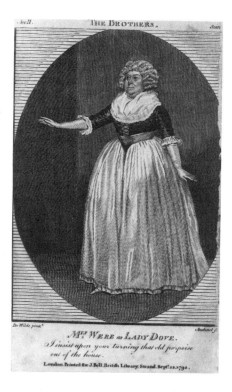

A portrait of Mrs Webb as Lady Dove, engraved by J. Chapman, after H. Moses, was published by C. Cooke as a plate to *British Drama* (2 September 1808).

The role of Lady Dove was created by Jane Green in the premiere of Richard Cumberland's play on 2 December 1769 at Covent Garden Theatre. Mrs Webb acted Lady Dove for the first time on 25 April 1787, also at Covent Garden.

# 330

Anthony Webster   d. 1780
as Douglas in *Douglas*

by John Home

ARTIST: J. Roberts

ENGRAVER: J. Thornthwaite

DATE PUBLISHED: 1778

BELL EDITION: BBT76–77 and 80.XX

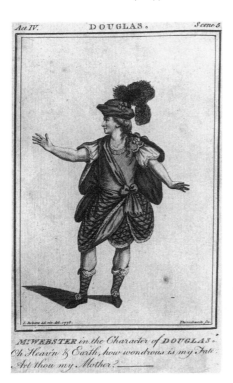

Full-length, standing, looking to left, his arms extended at sides; wearing a kilt and a hat with plume of feathers.

Line engraving 14 × 9.2, with Douglas's line (IV.3): "Oh Heav'n & Earth, how wondrous is my Fate! Art thou my Mother?" The engraving is inscribed "I. Roberts ad. viv. del. 1778."

LOCATION OF ORIGINAL: Unknown.

PROVENANCE: Unknown.

RELATED: A pencil drawing of Webster by James Roberts in the Harvard Theatre Collection may be a study for this picture.

Webster made his debut at Covent Garden Theatre as Douglas on 15 January 1776, when he was introduced as "A Young Gentleman." He may have appeared in London earlier, as Sir Richard Wealthy in *The Minor* at the Haymarket Theatre on 15 October 1770. After his introduction as Douglas, he was described by the *Westminster Magazine* (January 1776): "His person is rather elegant; his voice is full and harmonious, his pronunciation distinct and correct, and his delivery graceful and unembarrassed. . . . On the other hand he is aukward [*sic*], and in some parts unanimated." His tenure in London was brief; he ended his career as a member of the Drury Lane company in 1779–80.

# 331

Mary Wells   1762–1829
as Anne Lovely in *A Bold Stroke for a Wife*

by Susannah Centlivre

ARTIST: S. De Wilde

ENGRAVER: W. Leney

DATE PUBLISHED: 19 November 1791

BELL EDITION: BBT97.XII

Oil on canvas (35.55 × 26.7), full-length, standing in a room, her hands joined at waist; wearing long gloves to elbows, a bonnet with a band round, and a dress laced at the bodice. Line engraving 10.5 × 7.6, for Bell's British Library, with Anne's line (V): "I greatly fear the flesh and the weakness thereof, hum—." A window is added.

LOCATION OF ORIGINAL: Garrick Club (Ash837, CKA265).

PROVENANCE: John Bell; Charles Mathews (No. 371).

RELATED: A copy was printed by C. Cooke, 1807, and as a plate to *British Drama* (1817).

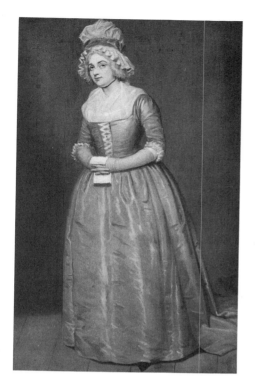

Mary Wells first played this role in London on 31 May 1787, at Covent Garden Theatre. A colorful personality, Mary Wells was described by one of her contemporaries as "a noted and infamous woman." But she was a good and competent actress who enjoyed popularity.

# 332

## John Whitfield  1752–1814
as Captain Dormer in *A Word to the Wise*

by Hugh Kelly

ARTIST: J. Roberts

ENGRAVER: J. Thornthwaite

DATE PUBLISHED: 2 December 1795

BELL EDITION: BBT97.XXX

Full-length, standing, drawing a sword at his left side; wearing a long coat, breeches, and waistcoat. Line engraving 11.8 × 7.9, for Cawthorn's British Library, with Dormer's

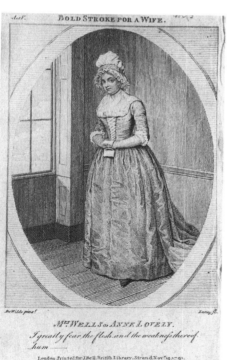

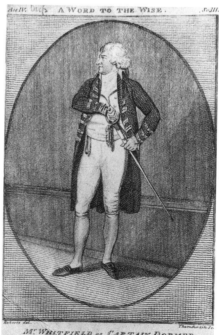

line (IV.3): "—draw and give me instant satisfaction."

LOCATION OF ORIGINAL: Unknown.

PROVENANCE: Unknown.

RELATED: None.

After spending several years on provincial stages, John Whitfield made his London debut at Covent Garden Theatre on 16 September 1774 as Trueman in *George Barnwell*. The next season he moved to Drury Lane Theatre, where he remained until his return to Covent Garden in the autumn of 1798. Whitfield first acted Captain Dormer in London on 13 May 1777, for his benefit at Covent Garden. According to fellow actor F. G. Waldron, in *Candid and Impartial Strictures* (1795), Whitfield had "respectable talents." He acted numerous supporting roles in both comedies and tragedies.

# 333

## Elizabeth Whitlock   1761–1836
as Margaret in *The Earl of Warwick*

by Thomas Francklin

ARTIST: S. De Wilde

ENGRAVER: P. Audinet

DATE PUBLISHED: 6 October 1792

BELL EDITION: BBT97.XVII

Oil on canvas (36.5 × 28.3), full-length, standing to right, with a tent and field in background; wearing a long dress and a sleeveless cloak edged in ermine. Line engraving 11.1 × 8.1, for Bell's British Library, with Margaret's line (V.5): "From my breast I drew / A poignard forth and plung'd it in his heart."

LOCATION OF ORIGINAL: Garrick Club (Ash841, CKA450).

PROVENANCE: John Bell; Thomas Harris sale at Robins, 12 July 1819 (lot 62); then Charles Mathews (No. 173).

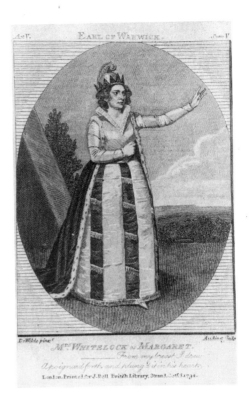

RELATED: None.

Elizabeth Whitlock never acted Margaret in London. She did act Lady Elizabeth Gray in this play for the first time on 3 November 1784 at Drury Lane Theatre, when she was still Miss Kemble. Her sister, Sarah Siddons, acted Margaret that night.

# 334

## Richard Wilson   1744–1796
as Sir Francis Wronghead in *The Provok'd Husband*

by Colley Cibber

ARTIST: S. De Wilde

ENGRAVER: W. Leney

DATE PUBLISHED: 20 October 1791

BELL EDITION: BBT97.XVIII

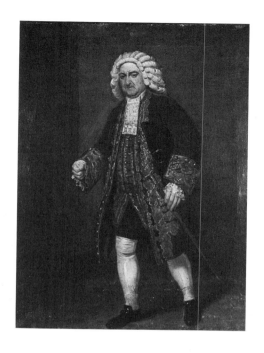

Oil on canvas (37.4 × 27.3), full-length, standing; wearing plum-colored coat, waistcoat, and breeches with green and gold embroidery, carrying a black hat and a gold-headed cane. Line engraving 11.4 × 7.6, for Bell's British Library, with Sir Francis's line (IV): "I don't know how 'twas—but I doubt I cried Ay! when I should ha' cried No!"

LOCATION OF ORIGINAL: National Theatre, London.

PROVENANCE: Somerset Maugham Bequest.

RELATED: A copy was engraved (10.5 × 7.3) by S. Close and published in Dublin as a plate for W. Jones's *British Theatre* (1794), and another copy by an unknown engraver was published as a plate to Cumberland's *British Drama* (1806).

Wilson first acted this role in London on 21 April 1781, at Covent Garden Theatre.

# 335

## Henry Woodward 1714–1777
as Bobadil in *Every Man in His Humour*

by Ben Jonson

ARTIST: J. Roberts

ENGRAVER: J. Thorthwaite

DATE PUBLISHED: 10 June 1776

BELL EDITION: BBT76–77 and 80.II

Watercolor on vellum (11.4 × 7.6), full-length, standing, with a cane in his right hand, smoking a pipe; wearing boots, tunic, cape, a hat with plume, and a sword at his left side. Line engraving 14 × 9.8, with Bobadil's line (IV.2): "I was planet-struck certainly."

LOCATION OF ORIGINAL: British Museum (Burney X, No. 106).

PROVENANCE: Bell sale, Christie's, 27 March 1793 (lot 14); it and twelve other drawings in lot were bought for £1 10s. by Bowden.

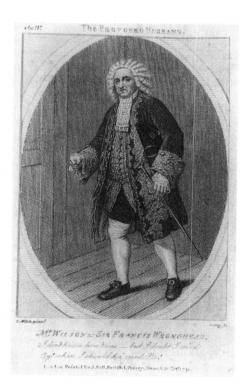

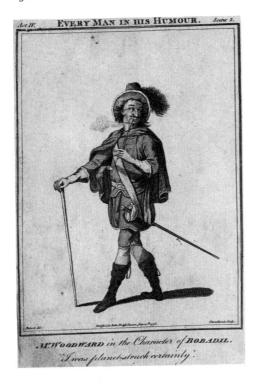

RELATED: The copy for the 1780 edition was engraved (13.7 × 9.5) by B. Reading. A copy was engraved by W. Darling and published by him. For other portraits of Woodward as Bobadil, see the *BDA*.

Woodward first acted Bobadil in London on 29 November 1751. It became one of his greatest roles. The anonymous author of the *Present State of the Stage in Great Britain and Ireland* (1753) praised his portrayal as "very great acting." Thomas Wilkes called Bobadil "a part of his own creation, and a proof of his genius."

# 336

Henry Woodward  1714–1777
as Captain Brazen in *The Recruiting Officer*

by George Farquhar

ARTIST: J. Roberts

ENGRAVER: J. Thornthwaite

DATE PUBLISHED: 20 August 1776

BELL EDITION: BBT76–77 and 80.IV; BET92.VI

Watercolor drawing on vellum (10.2 × 9.5), full-length, standing, his right hand out-

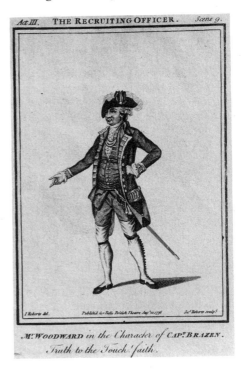

stretched, left hand on hip; wearing military coat, with sword at left side. Line engraving 13.7 × 9.2, with the quotation (III.9): "Truth to the Touch! faith."

LOCATION OF ORIGINAL: British Museum (Burney X, No. 99).

PROVENANCE: Bell sale, Christie's, 27 March 1793 (lot 14); it and twelve other drawings in lot were bought for £1 10s. by Bowden.

RELATED: The copy for the 1780 edition was engraved (13.3 × 9.2) by Roberts. The Roberts engraving was also used for BET92.

Woodward acted Captain Brazen for the first time at Drury Lane Theatre on 1 November 1748, with David Garrick as Plume. In previous productions of *The Recruiting Officer* at

that theatre, Captain Brazen had been played by Charles Macklin.

# 337

## Mary Ann Wrighten   1751?–1796
as Madge (Margery) in *Love in a Village*

by Isaac Bickerstaff

ARTIST: J. Roberts

ENGRAVER: J. Thornthwaite

DATE PUBLISHED: 29 March 1781

BELL EDITION: BBT80.XXI; BET92.XIV

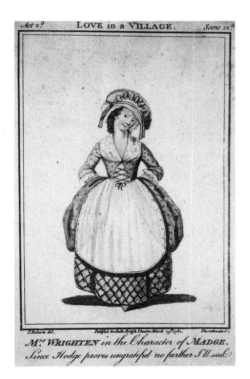

Colored drawing (14 × 10.2), full-length, standing to front, with her hands in the side pockets of her dress; wearing an apron and a hat with ribbon. Line engraving 13.4 × 9.2, with Madge's line (II.12): "Since Hodge proves ungrateful no farther I'll seek."

LOCATION OF ORIGINAL: British Museum (Burney X, No. 132).

PROVENANCE: Bell sale, 27 March 1793 (lot 14); it and 12 other drawings in the lot were bought for £1 10s. by Bowden.

RELATED: None.

Mrs Wrighten first acted Margery on 30 September 1775, at Drury Lane Theatre. She also played the role during her first season at the Southwark Theatre in Philadelphia in 1792 (when known as Mrs Pownall) and at the opening of the John Street Theatre in New York on 15 December 1794.

# 338

## Mary Ann Wrighten   1751?–1796
as Peggy in *The Gentle Shepherd*

by Allan Ramsey

ARTIST: J. Roberts

ENGRAVER: J. Thornthwaite

DATE PUBLISHED: 26 February 1777

BELL EDITION: BBT76–77 and 80.IX

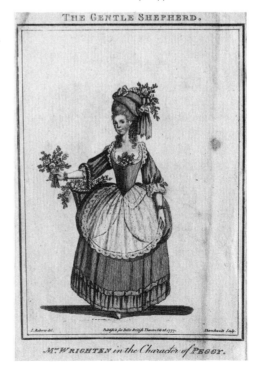

Colored drawing on vellum (10.5 × 7.9), full-length, standing to front, with basket of flowers hanging on her right arm and some flowers in her hand; wearing a hat with flowers and a dress with narrow waist and wide skirt. Line engraving 13.7 × 9.5.

LOCATION OF ORIGINAL: British Museum (Burney X, No. 136).

PROVENANCE: Bell sale, Christie's, 27 March 1793 (lot 14); it and twelve other drawings in the lot were bought for £1 10s. by Bowden.

RELATED: None.

Mrs Wrighten first acted Peggy in London on 9 May 1774, at Drury Lane Theatre.

# 339

## Richard Wroughton  1748–1822
as Edward in *Edward the Black Prince*

by William Shirley

ARTIST: J. Roberts

ENGRAVER: R. Pollard

DATE PUBLISHED: 24 September 1777

BELL EDITION: BBT76–77 and 80.XVI

Colored drawing on vellum (12.1 × 7.6), full-length, standing, holding a spear in his right hand, his left hand extended right; wearing armor and a helmet with plume. Line engraving 12.7 × 9.2, with Edward's line (V.13): "Give instant orders to recall our Parties; / I will not hazard by a rash Pursuit / So vast a Victory."

LOCATION OF ORIGINAL: British Museum (Burney II, No. 176).

PROVENANCE: Bell sale, Christie's, 27 March 1793 (lot 14); bought, with twelve other drawings in lot, for £1 10s. by Bowden.

RELATED: None.

Wroughton, who made his debut at Covent Garden Theatre as Zaphna in *Mahomet* on 24 October 1768, was a useful journeyman actor and sometime manager in London for

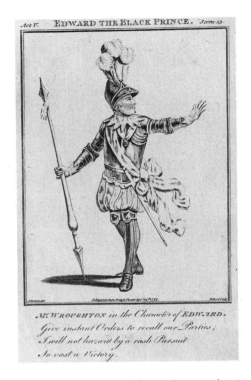

*Mr WROUGHTON in the Character of EDWARD.*
*Give instant Orders to recall our Parties;*
*I will not hazard by a rash Pursuit*
*So vast a Victory.*

forty-seven years until his retirement in 1815. He acted Edward the Black Prince for the first time in a revival at Covent Garden on 15 May 1778.

# 340

## Richard Wroughton  1748–1822
as Essex in *The Earl of Essex*

by Henry Brooke

ARTIST: S. De Wilde

ENGRAVER: W. Leney

DATE PUBLISHED: 25 August 1791

BELL EDITION: BBT97.VI

Full-length, standing to left before an arch, with his right arm extended, and holding a hat with plume in his left hand at side; wearing breeches, tunic, cape, and boots. Line engraving 10.4 × 7.6, for Bell's British Library, with Essex's line (III): "I've served you, Madam, with the utmost peril, / And ever glory'd in the illustrious danger."

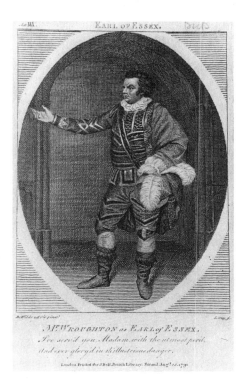

LOCATION OF ORIGINAL: Unknown.

PROVENANCE: Unknown.

RELATED: An engraving by Halpin, after De Wilde, was published by W. Jones in Dublin.

Wroughton first appeared in Henry Jones's *The Unhappy Favorite; or, The Earl of Essex* at Covent Garden Theatre on 24 April 1770, but in the role of Southampton, a part he continued to act regularly in the repertory. Sometimes he played Burleigh. He seems not to have played Essex in London in the eighteenth century.

# 341

## Richard Wroughton   1748–1822
as George Barnwell in *The London Merchant*

by George Lillo

ARTIST: J. Roberts

ENGRAVER: T. Cook

DATE PUBLISHED: 26 September 1776

BELL EDITION: BBT76–77 and 80.V; BET92.V

Full-length, standing, his left arm extended downward at side, the right arm across his

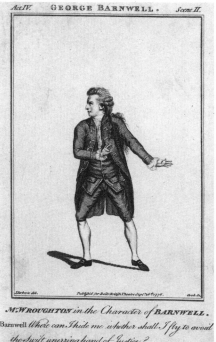

body; wearing breeches, waistcoat, and long coat. Line engraving 12.7 × 8.3, for *Bell's British Theatre*, with Barnwell's line (IV.2): "Where can I hide me whither shall I fly to avoid the Swift unerring hand of Justice?"

LOCATION OF ORIGINAL: Unknown.

PROVENANCE: Unknown.

RELATED: This picture by Roberts also appears on a delftware tile, an example of which is in the Thomas Greg Collection, Manchester City Art Galleries.

In the BBT76 edition, the engraver was not named. When the picture was published in the BBT80 edition, the engraving (with same date and measurements) was in reverse, and T. Cook was named as the engraver. The engraving in BET92 is the BBT76 version.

Wroughton played Barnwell for the first time at Covent Garden Theatre on 26 December 1770.

# 342

## Mary Ann Yates 1728–1787
as Berintha in *The Relapse*

by John Vanbrugh

ARTIST: J. Roberts

ENGRAVER: Anonymous [J. Thornthwaite]

DATE PUBLISHED: 11 May 1777

BELL EDITION: BBT76–77 and 80.XI

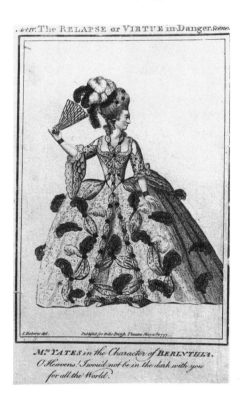

Full-length, standing to front, head to right, holding a fan in her upraised right hand; wearing a dress with a large panniered skirt richly decorated with feathers; her hair piled high, with feathers on top. Line engraving 14 × 9.2, with Berintha's line (IV): "O Heavens! I wou'd not be in the dark with you for all the World."

LOCATION OF ORIGINAL: Unknown.

PROVENANCE: Unknown.

RELATED: The engraving for BBT80 was published March 1778.

Mrs Yates acted Berintha in Richard B. Sheridan's *A Trip to Scarborough*—an adaptation of Vanbrugh's *The Relapse*—in the premiere on 24 February 1777 at Drury Lane Theatre.

# 343

## Mary Ann Yates 1728–1787
as Calista in *The Fair Penitent*

by Nicholas Rowe

ARTIST: J. Roberts

ENGRAVER: J. Thornthwaite

DATE PUBLISHED: 16 July 1776

BELL EDITION: BBT76–77 and 80.III

Colored drawing (12 × 8.6), full-length, standing, her head turned left, with her arms outstretched and feathers and pearls in her hair; wearing a dress with a large skirt decorated with feathers and with a train (of ermine?). Line engraving 13 × 10.2, with Calista's line (II.4): "Strike home, & I will bless thee for the blow."

LOCATION OF ORIGINAL: British Museum (Burney X, No. 173).

PROVENANCE: Bell sale, Christie's, 27 March 1793 (lot 14), bought by Bowden.

RELATED: The engraving (13.3 × 9.8) in BBT80 (a copy in reverse of the Thornthwaite) is by J. Page and was published 16 July 1776. Also in the Bell sale at Christie's on 27 March 1793 (lot 14) was another drawing by Roberts of Mrs Yates as Calista. That drawing was no doubt the one on vellum now in the British Museum (Burney X, No. 171) that shows her full-

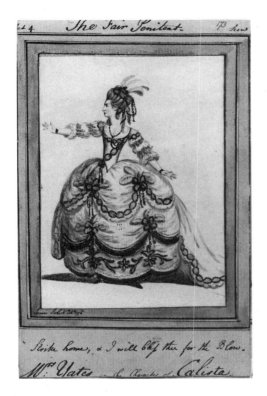

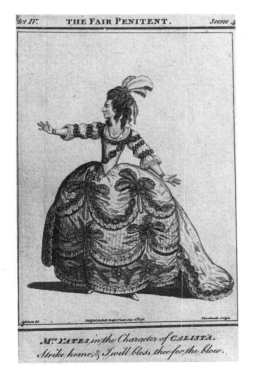

length, seated, with skull and crossbones on a table. It seems not to have been engraved. An anonymous engraving of her as Calista, standing, looking at a dagger in upraised right hand, was published by Wenman, 1777.

Mrs Yates acted Calista in London for the first time on 11 April 1760, at Drury Lane Theatre

# 344

## Mary Ann Yates 1728–1787
as Chruseis in *Heroick Love*

by George Granville

ARTIST: J. Roberts

ENGRAVER: Not Engraved

DATE PUBLISHED: Not Published

Drawing, description unknown.

LOCATION OF ORIGINAL: Unknown.

PROVENANCE: Bell sale, Christie's, 27 March 1793 (lot 14); bought by Bowden.

RELATED: None.

This drawing is known only by the mention of it in the catalog of the sale of Bell's drawings in 1793. *Heroick Love* (by George Granville, Lord Lansdowne) was not published in any of Bell's editions. It was acted in London only once in the second half of the eighteenth century, on 18 March 1766 at Drury Lane Theatre. In the bill noticed in *The London Stage*, the performers are named, but their roles are not specified. Mrs Yates played one of the characters, probably Chruseis, and the performance was for her benefit.

# 345

## Mary Ann Yates 1728–1787
as Electra in *Orestes*

by Thomas Francklin (after Voltaire)

ARTIST: J. Roberts

ENGRAVER: J. Thornthwaite

DATE PUBLISHED: 6 October 1777

BELL EDITION: BBT76-77 and 80.XVI

Full-length, standing, left profile, holding an urn in her right hand; wearing manacles and a dress with a voluminous skirt. Line engrav-

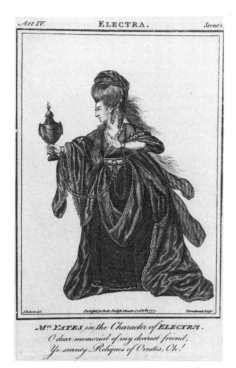

*Act IV.*    ELECTRA.    *Scene 1.*

*Mrs YATES in the Character of ELECTRA.*
*O dear memorial of my dearest friend;*
*Ye scanty Reliques of Orestes, Oh!*

ing 13.3 × 9.2, with Electra's line (IV.1): "O dear memorial of my dearest friend; / Ye scanty Reliques of Orestes, Oh!"

LOCATION OF ORIGINAL: Unknown.

PROVENANCE: Unknown.

RELATED: None.

A miniature on ivory by Samuel Cotes of Mrs Yates as Electra is in the Victoria and Albert Museum; a large (46.7 × 35.2) engraving of it by P. Daw was published by Bowles, 1771.

Mrs Yates acted Electra for the first time in London for her benefit at Covent Garden Theatre on 13 March 1769. The tragedy by Voltaire was presented in a translation by Dr Thomas Francklin. When she returned to Drury Lane Theatre after an absence of eight years, Mrs Yates acted Electra on 15 October 1774, when Voltaire's play was called *Electra*.

# 346

## Mary Ann Yates   1728–1787 and Master John G. Pulley   d. 1788
as Isabella and Child in *Isabella; or, The Fatal Marriage*

by David Garrick,
adapted from Thomas Southerne

ARTIST: J. Roberts

ENGRAVER: J. Thornthwaite

DATE PUBLISHED: 26 September 1776

BELL EDITION: BBT76–77.V

Colored drawing on vellum (10.8 × 10.5); Mrs Yates full-length, standing, her left arm outstretched, wears a dress with panniered skirt, curls in hair; a small child, Master Pulley, is at her side. Line engraving 13 × 18.4, with Isabella's line (I.4): "Indeed, I am most wretched."

LOCATION OF ORIGINAL: British Museum (Burney X, No. 182).

PROVENANCE: Unknown.

RELATED: See No. 347, Mrs Yates, without the Child.

Mrs Yates acted the title role in Garrick's play for the first time on 25 November 1774, at Drury Lane Theatre. That night Master Pulley first acted the Child. He acted children's roles in London until October 1778. He drowned at Maisemore Bridge, near Minsterworth, on 2 March 1788. Possibly, he was the son of the actress Mrs Mary Pulley (née Watkins), who died in 1793.

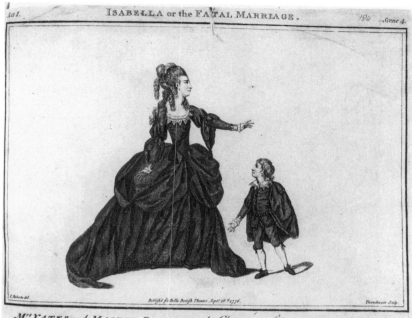

# 347

Mary Ann Yates  1728–1787
as Isabella in *Isabella; or, The Fatal Marriage*

by David Garrick,
adapated from Thomas Southerne

ARTIST: J. Roberts

ENGRAVER: Anonymous [ J. Thornthwaite]

DATE PUBLISHED: February 1778

BELL EDITION: BBT80.V; BET92.V

Full-length, standing, her head turned right,
with her left arm outstretched; wearing a
long panniered dress, with curls down to
shoulders. Line engraving 13.3 × 9.5, with the
quotation (I.4): "Indeed I am most
Wretched!"

LOCATION OF ORIGINAL: Unknown.

PROVENANCE: Unknown.

RELATED: This engraving is a copy of No.
346, but without the Child.

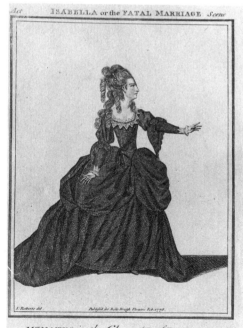

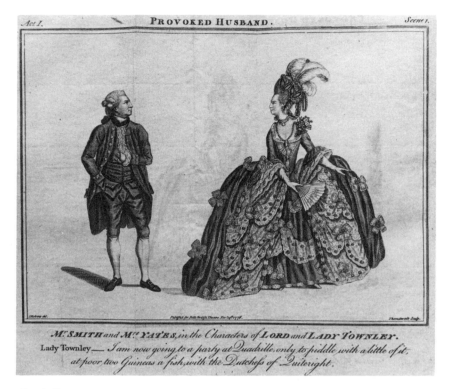

*Mr. SMITH and Mrs. YATES, in the Characters of LORD and LADY TOWNLEY.*

*Lady Townley — I am now going to a party at Quadrille, only to piddle with a little of it, at poor two Guineas a fish, with the Dutchess of Quiteright.*

# 348

## Mary Ann Yates 1728–1787 and William Smith 1730–1819

as Lady and Lord Townly in *The Provok'd Husband*

by Colley Cibber

ARTIST: J. Roberts

ENGRAVER: J. Thornthwaite

DATE PUBLISHED: 14 November 1776

BELL EDITION: BBT76–77 and 80.VI

Full-length, standing, facing each other; she, on the right, wears a richly decorated dress with panniered skirt and lace overlay, with feathers atop high-piled hair, and holds a fan in her right hand; he, on the left, wears breeches, waistcoat, and coat, with his left hand in vest, his right hand in pocket. Line engraving 13.7 × 19, with Lady Townly's line (I.1): "I am now going to a party at Quadrille, only to piddle with a little of it at poor two Guineas a fish, with the Dutchess of Quiteright."

LOCATION OF ORIGINAL: Unknown.

PROVENANCE: Unknown.

RELATED: The engraving for BBT80 is by Page. An engraving, after Roberts, of Mrs Yates only as Lady Townly was also published; the same picture is shown on a delftware tile, an example of which is in the Thomas Greg Collection, Manchester City Art Galleries.

Pencil drawings by Roberts in the Harvard Theatre Collection are individual studies of Mrs Yates and Smith for this picture; the drawings were acquired in 1976 from Thomas Agnew with a lot of fifty-two drawings, the majority by Roberts and of actors, that had been offered at Christie's on 6 November 1973 (lot 48). The single drawing of Smith as Lord Townly probably was the drawing so identified in the sale of Bell's collection at

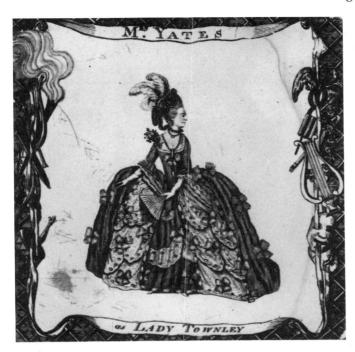

Christie's on 27 March 1793 (lot 13); it and five other drawings of Smith in the lot were bought for 15s. by C. Cooke.

Mrs Yates acted Lady Townly for the first time in London on 14 April 1757, for her husband's benefit at Drury Lane Theatre. Smith acted Lord Townly for the first time on 29 November 1769 at Covent Garden Theatre, when Mrs Yates appeared as Lady Townly, her usual role in that repertory favorite. Francis Gentleman wrote that as Lord Townly "Mr. Smith has freedom and elegance; but a most lamentable sameness of expression hangs heavy on the ears of an audience."

# 349

## Mary Ann Yates   1728–1787
as Virginia in *Virginia*

by Henry Crisp

ARTIST: J. Roberts

ENGRAVER: J. Thornthwaite

DATE PUBLISHED: January 1778

BELL EDITION: BBT76–77 and 80.XVIII

Full-length, standing to front, head left, arms crossed at front; wearing a richly decorated dress with pannier, feathers in hair, with train hanging from the back of her hair. Line engraving 14 × 9.2, with Virginia's line (V): "For tho' I love, yet still I am a Roman."

LOCATION OF ORIGINAL: Unknown.

PROVENANCE: Unknown.

RELATED: None.

When Mrs Graham, Mary Ann Yates made her debut on the London stage as Marcia (not Virginia) in the premiere of Henry Crisp's *Virginia* (the title role was acted by Mrs Cibber) at Drury Lane Theatre on 25 February 1754, when she was announced as "a Gentlewoman." The prompter Cross wrote in his diary that a woman "who never appear'd upon ye Stage before did Marcia & she had deservidly great applause." The play received only several other performances that season and was not seen again during the century.

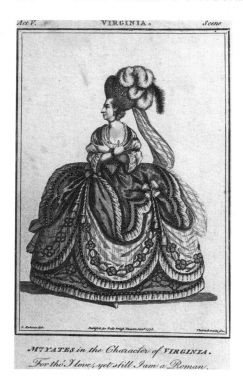

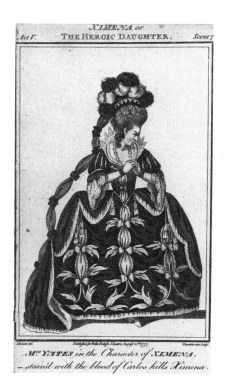

# 350

## Mary Ann Yates   1728–1787
as Ximena in *Ximena*

by Colley Cibber

ARTIST: J. Roberts

ENGRAVER: J. Thornthwaite

DATE PUBLISHED: 20 August 1777

BELL EDITION: BBT76–77 and 80.XIV

Full-length, standing, face to right, hands clasped; wearing a dress with pannier, the skirt decorated with knotted ribbons, and a hat with feather sitting upon hair piled high. Line engraving 14 × 9, with the quotation (V.7): "—stain'd with the blood of Carlos kills Ximena."

LOCATION OF ORIGINAL: Unknown.

PROVENANCE: Unknown.

RELATED: None.

An anonymous engraving of Mrs Yates as Ximena, showing her kneeling with hands clasped, was published by Harrison & Co, 1781. Mrs Yates acted Ximena at Covent Garden Theatre on 21 March 1772, the only performance of that play in the second half of the eighteenth century.

Mary Ann Yates. See also David Garrick, No. 163

# 351

## Richard Yates   ca. 1706–1796
as Don Manuel in *She Wou'd and She Wou'd Not*

by Colley Cibber

ARTIST: J. Roberts

ENGRAVER: B. Reading

DATE PUBLISHED: 16 November 1776

BELL EDITION: BBT76–77 and 80.VI

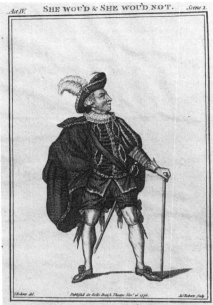

Act IV. SHE WOU'D & SHE WOU'D NOT. *Scene 1.*

*M.ʳ YATES in the Character of* DON MANUEL.

Don Man: *Pray give my humble Service to the Politician & tell him*
*that to your certain Knowledge the Old fellow the Old Rogue, & the*
*Old Put d'see, knows how to bamboozle as well as himself.*

Colored drawing on vellum (11.4 × 7.6), full-
length, standing, holding a cane in his left
hand; wearing a cloak over his right shoulder
and side, a braided waistcoat, and a hat with
feathers. Line engraving 3.3 × 7.9, with Don
Manuel's line (IV.1): "Pray give my humble
Service to the Politician & tell him that to
your certain Knowledge the Old fellow the
Old Rogue & the Old Put d'see knows how
to bamboozle as well as himself."

LOCATION OF ORIGINAL: British Mu-
seum (Burney X, No. 154).

PROVENANCE: Bell sale, Christie's, 27 March
1793 (lot 14); bought, with twelve other draw-
ings in lot) for £1 1s. by Bowden.

RELATED: The BBT80 engraving (13.3 ×
8.9) is by Roberts but bears the same date as
the 1776 engraving by Reading. A watercolor
drawing by Roberts (inscribed "Js Roberts delt
1781"), similar to the one in the British Mu-
seum, is in the Garrick Club (No. 560C) and
is probably the drawing used by Roberts when
he did the engraving for the 1780 edition.

Yates acted Don Manuel for the first time in
London on 18 January 1748, at Drury Lane
Theatre.

# 352

## Richard Yates   ca. 1706–1796
as Lovegold in *The Miser*

by Henry Fielding

ARTIST: S. De Wilde

ENGRAVER: Corner

DATE PUBLISHED: 4 February 1792

BELL EDITION: BBT97.II

Full-length, standing in a field before trees,
facing front; wearing a long coat, waistcoat,

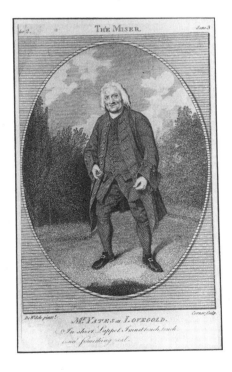

THE MISER.

*M.ʳ YATES as* LOVEGOLD.
*In short Lappet, I must touch, touch,*
*touch something real.*

and breeches. Line engraving 11.7 × 7.9, with
Lovegold's line (II.3): "In short Lappet, I
must touch, touch, touch Something real."

LOCATION OF ORIGINAL: Unknown.

PROVENANCE: Unknown.

RELATED: A copy dated 3 August 1808 was printed by C. Cooke as a plate to *British Drama* (1817). Another portrait of Yates as Lovegold, engraved by Charles Grignion, after T. Parkinson, was published as a plate to Lowndes's *New English Theatre* (1776).

Yates first acted Lovegold in London at Goodman's Fields Theatre on 16 March 1741 for his benefit shared with his wife; the bills announced that he would attempt the role "in the manner of the late Mr. Griffin." (Benjamin Griffin [1680?–1740] was a celebrated low comedian.)

Miss Younge. See Elizabeth Pope, Nos. 56–57, 271–74, 276.

Appendixes    Selected Bibliography    Photographic Credits

# APPENDIX 1
Scenes from the Plays and Other Engravings

When John Bell advertised the 1773 edition of *Shakespeare*, he expressed characteristic pride in its physical appearance—the graceful title page engraved by Whitchurch from the calligraphy of William Chinnery, the occasional ornaments, and especially the frontispiece "vignettes," or "scenes," from the plays.

Edward Edwards designed thirty-two of the thirty-six vignettes. The most prominent of the engravers was John Hall, who worked twelve plates.[1]

Rather pedestrian in execution, these little scenes (see plate 1) nevertheless added considerable interest to the volumes, and they apparently enjoyed a modest sale when offered separately or sewn in "setts."[2] But they were completely overshadowed by the portraits of actors that began to appear in the third edition of the "acting" *Shakespeare*.

When Bell returned to the concept of illustrative scenes from Shakespeare twenty years later, they bore little resemblance to the earlier ones. The illustrative vignettes that were tipped into the collected edition of Bell's second *Shakespeare* (1788) were all strongly influenced by P. J. De Loutherbourg, Garrick's celebrated scene designer, who furnished twenty of the designs. Seven others were painted by the young portraitist and caricaturist Edward F. Burney (who had also done twelve of the portraits), and five by the Rome-trained and romantic William Hamilton.[3] Jean Marie Delattre engraved ten of the pictures, John Hall eight, and Francesco Bartolozzi six.[4] (See plates 2, 3, 4.)

These pictures do not represent live actors, but they are nevertheless very lively. De

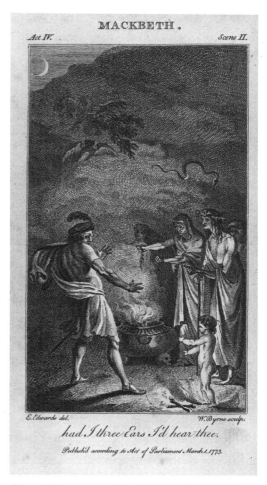

Plate 1. Vignette scene from *Macbeth* (*Bell's Shakespeare*, 1774). Engraving by Byrne, after Edwards. By permission of The Folger Shakespeare Library.

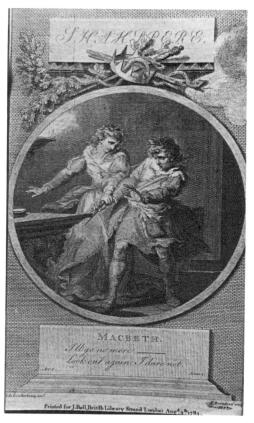

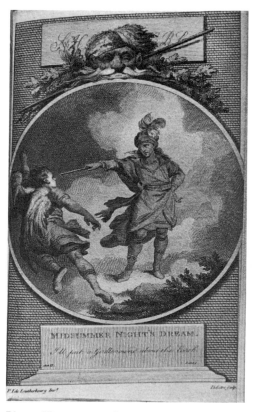

Plate 2. Vignette scene from *Macbeth*. Engraving by Bartolozzi, after De Loutherbourg, 9 August 1781. Courtesy of Jack Reading.

Plate 3. Vignette scene from *A Midsummer Night's Dream*. Engraving by Delattre, after De Loutherbourg, n.d. Courtesy of Jack Reading.

Loutherbourg (especially) and his cohorts seem almost to be motivated by a competitive spirit, vying with young Johan Ramberg and his associated portraitists to create more striking effects in more romantic vistas. Several of De Loutherbourg's designs possess more interest than the portraits painted for the same play. The designers of these vignettes obviously had even more freedom than the portraitists to "direct" the poses of the figures in their scenes. They fully exploited the freedom, but they seem to have been no less constrained than the portraitists were by the theatrical "rules" governing stance and gesture.

The introductory embellishments of *Bell's British Theatre* contain emblematic plates of a kind more nearly like the frontispieces to Bell's nondramatic books than to anything found in his *Shakespeare*. The frontispiece introducing the series of twenty volumes in which Bell collected the first two years' run of plays of the *British Theatre* in 1778 shows Britannia on her throne, with her cross-emblazoned shield. She gestures toward a distant, visionary temple bathed in celestial light.

A venerable, bearded, winged figure kneels at her feet, pointing to a stack of volumes. The picture is an attractive example of the easily interpreted symbolic frontispieces of which the century was so fond.

Britannia aptly introduced the succession of Melpomenes and Thalias who (with one Apollo, representing Opera) front the alternating volumes of Tragedies and Comedies. There

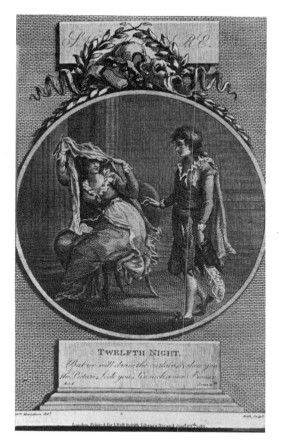

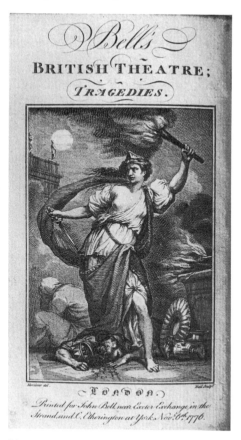

Plate 4. Vignette scene from *Twelfth Night*. Engraving by Hall, after Hamilton, 29 August 1785. Courtesy of Jack Reading.

Plate 5. *Bell's British Theatre: Tragedies.* Engraving by Hall, after Mortimer, 6 November 1776. Authors' Collection.

are in fact five different representations of each Muse. The conventional emblems and tokens of woe and merriment are displayed in nice variation: for Comedy, Pans with pipes, satyrs peering from the boscage, herms on pedestals, mirrors and masks, bare breasts, roguish smiles, and adorable putti; for Tragedy, sinking ships, poison bowls, daggers, fire, Furies, dead babes, and murdered monarchs. (See, e.g., plates 5, 6, 7.)

John Hamilton Mortimer, designer, and John Hall, engraver, appear to share with Edward Edwards and one of the Walkers the credit for those engravings—perhaps equally, though apportionment is difficult. Mortimer and Hall receive credit on only two plates, and

Edwards and Walker on one only. The vignettes that embellish the plays (see plates 8 and 9) were produced by a variety of artists from Bell's stable of painters and engravers (see chapter 2).

## Notes

1. One plate each was designed by Nathaniel Dance, Isaac Taylor, and John Keyes Sherwin. The other engravers were William Byrne with six, Charles Grignion five, Mathew Liart five, James Basire three, and Thomas Cook two. Peter Mazell and Anthony Walker each did one.

2. They have been disparaged a little unfairly by historians. Typical is T. S. R. Boas, who dismisses them as "clumsy, undistinguished works," in "Illus-

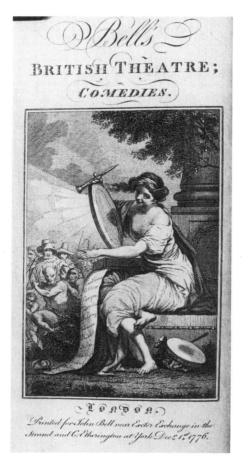

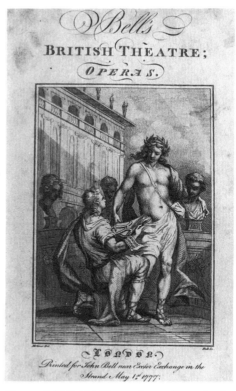

Plate 6. *Bell's British Theatre: Comedies*. Engraving by Hall, after Mortimer(?), 1 December 1776. Authors' Collection.

Plate 7. *Bell's British Theatre: Operas*. Engraving by Hall, after Mortimer, 1 May 1777. Courtesy of Jack Reading.

trations of Shakespeare's Plays," *Journal of the Warburg and Courtauld Institute* 10 (1948): 83–105.

3. Two were by the younger Moreau and one was by Ramberg.

4. Collyer, Cook, Dambrun, and J. K. Sherwin each engraved two, and De Longuiel, Heath, Lemire, Neel, Simonet, Sharp, and A. Smith one each.

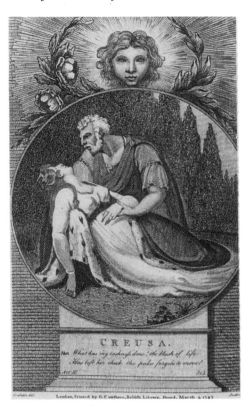

Plate 8. Vignette scene from *Samson Agonistes*. Engraving by Audinet, after Graham, 24 December 1796. Courtesy of Jennie Walton, Inverarity Bisset Collection.

Plate 9. Vignette scene from *Creusa*. Engraving by Audinet, after Graham, 4 March 1797. Courtesy of Jennie Walton, Inverarity Bisset Collection.

# APPENDIX 2
## List of Portraits Published Separately

This list includes the artist-engraver. The number in parentheses at the end of each entry is the catalog number.

Bannister, John, as Gradus; De Wilde-E. Bell plate to *Theatrical Inquisitor*, 1782 (93).

Bellamy, George Ann, as Comic Muse; Ramberg-Bartolozzi, 5 June 1785 (104).

Crouch, Anna Maria, as Emily; Anon.-Cook, printed for Bell's British Library, 20 Mar. 1784 (136).

Farren, Elizabeth, as Olivia; Ramberg-Grignion, 20 Aug. 1785 (26).

Garrick, David, as Bayes; Roberts-Pollard, 16 Sept. 1777 (159).

Henderson, John, as Iago; Stuart-Bartolozzi, 1786 (33).

Hull, Thomas, in private character; Graham-Leney, published by Cawthorn; 10 Jan. 1797 (202).

Hunter, Maria, as Lady Ann; Ramberg-Anon., 31 Dec. 1785 (38).

Macklin, Charles, in private character; Opie-Condé, July 1792, published as a plate to Murphy's edition of Macklin's *Works* (237).

Pope, Elizabeth, as Angelica; Roberts-Roberts, 1781 (271).

Pope, Jane, as Laetetia; Roberts-Roberts, 1781 (281).

Siddons, Sarah, as Desdemona; Ramberg-Sherwin, Nov. 1785 (62).

Siddons, Sarah, as Tragic Muse; by Roberts, 7 May 1783 (307).

Storace, Ann, as Euphrosyne; Corbauld-Thornthwaite, 1791 (316).

Wells, Mary, as Imogen; Ramberg-Sherwin, 1786 (71).

# APPENDIX 3
List of Portraits Not Published

The pictures listed below were in the Bell sale at Christie's on 27 March 1793 except the picture of Elizabeth Pope and William Smith as Phaedra and Hippolitus, which was sold at Leigh & Sotheby's 25 May 1805. The number in parentheses at the end of each entry is the catalog number.

Baddeley, Sophia, as a Pastoral Nymph; by Roberts (90).
Barry, Ann, as Lady Randolph; by Roberts (97).
Cargill, Ann, as Mandane; by Roberts (124).
Catley, Ann, as Polly; by Roberts (127).

Colles, Hester, as Polly; by Roberts (134).
Dodd, James, as Sir Andrew Aguecheek; by Ramberg (21).
Edwin, John, the elder, as Jerry Blackacre; by Roberts (147).
Edwin, John, the elder, as Justice Woodcock; by Roberts (148).
Palmer, Robert, as Bonario; by Roberts (265).
Pope, Elizabeth, and William Smith, as Phaedra and Hippolitus; by Roberts (275).
Smith, William, as Montezuma; by Roberts (311).
Yates, Mary Ann, as Chruseis; by Roberts (344).

# APPENDIX 4
Biographical Index of Painters and Engravers

This index is to catalog numbers. Numbers in brackets indicate that a version of the engraving was also published elsewhere; numbers preceded by BS or BBT indicate that the engraving is a "scene," or a nonportrait engraving, in one of Bell's editions. The following abbreviations are used throughout: ARA (Associate, Royal Academy), BI (British Institute), exh (exhibited), FSA (Free Society of Artists), RA (Royal Academy), SA (Society of Arts). Information on the artists derives in large part from the compilations of Bryan and Graves, supplemented by detail from Benezit, Burke, *Dictionary of National Biography*, Evans, Hammelmann, Heal, Hind, Redgrave, Smith, and Waterhouse.

Anonymous. 1, 7, 8, 10, 14, 16, 36, 38, 46 [47], 56, [58], [61], 66, 68, 76, 78, [79], 80, 81, [85], [88], [108], 116, [120], 136, [141], 161, [169], [173], 180, [191], [204], [207], [211], [224], [225], 226, ]227], [234], [238], 247, 257, [259], [260], [264], [266], [267], 274, [289], 299, 310, 311, 312, [315], 323, [327], [334], 347.

Audinet, Philippe (1766–1837). Painter and engraver, b. Soho 1766, of a French Huguenot family; apprenticed to John Hall; engraved portraits for *Biographical Magazine*; d. London, 1837: 88, 103, 106, 108, 113, 119, 140, 141, 142, 155, 174, 186, [191], 210, 211, 212, 214, 215, 216, 217, 218, 219, 220, 223, 224, 225, 235, 246. 251, 254, 256, 264, 287, 289, 303, 319, 324, 326, 329.

Baldwyn. Engraver: [33].

Bartolozzi, Francesco (1725–1815). Painter and engraver, b. Florence 1725, the son of a goldsmith; instructed in drawing by Ferreti, Florence, and in engraving by Joseph

Wagner, Venice. His son was Gaetano (1757–1851), engraver and the father of Madame Vestris. Francesco in 1802 was director of National Academy, Lisbon, where he died 1815: 26, 33, 104, [120], BS74 and BS88.

Basire, James (1730–1802). Engraver, b. London 1730, son of Isaac, a map engraver; early in Rome, copied Raphael; engraver to Society of Antiquaries; ca. 1770 engraver to RA; exh SA 1761–83, SA: BS74.

Bell, Edward [fl. 1794–1847]. Engraver, taught George Clint; exh RA 1811–47, RI 1814–47; 19 Great Portland St 1794–96, Islington Rd 1796–99; nephew of publisher John Bell.

Bell, S. (n.d). Engraver: 93.

Benoist, Antoine. French engraver, b. Soisson 1721, d. London 1770; engraver of the Lacky portrait of Louis XV: [184].

Brocas, Henry (1766–1838). Painter landscapes, b. Dublin 1766, drawing master Dublin schools: [11], [112], [119], [233], [287], [315].

Bromley, William (1769–1842). Engraver, b. Isle of Wight, apprentice to Wooding in London; engraver of Corbauld's drawings of the Elgin marbles over many years; elected ARA; exh SA 1790; two sons engravers; d. London 1842: 92, 173, 193, 213.

Brown, Mather Byles (1761–1831). Painter b. 7 October 1761 Boston, Massachusetts, the son of Gawen Brown, an eminent clockmaker, who had emigrated from London in 1759. Mather was a pupil of West in America; went to London 1781; exh RA 1782, and often thereafter; earned wide reputation as a fashionable painter; painter to Duke of Clarence; died 25 May 1831, Twickenham: 6, 34, 42, 55, 70.

Burke, Thomas (1749–1815). Engraver, b. 1749 Dublin, pupil of Dixon; engraved in style of Bartolozzi; did engravings after Cipriani, Kauffmann, and Dance (Mrs Siddons); d. 1815 London: BS88.

Burney, Edward Francis (1760–1848). Painter, b. 7 September 1760 Worcester, nephew of Dr. Charles Burney and cousin to Fanny Burney (whose *Evelina* he illustrated); RA schools 1777; exh RA 1780–1803; d. 16 December 1848 London: 3, 9, 15, 20, 27, 28, 47, 57, 65, 77, BS88.

Byrne, William (1743–1805). Engraver, b. 1743 London; studied in Paris under Aliamet and Wille; became eminent engraver of landscapes (he was to be found at the "Rev Mr Jacobs Long Acre," ca. 1766); Henrietta St Covent Garden 1773; No 69 Wells St 1775; exh thirty-four prints SA 1766–1780; a son, John, and two daughters, Frances and Letitia, were also artists; d. 1805 London: BS74.

Chapman, J. (n.d.). Engraver: 117, 190, 253.

Chinnery, William (1708–91). Calligrapher, painter, b. 1708, son of William C. Chinnery, cordwainer; trained under Miers, writing master in Tower Hill; apprenticed to bookseller and then to R. Ford of The Angel in the Poultry; worked for the celebrated publisher Bernard Lintot at "Cross Keys between the two Temple Gates in Fleet Street," by 1746 in business for himself; published *Writing and Drawing Made Easy*, 1750; 1765 operated at house in Gough Square, where he died in 1791; the father of William Chinnery, painter and Madras merchant: engraved title pages BS73–78.

Clayton, John (1728–1800). Engraver and still-life painter, d. at Enfield 1800: [227], [234], [250]

Close, Samuel (d. 1817). Engraver, b. Dublin; according to Bryan, "deaf and dumb, and of intemperate habits": [211], [334].

Collyer, J. (n.d.). Engraver; fourteen engravings for Bell's rival *New English Theatre*; also worked for Boydell: 96, BS88.

Condé, John. (n.d.). Engraver; did portrait of Macklin in his *Works*, 1792, and portraits for BBT97: [92], [234], 237, [287], [301], [315].

Cook, Thomas (n.d.). Engraver, pupil of Ravenet; engraved some Hogarth and plates for *Bell's Poets*; also worked for Boydell: 136, [262], [288], 307, 341, BS74, BS88.

Corbauld, Richard (1757–1831). Painter, b. London; did oils, watercolors, portraits, landscapes, history book illustration; exh RA 1777–1811; d. Highgate: 316

Corner, John (1742–1821). Engraver, in 1825 published series of twenty-five *Portraits of Celebrated Painters*: 110, [119], 154, 250, 266, 267, 270, 352.

Cosway, Richard (1742–1821). Painter, baptized Oketon, near Tiverton, Devon, 5 Nov. 1742. Painted portraits, miniatures, religious and mythylogical subjects; RA schools 1769; elected RA 1770, exh RA 1770–1806; principal painter to Prince of Wales; d. London 8 July 1821: 120, BS88.

Cotes, Francis (1726–70). Painter, scholar of Knapton, charter member RA and SA; eminent in crayons; d. in "prime of life" (Bryan), 1770: 104.

Cromek, Robert Hartly (1771–1812). Engraver, b. Hull 1771, son of Thomas Cromek, Berwick-in-Elmete, Yorkshire; studied Manchester, then to London to study with Bartolozzi; d. London, 1812: 189, 238.

Dambrun, Jean. Engraver, b. 1741, Paris; vignettes in books, notably after Fragonard, Moreau, and Queverdo: BS88

Dance, Nathaniel (1735–1811). Painter, b. 18 May 1735 London, son of the elder George Dance, architect; studied with Hayman 1749, Rome 1754–65; exh SA 1761–67; FSA 1764; RA 1769 (portrait king and queen); married wealth and changed his name to Nathaniel Dance Holland; knighted; d. 15 Oct. 1811, Winchester: BS73.

Darling, W. (n.d.). Engraver: [335].

De Faesch. See Faesch.

Delangueil (n.d.). "graveur du Roy": BS88.

Delattre, Jean Marie (1746–1845). Engraver, b. Abbeville 1746; went to England 1770, worked under Bartolozzi; exh print SA 1770 ("Mr. Delattre, opposite Mother Red Cap's"); plates for *Bell's Poets*; d. 1845, almost one hundred: 64, BS88.

De Loutherbourg, Philippe Jacques (1740–1812).

Painter, b. 31 Oct. 1740, Strasbourg; studied with Carl Van Loo, Casanova, Paris Academy; elected Academician 1767; went to England 1771 to work for Garrick as revolutionary scene designer, romantic landscapist; d. 11 Mar. 1812 Hammersmith Terrace, buried St Nicholas churchyard, Chiswick: BS88.

De Wilde, Samuel (1751–1832). Painter, baptized London 28 July 1751, of Dutch origin; apprentice to a joiner, then RA schools 1769; exh SA 1776 (he was then "At Mr Donald's, Crown St, Soho"); SA 1777–78, BI 1812 (No 9, Tavistock Row, Covent Garden); d. 19 Jan.1832: 84, 85, 86, 87, 88. 92, 93, 94, 103, 106, 108110, 112, 114, 117, 118, 119, 130, 131, 137, 141 142, 143, 150, 151, 152, 153, 154, 155, 162, 168 169, 172, 173, 174, 186, 190, 191, 182, 193, 196, 204, 207, 210, 211, 213, 214, 215, 217, 220, 221, 224, 225, 227, 229, 232, 233, 234, 235, 238, 240, 245, 246, 249, 250, 253, 254, 255, 256, 258, 259, 216, 262, 264, 266, 267, 268, 270, 277, 283, 284, 286, 289, 290, 294, 295, 301, 302, 306, 315, 325, 326, 328, 331, 332, 334, 340, 352.

Dighton, Robert (1752–1814). Painter, engraver, exh FS 1769 ("Mr Dighton Junr. 65 Fetter Lane," 1887 ("at Mr Glanville's opposite St Clements Church"); exh RA 1777; proprietor Charing Cross printshop, drawing master, occasional actor and singer; published *Book of Heads*, 1791; son Denis, b. 1791, also painter; d. 10 December 1806: 4, 5, 14, 73.

Droeshout, Martin [fl. 1620–51]. Engraver, either Martin, son of Michael Droeshout, engraver, and his wife, Susanna van Erbeck of Ghent, or another Martin, of Brabant, who flourished 1634; more likely the former, who was baptized 26 Apr. 1601 at the Dutch Church, Austin Friars, and who engraved, from a sketch now lost, the portrait of Shakespeare published 1623 in the First Folio: BS88.

Edwards, Edward (1738–1806). Painter, b. London 7 Mar. 1758, son of a cabinetmaker; studied painting at Duke of Richmond's Academy 1759, St Martin's Lane Academy 1761, RA schools 1769; exh FS 1766, SA 1767–72, RA 1771–1806; elected ARA 1773; taught perspective RA from 1788; in France 1775–76; remembered for frank *Anecdotes of Painters*,

published posthumously 1808; d. 10 December 1806: [29], 68, BS74.

Edwards, J. (n.d.). Engraver: [308].

Edwards, W. (n.d.). Painter: 78.

Edwin, David (1776–1841). Painter, engraver, b. Bath 1776, son of the actor John Edwin; apprenticed to engraver; ran away to sea and America in 1797; employed by Edward Savage; sight failed after twenty years; d. Philadelphia 1841 (Bryan): [120].

Esdall, W. (n.d.). Painter, engraver: [84], [137], [277].

Faesch, Johann Ludwig Wernhard (b. 1758). Miniature painter, b. Basel: probably inspired the design of the portraits in Bell's early *Shakespeare*.

Ferguson, A. (n.d.). Engraver: [108], [193], [267].

Fittler, James (1758–35). Painter, engraver, b. London 1758; exh FS 1776 sketch and portrait at Mr Fittler's, Wells Street, near Germain St; entered RA schools 1778; elected ARA 1800; appointed Marine Engraver to George III 1800; d. Turnham Green 1835: 229, 244.

Freeman, Samuel (1773–1857). Engraver; Bryan lists four religious plates for him: [74].

Fuseli, John Henry (1741–1825). Painter, b. Zurich 6 Oct. 1741 as Johann Heinrich Füssli, took Holy Orders, and had classical education; went to England 1764, studied Rome 1770–78; changed name to Italianate Fuseli; exh RA 1774, 1776, 1780–1825; BI 1806; elected ARA 1785, RA 1790; professor of painting RA 1799; elected Keeper RA 1804: BS88.

Godfrey, Richard S. Engraver, b. London 1728, exh SA 1765 ("At the Nun, in Wild St, Lincoln's Inn Fields"); engraved views of antiquities and portraits: 144, [191], 328.

Graham, John. (n.d.). Painter, apprenticed to coach painter in Edinburgh; entered RA schools 1783; exh RA 1780–97; history paintings, portraits, Shakespeare scenes for Boydell; Master New Trustees' Academy, Edinburgh: 109, 113, 129, 135, 138, 170, 194, 195, 202, 243, 265, 292, 317, 318.

Grignion, Charles (1716–1810). Engraver, b. 1716 London, of foreign parents, probably related to French engraver Grignion; one of the committee appointed to establish RA; exh

SA 1761–66; in 1762 lived in St James Street, Covent Garden; engraver Hogarth's Garrick as Richard III, *Antique Statues*, after Dalton, and *Bell's Poets*; d. Kentish Town 1810: 4, 12, 13, 18, 19, 22, 23, 24, 26, 30, 31, 35, 37, 44, 45, 48, 50, 51, 52, 54, 58, 59, 73, [141], BS74.

Gromek. See Cromek.

Hall, John (1739–97). Engraver, b. Wivenhoe, near Chester; studied with Ravenet; exh SA 1763–76 (including 1773: "Two Prints, intended for new edition of Shakespeare," and 1776 "Frontispiece to *Bell's British Theatre*"); engraved portrait of George Colman, after Gainsborough; appointed history engraver to George III; d. Soho 1797: 63, BS74.

Halpin, F. (n.d.). Painter: [340].

Hamilton, William (1750–1801). Painter, b. Chelsea, 1750, the son of a Scot assistant to Robert Adam; sent early to Rome, pupil of Zucchi; RA schools 1769; exh RA 1774–1801; elected ARA 1784, RA 1789; painter in high romantic style, worked for Boydell and Macklin and did many portraits of actors, including several of Mrs Siddons; d. London 2 Dec. 1801: 72, 219, 300, 304, 305

Harding, Sylvester (1745–1809). Miniature painter, b. 1745 Newcastle-under-Lyme; ran away from an unpleasant apprenticeship and joined strolling players, then came to London 1775; exh RA 1777–1802; d. London 1809: [42], [115].

Heath, Charles (n.d.). Engraver: BS88.

Holland. See Dance.

Houston, Richard (1721–75). Benezit: "peintre et graveur à la maniere noire," b. Ireland 1721; studied under J. Brooks; went to London when very young; dissipation caused him to be confined for years in the Fleet by the printseller Sayer until he was freed in 1760; in London until his death, in London, 1775; engraved mythological and historical subjects, and portraits: 152.

Keating, George B. Engraver, b. Ireland 1762; studied under W. Dickinson and worked in London 1784–89; Bryan lists ten portrait plates for him: [42].

Kneller, Godfrey (1646–1723). Painter, b. 8 Aug. 1646 Lübeck; studied Rome and Venice 1672–75; in England became court painter, knighted 1692, bart 1715; celebrated portraitist, d. London 26 Oct. 1723: BS88.

Le Mire, Noel. Painter and engraver, b. 1724 Rouen; numerous book illustrations, *Contes* of La Fontaine 1762, subjects after Cochin, Eisen, Moreau; portraits of Washington, Lafayette, Marie Antoinette, and Mlle Clairon: BS88.

Leney, William [fl. 1775–1808]. Engraver, b. London, pupil of Tomkins; engraver of Boydell Shakespeare Gallery; went to America; became bank-note engraver; in 1808 living on farm near Montreal: [19], [25], 85, 94, [98], 99, [103], [112], 114, 118, 120, 125, 130, 138, 139, 150, 169, 170, 177, 195, 202, 203, 204, 233, 239, 245, 252, 255, 260, 284, 301, 302, 325, 331, 334, 340.

Liart, Matthew (1736–ca. 82). Engraver, b. London of French parents; studied with Ravenet, SA and RA schools; exh SA 1762 ("At the Grasshopper, Wych St"); exh landscapes, heads, and still lifes at SA 1762–76: BS74.

MacKenzie, K. (n.d.). Engraver: [104].

Maguire, P. (n.d.). Engraver: [110].

Maradan, François. (n.d.). Engraver of portraits and vignettes, Paris ca. 1800: [104].

Matthieu, J. Painter, possibly Jean Matthieu, b. 1749 and d. 1815 Fontainebleu; a number of commissions noted in Bryan, but no evidence ever in England: 196.

Mazell, Peter [fl. 1763–90]. Engraver, member and exh SA 1763–90; prints of birds, landscapes, and portraits; 1763 at Peter St, Bloomsbury; 1764 at No 6 Windmill St, Tottenham Ct Rd; 1768 at Hassell's Row; 1780 Portland St; 1783 Gerrard St; 1790 No 7 Brydges St, Covent Garden; engravings for Pennant's *Ruins and Romantic Prospects in North Britain*: BS74.

Moreau, Jean Michel le jeune. Engraver, painter, b. Paris March 1741, called "le jeune"; his older brother Louis Moreau (b. 1740) was known as Moreau "l'aine"; went to St Petersburg for two years; visited Italy 1785; professor at École Central in Paris; more than two thousand designs: BS88.

Mortimer, John Hamilton (1740–79). Painter, engraver, b. 17 Sept. 1740, Eastbourne, Suf-

folk; studied with Thomas Hudson, R. E. Pine, Duke of Richmond's Academy 1759; exh SA 1759–77, FSA 1763–64, 1767; elected ARA 1778; exh RA 1779 (posthumously); painted history and romantic scenes, portraits, twenty-five plates for *Bell's Poets*; engraved *Nature and Genius Conducting Garrick into the Temple of Shakespeare*; designed window Salisbury Cathedral; d. 4 Feb. 1779 London: BBT frontispiece 1777.

Neagle, John [fl. 1760–1816]. Engraver, b. London ca. 1760; engraved some plates for Boydell's Shakespeare Gallery, after Wheatley and Smirke: 151.

Neele, Samuel John (1758–1824). Engraver, illustrated antiquarian works, engraved maps: BS88.

Newnham, Simon [fl. 1762–1788]. Engraver (amateur), SA (honorary exhibitor) four etchings 1762, four 1763: 25, 67.

Opie, John (1761–1807). Painter, b. May 1761 St Agnes near Truro, Cornwall, son of a carpenter; talent as painter recognized by Dr John Wolcot (pseud. Peter Pindar), who introduced him to London as the "Cornish Wonder"; exh RA 1782–1807; elected ARA 1787, professor of painting RA 1805; paintings for Macklin, Boydell; eminent portraitist: 237, BS88.

Page, J. (n.d.). Engraver: 176, 182, [309], [343], [348].

Parkinson, Thomas (1744–ca. 89). Painter, engraver, b. 10 Dec. 1744 Oxford; RA schools 1772; exh SA 1772 ("Mr Parkinson at Mr Stacy's, Colourman, corner of Long Acre"), FSA 1773 ("7 Baynes Row, Cold Bath Fields"); FS 1769 ("At Mr Cox's Great Russell Street, Covent Garden"); RA 1775–89; engraved plates for *New English Theatre*, a rival to Bell's: 7, 22, 23, 29, 37, 44, 46, 52, 59, 61.

Pegg, J. (n.d.). Engraver: 184.

Picart, C. (n.d.). Engraver; Benezit says only "graveur à manière noire travaillant vers 1755": [93].

Pollard, Robert (1755–1838). Painter, engraver, b. 1755 Newcastle-on-Tyne; apprenticed to silversmith; pupil of Richard Wilson; exh FSA 1783: 133, 159, 187, 200, 206, 279.

Ramberg, Johann Heinrich (1763–1838). Painter,

engraver, b. 22 July 1763 Hanover; 1781 went to England by invitation of George III; RA schools, perhaps the pupil of Benjamin West; exh RA 1782–88; painted for Boydell's Shakespeare Gallery; 1788 left England for Hanover, where he d. 6 July 1840: 2, 17, 19, 21, 24, 25, 26, 31, 32, 38, 39, 40, 41, 43, 49, 54, 58, 62, 63, 64, 67, 69, 71, 75, 104, BS88.

Read, William [fl. 1778–1808]. Engraver and miniature painter: [33].

Reading, Burnet. Engraver, b. mid-eighteenth century, "worked in the dot manner" (Bryan). He was riding master and drawing master to Lord Pomfret: [17], 109, 129, 175, 205, 263, 288, 298, 323, [335], 351.

Reading, D. (n.d.). Engraver: 115.

Reynolds, Joshua (1723–92). Painter, b. 16 July 1723 Plympton, Devon; apprenticed to Thomas Hudson; leading English portrait painter of century; president RA from its establishment; knighted 1769; exh SA 1760–68, RA 1769–90: BS88.

Roberts, James (1753–ca. 1809). Painter, engraver, possibly sometime scene painter; entered RA schools 1771; exh RA 1773–99; published *Introductory Lessons in Watercolours* (1809); created a large number of portraits for BBT 76–77: 1, 8, 10, 11, 12, 13, 16, 18, 30, 35, 36, 45, 50, 51, 56, 60, 66, 68, 74, 76, 78, 80, 81, 82, 83, [87], 89, 90, 91, 95, 96, 97, 98, 99, 100, 101, 102, 105, 107, 115, 116, 121, 122, 123, 124, 125, 126, 127, 128, 132, 134, 140, 144, 145, 146, 147, 148, 156, 157, 158, 159, 160, 161, 163, 164, 165, 166, 167, 171, 175, 176, 177, 178, 179, 180, 181, 182, 183, 184, 185, 188, 189, 197, 198, 199, 200, 201, 203, 205, 206, 208, 209, 212, 216, 221, 222, 223, 226, 228, 230, 231, 236, 239, 214, 242, 244, 247, 248, 249, 252, 257, 260?, 263, 269, 271, 272, 273, 274, 275, 276, 278, 279, 280, 281, 282, 286, 288, 291, 293, 296, 297, 298, 299, 303, 307, 308, 309, 310, 311, 312, 313, 314, 319, 320, 321, 322, 323, 324, 326, 328, 330, 332, 335, 336, 337, 338, 339, 341, 342, 343, 344, 345, 346, 347, 348, 349, 350, 351.

Roffe, E. Engraver (Bryan has a John Roffe, b. 1769): [79], [123].

Rogers, J. (n.d.). Engraver: 259.

Roubilliac, Louis François (1694–1762). Sculptor, b. Lyons; by 1730s had gone to England and had become the most eminent sculptor practicing there in the eighteenth century;

worked for Henry Cheere at his stone-yard and sculpture garden at Hyde Park; carved the statue of Handel for Tyers at Vauxhall Gardens, erected May 1738; fashioned notable statues of Milton, Swift, Pope, and Chesterfield; in 1758 did statue of Shakespeare for Garrick's temple at Hampton; his most popular work was the Nightingale monument at Westminster; d. 11 Jan. 1762 and buried in the churchyard of St Martin's-in-the-Fields: BS88.

Sallier, L. (n.d.). Engraver: [277].

Sanders, John (1750–1825). Painter, b. 1750 London, son of John Sanders (Saunders), portrait painter; entered RA schools 1769; exh RA 1775–88; exh FSA 1778; Norwich 1771–81, then London again, then 1790 to Bath, where he d. Clifton 1825: 53.

Sands, J. (n.d.). Engraver: [104].

Scriven, Edward (1775–1841). Engraver "in the chalk and dotted manner" (Bryan), b. 1775 Alchester; pupil of Robert Thew; engravings for Boydell and Society of Dilettante; d. 1841: [15], [26], [32], [39], [63]

Sharp, William (1749–1824). Engraver, b. 1749 London, son of gunmaker; apprenticed to Barak Longmate, engraver; became a celebrated line engraver; honorary member Royal Academy, Munich; had four daughters who were painters; d. 1824, buried Chiswick churchyard: BS88.

Shelton. See Skelton.

Sherwin, Charles (ca. 1764–94). Engraver, worked with his brother J. K. Sherwin: 2, 19, 39, 40, 62, 69, 71, BS88.

Sherwin, John Keyes (1751–90). Painter, engraver, b. May 1751 East Dean, Sussex, son of a laborer; in London at age sixteen, awards for drawing; engraver SA 1769–78; pupil of John Astley and Bartolozzi; RA schools as engraver 1770; exh RA 1774–84; engraver to the king; but d. in poverty 1790: 74?; BS74, BS88.

Simonet, Jean Baptist (1742–1810). Painter, engraver, b. Paris 1741; vignettes for Ovid's *Metamorphoses* and other works; d. 1810 Paris: BS88.

Skelton, William (1763–1848). Painter, engraver, b. 1763 London; studied with James Basire and William Sharp; enjoyed patronage of Sir

Richard Wolsey; worked for Townley, Boydell, Macklin, Dilettanti Society; published a series of royal portraits, including George III and Queen Victoria; d. 1748, London: 135, 317.

Smith, Anker (1759–1819). Engraver, trained for law but turned to engraving; frontispiece by Fuseli for Darwin's *Botanic Garden*; engraver for *Bell's Poets*: [287].

Smith, J. R.(n.d.): [74].

Stewart. See Stuart.

Stothard, Thomas (1755–1834). Painter, engraver, b. 17 Aug. 1755 London; apprenticed to designer of silk patterns; RA schools 1777; exh RA 1778–1834; BI 1806–23; elected ARA 1791; librarian RA 1812; painted for Boydell, Macklin, and illustrated works of Scott and Byron, and *Bell's Poets*; also did plates for *New English Theatre*, Bell's rival; d. 27 Apr. 1834 London: frontispiece of Thalia for *Supplement* BBT84.

Stuart, Gilbert (1755–1828). Portrait painter, b. 3 Dec. 1755, North Kingston, Rhode Island; went to London in 1775 and studied under Benjamin West; his *Skater* painted there in 1782 is in National Gallery, Washington, DC. Stuart became the most prominent American portraitist; one of his portraits of George Washington (the Athenaeum version, now in the Boston Museum of Fine Arts) is used on the U.S. one-dollar bill; d. 9 July 1828 Boston, where he had resided from 1805: 33, 34, 42, 55.

Taylor, Isaac (1730–1807). Engraver, b. 1730 Worcester; engraver in London by 1765 (then a resident in Holles St, Clare Market); exh SA 1765–80 (1772 at the Bible and Crown, Holborn; 1775 at No 306 Holborn, near Chancery Lane); elected FSA 1770, secretary 1774; engraved eleven plates for *New English Theatre*, Bell's rival; d. 17 Oct. 1807, Edmonton: BS74.

Thomas (n.d.). Engraver: [315].

Thomson, J. (n.d.). Engraver: 194.

Thomson, Paton [fl. 1794–1821]. Engraver; among his plates of actors are Charles Kemble as Romeo (1819) and Edmund Kean as Coriolanus (1820): 222.

Thornthwaite, James. Engraver, b. ca. 1740; very active from 1770 to 1797, many engravings for

Bell: 3, 6, 9, 15, 17, 20, 27, 28, 32, 34, 42, 47, 53, 55, 57, 65, 70, 72, 75, 77 82, 83, 84, 86, 87, 89, 91, 95, 98, 100, 101, 102, 105, 107, 111, 112, 121, 122, 123, 126, 128, 131, 132, 137, 143, 145, 149, 152, 153, 156, 157, 158, 160, 162, 165, 166, 167, 171, 176, 178, 179, 181, 182, 183, 188, 191, [196], 197, 198, 199, 201, 207, 208, 209, 227, 228, 231, 232, 234, 236, 239, 240, 241, 242, 248, 251, 259, 261, 262, 268, 269, 272, 273, 276, 277, 278, 280, 282, 283, 285, 286, 290, 291, 293, 294, 295, 296, 300, 305, 306, 308, 309, 313, 314, 315, 316, 320, 321, 322, 327, 330, 332, 335, 336, 337, 338, 342, 343, 345, 346, 348, 349, 350.

Trotter, Thomas (1756–1803). Painter, engraver, b. May 1756 London; entered RA schools as engraver 1779; exh RA 1780–82, 1801; had instruction from Blake; d. 14 Feb. 1803 Westminster: 258, *Supplement* BBT84.

Vandergucht, Benjamin (1753–94). Painter, RA schools 1769; exh FS 1767–70, RA 1771–87; many theatre scenes and portraits, including Moody and Parsons in *The Register Office* and a head of Garrick in 1779, reputed the last picture the actor sat for; drowned in a boating accident on the Thames 16 Sept. 1794: [74].

Walker, Anthony (1726–65). Engraver, b. London 1726; studied engraving in London with John Tinney and at St Martin's Lane Academy; book engraver, plates for Boydell; d. 1765 London: 297.

Walker, J. G. (n.d.). Engraver: 257.

Walker, William (1729–93). Engraver, b. November 1729 Thirsk; apprenticed to a dyer; followed to London his more famous brother Anthony, who taught him engraving; excelled in book illustrations; developed the important process of "re-biting"; d. 18 Feb. 1783 Rosoman St, Clerkenwell: 163.

Westall, Richard (1766–1836). Painter, b. 2 Jan. 1766 Hereford; apprenticed to silver engraver 1779–84; RA schools 1785; exh RA 1785–36; BI 1806–34; elected ARA 1792, RA 1794; painted for Boydell and Macklin, drawing master to Queen Victoria: 111, 218.

Whitchurch, Charles (1751–1825). Engraver: BS74 (Chinnery's title page).

White, Charles (1751–1825). Engraver, b. London; pupil of Pranker; married daughter of Vandergucht; line engraver, but turned to stipple; illustrated *Bell's Poets*; comic drawings, including *Masquerade at Pantheon*; d. 28 Aug. 1825 at Pimlico: 29, 60.

Wilson, J. (n.d.). Engraver: 164, 168, 172, 185, 192, 230, 243, 318.

Wilson, William Charles. Engraver, b. ca. 1750; worked principally in mezzotint; employed by Boydell's Shakespeare Gallery: 172?

Woodman, Richard [fl. ca. 1750–1810]. Engraver, in London; his son Richard (b. 1784) also prominent engraver: [24], [34], [69].

Wray, P. (n.d.). Engraver: 259.

Wright, T. (n.d.). Engraver: [93].

# APPENDIX 5
Index of Plays

This index is to catalog numbers.

# SELECTED BIBLIOGRAPHY

*A Catalogue of Books Newspapers &c. Printed by John Bell . . . and by John Browne Bell.* London: First Edition Club, 1931.

Appleton, William. *Charles Macklin: An Actor's Life.* Cambridge, MA: Harvard University Press, 1960.

Ashton, Geoffrey. *Pictures in the Garrick Club. A Catalogue.* Edited by Kalman A. Burnim and Andrew Wilton. London: Garrick Club, 1997.

Barber, Jonathan. *A Practical Treatise on Gesture, Chiefly Abstracted from Austin's Chironomia.* London: Rivington, Payne, 1831.

Barnett, Dene. *Art of Gesture: The Practice and Principles of Eighteenth-Century Acting.* Heidelberg: Carl Winter Universitätsverlag, 1986.

Benezit, E. *Dictionnaire critique et documentaire des Peintures, Sculpteurs, Dessinateurs et Graveurs.* New ed. Paris: Libraire Grund, 1961.

Bevington, David. *Action Is Eloquence: Shakespeare's Language of Gesture.* Cambridge, MA: Harvard University Press, 1984.

*Biographia Dramatica.* Vol. 1. Edited by Isaac Reed. London: Rivington, Payne, 1782.

Boaden, James, ed. *The Private Correspondence of David Garrick.* 2 vols. London: H. Colburn & R. Bentley, 1831.

Boas, T. S. B. "Illustrations of Shakespeare's Plays in the Eighteenth Century." *Journal of the Warburg and Courtauld Institute* 10 (1948): 83–105.

Boswell, James. *Boswell's Life of Johnson.* 6 vols. Edited by John Birkbeck Hill. Revised and enlarged edition edited by L. F. Powell. Oxford: Oxford University Press, 1934–50.

Brüntjen, Sven H. A. *John Boydell, 1719–1804: A Study of Art Patronage and Publishing in Geor-gian London.* New York and London: Garland, 1985.

Bryan, Michael. *Bryan's Dictionary of Painters and Engravers.* 5 vols. Revised and enlarged edition edited by George C. Williamson. London: G. Bell & Sons, 1926–30.

Burke, Joseph. *English Art, 1714–1800.* Oxford: Clarendon, 1976.

Burnim, Kalman A. *David Garrick, Director.* University of Pittsburgh Press, 1961.

Cameron, William J. *A Bibliography in Short-Title Catalog Form of "Bell's British Theatre," 1791–1797. Western Hemisphere Short-Title Bibliography,* no. 5. London and Ontario: University of Western Ontario, 1982.

———. *A Bibliography in Short-Title Catalog Form of "Bell's British Theatre," 1776–1780. Western Hemisphere Short-Title Catalog Bibliography,* no. 9. London, Ontario: University of Western Ontario, 1982.

———. *A Short-Title Catalog of Eighteenth-Century Editions of "Bell's British Theatre." Western Hemisphere Short-Title Catalog,* no. 5. London and Ontario: University of Western Ontario, 1982.

———. *A Short-Title Catalog of James Barker's Continuation, 1795–1799, of "Bell's British Theatre." Western Hemisphere Short-Title Catalog,* no. 17. London and Ontario: University of Western Ontario, 1984.

———. *A Union Catalogue in Short-Title Catalog Form of Editions of Individual Plays and Parts of Book That Went to Make Up John Bell's "Acting Edition" of Shakespeare's Plays, 1773–1779. Western Hemisphere Short-Title Catalog,* no. 15. London and Ontario: University of Western Ontario, 1983.

Cumberland, Richard. *Memoirs of Richard Cumberland.* Vol 1. London, 1808.

De Marly, Diana. *Costumes on the Stage, 1600–1940.* London: B. T. Batsford, 1982.

*Dictionary of National Biography.* Edited by Leslie Stephen and Sidney Lee. Oxford: Oxford University Press, 1917.

Donohue, Joseph. *Dramatic Character in the English Romantic Age.* Princeton University Press, 1970.

Downer, Alan S. "Nature to Advantage Dressed: Eighteenth-Century Acting." *PMLA* 58 (1943): 1002–37.

Evans, Dorinda. *Mather Brown: Early American Artist in England.* Middletown: Wesleyan University Press, 1982.

Feather, John. *The Provincial Book Trade in Eighteenth-Century England.* Cambridge: Cambridge University Press, 1985.

Garrick, David. *The Letters of David Garrick.* Edited by David M. Little, George M. Kahrl, and Phoebe de K. Wilson. Cambridge, MA: Harvard University Press, 1963.

Gentleman, Francis. *The Dramatic Censor; or, Critical Companion.* 2 vols. London: J. Bell, 1770.

Godfrey, Richard. *Printmaking in England.* New York: New York University Press, 1968.

Graves, Algernon. *A Dictionary of Artists Who Have Exhibited Works in the Principal London Exhibitions from 1760 to 1893.* New ed. London: Henry Graves, 1895.

———. *The Royal Academy of Arts: A Complete Dictionary of Contributors and Their Work from Its Foundation in 1769 to 1904.* London: S. R. Publishers, 1970.

———. *The Society of Artists of Great Britain, 1760–1791; the Free Society of Artists, 1761–1783: A Complete Dictionary of Contributors and Their Work from the Foundation of the Society to 1791.* London: G. Bell. 1907.

Hammelmann, Hanns Andreas. *Book Illustration in Eighteenth-Century England.* Edited and completed by T. S. R. Boas. New Haven: Paul Mellon Center for British Art, Yale University Press, 1975.

Heal, Ambrose. *The English Writing Masters and Their Copy-Books.* Cambridge: Cambridge University Press, 1931.

Heawood, Edward. *Watermarks, Mainly from the Seventeenth and Eighteenth Centuries.* Vol. 1, *Monumenta Chartae Papyraceae Historiam Illustrantia,* edited by E. J. Laborie. Hilversum: n.p., 1950.

Highfill, Philip H. Jr. "Rich's 1744 Inventory of Covent Garden Properties." *Restoration and Eighteenth-Century Theatre Research* (November 1966), 5: 7–26; (May 1967), 6: 27–35.

Highfill, Philip H. Jr., Kalman A. Burnim, and Edward A. Langhans. *A Biographical Dictionary of Actors, Actresses, Musicians, Dancers, Managers, and Other Stage Personnel in London, 1660–1800.* 16 vols. Carbondale: Southern Illinois University Press, 1973–93.

Hills, Richard H. *Papermaking in Great Britain, 1488–1988.* London: Athlone, 1988.

Hind, Arthur M. *A History of Engraving and Etching, from the Fifteenth Century to the Year 1914.* 3d ed. London: Constable, 1923.

Hogan, Charles Beecher, ed. *The London Stage, 1660–1800.* 3 vols. Carbondale: Southern Illinois University Press, 1970.

Howe, Ellic. *The London Bookbinder, 1780–1806.* London: Dropmore, 1950.

Hughes, Leo. *The Drama's Patrons.* Austin: University of Texas Press, 1971.

Hunt, Leigh. *The Autobiography of Leigh Hunt.* Rev. ed. Introduction by Edward Blunden. Oxford: Oxford University Press, 1928.

[Huth, Henry]. *Catalogue of the Famous Library of Printed Books, Illuminated Manuscripts . . . Collected by Henry Huth.* London: Dryden, [1911–20].

Joseph, Bertram. *The Tragic Actor.* London: Kegan, Paul, 1959.

Knight, Charles. *The Shadows of the Old Booksellers.* London: Bell & Daldy, 1865.

Langhans, Edward A. "The Theatres." In *The London Theatre World, 1660–1800,* edited by Robert D. Hume. Carbondale: Southern Illinois University Press, 1980.

Maxted, Ian. *The British Book Trades, 1710–1777.* Exeter: by the author, 1983.

———. *The London Book Trades, 1775–1800. A Preliminary Checklist of Members.* London: Dawson, 1977.

Mayes, Ian. "John Bell, *The British Theatre,* and Samuel De Wilde." *Apollo* 113 (1981): 100.

Morison, Stanley. *John Bell 1745–1831: Bookseller, Printer, Publisher, Typefounder, Journalist, &c.* Cambridge: Cambridge University Press, 1930.

Pedicord, Harry W. *The Theatrical Public in the Time of Garrick.* New York: King's Crown, 1954.

Plomer, H. R., G. H. Bushnell, and E. R. McC Dix. *A Dictionary of Printers and Booksellers . . . in England, Scotland, and Ireland from 1726 to 1775.* Oxford: The Bibliographical Society, Oxford University Press, 1932.

Redgrave, Samuel. *A Dictionary of Artists of the British School.* London: George Bell, 1878.

Roach, Joseph R. *The Player's Passion: Studies in the Science of Acting.* Newark: University of Delaware Press, 1985.

Rosenfeld, Sybil, "A Diary by Samuel De Wilde." *Theatre Notebook* 20 (1965/66): 35–36.

———. *Temples of Thespis: Some Private Theatres and Theatricals in England and Wales, 1700–1820.* London: Society for Theatre Research, 1978.

Sessions, William, and E. Margaret Sessions. *Printing in York from the 1490s.* York: William Sessions, 1976.

Shorter, Alfred H. *Paper Making in the British Isles; an Historical and Geographical Study.* New York: Barnes & Noble, 1972.

Smith, John Chaloner. *British Mezzotint Portraits.* 6 vols. London: H. Sotheran, 1884.

Stone, George Winchester Jr., and George M.

Kahrl. *David Garrick: A Critical Biography.* Carbondale: Southern Illinois University Press, 1979.

Thieme, Ulrich, and Felix Becker. *Allgemeine Lexikon der Bildenden Kunstler von der Antike bis zur Gegenwart.* Leipzig: W. Engelmann, 1912.

Timperley, C. H. *Encyclopedia of Literary and Typographical Anecdote.* London: H. Johnson, 1842.

Todd, William H. *A Directory of Printers and Others in Allied Trades: London and Vicinity, 1800–1840.* London: Printing Historical Society, 1972.

Walpole, Horace. *Horace Walpole's Correspondence with the Countess of Upper Ossory.* Edited by W. S. Lewis and A. Dayle Wallace, with the assistance of Edwin M. Martz. New Haven: Yale University Press, 1965.

Waterhouse, Ellis K. *The Dictionary of British Eighteenth-Century Painters in Oils and Crayons.* Woodbridge, Suffolk: Antique Collectors Club, 1981.

Waugh, Nora. *The Cut of Women's Clothes, 1600–1930.* New York: Methuen, 1968.

West, Shearer. *The Image of the Actor: Verbal and Visual Representation in the Age of Garrick and Kemble.* London: Pinter, 1991.

Worthen, William B. *The Idea of the Actor, Drama, and the Ethics of Performance.* Princeton University Press, 1984.

# PHOTOGRAPHIC CREDITS

The authors wish to thank the following individuals and institutions for kindly allowing them to reproduce the illustrations used in the Catalog of Portraits.

British Museum: 59, 61a, 62, 68a, 68b, 70, 71, 73,74a, 127, 134, 147, 148, 275, 293a, 296, 307, 319, 337, 343a, 346.
Garrick Club: 93, 233a, 237, 237a, 246a, 251a, 254a, 256a, 266a, 267a, 268a, 283a, 284a, 326a, 329a, 331a.
Harvard Theatre Collection, The Houghton Library: 136, 316.
Manchester City Art Galleries: 327b, 348b.
Jack Reading: 25, 27, 41, 64, 65, 86, 308
The Royal National Theatre: 262a, 334a.

All other photographs are from the Collection of Jennie Walton.

KALMAN A. BURNIM is Fletcher Professor of Drama and Oratory emeritus at Tufts University. He is the author of *David Garrick, Director* and the six-volume *The Plays of George Colman the Elder*, and editor, with Andrew Wilton, of *Pictures in the Garrick Club: A Catalogue*, by Geoffery Ashton.

PHILIP H. HIGHFILL JR. is a professor emeritus of English at George Washington University. He is the editor of *Shakespeare's Craft: Eight Lectures* and, with George Winchester Stone, author of *In Search of Restoration and Eighteenth-Century Biography*.

Professors Burnim and Highfill, together with Edward A. Langhans, wrote and compiled the sixteen-volume *Biographical Dictionary of Actors, Actresses, Musicians, Dancers, Managers, and Other Stage Personnel in London, 1660–1800*, which received special citations from the American Society for Theater Research and the Theater Library Association.